FV

WITHDRAWN

LISETTE model

Ann Thomas

National Gallery
of Canada

OTTAWA 1990

LISETTE model

Published in conjunction with the exhibition **LISETTE MODEL**, organized by the National Gallery of Canada

National Gallery of Canada, Ottawa
5 October 1990 – 6 January 1991

International Center of Photography, New York
2 February – 23 March 1991

Museum of Art, San Francisco
18 April – 9 June 1991

Vancouver Art Gallery, Vancouver
17 July – 9 September 1991

Museum of Fine Arts, Boston
Autumn 1991

Museum Ludwig, Cologne
Spring 1992

This catalogue was produced by the Publications Division
of the National Gallery of Canada, Ottawa.
Serge Thériault, Chief
Susan McMaster and Jacques Pichette, Editors
Colleen Evans, Picture Editor
Jean-Guy Bergeron, Production Manager

Designed by Grauerholz Design Inc., Montreal
Printed by Tri-Graphic, Ottawa, on Warren's Patina
Typeset in Caslon (540), Trade Gothic and Franklin Gothic
by Zibra, Montreal
Duotone separations by Chromascan, Ottawa

Available from your local bookstore or
The Bookstore
National Gallery of Canada
380 Sussex Drive, Box 427, Station A
Ottawa K1N 9N4

PRINTED IN CANADA

Canadian Cataloguing in Publication Data

Thomas, Ann.
Lisette Model.

Issued also in French under the same title.
Includes bibliographical references.

ISBN 0-88884-605-3

1. Model, Lisette, 1901-1983. 2. Photography, Artistic.
3. Photographers – United States – Biography.
4. Women photographers – United States – Biography.
I. Model, Lisette, 1901-1983. II. National Gallery of Canada.

TR647M62T56 1990 779'.092
 CIP 90-099163-1

Photograph Credits

Copy photographs have been provided by the owners or custodians
of the works reproduced, except for the following:

Copy photographs of all works in the collection of the Estate of
Lisette Model: National Gallery of Canada

Catalogue:

18, 23 Alex Jamison Photography, Alexandria, Virginia
145 Estate of Lisette Model
9, 15, 18, 40, 41, 66, 71 National Gallery of Canada
47, 70, 72, 85, 113, 114, 118, 120, 126, 183 Adam Reich, New York
78, 139 Michael Tropea, Highland Park, Illinois

Figures:

67 The author
133 Callaway Editions Inc., New York
8, 20 The Galerie St Etienne, New York
1, 4, 32, 35, 43, 54, 59, 73, 76, 77, 100, 101, 105, 109, 113
Estate of Lisette Model
15, 19, 28, 31, 34, 36, 60, 69, 71, 112, 119
National Gallery of Canada
56 Photofind Gallery, New York
55 Sotheby's, New York
51 Zindman / Fremont, New York

*To Berenice Abbott, Rogi André, Diane Arbus, Valeska Gert,
and Elizabeth McCausland, and to the memory of Olga Seybert*

CONTENTS

FOREWORD

Lisette Model was an extraordinary photographer, bold and compassionate.
Utterly convinced of the power of images, she was also one of the truly outstanding teachers of photography in the twentieth century, numbering among her students photographers Diane Arbus and Rosalind Solomon, and influencing such peers as Minor White. Through this retrospective, the National Gallery acknowledges the importance of her great contribution to photography in this century: too often her *œuvre* has been dismissed as too small, or as created in too contracted a period of time to warrant the dedicated attention it deserves. I believe the exhibition and this catalogue will right the balance.

The exhibition has also become an occasion to celebrate a splendid gift to the National Gallery: the Lisette Model archives of negatives, teaching notebooks, correspondence, and two hundred prints, as well as funding for research in the history and criticism of photography. We are grateful to Joseph Blum, executor of the Estate of Lisette Model, for choosing the Gallery to house and disseminate the work of this major figure in twentieth century photography.

The National Gallery of Canada Photographs Collection is international in scope, and includes notable individual examples and groups of North American, European, and Middle and Far Eastern photographs. As a result, the Photographs Collection has received some outstanding donations, including Phyllis Lambert's gift of European daguerreotypes and of work by Walker Evans, and the gift of almost a hundred portraits by Yousuf Karsh.

The first photograph by Lisette Model to form part of our collection was given to the Gallery in 1968 by Dorothy Meigs Eidlitz, along with a number of photographs and paintings by American artists Edward Weston, Lionel Feininger, and Arthur Dove. Dorothy Meigs Eidlitz, an American who spent her summers in St Andrews, New Brunswick, and who founded the Sun and Sunbury Shores arts and crafts school in that city, was also a photographer. She earned the distinction of being the only person who consistently purchased works from New York's first photography gallery, the Limelight. It was there in 1954 that she bought Model's *Woman with Veil* (pl. 10) from the gallery's first exhibition, *Great Photographers*.

Recognizing the importance of Lisette Model, the National Gallery of Canada made a major commitment to her work several years ago by purchasing twenty-six of her photographs in 1985 and an additional three images in 1986. This exhibition presents many of these works in the context of her *œuvre*.

Without the support and generosity of lenders there would have been neither exhibition nor book. The works made available to us by Frank and Peggy Canale, David Carrino, Edward R. Downe, Jr, Elaine Ellman, John Erdman and Gary Schneider, Arnold Kramer and Emily Carton, Mr and Mrs Richard L. Menschel, Janet Rosen, Gerd Sander and the Sander Gallery, Dr Richard Sandor, and Andrew Szegedy-Maszak and Elizabeth Bobrick have added an invaluable dimension to this exhibition. Similarly, the Center for Creative Photography, Tuscon, the J. Paul Getty Museum, Malibu, the Museum Folkwang, Essen, the Museum of Fine Arts, Boston, the San Francisco Museum of Modern Art, The Art Institute of Chicago, The Chrysler Museum, Norfolk, Virginia, The Library of Congress, Washington, D.C., The Metropolitan Museum of Art, New York,

and the National Portrait Gallery of the Smithsonian Institution, Washington, D.C., in lending their Lisette Model holdings, have contributed greatly to the success of the exhibition of this important photographer.

Lisette Model's convictions, aesthetic and moral, were passed on to her students both by example and in the words of artists she admired. One source from which she quoted often was *Conversations of Goethe with Eckermann* (New York: Dutton, 1930). Goethe remarks that "People always talk of the study of the ancients. But what does that mean except that it says, 'Turn your attention to the real world and try to express it,' for that is what the ancients did" (p. 126). Certainly Model attempts just that, and in the work presented in the exhibition and celebrated in this book, I believe the viewer will be convinced that she succeeded in expressing the real world.

Lisette Model was an artist of courage, exploring at the limits of the conventional, changing fundamentally the art of photography, and, as all great artists, transforming our image of ourselves.

Dr SHIRLEY L. THOMSON
Director
National Gallery of Canada

In 1986, when this retrospective exhibition of Lisette Model's photographs and the accompanying book were first conceived, virtually nothing existed that placed her work within a biographical and art historical context. Given the strength of her imagery and her powerful influence as a teacher, this was an obvious hiatus; however, it was not one attributable to critical indifference, for during the last five years of her life she had been the subject of several articles, numerous published and unpublished interviews, and two monographic publications, one an exhibition catalogue and the other a handsome picture book. The absence of any comprehensive or in-depth examination of her work can be traced back to the will of the artist herself who, despite her gift for and enjoyment of the spoken word, harboured a surprisingly deep suspicion of the written word, particularly when her work or thoughts or life were the subject of such discourse: her expressed preference was for a book that would dispense entirely with words. She also exercised vigorous control over the interpretation and dissemination of her photographs.

Were it not for the two acquisitions of her photographs by the National Gallery of Canada, one in 1985 of twenty-six and the other in 1986 of three images, I might simply have taken a note of this lamentable gap, and persisted with my plans to work on a nineteenth century British male photographer of uncomplicated character. But the process of undertaking research in support of these acquisitions intensified my already strong attraction to Model's photography and prompted me to ask a great many questions of Gerd Sander, who had been closely associated with her from 1975 until her death in 1983, and whose gallery represented her work. One question concerned the possibility of undertaking a major Lisette Model retrospective. This led me to examine the entire archive, including many images that had not been put before the public eye, and consequently to discover a depth and breadth in her vision that made a more profound exploration of her art and life seem to be a necessity.

In producing an exhibition and a book that draw heavily from the raw contents of the archive (photographic prints, negatives, teaching notebooks, and correspondence), I have aimed to present a fuller and more accurate picture of her accomplishments as a photographer and teacher than has so far been made, and to provide a glimpse into a life lived with passion, commitment, and humour, but marked more deeply by pain than she would have led anyone to believe.

This accomplishment would not have been possible were it not for the many individuals who gave generously of their time, participating in interviews and permitting me access to their correspondence and photographs. Joseph Blum, executor of the estate of Lisette Model, and his staff, Richard Blakeman and Lilian Maisel, must be thanked not only for having made the contents of the Model archive accessible but also for responding to an overwhelming number of requests. In a similar manner Gerd Sander provided enormous support at every stage for the writing of this book and for the organization of the exhibition. In addition to making photographs and documents available for my viewing, he shared his impressive knowledge of and enthusiasm for her work.

My task was also made easier by the availability of taped and unpublished

interviews by a number of individuals with this engaging but elusive subject, long before my forays into the field. I have drawn heavily on the interviews of Jim McQuaid and David Tait of the Oral History of Photography Project, International Museum of Photography at the George Eastman House, New York, and in addition would like to thank Janet Beller, Tom Cooper and Paul Hill, R.H. Cravens, Joe Cuomo, Philip Lopate, Dianora Niccolini, Charles Reynolds, and Sheila Seed, as well as Haverford College, Haverford, the International Center of Photography, New York, the Photographic Resource Center, Boston, and the Pratt Institute, New York.

Family members, friends, and students of Lisette Model not only extended generosity in terms of the time they spent talking to me about her work and life, but were without fail hospitable and friendly. Although Olga Seybert, the only remaining member of the Seybert family when this project first began, sadly did not live to see the exhibition or this book in print, her contribution was invaluable, as was that of Bianca Bauer, her sister-in-law. I am most grateful for the assistance I received from American relatives of Evsa Model, in particular, his nephew, Constantine Ash, and also his second cousin, Dr Jacob Avshalomov. But for their cooperation, an important aspect of Lisette's life in the United States of America would have remained unknown. I owe thanks also to Julia Heinz and Anita Lassance, close friends of Lisette's from Vienna and Paris. Their clear memories of and affection for her informed my vision of her early years, as did Michel and Suzanne Seuphor's recollection of her and Evsa in the mid-thirties in Paris.

A special note of thanks is due to Peter C. Bunnell, McAlpin Professor of the History of Photography and Modern Art, Princeton University, for clarifying the relationship between Lisette and Minor White by providing me with valuable information and by reading several chapters of the manuscript.

The many other people who shared memories with me, provided documents, furnished photographs, and generally went beyond the call of personal and professional duty were: Elaine Ellman, Bill Ewing, Helen Gee, Dee Knapp, Dr Elizabeth Mach, John Morris, and Nata Piaskowski. In addition, the following people kindly responded to my letters and requests for interviews: Virginia Adams and Pamela Feld of the Ansel Adams Estate; Allan Arbus; Doon Arbus and Mary Drugan of the Diane Arbus Estate; Alan Arkin; Henrietta Brackman; Eve Tartar Brown; Harry Callahan; Thomas Carr-Howe; Henri Cartier-Bresson; Howard Chatnick of Black Star Photo Agency, New York; Arlene Collins; Mrs Sidney Cowell; Bruce Cratsley; Nancy D'Antonio; Hans Deichmann; Phyllis Diller; Sebastian Dubroskin; Arnold Eagle; Dorothy Wheelock Edson; Viviane Esders; Ben Fernandez; Kaspar Fleischman; Marty Forscher; Stephen Frank; Chuck Freedman; Professor Alice Gerstl-Duschak; George Gilbert; Renate Gollner; Howard Greenberg of Photofind, New York; Jane and Manny Greer; Hermann Greissle; Miriam Grossman Cohen; Andy Grundberg; Suzy Harris; Paul Hertzman; Gloria Hofman; Walter Hopps; Diana Emery Hulick; Gerald Incandella; Eleanor and Ray Jacobs; Ruth Baruch and Pirkle Jones; Marc Kaczmarek; Clemens Kalisher; Barbara Kasten; Arnold Kramer; Ziva Krauss of the Ikona

Photo Gallery, Venice; Helen Levitt; Sol Libsohn; Sol Lopes; Stefan Lorant; Harry Lunn; Martin Magner; Robert Mann; James Mathias; Grace Mayer; Jim McQuaid; Wayne Miller; Marie-Claire Montanari; Herbert Moss; Beaumont Newhall; Dianora Niccolini; Jon Pearce; Christopher Phillips; Allan Porter; Dr Pearl Primus; Julie Pratt; Karen Radkai; Celia Rogers; Mrs Miriam Rose; Walter and Naomi Rosenblum; Joan Roth; Eva Rubinstein; Nancy Rudolph; Antonella Russo; Felicia Sachs; Lawrence Schoenberg; Mark Schubart; Robert Shamis; Aaron Siskind; Rosalind Solomon; Kurt Steinitz; John Szarkowski; G. Thomas Tanselle; Alexandra Truitt; David Vestal; the late Diana Vreeland; Lisel Neuman Viertel; Robert Walker; Todd Webb; Bruce Weber; Wilma Wilcox; William Earle Williams; and the Sidney Janis Gallery, New York.

Many individuals and institutions have provided professional support: Artur Bablok, Counsellor for Press and Culture at the Austrian Embassy, who was especially helpful; Bruno Bellone, Cultural Attaché at the Italian Embassy; Gilberto Carrasquero, the Ambassador of Venezuela in Canada from 1987 to 1989; and Agnès de Gouvion Saint-Cyr, Head of the Photography Mission, Ministry of Culture and Communication, France. I am very grateful to the archivists, librarians, and staffs of the archives, libraries, and other institutions listed in the sources, for the assistance they provided. In addition, I would like to thank Madeleine M. Nichols, Curator, Dance Collection, New York Public Library Performing Arts Research Center; Becky Simmons, Serials Librarian, International Center of Photography at the George Eastman House; Dr Helmut Kretschmer of the Landesarchiv, Vienna; James P. Crowley, Director of Dog Events, American Kennel Club; Amy Rule, Archives Librarian, Center for Creative Photography, University of Arizona, Tucson; Wayne Schoaf, Archivist, Arnold Schoenberg Institute, University of Southern California, Los Angeles; Wayne Shirley, Music Specialist, Music Division, Library of Congress, Washington, D.C.; and Miles Barth of the International Center of Photography, New York. I am also grateful to the staffs of the Periodicals Division, National Library of Canada, Ottawa; the Music Division, National Library of Canada, Ottawa; the Allgemeines Verwaltungsarchiv, Vienna; the Österreichisches Staatsarchiv, Kriegsarchiv; the Archives départementales, Alpes-Maritimes; the Archives Municipales de Nice; the San Francisco Art Institute Archives; the Archives Municipales de Lyons; the Porträtsammlung-Bildarchiv, Österreichische Nationalbibliothek; the Bibliothèque de la Ville de Paris; the Bibliothèque nationale, Paris; and the New York Historical Society.

Within my own institution, many people of all departments applied their considerable talents to this project. The Publications team: Serge Thériault, Chief, Colleen Evans, Picture Editor, Jean-Guy Bergeron, Production Officer, Irene Lillico, Editorial Coordinator, Micheline Ouellette, Word Processing Operator, and, in particular, English Editor Susan McMaster and French Editor Jacques Pichette worked with a passion and exactitude on the editing and production of this book that Lisette herself would have admired. Jim Borcoman, Curator of Photographs, gave thoughtful and invaluable guidance to the project. John McElhone, Conservator of Photographs, and Allan Todd, Designer of the

exhibition, used their specialized knowledge to support and enhance the work of an artist they both enjoyed; Librarians Maija Vilcins and Sylvia Giroux serviced numerous interlibrary requests and assisted in other ways, as did Acting Head Librarian, Roy Engfield. Anne Newlands of the Education Department organized the many educational enhancements for the exhibition with energy and a contagious enthusiasm. The successful realization of this exhibition depended heavily on the participation of Registration and I thank Delphine Bishop, Registrar, and Kate Laing, Coordinator, Art Loans Program, for their commitment to the exhibition. Finally, Naomi Panchyson, Coordinator, National and International Programmes, Jacques Naud, Coordinator, Special Projects, Michael Gribbon, Barbara Boutin, and Hazel Mackenzie of the Photographs Collection, and Ches Taylor, Roland Bernard, and many others not mentioned, also made a most important contribution.

The thoughtfulness, quick intelligence, and elegance that characterize the book's design are due to the extraordinary efforts of designer Angela Grauerholz, who has enjoyed a longtime fascination with the images of Lisette Model.

Above all I owe a debt of thanks to Lori Pauli, Curatorial Assistant, for her work on the bibliography, chronology, and general research, and for handling unorthodox and overwhelming requests with perseverance, imagination, and a sense of humour that tipped the balance when things got desperate.

There are friends and family members whose patience and support have been sorely tried throughout my involvement with this project. I thank them. I especially acknowledge, in this respect, Rebecca.

A.T.

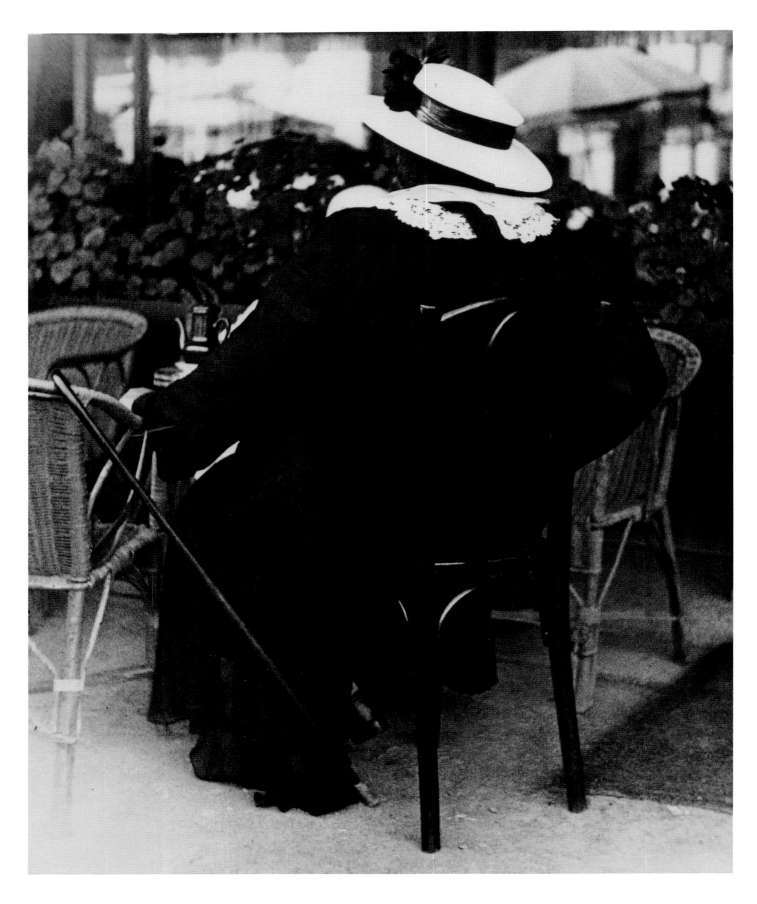

1 **Famous Gambler** French Riviera 1934?

INTRODUCTION Lisette Model was, to a large extent, her own creation. In over eighty years of life she changed the recounting of her history as she saw fit, constructing a self-made narrative impossible to separate from her work. To an art historian and biographer, her insistence upon the significance of this narrative gives it a virtual status as an unpublished and unpublishable biography. It cannot be dismissed as an irrelevant fiction, despite her evident struggles with its inconsistencies and elaborations: it reveals too much about her hopes and disappointments, offers too many missing connections. The ominous shadows in the *Reflections* series, for example, or the fragmented forms of the 1953 Italian work, combine with Model's varying stories of their making to allow insights into the nature of a woman, sexually betrayed as a child, perceptive and ambitious as an adult, courageous and influential as an artist, who came of age in a time profoundly different from our own.

The contradictions that are the root of Lisette Model are the root also of her work. However, just as there is some elusive and mystical ingredient in every human life, there exists an equal element of the banal. The recording of history demands an allegiance to specific facts of time and place: it is useful to know what paths we have taken and when. This book, therefore, considers both sides of Lisette Model – the facts, as uncovered in the archival records, and the shifting narrative, which provides an essential key to her story.

Few have controlled as fiercely the documenting of their histories. During Model's life, whenever a biography was begun, even based on

information she herself had provided, some shadow always fell, usually shortly after the initiation of the project. Her seemingly curious habit of first talking freely about her life, and then denying her words or refusing to permit publication resulted in collapsed projects, censored writings, and severed friendships.

On consideration, her resistance to letting go of the legendary self seems less a desire to retain a public image than an attempt to protect the sense of creativity and possibility that she had constructed. This self, complex and uncapturable, was what made her an outrageous photographer and a teacher without peer. Certainly it became more developed in response to the admiring American public of the 1940s, for whom she was exotic, noble, and an extraordinary photographer, and no doubt she encouraged the image, changing facts to fit what she wanted to feel was true. While she did not run away from school eighteen times in as many months, as she once claimed to have done, she truly was a rebel. If she was not of noble birth, she behaved as if she were. It was the collision of the two worlds of experience, one created by her and one determined for her, that she could not accept. For example, poised to fill out an application for a grant, she would hesitate over the birth date: 1901 or 1906? Sometimes she left off the last digit.[1] This was not simply data to her, but represented an area of great vulnerability: the station of her birth; her unhappy childhood; her father's Jewish heritage; the family name change; her education; her friendship with the Schönberg family; and her desire to become a concert pianist[2] – parts of her life associated with pain, confusion, and unrealized potential.

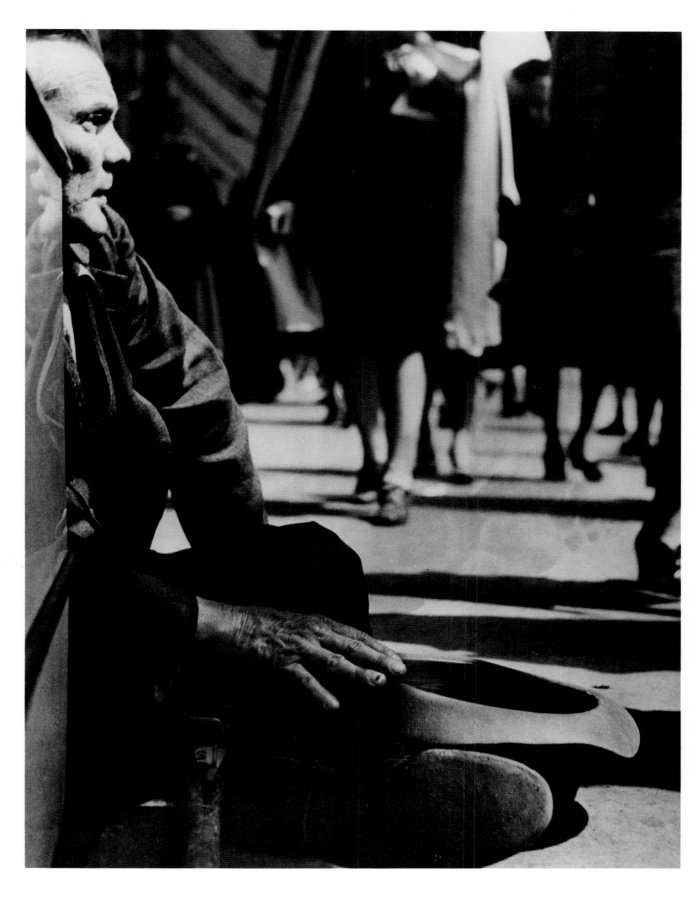

2 **New York** between 1940 and 1941

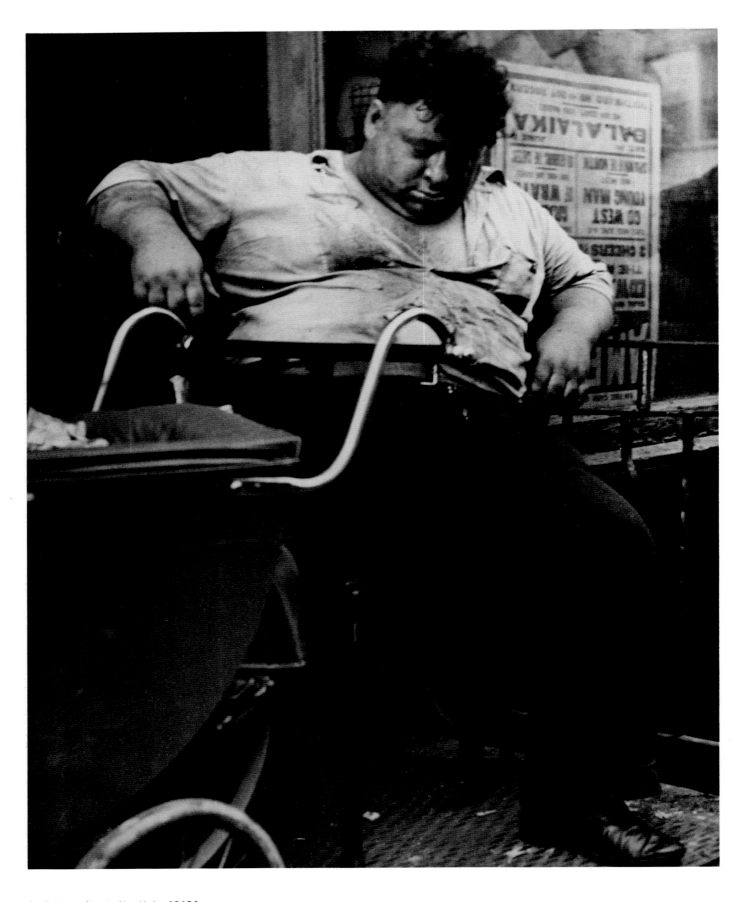

3 **Delancey Street** New York 1942?

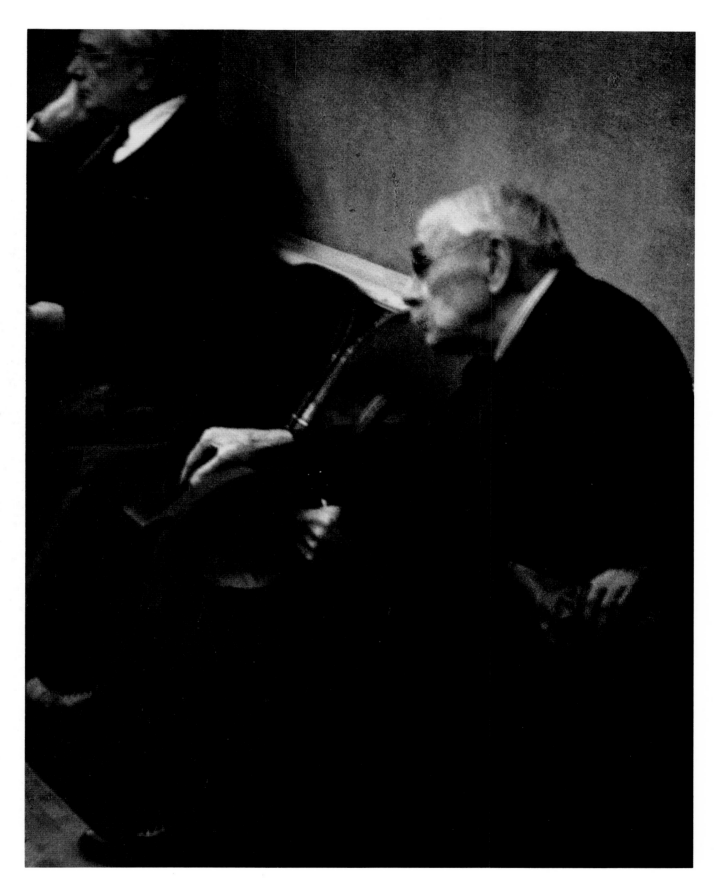

4 **International Refugee Organization Auction** New York 1948

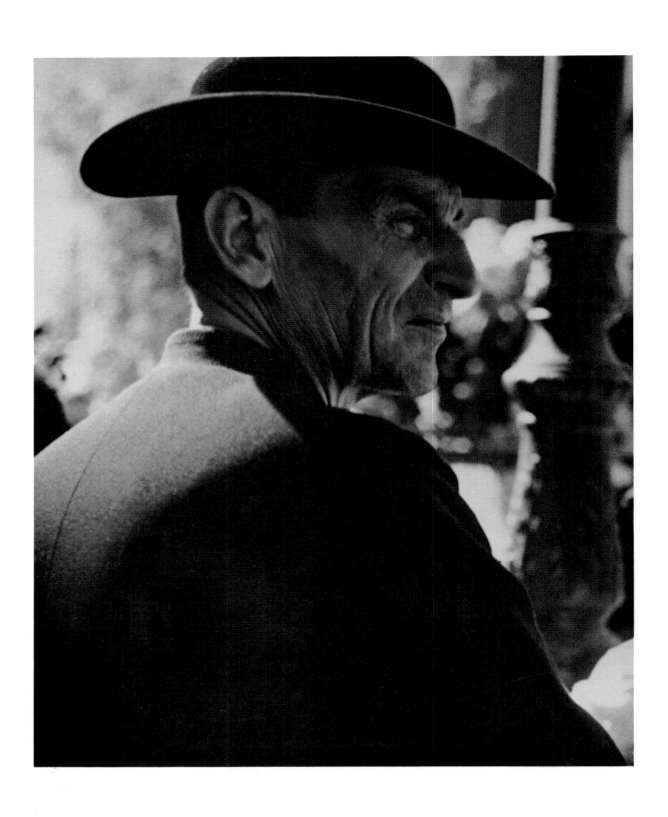

5 **Cardinal** Nice between 1933 and 1938

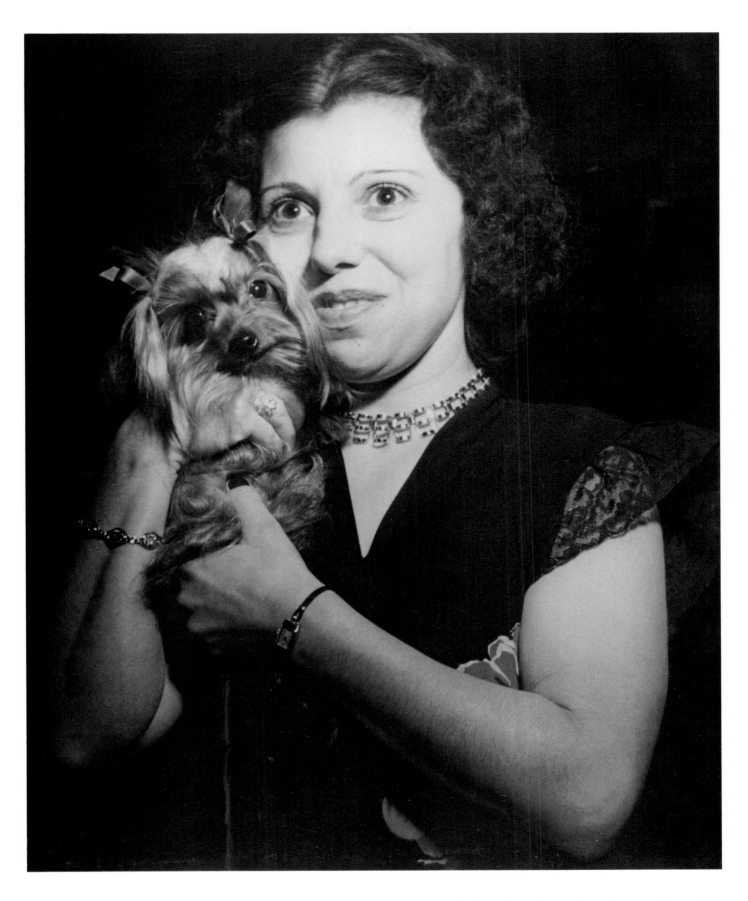

6 **Westminster Kennel Club Dog Show** New York February 1946

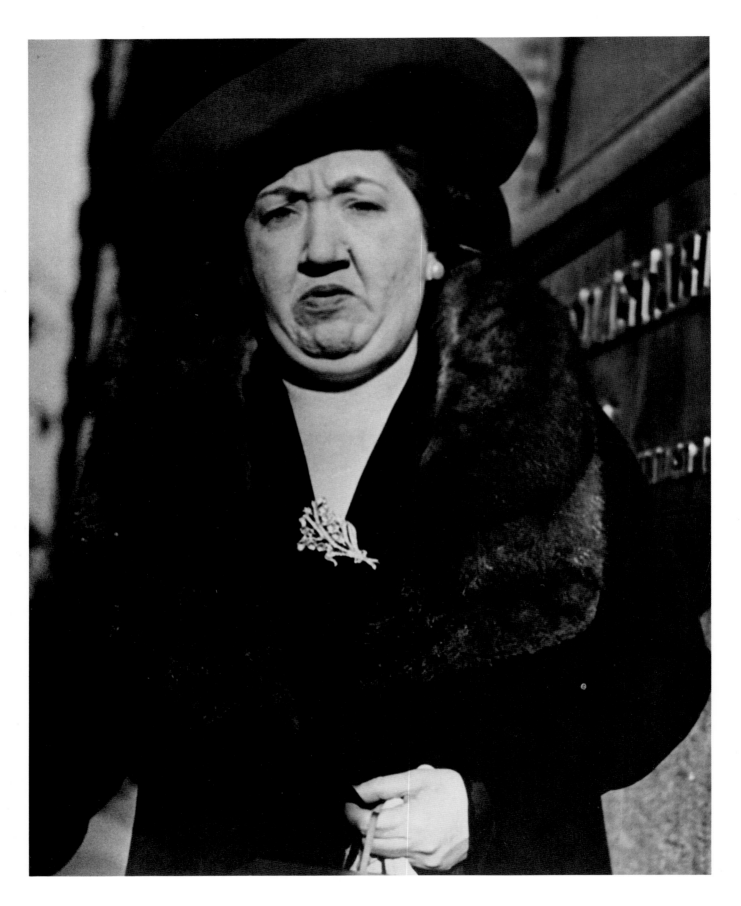

7 **Pedestrian** New York c. 1945

The truths to which Lisette Model held herself accountable were those of the inner self – truths formed out of a fiercely subjective connection to the outer world. She believed that the ideals by which we live and die should not be formed by the orthodox or banal, nor should a life be measured by external conventions. She once described to one of her classes the battle she waged against complacency and ambition for its own sake:

> The thing that shocks me and which I really try to change is the lukewarmness, the indifference, the kind of taking pictures that really doesn't matter.... This kind of looking for a good photograph or the *trying* to self-express oneself – you see self-expression but the motivation is not something irresistibly important. It is something [which is done] in order to make a career, to be proud of one's photographs, to become a great photographer, to become famous.... The so-called great photographers or great artists ... they don't think so much about themselves. It is what they have to say that is important. [3]

Model's frequent references in her notebooks to the world as a stage indicate the degree to which she understood the people and events around her as raw subjects for a narrative of her own. She experienced the mundane world intensely, presenting it as an opera filled with characters. Whether attired in the latest fashions or in rags, each person was, to her mind, richly costumed and living out a drama worthy of attention. Her interest in her surroundings and in human behaviour was, by all accounts, insatiable. Hers was a fecund, intuitive intelligence searching for the facts of life in their most extreme form, and when she found them she recorded them in the only way she saw fit: boldly, exaggeratedly. She brought all available tools of manipulation and emphasis to bear upon the image so that it would never be tepid. She loathed any condition that skirted total declaration. The images she left with us reflect both her curiosity and her passionate attachment to the world at large.

8 **Coney Island Bather** New York between 1939 and July 1941

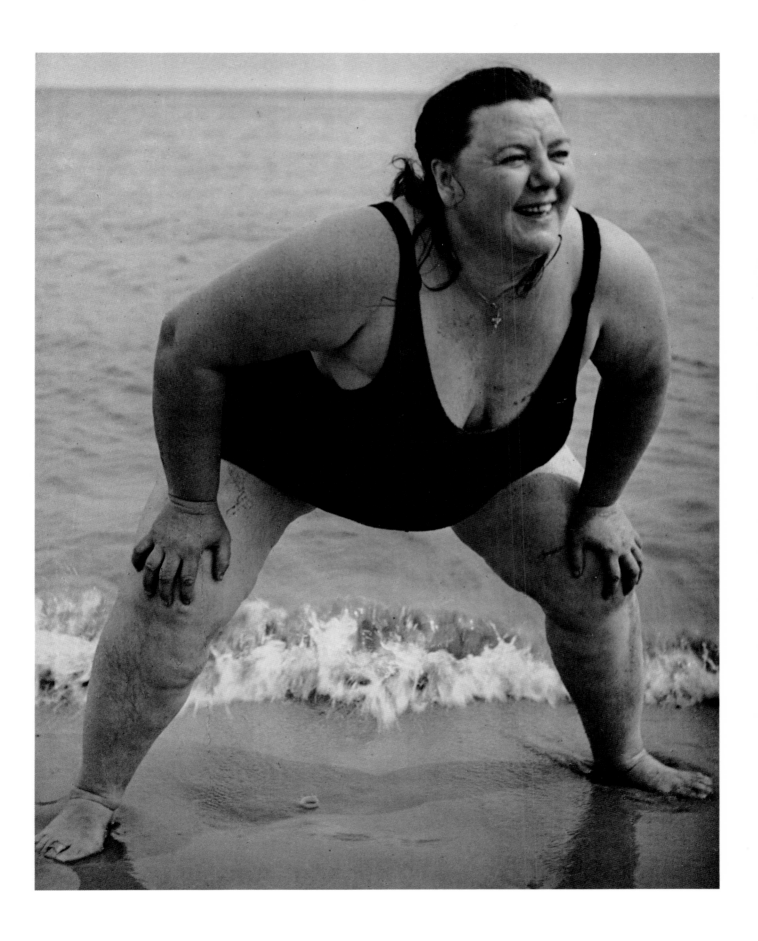

9 **Bois de Boulogne** Paris between 1933 and 1938

Tell me about your childhood, Lisette.

My childhood? Why do you want to know about that? You must not write about my childhood! That is out of the question, darling.

Why not?

Because it was a horrible childhood. Besides, I do not believe in this Freudian idea that you are completely moulded by your early years. Sometimes people change very much in their adult years.

Nevertheless, there is a correspondence . . .

Certainly. But there is also the problem of truth. I don't believe that one can say the way it was. If I speak about my childhood I am not telling the truth about it, I am interpreting it from my present mind.

Nevertheless, it will shed some light, however distorted . . .[4]

THE EARLY YEARS: VIENNA AND PARIS 1901–1933 CHAPTER ONE

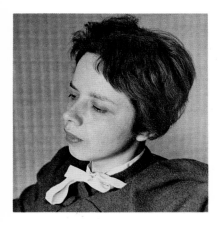

fig. 1
Lisette Seybert c. 1930

fig. 2
Olga Seybert c. 1936
Estate of Olga Seybert

VIENNA

The first of the contradictions that drove Lisette Model appears in the fact that all her creative energy, like that of many others of her time, place, and station, was directed toward music during her years in Vienna. No one who knew her during her youth could have guessed that she would one day make an important contribution to twentieth century photography. And yet, her sense of confrontation, acquired during this same period and a powerful force throughout her life, was essentially Austrian. To the Austrian way of thinking, resistance is a catalyst necessary for growth:

> To a large extent culture is the product of resistance to the *status quo* and the impulse man feels to oppose it. The forces that effectively influenced events in Vienna were of various kinds, some deriving from the past, others pointing to the future.[5]

Similarly, her passion for probing the psychology of others and observing the range of human types links her with the Expressionist art of the Vienna of her youth. The notebooks she compiled throughout her career as a teacher provide glimpses of her fascination with the neurological linking of eye and brain which triggers visual perception. Her appreciation of the crucial role that "nerve endings"[6] perform in connecting thought, feeling, and the thing seen went further than an understanding of it as a mechanical system. She believed in living intuitively and intensely, rejecting a filtering of human experience through any rationalizing process; paradoxically, she also believed that you had to train yourself in order to remain alive and open to the world in this way.[7]

In the Magistrate's office in Vienna, Lisette's arrival into the world is documented as follows: born on 10 November 1901, at the family home, 9 Josefsgasse in

fig. 3
Ann Thomas
9 Josefsgasse Vienna 1988
National Gallery of Canada,
Curatorial files

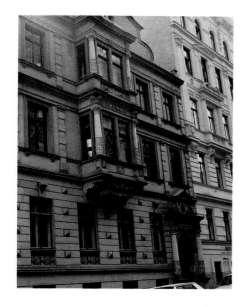

the 8th district of Vienna. The second child (fig. 1) of Félicie and Victor, she was baptised into the Catholic faith and named Elise Amelie Felicie Stern. It was during that year that the family took up residence at 9 Josefsgasse. A short, narrow street, Josefsgasse is located in the Josefstadt close to monuments of Austrian culture such as the Kunsthistorisches Museum, the Burgtheater, the Rathaus, and the Parlament. Developed extensively in the 1870s, this area, through its architecture and public monuments, projected an image of the power of the Austro-Hungarian Empire, with vast public parks and gardens, sculptures of rearing horses, robust nudes in fountains, and opulent buildings. By the end of the Second World War, these no longer testified to strength and riches, but to their illusory nature. A description of Vienna written after the First World War evokes the physical magnificence of the area around the Josefstadt:

> Yet what a proud show Vienna makes! – its Burg Theatre with its view over the Ring, formerly the old walls of Vienna and now its boulevards; its beautiful Volksgarten, its Rathaus Tower, its Belvedere, its picture gallery, its palace dating from the Thirteenth Century. . . . And the Prater Park with its chestnut trees, its café tables, its orchestras playing Strauss waltzes, Hungarian melodies, and Wagnerian operas! And the Stadt Park, into which poured students, laughing girls, and comfortable looking bourgeois;

but hints also at the changed social pattern:

> Well, Sacher's has certainly no aristocratic air today; its habitués are of the student and bourgeois classes, with the inevitable sprinkling of gay girls. . . . Perhaps there never were so many Grand Dukes as is pretended at Sacher's; any more than there were at Montmartre. Every European capital has this kind of legend; it did no harm, and you could persuade yourself that your neighbour was a Balkanic potentate, while he could persuade himself that you were one of the numerous Germanic Kinglets. . .[8]

The Josefsgasse home was a fairy-tale house built in 1890 (fig. 3). With its ornate façade, a fantasy of lavish ornamentation composed of *putti* heads, garlands, and cornucopia, it impressed itself so vividly on Lisette's memory that she recalled it in almost every interview she gave. In 1909, when Olga (fig. 2), the third and last child, was born, a fourth storey was added to the house.

Victor, her father, was Jewish. Continually throughout his life he faced anti-Semitic discrimination, and consequently experienced a recurring crisis of self-identity common to many Austrian Jews who were forced to struggle with loyalties divided between nation and religion. Symptomatic of this was Victor's official change of the family name from Stern to Seybert in February 1903 when Lisette was about fifteen months of age.[9] A growing climate of anti-Semitism in Austria generally, and in Vienna in particular, at that time, made name changes relatively commonplace. As small as such concessions to peace and anonymity may have then seemed, they tragically ruptured the sense of personal historical continuity of these families. If this provided an early lesson for Lisette on the conformist nature of Viennese society, she also learned that any correspondence between

fig. 4
Françoise Antoinette Félicité Picus (Seybert) c. 1890

At the age of nineteen he volunteered for military service at his own expense, becoming part of the prestigious reserve unit. Assigned to Company 4 of the Ritter von Ludwig Regiment, he was posted three years later to the Garrison Hospital No. 2 in Vienna, and then was transferred several times. On 26 July 1892, he was awarded a Doctor of Medicine from the University of Vienna. Then appointed Medical Assistant (First Class), he was soon after transferred to the Ritter von Ludwig Regiment No. 14, where he seems to have been stationed for some time. In 1898 he was awarded the Jubilee Medal. In 1910, he was discharged from the Imperial and Royal Home Guard after completing a tour of duty. At some point he became connected with the International Red Cross.[11]

appearance and reality was more fortuitous than not, and that under the surface of polite bourgeois behaviour there might well commingle suppressed realities of pain, suffering, and despair.

Victor Hypolite Josef Calas Stern was the only child of an Austro-Czech father, Bernhard Stern, and a Venetian-Italian mother, Elisa Pacifico. He was born in Vienna on 23 August 1866.[10] For most of his adult life, Victor was attached in some capacity to the Imperial Army, mainly as a medical doctor.[11] A cultivated individual, he enjoyed the music of Mahler, and played the piano well. Both his daughter Olga and his daughter-in-law Bianca recalled a vast library, of which he was proud. His family belonged to the bourgeoisie, living not in Leopoldstadt, the Jewish ghetto, but in the Schottengasse district, at 1 Schottenring, where the birth of their first child, Salvatór, a son, was registered on 23 October 1900.[12] As well, Victor possessed extensive land holdings in Italy through the Italian side of his family.

Lisette's mother, Félicie (fig. 4), also an only child, came from a Savoyard family about whom scant records exist, other than that they left the region in 1878. A devout Catholic, baptised Françoise Antoinette Félicité Picus, she was born in Albens, Department of Savoy, France, on 3 July 1866, to François Hypolite Picus and Michelle Matrod. She came to Austria either to work in the Austrian court[13] or on a language exchange,[14] and there she met her future husband. In December 1899 she married him in a civil ceremony in Vienna.[15]

With the First World War, the fortunes of many bourgeois Viennese were lost overnight, prompting prominent Viennese educator Eugenie Schwarzwald to open soup kitchens for the middle class. To the extent that they owned property and generated their wealth from this, the Seyberts were among those affected. Lisette remembered her father seated in front of the fire burning his papers, undoubtedly stock certificates and land deeds. Later in her life, Lisette several times described the fate of humankind as a common vulnerability to the uncertain twists and turns of events. Although she couched her description in universal terms, she was really speaking from personal experience. When students confronted her with the question of the ethics of photographing a stranger, particularly somebody who was down and out, she would respond that, only photographers who understood that the life before them could be their own should take such photographs.[16]

Compared to those who were reduced to surviving from hand-outs, the losses of the Seybert family were less drastic. Servants and tutors were dismissed and they lost social standing: the colleagues and friends Victor Seybert had wined and dined in his Josefsgasse house now shunned the family.[17] Both parents were forced to teach languages and sell some possessions in order to maintain their home and have sufficient to live on.[18] Although the family was not reduced to penury – Lisette would take piano and voice lessons and Salvatór continue to travel back and forth to Italy – they would never again live with the privilege and ease to which they had become accustomed.

In later life, Lisette described her childhood as very difficult and at times intolerable. While she never elaborated on the substance of the events which seem to have been traumatic to her as a child, close acquaintances from her years in Paris

fig. 6
Eugenie Schwarzwald 1923?
Österreichische Nationalbibliothek, Vienna

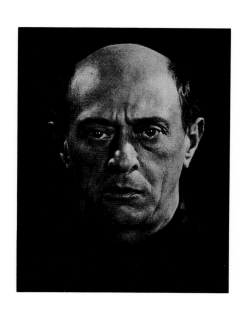

fig. 5
Man Ray, American
(1890–1976)
Arnold Schoenberg **1927**
Gelatin silver, textured surface
28.2 × 22.8 cm
The Art Institute of Chicago,
Julien Levy Collection,
Gift of Jean and Julien Levy
(1975.1139)

"Five years of elementary school
and eight years of *Gymnasium*
were spent on wooden benches;
five to six hours were thus taken
up each day, and homework was
to be mastered in the time that
was left. . . .
"I can vaguely remember that,
when we were seven, we had to
memorize a song about 'joyous
and blissful childhood', and sing
it in chorus. The melody of that
simple, artless little song is still
in my ears, but even then the words
passed my lips only with difficulty
and made an even less convincing
impression upon my heart
I cannot recall ever having been
either 'joyous' or 'blissful' during
that monotonous, heartless, and
lifeless schooling . . ."
— Stephan Zweig.[20]

and from the forties in the United States recall that she had been sexually molested by her father. This was probably the reason for the years of psychoanalysis that she later underwent in Paris. Lisette's sister-in-law, then Bianca Caspilli, who saw the family almost daily from around 1915 until Bianca married Salvatór in 1922, recalls her as having been a solitary child with a compulsive interest in people. Endowed with intelligence and a rich imagination, she recounted stories with impressive dramatic skills. It was Lisette's sister, Olga, however, who was the beautiful, cherished child. Slender, with long hair, she enchanted family and friends with her good looks and quick mind.[19]

Educated by tutors in the home, Lisette and her brother and sister spoke German, Italian, and French. Left to her own resources with the departure of tutors from the household during the First World War, Lisette came closer to experiencing a kind of life that she perceived as being more normal and attractive. Education for girls was possible through the existing state-run facilities, the Austrian Gymnasium, but was merely a grudging permission to attend school without any encouragement to do anything with the knowledge gained. Instead, in 1920, although not a regular pupil, she began two years of study of harmony, analysis, counterpoint, and instrumentation with the composer Arnold Schönberg (fig. 5) at the Schwarzwald School.

This was a private school for girls started by Eugenie Schwarzwald (fig. 6) in 1903. The educational philosophy, essentially child-centred, provided a fertile ground for exploration and discovery for students through open contact with teachers and a lively curriculum. It was, in short, a humanizing alternative to the severe and authoritarian system of the Gymnasium.[20] The curriculum encouraged education for girls, providing them with proficiency in the sciences, mathematics, and other subjects required for university entrance. It also operated progressive programs of instruction that used contemporary artists such as Oskar Kokoschka and Adolf Loos as instructors, thereby ensuring the artists also of some means of earning a living. In 1918, for example, Eugenie Schwarzwald allowed Schönberg to operate his own workshops on the school premises.

Located at 9 Wallnerstrasse, the school was just a ten-minute walk from the Seybert family home through the grounds of the town hall and the Volksgarten park. Lisette's two-year stint there brought her the closest contact with public education she experienced. Her feelings about the absence of a formal education remained

Lisette sometimes made contradictory claims to auto-didacticism and formal training in the same interview. In her teaching notebooks she once created a curriculum vitae in which she listed a Gymnasium schooling.[21]

ambivalent throughout her life. She wavered between pride and self-consciousness, sometimes boldly asserting her lack, and other times inventing years of formal training in a Gymnasium or the Schwarzwald School.[21]

Little is known about her art education. There is reason to doubt, however, the total ignorance of the visual arts to which she laid claim with pride. The Kunsthistorisches Museum, constructed some thirty years prior to Lisette's birth, was a five-minute walk from her home. Later, spending the summers in Nice, she would have witnessed the opening of the Musée des Beaux-Arts Jules Cheret, right next door to her mother's apartment on avenue des Baumettes.

More importantly, her home environment and circle of friends argue against a complete innocence of contemporary developments in art. It would be surprising if she had not heard of the work of well-known Viennese artists Egon Schiele and Gustav Klimt. Apart from her later relationship with the Schönberg circle, her sister and friends from Vienna affirm such awareness. As one friend put it: "One *knew* of Kokoschka; my sister was in the class of Loos,"[22] referring to the Schwarzwald School.

However, Lisette was clearly not driven to become a photographer by force of early environment. Her life from age seventeen to her late twenties was shaped entirely by love of music. There was no interest demonstrated in photography in her home, either as a hobby or as a serious form of expression. Olga does not recall a camera being owned by anyone in her family, and her sole memory of a childhood portrait of herself is a multiple exposure taken by a family friend, recording her for posterity with a goat emerging from her stomach.[23]

The overriding passion of Lisette's youth was to become, first, a concert pianist, and then, a singer. The greatest disappointment of her life was that she never achieved this desire. Her father had insisted that she, as the daughter, study violin (which she did, starting at age seven), and that it was the son, Salvatór, who should study the piano. Nonetheless, she taught herself basic piano technique at age fourteen, although her formal training in the instrument came later.

The Seybert's drastically reduced family fortunes throughout and after the First World War did not prevent her from having access to the best teachers and training in music when she expressed an interest in it. In this respect she was like most Viennese children from families with money. Formal piano lessons began in 1918 when she was seventeen with Edward Steuermann.[24] He had moved permanently to Vienna in 1918, and was the teacher to whom all the serious young pianists gravitated. Lisette was introduced to him through a family friend.[25] Another acquaintance from those days, Julia Heinz, a talented musician and later a teacher herself, remembers Lisette as a very gifted pianist.

In 1920, she became a student of Arnold Schönberg,[26] and part of the group that met at the Schönberg Studentenverein: "Lisette always belonged as we all did in this group, as a younger person," according to Heinz.[27] Despite the fact that she never became a practising musician, this period would profoundly affect the path of Lisette's life, influencing the direction of both her photographic work and her teaching. Although she studied with Schönberg after he had stopped painting, as his student she was exposed to the contemporary art scene. When she eventually

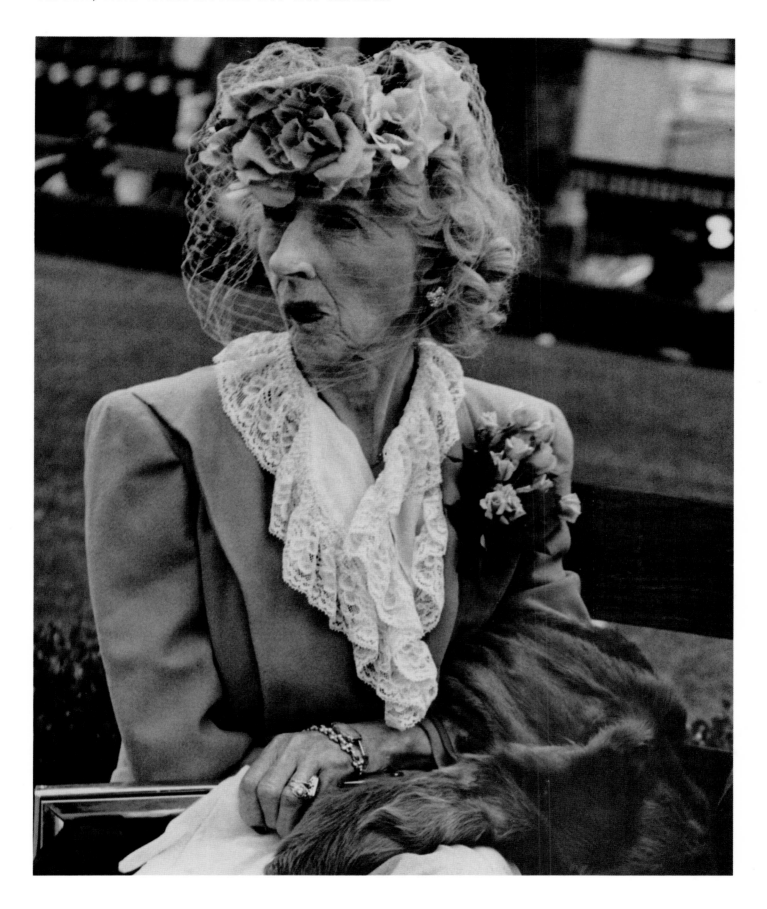

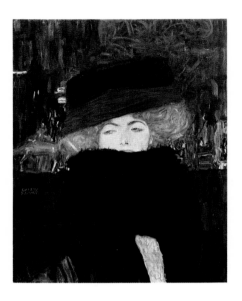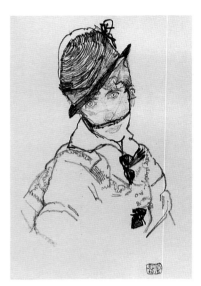

turned to photography, the connections that link her images to those of the Austrian Expressionist painters – part formal, part cultural – are clear. The artists whose work is most related in spirit to Model's were those who scandalised middle-class Vienna with their overt description of sexuality, direct expression of emotion, and particular value placed on the expression of inner conflict and pain. Gustav Klimt, Richard Gerstl, Egon Schiele, and Oskar Kokoschka led the avant-garde of aesthetic practice and philosophy in the first two decades of the twentieth century in Vienna. Kokoschka's sculpture of a gaping head with exposed nerve endings painted on the cheek, sadly no longer extant, so shocked the public that it earned him the name "Bürgerschreck", or Terror of the Middle Class.

Perhaps one of the most pertinent summations of the role of art in society and history, as seen by an Austrian Expressionist of the time, was Schiele's:

> Art always remains the same: art. Therefore there is no new art. There are new artists.... The new artist is and must be absolutely himself. He must be a creator and he must construct an unprecedented foundation, all alone, without utilizing anything of the past or present.... Formula is his antithesis.[28]

This was art with a strong message: question and do not be complacent. Out of the spiritual discomfort that artists suffered within a conservative social structure and their determination to comment on their times came works in the most lashing satirical style. Satire, with its balance of the universal and the specific, its bringing together of tragedy and comedy in a specific time and place in history in uneasy collaboration, became a popular vehicle of expression. The outlets for visual and written satirical pieces were the illustrated journals and the *feuilletons*. Cabarets became the popular location for the performance of satirical sketches.

Model's art owes a little to both styles of visual expression: her more anecdotal imagery draws from the popular journalistic forms of satire, and the intense psychological portraits relate to Expressionism. Given the climate of extremism that dominated art expression in her youth, it is not surprising that, in later years in the United States, she would rigorously push the limits of the accepted norms of a society torn by racial and class friction. As well, the psychological connected-

ness between artist and subject that she demonstrated in her work (pl. 10), and that she insisted upon in her teaching, is also seen in the work of painters like Klimt (fig. 7), and Schiele (figs. 8, 20).

As a young musician, Schönberg's radical paring away of the conventions surrounding contemporary music attracted Lisette and later became a fundamental principle of her visual art. She had yet to show any interest in photography. Austrian photographers of the period 1900 to 1930 do feature in the mainstream survey texts of the history of photography, but there is little to indicate that the medium in any of its phases – modernist or pictorialist – ever excited the kind of attention there that was paid to new developments in painting or music. There were, however, three major exhibitions of photographs held in Vienna around then: the 1891 *Internationale Ausstellung künstlerischer Photographie*, which basically showed works from the Linked Ring, including the work of Heinrich Kühn and Hans Watzek; *Film und Foto*, the groundbreaking 1929 exhibition of the Deutscher Werkbund; and *Land und Leute*, held in 1935, showing works by the photographer Rudolf Koppitz, at the Kunstgewerbemuseum.[29]

Despite the "New Vision" (a term used by avant-garde photographer László Moholy-Nagy to describe a break with Naturalism) and the work of photographers like Trude Fleischmann, the dominant aesthetic in Austrian photography of the time developed from the Romantic painting of the late nineteenth century. It was not a response to Expressionism as Model's photographs were to be. The only stylistic shifts in the medium were a moving away from Naturalism to Romanticism – the exchange of one Pictorialist style for another. It seemed to have more to do with the transformation of the image than with a radical and direct relationship to either the underpinnings of art, the external world, or the inner self. The only efforts that came close to challenging the terms of Pictorialist photography were explorations within the avant-garde, for instance in collaborations such as the one between the photographer Anton Josef Trčka and Schiele on a series of portraits. As Monika Faber points out in a monograph on the era, the subjectivity of vision sought by photographers like Hans Watzek was more based on P.H. Emerson's notions of optics and subjective vision than on expression of inner temperament.[30] Paradoxically, the cultural climate in Vienna at that time was both highly progressive and staunchly conservative. Schönberg and his disciples had to be prepared to stand their ground and to defend their art against philistinism and prejudice. And just as a dichotomy existed between the radical experimental musicians and the traditionalists in Vienna, a schism existed in the visual arts, with photography leaning more toward the conservative side. In contrast to Germany, the New Vision attracted few photographers in Austria, and attempts to make photography more "psychological" and subjective were rejected. Manifestations of the New Vision, such as the installation of *Film und Foto*, were strongly and unanimously criticized. In his review of the exhibition, Rudolf Junk wrote:

> ... it is not the stubble on the chin of an ill-shaven man that we are asked to retain: rather than the skin texture of someone whose image we want to keep, it is that person's being, the soul, that is important to us ...[31]

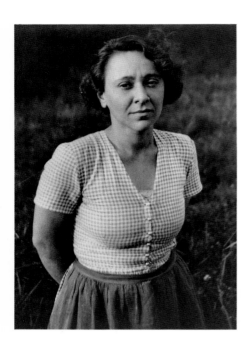

fig. 9
Trudi Schönberg c. 1925
Arnold Schoenberg Institute,
University of Southern California,
Los Angeles

Model characteristically denied influence from any source upon her work. However, with Schönberg in Vienna, she aligned herself with the radical movements in music, and thus, when she came to photography, rejected Pictorialism.

Schönberg's radical approach also later gave her a strong impetus towards knowing the nature and potential of her own medium, just as the composer had so brilliantly understood his. Like him, Lisette abhorred imitation and vigorously encouraged independence of expression in her students. Another Schönberg student described his method:

> His teaching centred on the work of the classical masters. He did not teach the twelve-tone method, on the other hand he did not stop pupils using it – or any other idiom – so long as the results were musical.[32]

It was not by accident that Lisette found her intellectual niche in the radical segment of Vienna's musical community. The environment of opposition to existing orthodoxies was as attractive to her as the concerts. She shared the conviction that, if you were in favour of new music, literature, and the search for truth and beauty through new departures, you went all the way, you did not dabble.

Schönberg's relationship with his students was intense, demanding commitment, loyalty, and honesty. The inclusion of Lisette's photograph accompanied by a testimony of her studies with Schönberg in the fiftieth birthday album compiled for him by Anton von Webern in 1924 testifies to her seriousness as a student. This portrait of a young woman of twenty-three, with her strong carriage, erect neck and shoulders, determined thrust of chin, and eyes downcast, projects an image of someone responding to a formal occasion, someone fully aware of the fact that being recorded by a Viennese photographer of high society of the time was an act of shared expectation and theatre (fig. 10).[33]

In addition to the powerful impact of Schönberg upon Lisette as a musician and teacher, his family left a lasting impression on her, with its atmosphere of creativity and conviviality in spite of difficult and impoverished circumstances.[34] A close friendship developed between herself and Trudi Schönberg (fig. 9), Arnold and Mathilde's first child. Trudi married Felix Greissle, a student of her father, in 1921.[35] In 1923, when Mathilde was dying in Dr Luithlen's Sanatorium,[36] a hospital specializing in renal diseases close to the Josefsgasse house, Schönberg stayed with the Seyberts.[37] Around this time, it seemed that he made a gesture of appreciation to the family by giving them a string quartet manuscript.[38] In his letter acknowledging the gift, Victor in turn expressed their great admiration for the composer, and asked him and his family to consider 9 Josefsgasse as their home whenever they were in Vienna.[39]

During the period 1926 to 1938, when Lisette was living in Paris and Nice and Trudi was still in Mödling, the two friends saw little of each other. However, in 1939 in New York, Lisette, concerned for the fate of the Greissles, wrote Arnold Schönberg with advice on how he might secure immigrant status for his daughter and her family (see chapter 3). Trudi and Lisette were reunited in the United States, and maintained their friendship up until Trudi's death in 1947.

fig. 10
**Franz Xaver Setzer,
Austrian (1886–1939)**
Lisette Seybert 1924
Gelatin silver
8.2 × 5.6 cm
Arnold Schoenberg Institute,
University of Southern
California, Los Angeles

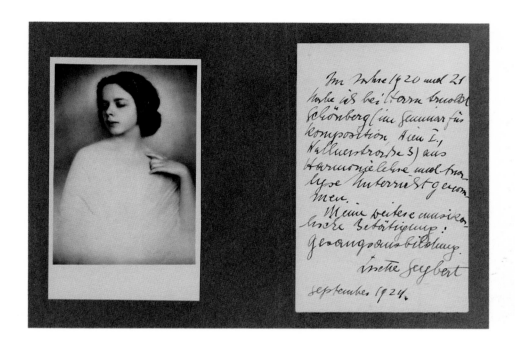

The inscription that
accompanies her portrait in
Schönberg's fiftieth birthday
album reads: "In 1920 and
1921 I received instruction
from Arnold Schönberg...
in Harmony and Analysis." [33]

They, too, had experienced
tragedy, including the
attempted suicide of their
daughter Trudi, at the time
that she and Lisette would
have been acquainted. [34]

One of Lisette's great regrets
was that the string quartet
manuscript Schönberg had
given them, along with other
possessions from Paris, was
apparently lost during her
later immigration to
New York. [38]

Well before Lisette left Vienna for Paris in 1926, her own family had begun to break up. In 1917 it had become clear that Victor Seybert, who periodically suffered from severe depression, was now also seriously ill with cancer. Discharged from the army and aware that he was dying, he set about preparing his papers and investing what was left of his fortune in a partnership in a pharmaceutical company in Milan, so that his family, and particularly the young Olga, thirteen at the time of his death, would have a degree of economic security. On 6 June 1924, at the age of fifty-eight, he died. [40] By this time Salvatór, whose bouts with tuberculosis had caused him to make frequent visits to Italy, had married Bianca Caspilli.

PARIS

Thus, in 1926, Félicie decided to return to France. She chose to settle in Nice on the Côte d'Azur, where a favourite uncle, a priest who ran an orphanage, lived. [41] Since there were no family members interested in taking over the house on Josefsgasse, and since, seemingly, money was still owed to the architect, it was put up for sale.

By the end of the First World War, Vienna was no longer the hub of artistic excitement; economic depression and social unrest marked the mood of the city, as other European centres such as Berlin and Paris took the cultural spotlight. Lisette left for Paris, along with Félicie and Olga, in 1926. Her mother and sister went on to Nice, but she chose to remain in the city to study voice. A time of

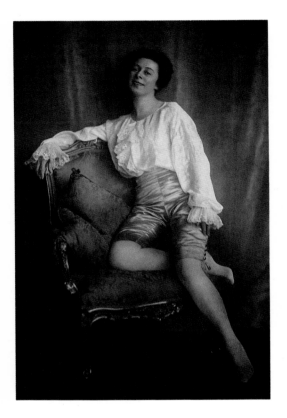

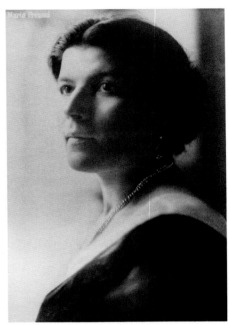

fig. 11
Franz Xaver Setzer, Austrian (1886–1939)
Marie Gutheil-Schoder in "Rosenkavalier" 1926
Gelatin silver
22 × 15.5 cm
Collection Walter Tschiedel, Vienna

fig. 12
Marya Freund n.d.
Arnold Schoenberg Institute,
University of Southern California,
Los Angeles

confusion and excitement lay ahead for her. It was her first experience of living on her own and the twenties were heady times for intellectual women in Paris. The freedom to pursue an independent life, become an artist, participate fully in a chosen career, and enter into sexual liaisons without marriage was, if not exactly socially approved, considered an inalienable right by a small but vocal group of women living in the city at the time. Many were émigrées like herself, from Germany, Hungary, Austria, and the United States. Some were to become photographers and friends, such as Rogi André and Florence Henri.

Prior to her departure for Paris, Lisette had begun to study voice with Marie Gutheil-Schoder (fig. 11), of the Vienna Hofoper. In Paris, she persisted in her training as a singer, this time with Marya Freund (fig. 12), a Polish soprano who performed the avant-garde music of Debussy, Ravel, and Berg in Paris, and who would be renowned as a teacher of voice for over thirty years. Both worked closely with Schönberg, executing various compositions by him. Lisette, who had first met Freund in Vienna when she came from Paris to perform a Schönberg piece, described her as "quite an extraordinary woman [who] performed the Pierrot *lunaire* to an audience which started to yell and interrupt – and Schönberg had to get out".[42]

38

During the period in Paris, Lisette herself enjoyed only brief contact with Schön-berg, translating a speech from German to French for him in 1927, when he came there to lecture.

Thus the eight years from 1926 until 1933 – the year that she started to take photographs – were spent in studying voice and in the company of a small group of friends and, of course, in visiting with her mother and sister in Nice. She commuted back and forth between her rooms at, first, 15 rue de la Tour, and, later, the Palais d'Orléans in Paris, and 27 avenue des Baumettes in Nice (fig. 13). At the same time, she underwent psychoanalysis, trying, it appears, to untangle some of the deep trauma inflicted upon her as a young girl.[43] She recalled this as a period of loneliness. Like the young women seated by themselves in cafés and restaurants that she was to photograph later in her career, she passed the time in Parisian bistros alone. Ilya Ehrenburg, a Russian journalist who allowed no-one to escape his attention, noted her presence in one of the cafés he frequented, probably the Café du Dôme, and remarked upon her solitude to his friends.[44] At some point she had a boyfriend, Georg, a Russian engineer who appears in several early photographs. His views were strongly left-wing, very different from those which had surrounded her in the sheltered environment of her early Vienna upbringing. Georg's opinions might well have influenced Lisette's own political thinking, then and in later life. She herself testified to the changes that came about in her life through her adaptation to life in Paris and a radically different social group to that in which she had been born. Her private struggle to liberate herself from what she termed "the culture of the bourgeoisie" is best described in her words:

> It was very difficult for me in the beginning to switch from one into the other. Many times I wanted to run away because I was a stranger . . . but I didn't run away. I stuck it out, and I think that was decisive for my life.[45]

And then, somewhere around 1933, her musical career came to an abrupt halt. It is not clear what triggered Lisette's decision to abandon her study of voice, or even whether this decision was made by her. In interviews, referring to the wretchedness of this moment, she was evasive about the precise nature of the events that caused her to divert her creative energies into a completely different medium of expression. That she was musically gifted is borne out not only by her own observation that she "had no trouble with the violin, the piano, . . . or with the harmonica",[46] but by the opinions of both the musician Julia Heinz, and friends from slightly later years. The reason for this decision could have been any one or combination of inadequate training, as Lisette suggested, blaming the failure of her voice on all of her teachers; strong feelings of social awkwardness in the milieu of her Paris teacher, Marya Freund, which she also talked about[47]; physiological problems with the middle range of her voice, an explanation put forward by her sister Olga; a lack of discipline in Lisette herself; or, quite simply, insufficient natural ability. Although Lisette was apparently devastated by this unexpected turn of events, the finality of the problem was such that it at least cleared the way for her to explore other expressive media.

fig. 13
Ann Thomas
27 avenue des Baumettes Nice 1988
National Gallery of Canada,
Curatorial files

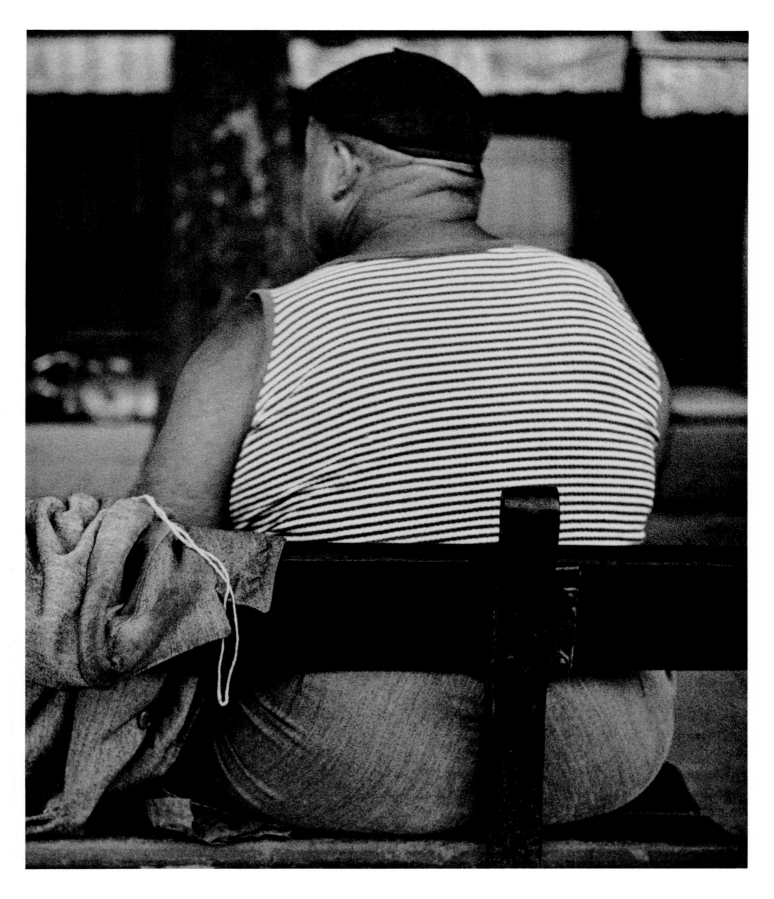

11 **Circus Man** Nice between 1933 and 1938

How Lisette Model came to be a photographer is a story that evolves by way of alternating events of coincidence and contradiction. Friends who knew her from Vienna recall that she had often confided a need to make something of her life, specifically to make a serious contribution as a musician. Without a chosen field of artistic expression and one in which she could excel, her life, she believed, would be intolerable. Driven by sentiments such as these, the knowledge that there could not be a future for her as a singer must have been terrible.

In time, however, buoyed by a natural resiliency that tended to surface in difficult periods, she began to explore other media, looking not so much for a métier as for a medium of creative expression. She decided to study painting. Why painting? Her constant claim throughout her career was that she was not in the least visually gifted or even oriented; later, she would say she fell into the medium of photography by chance. This begs the question: why study a medium in which she declared herself to be completely illiterate? While we study some subjects in order to learn, the motivation to paint, sculpt, draw, or photograph is rarely purely heuristic, but most often comes from interest and a belief that we have some ability to express what we have to say in a given medium. But Lisette Seybert possessed high standards; she wanted to excel in what she did. By relegating any success to serendipity, she insured herself against what she would have perceived as a second failure, her disappointment with her musical career still fresh in her memory. Yet, if she were uncertain about her abilities, friends who knew her from Vienna and Paris were not. To them it was clear that, no matter what she did, she would do it passionately, giving it "all she had".[2]

Alluding often in taped interviews to the period in which she studied painting, Model never furnished details. Her application for a Guggen-

heim Fellowship in 1949 names André Lhote as the painter with whom she studied. A French artist in the thirties who published a treatise on landscape painting, focussing on compositional elements and analyses of landscape painters, he was also the teacher of photographers Henri Cartier-Bresson and George Hoyningen-Huene. Although Model dates her association with Lhote at 1937 in the grant application, other evidence suggests it is more likely to have been the early 1930s. A sketchbook from 1937 or 1938 provides an opportunity to see her drawings: figurative and linear, they demonstrate the qualities of directness and interest in the human subject that are evident in her photographs (fig. 14).

fig. 14
Lisette Model
Woman Knitting
between 1937 and 1938
Graphite on paper
21 × 16 cm

fig. 15
Lisette Model
Rogi André Paris 1933?
Collection Gerd Sander, Sinzig

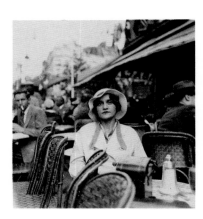

I just picked up a camera without any kind of ambition to be good or bad.

And especially without any ambition to make a living

My whole freedom working in photography comes because I say to myself,

let's see what is going on in this world. Let's find out. How do these people look?

What is it supposed to mean? In which way, you see,

then comes out the whole social structure. And I never try to

impose myself. I work the opposite way around.[1]

FIRST PHOTOGRAPHS

Recollections of family members and friends were that the Seybert sibling most involved in photography in the twenties and thirties was Olga, Lisette's younger sister.[3] Olga attributes her initial interest to an exhibition she saw in Vienna. Her involvement with photography was as a professional right from the start. For a short while she apprenticed in the portrait studio of Lotte Meitner-Graf in Vienna. In Paris, where she lived for a year,[4] she worked for Ergy Landau, Ylla (Kamilla Koffler),[5] and Nora Dumas. Olga's interest took a scientific rather than Expressionist direction. Intrigued by the world revealed by micrography and its application to medicine, she worked from 1945 on as a medical photographer, first in Paris, and then in Caracas, Venezuela.[6]

While Lisette did not undertake extensive training in photography, neither did she come to the medium without instruction. It was Olga who introduced her to the rudiments of the darkroom process:

I had a little sister who was a very good photographer. But I had no idea about photography and I said to myself, but I have seen people doing laboratory work, and so I talked to her and went to Italy and bought myself a camera and this and that and an enlarger . . . and this is the way I started to photograph. Just like that. With no intention to photograph. With no idea about photography, without even liking it. Without being interested. This is what happened . . .[7]

Interested also in architectural photography, Olga Seybert's photographs appear in *Have You Ever Seen Denver?* (Denver: Johnson Publishing, 1971). She immigrated to Venezuela in the fifties and lived in Caracas, after having spent a year there in 1948. She then immigrated to the United States.[6]

43

fig. 16
Lisette Model
Olga Seybert Nice between 1933 and 1938
Full frame enlargement by Justin Wonnacott
from original negative, 1989

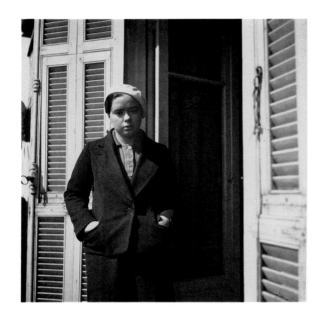

The early portraits referred to are those of Evsa and Olga, Florence Henri, and Rogi André. Model did photograph friends and family and even took some self-portraits although she would often profess that she "couldn't do it.... Nothing comes out. I don't know why. It has to be an unknown. When I know a person, I know a person's voice, what a person says, what the person is. If I don't know a person, it is the visual aspect that is the only thing that is known, and it gets much stronger if it is not diluted by other knowledge."[8]

The process of developing so stimulated Lisette that she thought only of becoming a dark-room technician at first. Early attempts show her making playful, casual experiments with the camera,[8] photographing Olga at the avenue des Baumettes apartment in Nice (fig. 16), and Olga, in turn, making a portrait of her sister (see back cover).

Lisette's decision to turn to photography as a profession resulted from a conversation in 1933 or early 1934 with a fellow Viennese émigré and former student of Schönberg, Hanns Eisler. While details of his meeting with Lisette in Paris are not known, she recalled that he berated her for her complacency and lack of survival skills in a time dark with menace. His message was blunt: learn something useful, get a job, and be prepared to leave Europe. A Marxist musician who had lived in Berlin in the twenties and early thirties, Eisler spoke from experience. With Hitler's ascension to power in 1933 he had had to flee Germany.[9] Often citing Eisler's message as her impetus for learning photography, it appears that Lisette, despite later protests to the contrary, was set at this point in her life on becoming a photojournalist.

Her education continued. A short time after she had been introduced to the medium through Olga, Lisette received a demonstration of the use of the Rolleiflex from Rogi André (fig. 15), a photographer and André Kertész's first wife, who had taken her under her wing. Her acquaintance with Rogi André dates from the early thirties and certainly no later than 1933, after the marriage with Kertész had ended.[10] They wandered the streets of Paris together, with Rogi, recent initiate into the medium herself, pointing out the pictorial possibilities offered by the streets and markets. Lisette's esteem for Rogi and recognition of the role she played in her development is best described in her own words:

I had no idea how to hold a camera, but she had just started to photograph too. I said, "Could you show me how?" She said "Yes." So we walked around in Paris, and then she said, "What do you see here?" I didn't see anything, because I was completely non-visual, you see. And then she said one sentence I have never forgotten! "Never photograph anything you are not passionately interested in." That was the only lesson in photography I've ever got.[11]

Clearly Model's famous dictum "Shoot from the gut!" is owed to this brief but important friendship of the two women. More than the lessons in seeing that she received from Rogi, more than the magic that she witnessed in the darkroom with Olga, it was this revelation that left its mark on her and that she lived by as a photographer. Thirty years later she would repeat it to her students, while opening their eyes to New York.

She also knew Florence Henri, the photographer (fig. 17), through the circle of friends she made through her future husband, Evsa Model, and referred to a period of apprenticeship with her in 1937.[12] Although there is little in her work that reflects the influence of Henri's highly stylized, geometric imagery, it is quite possible that she picked up certain tips on manipulative technique. Model often tilted her easel, cropped heavily, and controlled the dynamics of the final print by a variety of methods, including burning and dodging. In

44

fig. 17
Lisette Model
Florence Henri Paris
between 1933 and 1938
Full frame enlargement by
Justin Wonnacott from
original negative, 1989

fig. 18
Lisette Model
Paris between 1933 and 1938
Full frame enlargement by
Justin Wonnacott from
original negative, 1989

accordance with Henri's approach, the sovereignty of the negative or the integrity of its format held no sanctity for Model.

It was thus, Rolleiflex – and often also Leica – in hand,[13] that thirty-three year old Lisette Seybert began to look afresh at the world around her. In the early photographs (fig. 18) there is little of the powerful vision she asserted just months later in the summer of 1934. The range of subjects was diverse: vagrants, animals, fishermen, street events, air shows, and, to a limited degree, political events.[14] All were topical subjects in French illustrated periodicals of the day. The communist periodical *Regards*, in particular, was almost like a pattern book for Lisette in her current and future choice of subject matter.

PROMENADE DES ANGLAIS

By the summer of 1934, the power of visual imagery had worked its magic on her. Her comparison of the world to a stage, her perception of photographic images as occupying a dominant role in humanity's understanding of its place and time in history, were concepts that had become fully alive in her mind. The photographs she made that summer manifested an extraordinary, singular vision. Visiting her mother at the family home in Nice, the Promenade des Anglais, seven kilometres long, appeared to Lisette like one gigantic photography studio, catering to a clientele who fascinated her for the compelling reason that they connected at one level with her own life, and yet were alien to her values on another. Rich in dramatic potential, the entire setting of palm trees, azure sky, and sea drenched with the light of the Mediterranean sun, might have struck her as a theatrical variation on the Setzer studio in Vienna, which also served a bourgeois clientele, and where she had posed for her Schönberg album portrait.

In this open-air studio, the waiting customers, strangers all – French, American, Russian, sprawled along the boardwalk in their chairs, sedated by the sun, and unwittingly created their own poses. With an ever-changing cast of characters costumed and

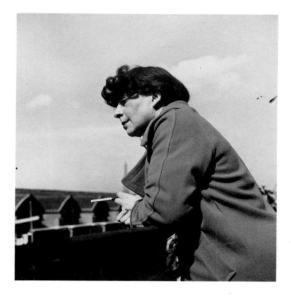

The Rolleiflex is a twin-lens reflex camera, particularly well-suited to recording portrait and landscape subject matter. Producing a 2 1/4 x 2 1/4 inch (5.7 x 5.7 cm) negative, it has a viewing system that requires that it be held at chest or waist level, making spontaneous or so-called candid photographing awkward. Model also possessed a Leica 35 mm range-finder camera in the thirties and, contrary to her recollections, did work with it. However, she clearly preferred the Rolleiflex, the camera she used most frequently to record her *Promenade des Anglais* images. An interchangeable lens system did not exist for the Rolleiflex at the time, so she could not have used a telephoto lens to do close-ups.[13]

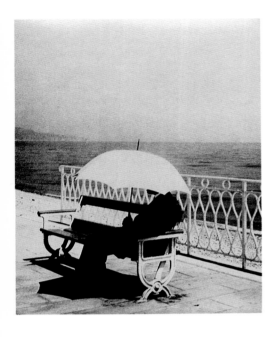

Often asked how she approached the ethics of photographing strangers, her answers give us insight into her perception not only of her position as an artist but also of her own place in the world. To David Vestal, a Photo League photographer, she replied: "I can [photograph them] because I am one of them." [15]

She distinguishes between the mechanical and the "selected" instant.[17]

Model's images of seated figures along the Promenade des Anglais are reminiscent, in their monumental forms and often brooding expressions, of Egon Schiele's painted portraits of Anton Peschka and Hans Massmann (fig. 20) from earlier in the century.[18]

made-up according to the dictates of current fashion, with a wealth of individual physiognomy and extremes of body shape and size, she had material enough to produce a visual epic.

Lisette focussed on her subjects one at a time and at eye-level, not from the fourth floor of the Hotel Métropole as did Martin Munkacsi, or as an abstract pattern as did Brassaï in Menton (fig. 19). This allowed her to size them up in the darkroom and examine what it meant to be bourgeois; to have time on her hands, as they did; to be, as she put it, "one of them".[15] In her choice of images, Lisette worked by compulsion and intuition: "I select what I am attracted to, I don't hesitate, question [or] analyse." [16] For her, time was a crucial element in photography, a property that distinguished it fundamentally from other visual arts. Later describing photography as "the art of the split-second", she wrote about the photographer as having "the instant at his disposal".[17]

Surprisingly, Lisette's photographs tell little about the initial relationship between photographer and subject. A number of unexpected things must have occurred between that electric moment when she seized on a subject and picked an individual from the crowd, and the moment when she closed the shutter. Two photographs in particular from the *Promenade des Anglais* series give rise to the assumption that Model worked in nerve-wracking proximity to her subjects: the one of the man smoking a cigar (pl. 51, figs. 21, 22), and the one of the man lounging in his chair (pl. 12, figs. 23, 24).[18] In the former, she did not budge, but neither did he. In the latter, the man with the unflinching gaze, who Lisette thought was probably an executive rather than a gambler, was, like many others she photographed, watchful and immobile. Their encounter was silent. Examination of the contacts of variant views of the same subject also reveals just how unhurried the process of taking the photographs really was. She often took two: one at a relatively great distance, and the other at closer range. The passage of time between the first and second "takes" was such that significant alterations of background activity occur: surrounding individuals come and go, or turn their attention from one activity to another.

The real confrontation occurred in the dark-room. This is clarified by comparing a contact from the negatives of either of these subjects with the final print. The initial psychological currents that flowed between photographer and subject occurred even more strongly a second time when she positioned her negative in the enlarger. For Lisette, the moment of taking the picture was like the making of a preparatory sketch to provide a point of departure for the constructing of a final image. Composition, in her view, was predetermined by subject. "Whenever we pick up the camera and look," she would write later, "we force *Composition*," [19] meaning that a degree of external ordering already exists and the simple act of photographing makes it manifest. In painting, sculpture, and music the element of composition, she would argue, was more conscious – and, one may add, more conceptual.

True to her ability to entertain and enact contradictions, however, she seldom printed her negatives without radically altering the original composition of the image, forcing expression upon any content which remained latent. She cropped extensively. The composition recorded within the frame of the negative was not immutable, she would maintain; how could one make the complexity and "Infinity of Life" [20] conform to the information contained within a given rectangle? What she argued for was acknowledgment of the many ways of dealing with raw visual data. [21] For her, composition was the result of bringing all tools, including the photographer, to bear upon the image.

When Lisette later talked about the structure of the image, she reduced the act of photographing to its essential abstract elements: the surface area of the negative, and the surface aspects of the object photographed. She insisted there should be "no rules, no preconceived ideas, no applied formulas". [22] As for what subject matter means to the photographer, she discussed this question in a variety of ways in her teaching notebooks, emphasizing both its personal association and its particular and universal nature [23]: "We are the subject, the object is the world around us." [24]

fig. 21 | fig. 22
Lisette Model
Promenade des Anglais **Nice**
2 September 1934
Full frame enlargement
by Justin Wonnacott from
original negatives, 1989

 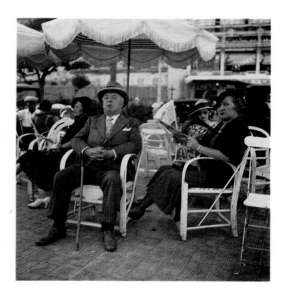

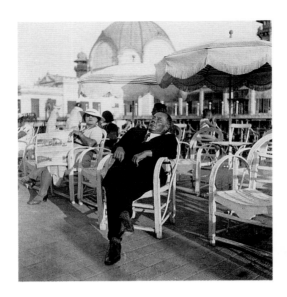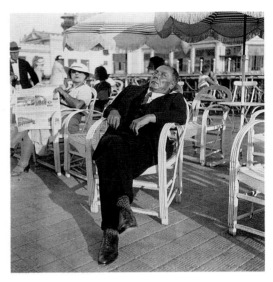

fig. 23 | fig. 24
Lisette Model
Promenade des Anglais Nice 7 August 1934
Full frame enlargement by Justin Wonnacott
from original negatives, 1989

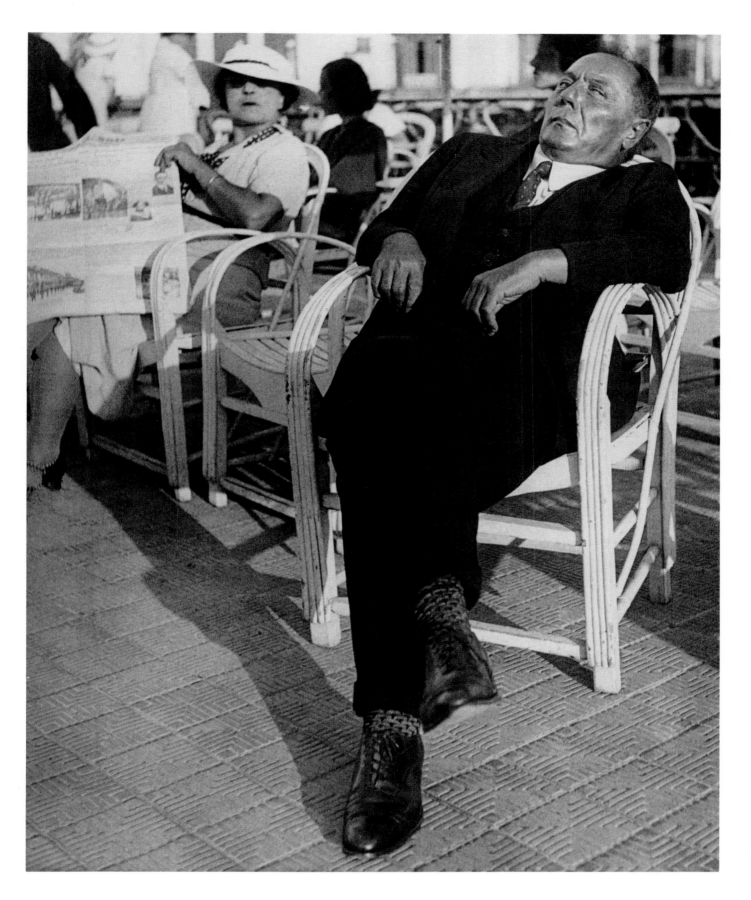

12 **Promenade des Anglais** Nice 7 August 1934

fig. 25
"Côte d'Azur," *Regards*, vol. 4, no. 59,
28 February 1935, n.p.
Photographs by Lisette Model
Bibliothèque nationale, Paris

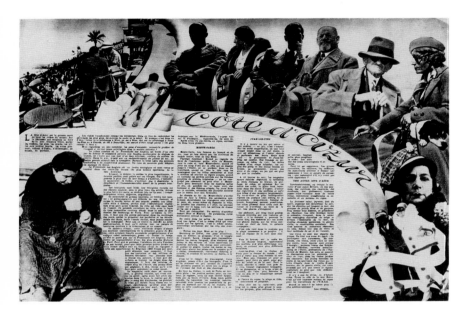

The Promenade des Anglais is a zoo, to which have come to loll in white armchairs the most hideous specimens of the human animal.

Boredom, disdain, the most insolent stupidity, and sometimes brutality mark these faces. These comfortably off people who spend most of their time getting dressed, making themselves beautiful, doing their nails, and putting on makeup never manage to hide the decadence, the incommensurable wasteland of middle-class thinking.

The middle class is ugly. Sprawling on chaise lounges under the fairest of skies, before the finest of seas, these people are revealed for what they are: irredeemably old, disgusted, and disgusting.

This monumental offence, this fat belly masquerading as a man, this fifty-year-old whose body smothers his chair and whose scorn stifles the entire world, owns a delightful villa at Cimiez, set among vast, luxuriant, nearly tropical gardens. His villa is empty eleven months of the year.[26]

Was it her intention that these photographs indict the subjects in the manner of the text: as rich layabouts occupying a place in the sun denied the proletariat? The same work was used again for the newspaper *PM* in America in January of 1941 in a feature entitled "Why France Fell", with captions that reiterated a similar message. While Lisette never alluded to the publication of her work in *Regards* after she left Europe, and insisted that the captions for *PM* were not of her making, the coincidence of the treatment suggests at least partial agreement on her part with a political interpretation of her work. *Regards* was a highly credible publication under the leadership of well-known writers such as Ilya Ehrenburg, André Gide, Maksim Gorky, and André Malraux; how could she not have known the use to which her images would be put? The front cover of this particular issue presented an image probably by John Heartfield, whose satirical collages frequently illustrated the pages of the periodical. The back cover depicted Lisette's portly *Promenade des Anglais* gentleman with sunglasses, cane, and fedora (fig. 26). There is no conclusive evidence that she was supplying photographs for *Regards* on a regular basis.[27] However, the subjects that attracted her at this time were without excep-

REGARDS

The use to which Model's photographs might have been put in Europe has always been something of a mystery. Model never denied having published her work in Europe, but neither did she ever precisely acknowledge having done so. That a selection of the *Promenade des Anglais* photographs appeared in February 1935 illustrating "Côte d'Azur" by Lise Curel in *Regards*[25] (fig. 25) was a startling discovery. Detached from the journalistic context, her portrayals of the sun-loving bourgeois of the Côte d'Azur, while filled with the biting humour of a satirist, also seem sufficiently open-ended to allow for a lighter, comic interpretation. Not so in *Regards*: here they became, by association with the text, visual whip-lashings:

tion those that illustrated its pages, and many of the images in the publication are reminiscent of her work.

Regards promoted and collaborated with a group of worker photographers, the Amateurs Photographes Ouvriers (A.P.O.), who furnished it with a considerable number of negatives that agencies either would not or could not provide. The A.P.O. also provided instruction in camera techniques, as well as darkroom facilities and training. When they launched their appeal for membership in 1932, they made clear the distinctions between their editorial interests and those of the bourgeois illustrated papers: they wished photographers to submit images demonstrating the difficulties of life, the hardships of labour, and the struggle of the proletariat. The following year they repeated their request:

> No manual or intellectual worker practising photography can ignore our appeal. Middle-class papers are making more and more widespread use of photographs as propaganda. And on what does the bourgeois evening news feed public opinion, if not on photographic illustrations?[28]

There is no evidence to suggest that Lisette responded to their call to become a member, but it might have influenced her decision to join the Photo League in New York nine years later. The Photo League was not oriented toward the same journalistic purpose as the A.P.O.; however, it was also organized according to social and political principles.

The period between the wars was turbulent for Nice, as it was for the rest of France. Labour unrest was high, exacerbated by a crisis in tourism. The number of hotels that went bankrupt increased significantly in the thirties, with Nice suffering the greatest economic depression as a result of competition from younger resort areas in the Côte d'Azur. The *Promenade des Anglais* photographs were taken just months after one of the largest labour demonstrations in Nice had occurred in February 1934. The Côte d'Azur, and Nice in particular, were the subject of several articles in the period 1932 to 1937 in *Regards*.

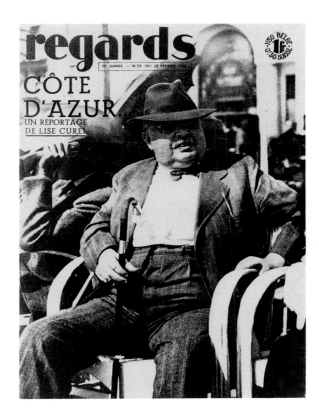

fig. 26
**Back cover of *Regards*, vol. 4, no. 59, 28 February 1935
Photograph by Lisette Model
Bibliothèque nationale, Paris**

It would nonetheless be too simple, and also misleading, to interpret Model's picture-taking along the Promenade des Anglais as being entirely politically motivated. It is true that her evident delight in satirizing the complacent rich and sympathizing with the downtrodden and marginal places her work in a context of social protest art. Of the woman reading in the Bois de Boulogne (pl. 9) she has said:

> She sits in the Bois de Boulogne ... and prays. That is a Bible – but I can identify this kind of a woman. She is from the haute-bourgeoisie. She is very well-off or well-off, probably a widow – she has nothing to do but live and pray with a kind of elegance and distinction...[29]

fig. 27
Visitor to England, Visitor to Monte Carlo
Lilliput, vol. 3, no. 3, September 1938, p. 260–61
Photograph on right by Lisette Model
National Library of Canada, Ottawa (NL 16677)

VISITOR TO ENGLAND VISITOR TO MONTE CARLO
260 261

Neither the Seuphors nor Bianca Caspilli were aware in the middle to late thirties that Lisette was seriously engaged in taking photographs, although she sometimes gave them prints. Nothing she said or did indicated to them that she had a deeper interest in the medium. In March of 1937, Michel Seuphor wrote a letter to Evsa with the message: "When Lisette is back from the Côte d'Azur, thank her for the charming photos which she sent us – the last are especially amusing and give us much pleasure..." The photographs are of their infant son, Régis, taken around December 1936.[32]

fig. 28
How Can I Stay Young and Beautiful?
"We women are spared nothing!"
Copied from *Simplicissimus*,
5 October 1925, Dover reprint 1975
(New York: Dover Publications, 1975)
Cartoon by Karl Arnold

It is also true, however, that she made images for the simple reason that a subject offered up a moment of pure visual enjoyment to her eye. Her photographs of backs, such as *Famous Gambler* (pl. 1) and *Circus Man* (pl. 11), are examples. *Famous Gambler* was published in the magazine *Lilliput* just as she and Evsa were preparing to leave for the United States in September of 1938 (fig. 27).[30]

Lisette's deliberately exaggerated treatment of her subjects, especially in the *Promenade des Anglais* series, revealed the humour and pathos of what she experienced. She recounted the reactions some of her photographs provoked:

I showed them to agents and people, and everybody laughed their heads off at these pictures. They were very funny pictures, you know. The French laugh very easily. They laugh at everything. I had no objection.[31]

Interestingly, this statement also reveals that, as early as 1934, she was using agents, and thus taking her work more seriously than she let on to family and friends.[32]

During this period, in addition to the bourgeois elderly gentlemen and matrons for whom time and events appeared to pass with the regularity of a ticking clock, she photographed street vendors and beggars. If the generous spaces and theatrically graphic qualities of her *Promenade des Anglais* compositions remind us of the satirical cartoons of magazines like *Der Knüppel* or *Simplicissimus* (fig. 28), then her street people (fig. 29) recall the documentary strength of Eugène Atget (fig. 30).

As someone whose life and inner world had until recently been so completely filled with sound, someone who had only just rediscovered her sense of sight, it is possible she felt a particular empathy for blind people, for she photographed them frequently (pls. 13–15). As with many of the themes that Lisette was to explore, the solitary figure of the blind beggar with his crude label "Blind" hanging around his neck was popular with European and American artists of that period. Otto Dix's *Blind Beggar*, illustrated in *Der Knüppel* (fig. 31), is just one such contemporary example.

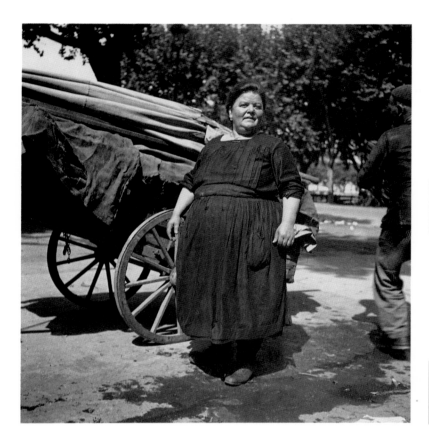

fig. 29
Lisette Model
Nice between 1933 and 1938
Full frame enlargement by Justin Wonnacott
from original negative, 1989

fig. 30
Eugène Atget, French (1857–1927)
Market Porter between 1898 and 1900
Gelatin silver
22.7 × 17.4 cm
National Gallery of Canada (21226)

fig. 31
Otto Dix, German (1891–1969)
Blind Beggar 1923
Lithograph 49 × 38 cm
Copied from Florian Karsch and Hans Kinkel,
Otto Dix: Das graphische Werk
(Hannover: Fackelträger-Verlag Schmidt-Küster, 1970)

13 **Blind Man in Front of Billboard** Paris between 1933 and 1938

14 **Blind Man Seated on Sidewalk** Paris between 1933 and 1938

15 **Blind Man Walking** Paris between 1933 and 1938

fig. 32
Lisette Model
Evsa Model Nice between 1935 and 1938

fig. 33
Evsa Model, American
(b. Russia, 1899–1976)
Portrait of André Kertész 1927?
Graphite on paper
Dimensions unknown

EVSA MODEL

In August 1934 Evsa was still living with an American woman, a sculptor in St Jeanneret, according to the Seuphors, who visited him there. Lisette thus met Evsa after August 1934 and before February 1936. They lived together in Nice and later in Paris.[33]

Evsa's parents were Constantin Model and Sarah Feitzer, both dead by 1920. On 25 March 1920, Evsa was in Shanghai, where he received a new passport.[36]

Michel Seuphor talks about two nieces of Evsa working in L'Esthétique. Other sources cite the store as having been owned by a cousin of Evsa.[37]

Lisette Seybert probably met Evsa Model, her future husband, in Nice around late 1934 or early 1935.[33] In a letter from him to Lisette we learn that, by February of 1936, he was preparing to move from Nice to Paris, where they were going to furnish an apartment together.

Evsei Konstantinovich Model (fig. 32), a painter, born 25 September 1899,[34] left his home town of Nikolayevsk on the Amur to avoid being drafted into the Czar's army. From a Russian Jewish family, he emigrated before the Russian Revolution. He is reputed to have left Russia by foot, travelling through China – where he might have visited relatives[35] – to Japan, Singapore, Bombay, and Port Said, reaching Italy after March of 1920.[36] In the latter part of 1920 he left Rome for France to study painting.

Evsa has been described as a gentle, stoic person of great personal integrity by friends of the time. How he supported himself on arrival in Paris is uncertain. The fact that he opened the bookstore L'Esthétique in 1927 suggests that he must have brought a relatively large sum of money with him, or else had relatives in Paris who helped him out.[37] L'Esthétique was one of the establishments that regularly stocked books and materials from all over Europe on issues in contemporary art. It served also as a gallery, allowing him to show both his own work and the work of other artists, such as Ossip Zadkine. Browsers were welcomed by a huge samovar of Russian tea and cushions for comfortably leaning against while perusing the most recent avant-garde periodicals. It was located at 90 Montparnasse near the Café du Dôme, which Evsa frequented regularly. The photographer André Kertész, who lived at 75 Montparnasse, and Evsa were good friends; he made a drawing of Kertész, for example, the night of his exhibition opening at the gallery Au Sacre du Printemps (fig. 33). Evsa was a graphic designer as well as a painter. He designed the cover for Michel Seuphor's first book of poems, *Lecture élémentaire, (1926–1927)* (Paris: les Écrivains réunis, 1928), and was responsible for unusual window displays in his store, arrangements which he asked Kertész to record. The façade of the building demonstrated Evsa's Constructivist aesthetic (fig. 34). L'Esthétique closed in 1930.

Evsa's painting up until his departure for the United States was in the Constructivist style. At the time that he associated with Piet Mondrian and Michel Seuphor he was identified with the *Cercle et Carré* group in Paris. Seuphor recalls seeing a large and impressive painting of a circle and square hanging on the studio wall of Evsa's American sculptor-friends' studio in St Jeanneret, where he was living in the summer of 1934.[38] He exhibited his work at Galerie Vavin on the rue Vavin and the Galerie Powolowsky on the rue de la Seine.[39]

Although she does not appear to have studied formally with him, Lisette shared his interest in art and the teaching of it. Over the next three to four years, from the time they formed a relationship to the time they left Europe for New York, they divided their time, separately and together, between Nice, Paris, and Italy. Lisette travelled

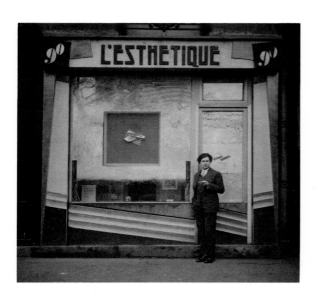

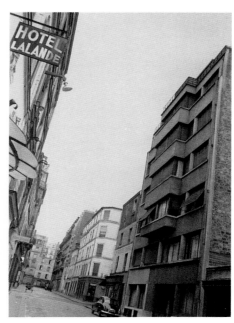

fig. 34
**André Kertész, American
(b. Hungary, 1894–1985)**
Evsa Model in Front of L'Esthétique
**between 1927 and 1930
Gelatin silver
7.9 × 8.4 cm
Collection Constantine Ash, Carmel**

fig. 35
**Lisette Model
12 rue Lalande Paris 1953**

frequently to Milan, Trento, and Pamparato supervising family finances and attempting to settle her share of Victor's estate. Sometimes she and Evsa travelled with members of the family, as on one trip to Milan with Salvatór and Bianca. At other times, Lisette travelled alone.

During her absences, Evsa painted, frequented the local bistros, sunbathed, and kept her informed by mail of the various journalists and agents who came to see her photographs. In October of 1936,[40] for example, Lisette was visiting Milan and Trento when she received a letter from Evsa telling her he had seen her agent and sold some of her photographs. As with all of his correspondence to her, it is sprinkled with word-play: "J'ai vu ton agence il a vendu tes photosses." From the Café du Dôme he wrote her[41] that he had seen "Seuphor, some glasses of lemonade, René, some agents, some Polish people from Mont Rouge, etc., etc...." and that "Stava" had asked for her address in order to write her.[42] During the last half of 1936,

their correspondence indicates that Model was working hard at her photography, attempting to photograph landscapes as well as people.[43]

On 7 September 1937, Lisette and Evsa were married in a civil ceremony in Paris.[44] From then until they left the city, they lived in a small apartment at 12 rue Lalande (fig. 35). Evidence that Europe was on the brink of war was bringing them to a realisation of the precariousness of their situation: Lisette, as a half-Jewish, Austrian citizen and Evsa, as a Jew with only refugee status in France. In spite of this, Evsa's news to Lisette of the impending war is curiously innocent: "Did you know that the Italian border is closed to French and Italian nationals?... But that doesn't concern you particularly..."[45] However, by August of 1938[46] the mounting political tensions had escalated to the point where Lisette made a final attempt to withdraw her money from Italy, and slipped back into France only in the nick of time. The Models prepared to leave Europe for the New World.

Something appears to have occurred in their relationship in early 1937, of which we learn only cryptic details from Evsa's response to a letter from Lisette. In it he expresses shame and shock, and writes that, while she has "understood the meaning of my complex... it is too much of a sacrifice on your part".[42]

Photographing New York 1938–1945 CHAPTER THREE

fig. 36
Lisette Model
Luba Ash and Mania Zimmerman 1947
Gelatin silver
34.8 × 25.9 cm
Collection Constantine Ash, Carmel

When we put our feet on Riverside Drive we fell in love with

the city in one split second The beauty of the highways –

the poetry of the skyscrapers . . .[1]

While the ostensible reason for going to New York was to visit Evsa's sister, Luba (fig. 36), and her husband, Moise Ash,[2] the Models seem to have been prepared in every respect to settle abroad. Tensions in Europe had escalated to a palpably high level when they began to plan to leave, and war appeared to be inevitable. In view of their political status – neither of them were in possession of French citizenship and they were respectively half-Jewish and Jewish – emigration to America must have seemed like an opportunity they could not reject. Their immediate family ties in Europe were minimal. As well, both were immersed in a modernist aesthetic that found sustenance in urban order, and articles that had appeared on New York in magazines such as *Regards* may also have piqued their interest.

IMMIGRATION

The Models departed France early in October 1938 aboard the *Île de France* and arrived in New York on the eighth of that month. All Lisette recalled of the crossing was that she was horribly seasick.[3] For the first week or two after their arrival they stayed with Luba and Moise, who had sponsored their immigration to the United States and who helped them financially after their money ran out.[4] Also from Nikolayevsk on the Amur, Moise had immigrated to the United States in 1929, entering the fur trade in New York. It was at this time that he changed the family name from Avshalumoff to Ash.

If Lisette ever went through the experience of displacement felt by most people who leave their home for a new land, it seems to have been overshadowed by her enjoyment of the pure vitality of the city in which she now found herself. While she clearly came to New York as an immigrant and a refugee, and was described in these terms – as a "great refugee photographer"[5] – by magazine editors shortly after she arrived, in the last decades of her life she preferred to describe herself as a happy-go-lucky tourist who had fallen in love with New York and freely made the choice to stay.

Although Lisette was remote from all that was going on in Europe, her mother's letters kept her well informed about the family and the increasingly tense political climate. The events of 1939 must have seemed to her like the end of an

epoch. Ties that had attached her to family and friends were becoming undone: a letter dated August 1939 informed her of the death of "Marini", an old family friend, business partner of her father, and manager of the Seybert family affairs. On 13 September 1939, her mother wrote, "We are at war . . . the hotels of Juan-les-Pins are taken by the military", and told her that her brother, "Salva", had been held by the Nazis in a concentration camp for one and a half days but "because he has only one lung and experienced so many illnesses they let him go".[6]

Memories of another war and the hard times previously experienced also surfaced in Félicie's letters as she recalled their life in Vienna during the First World War:

> In the House we dress for the mountains, like bears – we're only warm in bed! – the way it once was in Vienna. Do you remember, my dear Lisette – how our beautiful palace was freezing. It's the same now and since we don't have enough to eat, we're a lot more susceptible![7]

By December of that year, Evsa and Lisette had located themselves in the distinguished Art Deco Master Apartments (fig. 37) at 310 Riverside Drive, at the corner of West 103 Street.[8] Just ten years old when they moved there, it was built to house a school, a museum, an auditorium, and a restaurant, in a residential hotel. The concept of this multi-usage apartment block was that of Nicholas Roerich, a Russian émigré painter, designer, explorer, and philosopher, whose museum was also located there. He is claimed to have been responsible for shading the building's brickwork from a purple base to a pale yellow top, a feature that would no doubt have appealed to Evsa.

In their apartment on the twentieth floor they could watch the ships go by on the Hudson and feel the full inspiration of New York. Evsa's paintings, which he showed at the Pinacotheca in May 1941, including titles such as *Hudson River*, *Canton, Ohio*, and *New York Home*, indicate the degree to which immigration had stimulated new subject matter in his art. In the spring of 1946 he composed and sent to Douglas MacAgy, Director of the California School of Fine Arts, what he called his "short biography": "Born in snowy Siberia, artschooled in Paris, inspired by New York."[9]

THE GREISSLES

A letter from Arnold Schönberg, by then in the United States, to his son-in-law Felix Greissle on 7 June 1938, speaks succinctly and directly about being a Viennese immigrant in the United States:

> People here expect very hard work, but they also give it its due. Only I do beg you: be very careful. Here they go in for much more politeness than we do. Above all, one never makes a scene; one never contradicts; one never says "to be quite honest", but if one does, one takes good care not really to be so. Differences of opinion are something one keeps entirely to oneself. Servility is superfluous, is indeed likely to annoy. But everything must be said amiably, smiling, always with a smile.

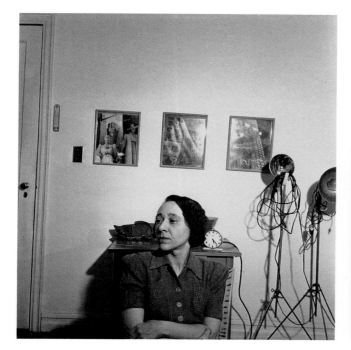

fig. 38
Lisette Model
Trudi Schönberg Greissle
New York between 1940 and 1947
Full frame enlargement
by Justin Wonnacott from
original negative, 1989

fig. 39
Trude Fleischmann, Austrian (b. 1895)
Lisette Model **1943**
Gelatin silver
33.9 × 27.7 cm

Something very important: don't say anything you don't have to say about your experiences of the last few weeks. Especially not to newspapermen or to people who might pass it on to them. You know the Nazis take revenge on relatives and friends still in their power. So be very reserved and don't get mixed up in politics.[10]

Schönberg had written this letter in anticipation of the Greissles' immigration. In 1938 they came to the States on visitors' visas, but apparently there were problems in remaining, because Lisette wrote to Schönberg in 1939, anxiously offering help. Although she said later that she had felt easily accepted as an immigrant in the United States because of Evsa's relatives, one senses a longing for the familiar faces of family and old friends in her letter:

I trust that you will not hold it against me if I turn to you in the matter of the Greissles. I have an idea how one could help them in their immigration effort; namely, if you would write to President Roosevelt requesting whether their *non*-minor children could not be allowed to immigrate on the preferred quota as an exception, since the affidavit you sent to Vienna got lost. I'm convinced you can find some way to see to it that the letter will end up in Roosevelt's hands.

The American immigration laws are immovable, and I believe the only possibility to settle the matter is by way of converting the currently completely bogged-down case into an exception, capitalizing on the fact that they are dealing with *your* daughter and grandchildren.

If I have taken the liberty of turning to you in a matter which only concerns me to the extent that my best friends are involved, it is because I am of the opinion that in a catastrophic situation where existence and future are at stake one must not leave anything untried.[11]

The appeals succeeded, and the Greissles gained immigrant status in 1941. Lisette and Trudi kept up their friendship, meeting three to four times a month. Either Lisette would go out to Connecticut, or Trudi would visit her in her apartment.[12] On one occasion, she photographed Trudi's son, Hermann, who was home on furlough. On another, she photographed Trudi in the Model's apartment amid Lisette's photographic equipment (fig. 38).

It is very likely that Lisette and Evsa attended a performance of Valeska Gert's on 6 October 1940, in which Sonja Wronkow was also featured singing "Songs from Different Countries".... The program notes used an excerpt of a review by Alfred Richard Meyer: "Go [one year] to every recital of Valeska Gert and you will change from a psychologist to a metaphysician. You will go through hell. Sometimes she will make you beastly drunk but finally you will arrive smiling at the comic only to look eternally for this one shining meteor Gert, for whom downfall means only resurrection."[13]

"The Models stayed clear of the growing circle of European professional émigrés in NYC, who came together not only to rejoice in their freedom from Hitler, or to play some chamber music, but often to laugh at the natives with their Hollywood culture, puritanical confusions and ridiculous packaged white bread. Evsa and Lisette mainly had American friends."
– Phillip Lopate.[15]

Evsa used to sign his letters to Lisette in the forties with a string of names, including "Didi".[17]

"Do you still remember Hans Heinz's evenings of Mahler songs, with Steuermann at the piano? . . . how we would love to welcome you once more."
– Julia and Hans Heinz. Although one person recalls that there might have been an upright piano in their apartment on Manhattan Avenue, nobody remembers Lisette playing for them in New York. She appears to have abandoned the practice of music completely.[18]

THE COMMUNITY

New York during the Second World War was vibrant with creative energy. With the influx of European Jews, many of whom were intellectuals and artists in the performing and visual arts, its cultural ambience was strongly coloured by the European avant-garde. On a Sunday night the Models could attend events at the Cherry Lane Theatre on Commerce Street and hear Polish singer Sonja Wronkow or see Valeska Gert perform her revolutionary dances and poem studies. Among the latter were *Vienna 1890*, *Death*, and *Baby*, which Lisette would photograph in 1940.[13]

The Models were sociable people, and they soon established friendships with individuals and couples in New York, most of whom were connected with the arts – either as established painters, photographers, or musicians, or as students of these media. In 1939 or 1940 the painter Norman Rabin, whom Evsa had known in Europe, took his students to see Evsa's paintings in the Model apartment at 310 Riverside Drive.[14] In this group were Eve Tartar, milliner to New York Society at the time, Celia Rogers, a musician, and Pauline Schubart, a painting student. Then there were the friends from Europe: Julia and Hans Heinz, Felicia and Hans Sachs (a friendship that developed in the fifties), and, from Lisette's connections with the photography community, André Kertész, and Trude Fleischmann, who photographed Lisette in 1940 (fig. 39). Evsa's contacts with painters and dealers – Ossip Zadkine, Hans Hofmann, Piet Mondrian, Fernand Léger, and Sidney and Harriet Janis – formed another circle of contacts. Lisette photographed Mondrian at the opening of the *Masters of Abstract Art* exhibition at H. Rubinstein's New Art Center on 1 April 1942 (fig. 40), for example. New contacts were formed with photographers Ralph Steiner, Berenice Abbott, and Ansel Adams, *Harper's Bazaar* art director Alexey Brodovitch, photography critic Elizabeth McCausland, and photographic historians Beaumont and Nancy Newhall.[15] All these people were to become a network of support for her photography, critiquing it, acquiring it, and engaging her for photographic assignments.

Evsa, typically attired in his green scarf and black jacket in the fall and winter, was, in particular, a very social being. For him, visiting taverns, coffee shops, night clubs, and cabarets – such as Marie's Crisis at 59 Grove, run by Marie Du Mont of French-Austrian extraction; Valeska Gert's Beggar's Bar on Morton Street; Nedick's (the poor man's coffee shop); or Sammy's Bowery Follies, whose owner, Sammy Fuchs, was also Austrian – made life in New York an extension of that in Paris. In her autobiography, *Die Bettler-Bar von New York*,[16] Valeska Gert divides her clientele at the Beggar's Bar into two social types, the bohemian and the gangster. She refers to Evsa – "die [sic] Maler Didi Model"[17] – as being a regular, along with the poet Maxwell Bodenheim.

fig. 40
Lisette Model
Opening of *Masters of Abstract Art*
Exhibition at H. Rubinstein's
New Art Center,
(left to right)
Burgoyne Diller, Fritz Glarner,
Carl Holty, Piet Mondrian,
Charmion von Wiegand
New York 1 April 1942

In fact, there was enough about New York that was different to make it an environment that stimulated new work for both Models. The cafés and the cabarets were a source for a good part of Lisette's work in the early to mid-forties. There were also evenings of listening to music with Steuermann,[18] and trips to Province-town with Pauline Schubart to the Hofmann studio.

Lisette and Evsa had an uncommon way of capturing interest, especially that of students. Not only did they have the ability to focus with such intensity on an individual that they seemed to occupy a special place in his or her life, but they drew others toward them with their passion for art, their open-mindedness to the avant-garde, and their interest in the diverse ideas and issues of the day. Friends of the period describe intimate get-togethers that most often occurred outside of the Models' home and that would begin in the late hours of the evening and go until early morning. These evenings would be passed with wine, sharing of experiences, and a great deal of talk, ranging from art and psychoanalysis to music and politics or perhaps Lisette's interest in the occult. This pattern persisted into the sixties. Lisette kept her friends separate, to the degree that some of her non-photography friends knew nothing of her photographic activity, and would be surprised, years later, to discover how active she had been in the forties, and how well-known she was as a photographer.

In the first few years after their arrival in New York, the Models moved several times. A year after settling into the Master Apartments, they could no longer afford the rent and found more modest quarters, first at 50 Manhattan in apartment 6H, and then, by 1943, at 55 Grove Street in the East Village (fig. 41).

fig. 41
Lori Pauli
55 Grove Street New York 1989
National Gallery of Canada,
Curatorial files

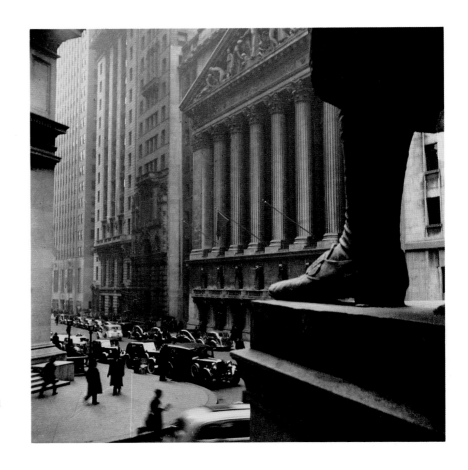

Modern people city people, in particular, are bombarded

by impressions. All five senses are rushed, crowded,

besieged by sights, sounds, smells, events. Relentless and pell-mell.

Images of America: the Instant 1940–1947 **CHAPTER FOUR**

We keep sane by filtering most of them out,

by keeping an inner shelter veiled and protected.

The cost is terrible: an even more benumbed, muted existence.

Model reminds us – or, forces into our vision reminders

– of life's intensity. The portrait of Model is a window and a mirror.[1]

In 1938 New York was the second largest city in the western world. It had a population of seven and a half million, with over one million people living in Manhattan alone. The Models, like other European artists arriving in New York around this time, were deeply impressed by the city. Given the sense of invigoration and visual excitement that Lisette and Evsa experienced upon their arrival, it is hard to imagine that she did not take any photographs at all for the first eighteen months, as she repeatedly insisted in interviews.

And, in fact, glassine envelopes marked in her hand "1939" containing views of Battery Park and Wall Street (fig. 42) suggest she began to take photographs earlier. The images from the period 1939 to 1940 chronicle Lisette's early impressions. She responded to the qualities of New York that had an immediate impact on her – the highly charged energy level, the dramatic plays of shadow, the tall buildings and intense light, the glamour, the paradoxes, the people. Her impressionistic treatment of human figures in the early work undoubtedly developed out of her relationship as an immigrant to an unfamiliar environment. She appeared to be searching for some understanding of the society of which she had recently become a part, and also confirming links with her European past. Fifth Avenue in particular moved her to produce hundreds of images of pedestrians and store fronts. These took the city environment as subject, but were also a portrait of its people. In Evsa's early American paintings (fig. 43), the city is depicted as a dense conglomerate of geometric structures penetrated here and there by a single human stick figure, whereas in Model's *Reflections* photographs (fig. 44), figures and buildings play out against each other in constantly changing combinations.

Along with New York's icons and monuments, Lisette focussed upon Delancey Street in the Lower East Side. While continuing to make portraits of people on the street which had the same compelling sense of presence that we see in her European work, the energy and excitement of the city propelled her also into making photographs such as those in the *Reflections* and *Running Legs*

series, photographs as fluid, layered, and open as those from Nice and Paris are solid, immutable, and closed. Everything that dazzles, bewitches, and overwhelms the first-time visitor to New York dazzled, bewitched, and overwhelmed her: skyscrapers, throngs of pedestrians, and window after window promoting objects of all kinds with seductive and sophisticated displays.

Making photographs in New York, Model discovered the pervasiveness of visual images in both two- and three-dimensional forms. At the core of marketing techniques, advertising slogans, and other commercial strategies was the notion of a deficient human life that needed to be transformed – but only temporarily. In order for the machinery of commerce to keep going, fashion changes had to be abrupt and intense, and advertisers used photographs to supply the imagination with fresh possibilities and yearnings. Here in America, the legendary land of opportunity, Model discovered one could create oneself anew, daily if desired.

Model clipped photographs of stars and politicians from tabloids like the *New York Post* and the *New York Herald* throughout her career in the States, trying to come to terms with what the image-making machinery was all about. In the early phases, one body of her photographs in particular explored "manufactured images": the series which she loosely referred to as *Reflections*, but which also included objects displayed in windows as subjects.

The opulence, the style, the lighting, the mood. Paris couldn't compare. I try to capture New York.[3]

"The first thing I do when I go into the street is look at the windows."
— Lisette Model.[6]

Some twenty years later she would synthesize her photographic work as an exploration of "glamour" and an examination of the "hidden face".[2] Naturally, an investigation of both implied a look at their reverses, anti-glamour, and the mask. The period 1940 to 1947 was the most prolific of her life. She photographed Wall Street, Battery Park, *Reflections*, *Running Legs*, pedestrians on Fifth Avenue, night clubs, Broadway, the Bowery, settlement houses, circuses, theatre rehearsals, radio shows, and jazz and stadium concerts (for the Office of War Information), and produced numerous assignments for *Harper's Bazaar*.

fig. 45
Lisette Model
Window, Lower East Side New York
between 1939 and 1945
Full frame enlargement by Justin Wonnacott
from original negative, 1989

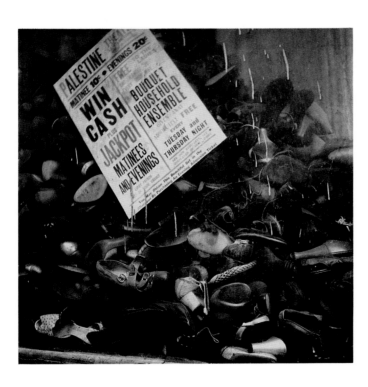

REFLECTIONS

Model observed, with a curiosity and an attraction that remained with her throughout her life, the objects and reflections in store windows. Visiting a new city, she would walk the streets looking for interesting windows. One of the earliest subjects she photographed after arrival, they were also among her first photographs to be published in the United States: in December of 1940, *Cue* magazine presented them in a two-page spread, noting that they achieved "surrealist-like effects..."[4]

In these images, Model captures both the feeling of flux and transitoriness that is the essence of the excitement of New York, and a sense of its underlying permanence. She approached both aspects with serious thought and playful lyricism. The coupling of a fresh and casual interest in what she saw with a deeper sense of implication is reflected in these comments by Model, and is characteristic of her approach to photography:

I really wanted to send a photograph to my sister in France, to show her what Fifth Avenue was. I was a little bit disappointed, such a small street and such a big reputation. I put myself in the middle of that and I couldn't photograph that. And accidentally I looked into one of those magnificent windows, and then I saw this natural photo-montage. Immediately, I started again to do something. And that became a passion, and a hobby of mine I have never given up.[5]

For Model, the window was a frame, a geometric vehicle for containing the chaos of the city,[6] and the images reflected in them in these photographs became a template for future themes, which she plucked out and examined later: pedestrians, couples, faces, legs. Her preoccupation with notions of glamour in America lies at the root of much of her work. Many years later, she remembered her first impressions:

I found that America was the country, *par excellence*, of making images of everybody, everything. Everything had to have an image, the car had to have an image, a shoe had to have an image, the politician has to have an image. One day

 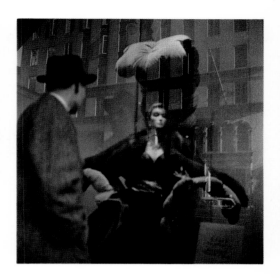

I was sitting in a kind of a bar, and I saw a politician projecting his image, and I said to myself: *"Glamour,* the image of our image – that is my project."[7]

With hindsight, it is easy to see that this interest was present from her first American photographs. It appears here in the window reflections, with their obvious cosmetic manifestations of the glamour of the advertising of ideal looks, clothes, and material aspirations. She was also alert to the fact that, deep within North American culture, the cult of glamorization has absorbed the art object into its sphere of influence. For instance, a Picasso painting is mirrored in a Bergdorf Goodman window, along with other objects. Examining glamour, Model revealed also its flip-side, anti-glamour. The windows of the Lower East Side stores, with their dishevelled, dusty displays of hats or shoes (fig. 45), layers of unrelated merchandise accumulated over the years, animal carcasses (fig. 46), or plucked birds provided a sharp contrast to the chic, ever-changing, midtown displays. According to Model:

> What we see in windows says a great deal about America and the civilization and the culture. It was not just something I did for the beauty of it.[8]

In addition to a formal interest in the displayed objects, there was a pragmatism behind the making of these images. Given New York's narrow streets and tall buildings, the windows provided a unique opportunity to capture both sides of the street in one frame: a multiple image of chunks of city life. Everything that would otherwise require a series of separate views from different angles appeared here magically compressed: architecture;

passing human and vehicular traffic; the skyline; the sky itself. It was sleight-of-hand photography – presto! – and in one frame of an Altmann window you could contain the steel side of the Empire State Building.

The theme from 1939 to 1940 most predictive of Model's later New York window photography was the male figure in relation to the store, either outside the glass peering in or turned away from it. This is demonstrated in the well-known photograph *First Reflection* (pl. 59), the first of her American works acquired by the Museum of Modern Art in 1940; in the photograph of the man with the bowler hat and cane reading a newspaper in front of Bonwit Teller published in *Cue* in December of 1940; and in other images she never printed. These photographs not only reveal some surreal juxtapositions, but also allude to the psychological relationship of people to objects. In some of her images, plaster female effigies representing an ideal type and live males, separated by a sheet of glass, stare dumbly at one another (fig. 47). Sometimes the fantasy created within and without is interrupted by the shadow of an onlooker.

Model's vision of these windows is, on the one hand, a response to a cultural phenomenon, seeing in the choice of objects displayed and in the nature of the display itself an index to societal values and aspirations, and, on the other, a reaction to the sheer visual lyricism of the event. She was attracted to the play of light and form as an abstract phenomenon as much as she was to the content of the windows. To Model, the shadow was sometimes more real than the substance in a world in a perpetual state of transit, the pedestrians arrested for an instant by the lure of store displays more present as layered silhouettes than corporeal beings. She

fig. 46
Lisette Model
Window, Lower East Side **New York**
between 1939 and 1945
Full frame enlargement
by Justin Wonnacott from
original negative, 1989

fig. 47
Lisette Model
Window, Bonwit Teller **New York**
between 1939 and 1940
Full frame enlargement
by Justin Wonnacott from
original negative, 1989

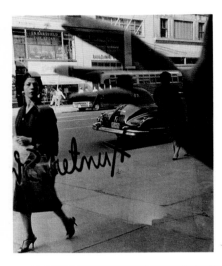

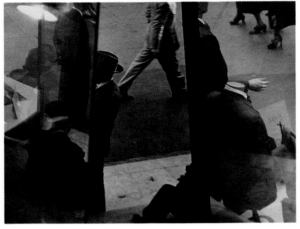

fig. 48
Lisette Model
Reflections, Hunter Shop
New York c. 1950
Gelatin silver
31.7 × 25.9 cm

fig. 49
Lisette Model
Window San Francisco 1949
Gelatin silver
26.8 × 33.9 cm
J. Paul Getty Museum,
Malibu (84.XM.153.14)

Another interest for her was the window as a ready-made, as an object itself and not just a vehicle of display. In the photographs depicting layers of pedestrian window-shoppers, the logic of space has been subverted and the photographer's viewpoint is ambiguous. Similarly, the relation of the plane of the window surface to the reflections or display of objects – with some photographs taken from the outside of the window, and some through it from the inside (fig. 48) – challenges the viewer's perception of order. In a San Francisco image from 1949 (fig. 49), Model exploits the mannequin/human inside/outside ambivalence of the window, and also uses a combination of the architectural features and the 35 mm film structure as an interruptive and sequencing element: the photograph embraces parts of two consecutive frames, with the interstice between the frames integrated into the image as part of its architectural character and assisting in slicing the view into a complex, kaleidoscopic, visual event.

In 1945, on the occasion of the death of U.S. President Franklin D. Roosevelt, Model photographed at least twenty store windows containing tributes to him. Many displayed his image alongside the regular bric-a-brac of merchandise with handwritten messages such as "We Mourn Our Loss" (pl. 61). By recording more than a single window, Model showed how the store display became the site of personal political expression.

Model's American photographs are, in part, a response to a culture whose temporal and philosophical base differed dramatically from her own, but they are also an impressionistic response to an overwhelming sensory experience. New York was a

described the seductiveness of the arrangements: "When I came to the United States, I saw window displays that I had never seen before – magnificent. Everything was beautifully arranged, everything had colour – pink, red, cream, blue." [9] That colour not only compelled her to capture the images of the windows, but also fed into the manner of presentation of her monumental *Promenade des Anglais* works, which she began mounting on boards coloured vivid red, green, and blue. Strong primary colours were also on Evsa's palette at this time.

The reflections of pedestrians who pause to check out objects are among the most impressionistic and lyrical, with plays of silhouettes and light qualities that are rich and complex (pls. 73, 74). One image, published in *Poet's Camera*,[10] accompanied a poem by Christopher Morley:

catalyst. If the *Promenade des Anglais* was an open air studio for Model, New York was an illusory and refractive kaleidoscope of pedestrians, store windows, and passing traffic.

There were also external factors that might have predisposed Lisette towards an interest in window displays. Evsa had decorated the windows of L'Esthétique with witty and somewhat surreal arrangements of objects, several of which were photographed by Kertész (fig. 51); while she herself may never have seen them, she would certainly have heard about them. Also, Vienna had a reputation for dazzling window displays. As well, store windows and their contents had been a source of great visual interest for French photographer Eugène Atget some thirty years earlier (fig. 50).

They had also been the subject of an article in *Regards*, the magazine which had first published Model's *Promenade des Anglais* photographs. Entitled "Femme en vitrine", the article had appeared in the issue of 14 May 1936. Heavily illustrated with photographs, it had exposed the plight of women who worked as living mannequins in store windows in Paris, advertising consumer items and displaying clothing. The accompanying photographs had showed the women in the windows and the curious crowds outside looking in. In another article that had appeared in 1936 in this same magazine, this time on Fascist morality in Italy, among the illustrations was a photograph of a man examining the contents of a store window opposite a brothel. From the interior of the window looms a massive plaster cast of *Il Duce*'s face (fig. 52).

While there is no extant documentation or negatives to prove that Model was the source of any of the numerous window photographs reproduced in *Regards*, it is a subject she might easily have been attracted to in Europe. With both her family and her sole source of revenue tied up in property in Italy, Model had certainly visited and photographed the country frequently from 1933 to 1938,[11] although negatives which documented events in such a way that they were critical of Mussolini's regime have not survived. At minimum, it is highly likely she would have seen the images in *Regards*.

fig. 50
Eugène Atget, French (1857–1927)
Avenue des Gobelins 1925
Gelatin silver
22.7 × 16.7 cm
National Gallery of Canada
(21227)

fig. 51
André Kertész, American (b. Hungary, 1894–1985)
Still Life in Bookshop Window 1927?
Gelatin silver
9.9 × 7.2 cm
Collection Ealan J. Wingate, New York

fig. 52
Mask of *Il Duce*, «Morale fasciste,»
Regards, no. 26, September 1933, p. 4
Bibliothèque nationale, Paris

fig. 53
Lisette Model
Reflections,
Legs in Bergdorf Goodman Window
New York between 1939 and 1945
Gelatin silver
32.2 × 26.9 cm

RUNNING LEGS

The crowd increases with the light, a black moving mass, workbound; a million pale faces; a clicking of heels that swells to one sustained roll of thunder...[12]

Model topples conventional perspective in both her *Reflections* and her *Running Legs* series. The transitional photograph shows a Bergdorf Goodman window decorated with a Bemelmans backdrop of a caricature of a male face beside a pair of mannequin's legs (fig. 53). Like *Reflections*, the *Running Legs* photographs were also done in the first years of her settling into New York. With their radical treatment of viewpoint, they can be linked in part to the concerns of the European avant-garde. She attributes their inspiration to a more fundamental experience, however. Frustrated by the perspectival distortions she acquired when photographing skyscrapers, she claimed she pointed her camera downward and discovered this intriguing display of legs in motion.

In the *Running Legs* series, the viewer is thrown belly-down onto the sidewalk and must see the world from a perspective totally foreign to a sober adult – that of a child in a stroller, a beggar, or a fallen-down drunk. One photograph which aptly makes this point is the seated beggar on a sidewalk surrounded by a sea of legs: it implies the confusion and even sensation of being overwhelmed that Model herself must have experienced in the midst of the endless flow of human traffic (pl. 52). The works were reviewed in *U.S. Camera*:

These photographs by Lisette Model are hardly portraits of feet, but they are an unusual and satisfying approach to a baffling subject, the legs, and specifically the feet, in motion. She made several trips to New York's financial district where she found these hurrying feet of workers in the noontime crowds. Speed, stride, stamp, and strength – all are here.[13]

These images clearly inspired many viewers to wonder what position she herself was in when she took them, as shown by a photograph of Sam Wagstaff on the floor at the Corcoran in 1978 (fig. 54).

This is perhaps the only series of works by Model that can be described as elegant. Her response to the dense crowding of narrow New York sidewalks at peak times, when literally thousands of people would stride the paving stones within the space of an hour, was musical. Legs, feet, shoes, and coattails are all but reduced to visual abstractions and become evocations of the sound of feet pounding the sidewalk. Her sense of the extreme drove her into the thick of the crowd, covering a territory of several Midtown and Lower Manhattan city blocks. She photographed pedestrians on Wall Street, descending the New York Library stairs, entering and exiting the Fourteenth Street subway, along Fifth Avenue, and in Times Square, and recorded the rhythm of endless footfalls, clicking heels, and shuffles, catching a silhouette of pant legs or light tracing the sweep of a coat edge like

fig. 54
Gerald Incandela
Exhibition *Photographs from*
Samuel J. Wagstaff Collection,
Sam Wagstaff on floor,
André Jammes far left,
and unidentified viewer.
Corcoran Gallery of Art,
4 February–26 March 1978

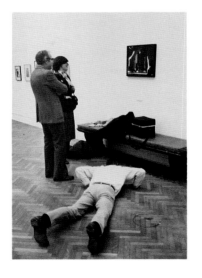

the inflection of a high note. With a well-trained sense of pitch, emphasis, crescendo, and repetition, the cropping she performed both in her camera and in her darkroom was executed with an impeccable orchestration of movement, form, and sound.

The radical sense of composition, with the bulk of the forms and the striding legs reduced to silhouettes against a virtually minimal backdrop, again emphasizes the fragmentary, and relates to the formal developments in German avant-garde photography of the twenties and thirties. Other photographers such as Martin Munkacsi, Cami Stone (fig. 55), Weegee, and Rebecca Lepkoff (fig. 56) were engaged in making images with similar subjects.

PERFORMERS

The manner in which the camera could record human movement intrigued Model almost as much as its capacity to capture the sedentary and monumental. Two important female performers, both brilliant pioneers in expressive dance and mime but drawing their inspiration from completely different sources, were photographed by her in the early forties: Valeska Gert and Pearl Primus.

Valeska Gert's work as a mime, dancer, and performance artist was definitely not lukewarm (pls. 16, 17). She was the subject of many photographers, among them Herbert Tobias, Man Ray, and Erwin Blumenfeld.[14] Model's fascination with Gert went further than strong admiration for her work, however. In several respects they shared common characteristics and had similar backgrounds. European, female, of the same generation, one Jewish and the other half-Jewish, they were both engaged in questioning the mores of their new society. As well, Valeska Gert's acts were diversely described as "portrayal of bizarre human types", "social-critical dance pantomime", and "grotesque personifications"; the "tragic and satirical types"[15] that she was enacting in sound and movement Model was capturing on film.

Insouciant, edgy, and confrontational, Gert's

 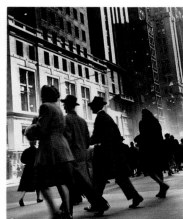

fig. 55
Cami Stone
Crossing the Street 1925
Gelatin silver
23.2 × 16.8 cm
Private collection

fig. 56
Rebecca Lepkoff
West Street Morning 1947
Gelatin silver
Dimensions unknown
Collection Rebecca Lepkoff, New York

early performances in Hollywood in 1936 were excised from films because they were considered too strong for American audiences [16]:

The critics write I'm sparkling as champagne, fresh as a forest, clear as glass, poisonous as a toadstool, and I rush to their head like heavy wine. I remind them of Rodin, Barlach, George Grosz, Baldung Grien, Toulouse-Lautrec, Daumier, Pascin, Félicien Rops, Thackeray, Balzac, and Goya. They find me grotesque, bizarre, tragic, comic, vicious, classic, gothic, expressionistic, surrealistic, dadaistic, baroque. [17]

The aggressively unconventional nature of Valeska Gert's art form and her highly spirited enactment of it would seem to have presented Model with the ideal collaboration: kindred spirits pitting their art against tired bourgeois mores. In 1941, Gert received a very sharply worded letter from *Aufbau*, a Jewish newspaper that described itself as "Serving the Interests and the Americanization of the Immigrants", criticising her for producing performances that they found to be tactless, tasteless, and working against the acceptance of immigrants in America. Interestingly, *American Daughter of Revolution in Coney Island* was singled out as the offending parody. This piece was performed in 1941, the same year that Model made her images of the Coney Island bather (pls. 8, 25). The possibility that Valeska saw and was inspired by these photographs is strong; their association dated back to at least 1940, when Model first documented Gert's dance *Death*. A friend of both, Eric Kocher, wrote that "they knew each other from before they came to America and continued good friends after coming to the U.S. I know they admired each other's work and remained close in New York, and also in Provincetown where they both summered." [18]

Around this time Model photographed several of Valeska's major studies: *Death*, *Baby*, and *Olé*. One image from *Death* was exhibited in her Photo League exhibition in May–June 1941 (see chapter 5). In the photography sessions, Gert's sense of the extreme, her passions, and her forays into the bizarre and grotesque dominated. Curiously, Model seems to have recorded her dances somewhat

mutely, playing more the role of documenter than of interpretive artist. Only in the late seventies did she return to these images and attempt to realize them in a sequence (fig. 57).

In 1941, Valeska Gert opened the Beggar's Bar on the corner of Bleeker and Morton streets, [19] not far from the Model's Grove Street apartment; later, in Provincetown, she ran "Valeska's", a restaurant which advertised "Different Food and Different Entertainment". She and Model kept constantly in touch in both places. In Provincetown, where Evsa and Lisette vacationed regularly throughout the forties and fifties, Model photographed both Gert and the Polish singer Sonja Wronkow.

Another extraordinary dancer whose work attracted Model and whose name, along with that of Katherine Dunham, was to become synonymous with modern dance in the forties was Pearl Primus. A Black American born in Trinidad, she introduced African dance forms into the vocabulary of dance in the States. Model photographed her performing *Hard Times Blues* in 1943 (pl. 18, fig. 58), and exhibited at least one of the images from the series of about ten in the 1944 A.C.A Gallery exhibition *Contemporary Photography*.

Model was extremely interested in Black American culture, admiring exponents of its music and literature. She, like many Europeans of her generation, loved jazz, and not only attended clubs in New York but made several pilgrimages to Newport, Randall's Island, and Music Inn in Lenox, Massachusetts. Langston Hughes, Black poet, novelist, and participant in the Newport Jazz Festival in 1957, was someone she held in high esteem and had hopes for collaborating with on a book in the fifties. [20]

In the sixties, Model again tried her hand at photographing dancers. This time the subject was the renowned American ballet dancer Hugh Laing; he was also an aspiring photographer and studied briefly with Lisette. Laing and his friend Antony Tudor, the choreographer, became personal friends of Lisette's, but these later photographs never attained the spirit of intensity of the Primus and Gert photographs.

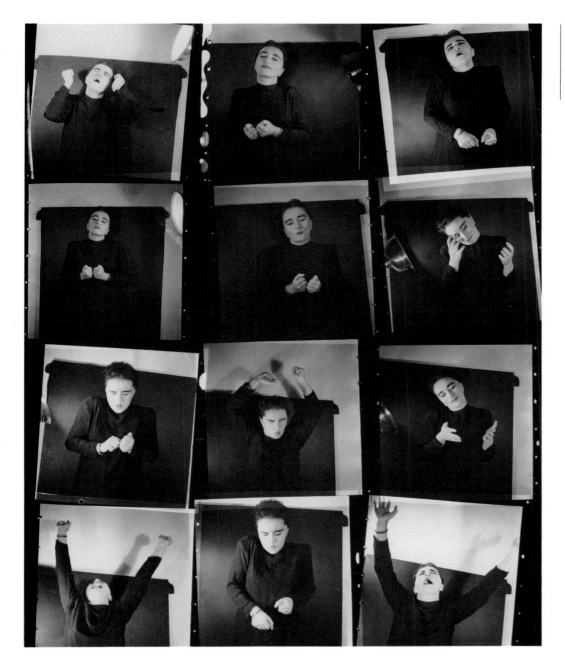

fig. 57
Lisette Model
Valeska Gert in "Death"
New York 1940?
Gelatin silver
50.8 × 40.6 cm
Modern enlarged contact sheet

16 **Valeska Gert, "Death"** 1940

17 **Valeska Gert, "Olé"** 1940

fig. 58
Lisette Model
Pearl Primus in "Hard Times Blues"
New York 1944?
Contact sheet printed by Justin Wonnacott
from original negative, 1989

18 **Pearl Primus** New York 1943

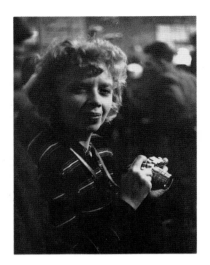

fig. 59
Dee Knapp
Lisette Model at Sammy's 1947
Collection Dee Knapp, New York

popular steak house, provided her with the opportunity to make some of her most memorable images.

Lisette was introduced to Sammy's Bowery Follies by George Davis when he was fiction editor at *Harper's Bazaar*.[23] Described as a poor man's Stork Club, both down-and-out and uptown well-heeled New Yorkers congregated there.[24] It teemed with characters, from the singers and other performers to the regulars and the proprietor himself. Lisette said:

> I felt totally and completely at home. Sammy's was a very interesting place – owner of Sammy's was Mr Fuchs. He built a nightclub for the bums, and they came there, and really they were bums. They heard marvellous singers – they were professional singers. Eventually he gave them a drink, he gave them a haircut, he gave them somewhere to sleep.[25]

In 1947, Model gave Dee Knapp – an assistant in the Department of Photographs at the Museum of Modern Art – the same kind of guidance in photography that Rogi André had given her. Introducing Knapp, who described herself as "a young innocent from the Midwest", to interesting and inexpensive places where she might photograph in New York, Lisette took her to Sammy's. When instructed to photograph the people there, Knapp balked despite Lisette's repeated entreaties to "just do it", and photographed Lisette instead (fig. 59).

Model always professed not to speak to people or ask permission of her subjects before photographing them. On at least one occasion, Knapp recalls something quite different. Intrigued by a group of women occupying a booth in a nightclub they had visited, she pointed them out to her companion, whereupon "she walked over to the women, talked to them, they all laughed, and Lisette took their photograph."[26]

By 1944, Model had recorded images in a variety of restaurants, bars, and clubs. Working at a time when it was still possible for a photographer to propose an assignment independently or to interest a publication in a body of photographs already produced, neither the *Sammy's* nor the *Nick's* series were, according to Lisette, done on

SAMMY'S, NICK'S, GALLAGHER'S

I want to prove nothing with my pictures. The photographs
I take prove something to me. What counts is sincerity, realism and truth.
The art of the split second is my means of exploring.[21]

"At no. 267 Bowery, sandwiched in between Missions and quarter-a-night flop houses, is 'Sammy's', the poor man's Stork Club. There is no cover charge nor cigarette girl, and a vending machine dispenses cigarettes.... Patrons prefer to dance with their hats and coats on ... lively floor show ... only saloon on the Bowery with a Cabaret licence ... uptown crowd mingles with the Bowery crowd and enjoying it ... woman called 'Pruneface,' a man called 'Horseface,' ... 'Ethel', the queen of the Bowery, ... sports a pair of black eyes.... Sammy known as the Mayor of the Bowery, and his ambition is to become Mayor of New York City." – Weegee.[24]

The camera's capacity for arresting movement fascinated Model from the beginning. For her it was an instrument of detection. Her images capture movement and time in a myriad of ways. The Côte d'Azur portraits, with their quality of stillness, make visible the passage of time only within the scarcely perceptible alterations of background. In *Running Legs*, the fugitive instant is brought to the foreground and made manifest in powerful silhouettes full of potential movement. By the capturing of significant gesture, as in her image from the Café Metropole (pl. 19), and in her series from places like Sammy's, Model distils both time and action.

When the Models first arrived in New York, Evsa's cousin Jacob Avshalomov recalled that Nedick's, the "poor man's coffee shop", was one of their favourite spots.[22] Places with performers, entertainers, audiences, and diners inspired Lisette to photograph people in a variety of moods, some letting loose, others lost in contemplation. Sammy's, a cabaret, Nick's nightclub, and Gallagher's, a

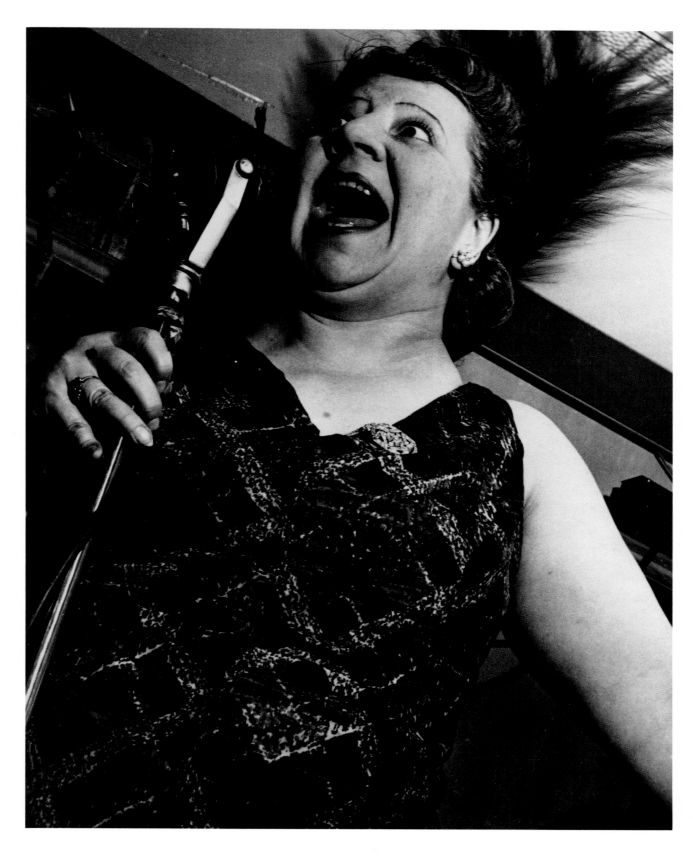

19 **Café Metropole** New York c. 1946

20 **Weegee (Arthur H. Fellig)** New York c. 1945

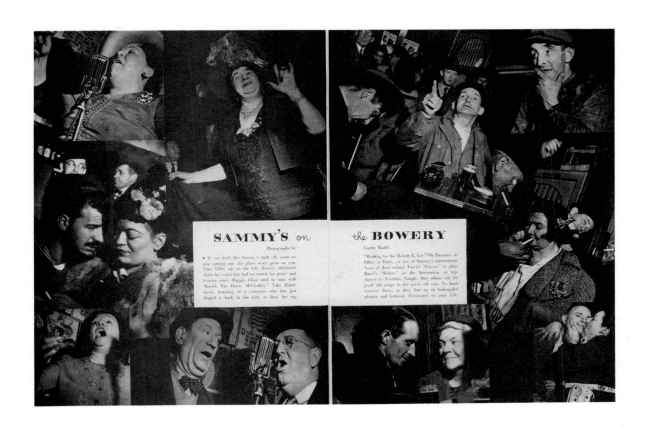

fig. 60
"Sammy's on the Bowery,"
Harper's Bazaar, September 1944,
p. 88–89
Photographs by Lisette Model

U.S. Camera indicates that Nick's nightclub was done on assignment. Model contradicted this:
Janet Beller: You did *Sammy's*, *Nick's*, and *Gallagher's* all on your own?
Lisette Model: Yes. *Gallagher's* was for *U.S. Camera*.[27]

"Bowery Christmas: Lisette Model's Photographic Impressions of Sammy's Famous Bar Down on the Bowery." Model's photographs were published in eight of twelve issues of *Harper's Bazaar* in 1944. "Sammy's on the Bowery" was presented as a collage of ten photographs. Likewise, a number of *Nick's* photographs appeared in *U.S. Camera*: "The night club pictures were taken on assignment for *Harper's Bazaar*, where she has been working recently. More of this series will appear in future *U.S. Cameras*."[28]

An exhibition featuring the photographs of Model, Arthur Siegel, Walter Rosenblum, Morris Engel, Dorothy Norman, and John Candelario. The press release announced that both had been done on assignment for *Harper's Bazaar*. Elizabeth McCausland reviewed the exhibition: "The exhibition [is] . . . to be the first in a series to present . . . work of men and women 'who are using photography as an expression in the tense, taut days of our own time' . . . Thus when she [Model], for example, photographs Sammy's Broadway Frolics [sic] or Nick's, she reveals a face of life in the United States in wartime which is not pleasant to see – those who fiddle, perchance, while Rome burns. Is this, then, an indictment of the human race, of the American people? No, rather, as the museum press release observes, it is an indictment 'of a society that offers them nothing better.'"[29]

assignment,[27] although images from both were published in *U.S. Camera* and in *Harper's Bazaar* (fig. 60).[28]

Photographs from *Sammy's* and *Nick's* were included in the *New Workers 1* exhibition at the Museum of Modern Art in 1944.[29] They apparently touched a sensitive nerve for John Adam Knight, *New York Post* photography critic, who seems to have subscribed to the idea of a neutral and objectively created truth, and who favoured a tempered approach to photography, avoiding any extreme of expression. In a snide and cynical tone he attacked the photographs of Nick's and Sammy's as theatrical, staged, and pseudo-candid, and accused Model of using the tricks of a theatre director.[30] Although not deliberately staged as such, her photographs undoubtedly were unabashed, theatrical, and extreme. W. Eugene Smith came to her defence, and Model replied to Knight by letter to *U.S. Camera*.[31]

Weegee also frequented Sammy's. Since he worked as staff photographer for *PM'S Weekly* from 1940 to 1945, he would have seen Lisette's work as early as January 1941, when "Why France Fell" was published. As members of the Photo League, they saw one another's work exhibited there.

fig. 61
Lisette Model
Mrs Cavanaugh and a Friend at an Opening of the Metropolitan Opera
New York c. 1943
Full frame enlargement
by Justin Wonnacott from
original negative, 1989

fig. 62
**Weegee (Arthur H. Fellig), American
(b. Austria, 1899–1968)**
The Critic 1943
Gelatin silver
26.5 × 33 cm
Museum of Modern Art,
New York, Anonymous gift

fig. 63
Weegee (Arthur H. Fellig), American (b. Austria, 1899–1968)
Lisette Model **between 1940 and 1946**
Gelatin silver
21.2 × 16.5 cm
Collection Mrs Alexandra R. Marshall, Houston

"Mrs Model, a competent photographer and an even better stage director, recently made a long series of flash pictures of the bobby sox crowd in attendance at a Greenwich Village hot-spot, noted, or notorious, for its swing band . . .
"Pick your own subject, anywhere in the world, aim a Speed Graphic camera at him, fire a couple of dozen flashbulbs in his face, one at a time, and see whether his attention remains fixed on something going on over your shoulder. Not even Goodman can send them like that.
"No, the twerps and chicks in Mrs Model's pictures were not photographed unawares while out of this world. They were merely doing, at her direction, I suspect, a job of ham acting."
– John Adam Knight.[30]

They were also exhibited together at the Museum of Modern Art in the forties and photographed many of the same events, such as the openings of the seasons of the Metropolitan Opera. Lisette's image of the woman with the tiara, Mrs Cavanaugh (fig. 61), who also appears in Weegee's *The Critic* (fig. 62)[32] is proof of this. The circumstances of the 1943 opening, as described by Weegee, indicate that it was a popular spot for photographers:

I took stock of the situation. It was a cold night. Inside the warm lobby about two dozen photographers were lined up Wolf Gang Fashion. If one flashed a bulb, all the others did too.[33]

Model's portrait of Weegee with his camera pressed into his face may well date from this occasion (pl. 20). Although he was born in Austria, this was not a link that connected the two. He did not retain any strong sense of attachment to his European roots and thought of himself as an American. Wilma Wilcox, Weegee's widow, recalls that although he and Model were not great friends, they had "a deep and true appreciation of one another's work". This is illustrated by Weegee's inscription in her copy of *Naked City*: "To Lisette Model, My favorite Photographer. Weegee 1945". But as far as Wilcox and Weegee were concerned, Model was "different", less like the other Photo Leaguers and more like "someone from the West Side".[34] Wilcox remembers seeing her rarely at the Photo League but frequently on the street with her string bag. Many years later, Model would talk to her students about the ease with which she was able to use a flash and move around because of the convenience of the string bag, which held her unused and spent bulbs.[35] The bag features in Weegee's portrait of her (fig. 63), which surely caught Model unawares, as she disliked being photographed in profile.

By the end of the forties and into the early fifties, Model and Weegee were in competition for the same jobs. As a result of Weegee's request to Brodovitch to replace her at *Harper's Bazaar* (see chapter 5), they had a falling out. In spite of this, she continued to hold his work in high regard.[36]

Model's retort included a partial reprint of the article: "Gentlemen: Here is the masterpiece! Many people have sent me copies – some of whom were afraid you might have missed it. To me, it does not matter but Mr Knight might have given you a chance to correct his notes. Model." It was followed by an editor's note: "The masterpiece referred to above appeared under John Adam Knight's byline in the *New York Post*. Since *U.S. Camera* is on the spot, we have reprinted the article. We add that it was a twin lens reflex from which Lisette fired the bulbs. She says: 'The youngsters simply were not interested in the camera.'"[31]

"It was like a game of 'follow the leader'. This is a big night for the cameramen, with the papers and syndicates sending only high class photographers who know society "I like to get different shots and don't like to make the same shots the other dopes do . . . so I went outside into the street A nice Rolls Royce pulled up I waited till the occupants got out and snapped the picture. I couldn't see what I was snapping but could almost smell the smugness. I followed the women into the lobby, where the other photographers then snapped their picture too." – Weegee.[33]

A postcard from Steiner
followed soon after this,
proposing Model undertake
a series of photographs of
refugees, a suggestion to
which she did not
respond.[38]

"#698 Photographing
New York and Its People....
Inside sessions for enlarging
and analyzing prints
alternate with field trips
on which students and
instructor work together
to photograph the city,
its people, its different
sections, i.e., the East
Side, the Financial district,
Rockefeller Center, etc."[41]

Schleppers are people hired
to attract passers-by into the
store.[42]

LOWER EAST SIDE

Model had certainly begun her substantial body of
work on the Lower East Side by early 1942. By
February of that year she had a sufficiently impres-
sive group of photographs to pique *PM* art director
Ralph Steiner's interest:

I have just seen some very wonderful pictures you've
done on the East Side. Could I see all you've done recently
– maybe there would be enough for a page in *PM*? Also,
would a letter on *PM* stationary help you if anyone asks why
you are taking pictures?[37]

The offer of an introductory letter from
Steiner related to both the Models' alien status in
the United States. In order to photograph free of
suspicion, Lisette was required to send letters from
her New York professional acquaintances to the
United States District Attorney; Abbott, McCaus-
land, Barbara Morgan, and Tom Maloney testified
to her character and political neutrality.

A few months later, Steiner enquired about
more of her work for the pages of *PM's Weekly*, this
time not completed work but a projected series of
photographs "showing how New Yorkers live and
work and play." He ended on a note of strong
encouragement, urging her on ". . . since I think
that your photography is more than good – it is
extraordinary."[38]

Lower East Side landmarks were the Orchard
and Mott Street Pushcart Markets; the Riis, Green-
wich, and Henry Street settlement houses ("The
Settlement"); the Bowery Mission; Sammy's
Bowery Follies; and Astor Place. Although the
population of the area had dropped and land values
declined as a result of immigration quotas in the
1920s, it was still a vivid and energetic community
when Model first began photographing there in the
early 1940s. Delancey Street, the Jewish quarter's
main traffic artery and shopping centre, was Europe
for Model. In 1953, returning to France and Italy for
the first time since 1938, she wrote to Evsa that she
now understood why she had been so attracted to
the Lower East Side: "I recognise these European

types They come from Poland, Hungary . . ."[39]
She could not identify with the people she first saw
in New York on Fifth and Park avenues, and found
herself more drawn to the people of the Lower East
Side. In a later interview, she said:

When I went to Paris in 1953, I wrote to my hus-
band: Now I know why I always ended up in Delancey Street
in the beginning, because Paris is one great Delancey Street
in French. Then I knew that I could only photograph the
Europeans in Delancey Street – not the Americans. Later
on, of course, I tried.[40]

Most of the *Lower East Side* images, of which
there are hundreds of negatives extant, were made
between 1942 and 1945. It was a subject she
remained attracted to for many years, even when
she had stopped photographing there, apparently in
the early 1950s. When she started teaching at the
New School (see chapter 7), one of her courses took
"New York and Its People" as a subject, and she
conducted her students on tours.[41] The Lower East
Side provided Model with an attractively wide
range of subjects: people seated in parks, checking
out merchandise at outdoor markets, or walking
their dogs, sandwichboard men, children holding
children, windows with pigs and poultry, merchants
outside their stores, street corners, settlement
houses (fig. 65), and stores with their *schleppers*[42] in
the doorways.

Model's *Lower East Side* photographs are por-
traits in the sense of those from the *Promenade des
Anglais*. The subjects, ironically, also have time on
their hands. Stationary and sculptural, they watch
the world go by sitting on park benches and tene-
ment fire escapes. Often they simply stand and
observe. If *Running Legs* and *Reflections* are about the
fragmentary, the layered, and the transient in New
York, the portraits of people of the *Lower East Side*
are about monumentality and time standing still. As
on the *Promenade des Anglais*, the photographer
again searches for physical extremes, only this time,
one feels, with more empathy for the subjects. As
with the portraits from Nice, Model preferred
photographing people whom she did not know.

fig. 64
Lisette Model
Lower East Side **New York**
between 1940 and 1942
Gelatin silver
27.4 × 31.5 cm

She selected subjects for the sense of presence they projected:

> People always think it's sarcastic what I do, but I do not believe in that at all.... I have the feeling that all the people I photograph are strong personalities.[43]

For Model, the boundaries between the objects of the world and their representations were in no way blurred. Recognizing the limitations inherent in any depiction of an individual, she chose a highly subjective approach: any psychological presence in a portrait is as much her own as that of the subject. She was sensitive to the fact that the photographic portrait offers a degree of sheer visual information that remains on the surface, and that this, without selectiveness, would exceed what the image was capable of delivering on the psychological plane.[44] Gesture, as with her café and restaurant photographs, was an important attraction of the people she photographed on Delancey and other streets.

Selections of the *Lower East Side* photographs were published in a variety of publications, including those that specialized in photography, such as *Good Photography*, and *U.S. Camera*. The latter presented block party and war rally photographs from the *Lower East Side* series along with *Coney Island Bather* images in October 1942.[45] Photographs also appeared in popular illustrated weeklies like *Look*, which published six under the title

"Their Boys Are Fighting" in November 1942. Accompanying the photographs was a blank-verse text written by Carl Sandburg specifically for this. A note described Model's participation:

> At an open-air patriotic rally in downtown New York, the distinguished photographer, Lisette Model, took these pictures of plain Americans. They are of diverse origins, but their faces show the pride and pain that fill America's heart.[46]

While the images of a man with a flag (pl. 23) and of the crowd at a war rally (fig. 66) are overtly emotional, many from the Lower East Side show people locked in a private impenetrable world: the dwarf (pl. 28), the woman seated on the stairs (pl. 85), and the girl looking into the window (fig. 64).

With the subjective and expressionistic element in her work being so deeply personal, despite her choice of subjects one would be hard pressed to call Model a politically motivated photographer. It is true that she became associated with artists and critics of the Left, and documented groups oriented toward social reform such as the National Association for the Advancement of Colored Peoples (NAACP) and the Institute for the Study of Fascism (INFA), of which she was a member.[47] These seem, however, to have been taken relatively randomly, and not as part of a larger or continuing project. Model also participated in exhibitions like *Artists in the War* – a very specific attempt at action through art, but the social-political orientation of her work at this time was stimulated to a greater degree by the mood of the war years than by a natural direction. *They Honor Their Sons* (pl. 21) was shown in June 1942 in the exhibition *Artists in the War* at the A.C.A Gallery. Perhaps inspired by the Museum of Modern Art's *Britain at War*,[48] this exhibition featured work in all media and was itself something of a rally composed of artists wanting to "win the war" through their art. Model's contribution illustrates the subjects that attracted her during this period. The event, a war rally, was a rousing emotional occasion; perhaps even more irresistible were the strong female faces, presumably of mothers with sons in the war, which she emphasized theatrically with the thrust of a

As opposed to being described as "relatively unknown in America," she became celebrated: "Pictures by a Great Refugee Photographer" includes the editor's note: "... her pictures have been published in many national magazines and newspapers throughout the country."[45]

Other photographers featured in the exhibition: Josef Breitenbach, Trude Fleischmann, Paul Strand, Berenice Abbott, Frank Elmer – "so that there is already the nucleus of a successful photographers' group in the Artists League." Other artists included William Gropper and Anton Refrigier, whom she photographed. A symposium in conjunction with the exhibition included Fernand Léger, Marc Chagall, Paul Strand, Ossip Zadkine, William Gropper, Berenice Abbott, Richard Wright, James Thrall Soby, and Elizabeth McCausland.[48]

The jury for the show included: John Sloan, Ryan Ludins, Elizabeth Olds, Raphael Soyer, Louis Tytell, Paul Strand, and Elizabeth McCausland.[49]

"A journalist came over and said: 'Who is this old hag?' And I said, 'That is not an old hag, it's a great personality. I was scared of her but she wasn't scared of me.' . . . Then I got another telephone call and this young woman said: 'This was my grandmother and when you took her picture she was over ninety. She was the greatest woman in the Lower East Side. She was at the head of many organizations and committees.'"
– Lisette Model.[50]

"As we go to press, we get word from the East Side group that their work is coming along nicely. This group consists of Dave Joseph, Dan Weiner, and Walter Rosenblum (all former members of the documentary class, who are continuing as a group under the leadership of Sid Grossman . . .)"
– *Photo Notes.*[51]

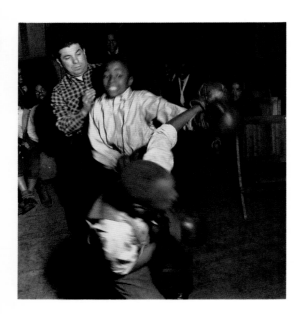

The Photo League often hosted speakers. "Ralph Steiner, . . . [spoke on] 'Art and Documentary Photography' . . . [and said the] trouble with most photographers is that they tell their stories too weakly . . . it is the intensity with which you say it that counts . . ." His view was countered by John Adam Knight . . . : "The trouble with most photographs, Mr Knight said, was that they shouted their message in a raucous voice, instead of speaking it normally. Another fault was that of overstatement . . . the photographs then tend to become hysterical in tone . . ."[52]

post just off-centre of the image.[49] It is also around this time that she made the now iconic image of the ninety-year-old woman known as the "Mayor of Delancey Street" (pl. 29).[50]

Lisette may have shown a small selection of *Lower East Side* photographs at her Photo League exhibition in 1941 in a grouping of work entitled *Dispossessed*. The titles of the groups of photographs were prepared with the assistance of Elizabeth McCausland. Coincidental to the making of her first photographs of the Lower East Side is the period of her strongest involvement with the Photo League. Photo League members formed Documentary Groups[51] that photographed areas such as Pitt Street and Harlem with the intention that their collective work would ultimately draw attention to the circumstances under which a large number of immigrants and Black Americans were living. Despite the fact that Model's *Lower East Side* work was done on her own, the Photo League, with its strong stand on social issues, provided her with a community of interests and ideas.[52]

Model did not have any specific long-term political affiliations, but she expressed definite anti-fascist views throughout her life. With respect to politically motivated artists, she greatly admired the work of George Grosz and John Heartfield. But even if her own images were used in the context of political discourse, Lisette had difficulty with the idea of the photograph being considered a document of literal fact. In her teaching notebooks she proposed that photographs are "abstracted"[53] images detached from the physical world, and cautioned her students against a prosaic interpretation, pointing out that they can only be analogies to reality and not replicas of the objects depicted. She alluded frequently to the symbolic, evocative nature of the photograph – "living its own independent life and projecting, if we like it or not, its magic".[54] For her, images like those from the Lower East Side endured in a culture and became part of a collective memory.[55]

fig. 66
Lisette Model
Crowd, War Rally New York 1942
Gelatin silver
34.6 × 27.6 cm

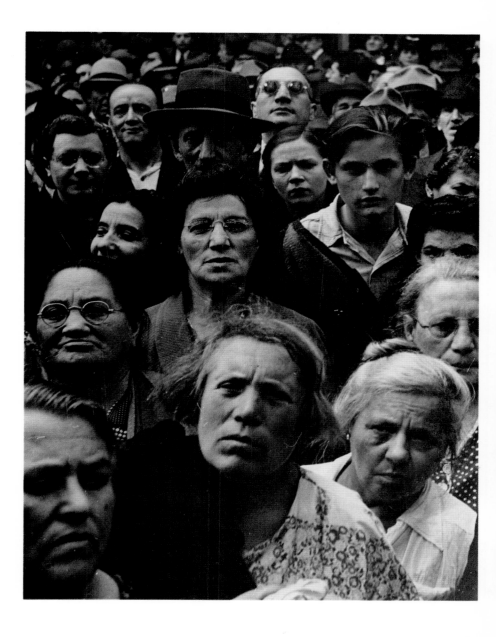

21 **They Honor Their Sons** New York between 1939 and 14 June 1942

fig. 67
Lisette Model
Dorothy Wheelock Edson and
Wesley Edson New York c. 1945
Gelatin silver 35.5 × 27.9 cm
Collection Dorothy Wheelock Edson, Easton

When Lisette Model arrived in the United States in October 1938, she had worked as a photographer for at least four years and established contact with agents and journalists since 1935, and yet, remarkable as her vision was, she was relatively unknown in Europe. Only months after making contact with the New York photographic community in 1940, by way of Alexey Brodovitch, Berenice Abbott, Ralph Steiner, Beaumont Newhall, Ansel Adams, and Elizabeth McCausland – individuals sufficiently open and courageous to applaud the uncommonness and strength of her vision – she had become celebrated as an exceptional talent. With a sharply honed critical sensibility directed often toward her own work, this took Model by surprise. Years later she would talk with some bitterness of the destabilizing effect that fame and its fugitive nature can have on an artist.[1]

In the United States, the debate that surrounded the work of serious photographers opposed the virtues of technique and the fine print to the idea of the supremacy of content in a photograph. In short, practitioners who valued a formal and technical aesthetic were pitted against those of the documentary school.

MUSEUM OF MODERN ART

Within the larger critical reception of Model's work, the *Running Legs* and the *Reflections* photographs, perhaps because of their radical execution of form and subject, have been overshadowed by those taken on the Côte d'Azur. Interestingly, however, the first two Model photographs acquired for the Collection of Photographs at the Museum of Modern Art represented both sides of her work. They were *First Reflection* (pl. 59), the first image she made in the *Reflections* series, and *Promenade des Anglais* (pl. 22).

It was in early to mid-1940, her capital exhausted, that Model first met Ralph Steiner. In the process of looking for employment, she answered an advertisement for a darkroom technician at *PM's Weekly*, where he was Art Editor. Too often told by Model to be repeated here,[2] Steiner's overwhelmingly positive response to her work created a chain of events that led to Alexey Brodovitch seeing her work. He, in turn, equally struck by its power and originality, talked to Newhall.

It was thus that, just two years after arriving in New York, Model's work was brought to the attention of Beaumont Newhall, Curator of the newly formed Department of Photography at the Museum of Modern Art. Newhall made a record of this event and a subsequent meeting in his diary:

October 22, 1940. *Model*/Brodovitch showed me a number of photographs by Lisette Model, a refugee from Paris. These documentary or reportage shots were very powerful and well seen. He felt, and I agreed with him, that *Life* Magazine might be interested in her work, and I said that I would be glad to introduce Miss Model if he could arrange an appointment.[3]

On 31 October 1940, he and Ansel Adams met with Model: "We were tremendously impressed by the force of her work and committed the Museum for the purchase of two or three prints at $10 each."[4] They did, in fact, purchase at least two. The meeting not only introduced Lisette's work to the museum and

"This week's Gallery Photographer: Mrs Lisette Model, who made the portraits on pages 33–39, is a young Frenchwoman [sic], who came to this country two years ago with her artist husband. She took up photography in France as a hobby, has been cautious about resuming it here until she knows New York better. She agrees with Ralph Steiner that a person can take good pictures only of things he understands and has specific feelings about. The specific feeling she had about most of the people she photographed at Nice was one of disgust. Besides photography she is interested in singing and painting. She finds New York 'fantastic' and its people 'somehow freer' than those abroad. She uses a Rolleiflex."[8]

There is no evidence to show that she ever exhibited her work prior to coming to the United States.[9]

its collection of photographs, but also led to friendships with Adams and with Nancy Newhall, whom she found "extremely intelligent and brilliant".[5]

As a photographer, Lisette could not have chosen a more exciting time to have settled in New York. Reflecting the democratic attitude towards visual imagery in all media that prevailed in the United States, the Museum of Modern Art, established in 1929, had exhibited photographs since 1932, beginning with an exhibition of murals by American painters and photographers. In 1940, the Department of Photography was founded, and the Photography Center opened in 1943 "to provide not only visual and documentation resources but to encourage debate on the medium."[6]

Commemorating the founding of the Photography Department, *Sixty Photographs: A Survey of Camera Aesthetics* opened on 31 December 1940. The exhibition featured, among others, the work of Berenice Abbott, Ansel Adams, Walker Evans, Dorothea Lange, Helen Levitt, Man Ray, Charles Sheeler, Edward Steichen, Alfred Stieglitz, Paul Strand, Brett Weston, Edward Weston, and Minor White, photographers already well established and respected. Within a few years, many of these photographers were to become personal friends of Model. The exhibition, curated around loosely determined criteria, was intended, as Adams and Newhall, the co-curators, explained, not "to define but to suggest the possibilities of photographic vision. As its title implies, the choice has been an arbitrary one and is not all-inclusive."[7]

It was Model's photograph entitled *French Scene* in the checklist (pl. 22) that Newhall and Adams selected for *Sixty Photographs*. This same image was published in an issue of *PM's Weekly* that appeared during the exhibition in January of 1941. In *PM* it was captioned *Self-Satisfaction*, with the note that "the photographer says middle-class Frenchwomen like this one saved and schemed so they could live like the woman on the cover."[8]

This selection of a *Promenade des Anglais* photograph to represent Model in a Modern exhibition – a photograph of a more documentary nature than the experimental work from the *Running Legs* or *Reflections* series – presaged later selections. The photographs exhibited there in the forties, fifties, and sixties were predominantly from the *Lower East Side*, *Sammy's*, and *Nick's*, and occasionally the *Promenade des Anglais*, series. Certain works, such as the woman in the shawl (pl. 87), the woman shielding her face (pl. 29), and *They Honor Their Sons* (pl. 21) from the *Lower East Side* images, and the woman in the floral dress (pl. 22) from the *Promenade des Anglais* group, were shown repeatedly.

The first exhibition to show Model's work in the United States,[9] *Sixty Photographs* provoked the first of many reviews which took special note of Model's photographs. Art historian and photography critic Elizabeth McCausland, an ardent and articulate analyst of Model's photographs from their first encounter, draws the reader's attention to Atget's *Street Musicians* and Dorothea Lange's *Pea Picker Family California 1939* as sociologically relevant. When she approaches Model's *French Scene*, she does so with uncharacteristic tentativeness, indicating her bewilderment about Model's relationship to her subject. Although she singles it out for mention, McCausland's commentary on the photograph is couched in the vaguest of phrases,

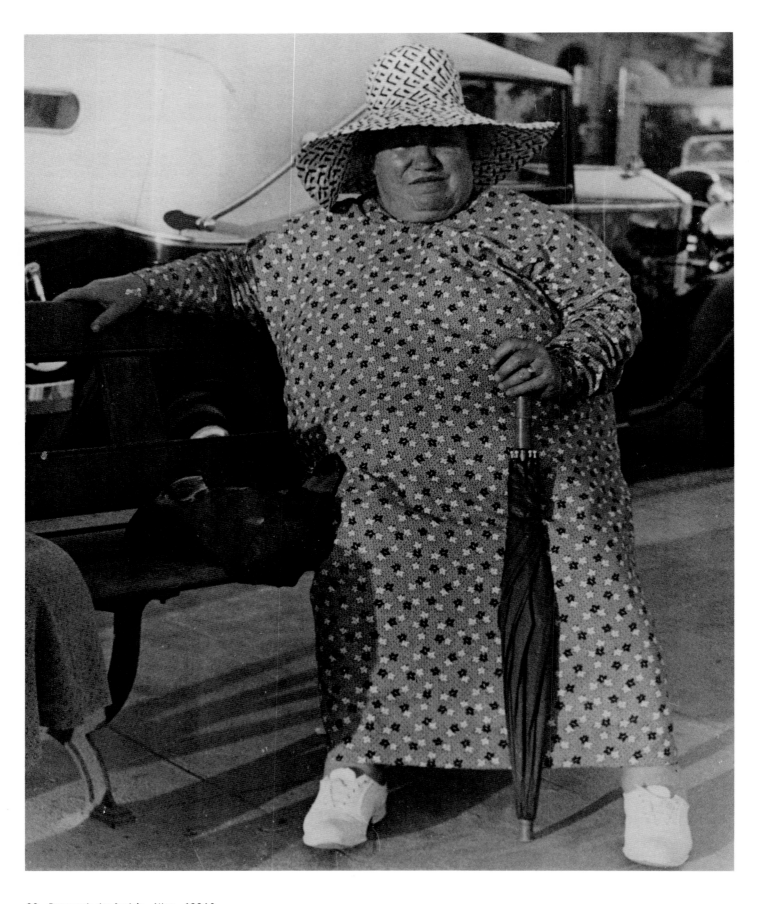

22 **Promenade des Anglais** Nice 1934?

"Lisette Model's photographs record her relentless and acute probing of people, their foibles, suffering, senselessness, and on occasion their greatness. The resulting pictures are often camera equivalents of bitter tongue-lashings. She strikes with a hard, sharp and swift observation, then comes to a dead stop, for her work is devoid of all extraneous devices or exaggerations."
– Edward Steichen.[12]

An active member of the League in the early forties, Steiner later severed his relationship with it over a difference of opinion about ideology and dogma.[15]

noting only that it "tells us a great deal about the character of a period."[10] Her uncertainties were to give way within a short while to lengthy, often perceptive and stirring appraisals of Model's photographs.

Acquisitions of her work by the Museum of Modern Art[11] continued steadily even after Newhall had relinquished control of the department to Steichen[12] in 1946. In contrast to Europe, where her work had received little exposure and was virtually unknown, it became a *cause célèbre* in New York. Her work was collected by the Museum of Modern Art in the forties more intensely than that of most other European photographers, such as André Kertész and Robert Frank, with the exception of Henri Cartier-Bresson. The appreciation of her vision by an American institution was more in keeping with the interest it accorded to photographers from the States such as Abbott. The Museum of Modern Art showed and acquired Model's photographs with consistency throughout the forties and fifties, tapering off in the sixties, and then ceasing after a few items were acquired by donation in 1964.[13]

THE PHOTO LEAGUE

The Photo League, located at 31 East Twenty-first Street, evolved from the Film and Photo League, an offshoot of the Workers' International Relief. Established in New York City in 1936, it was in many respects the equivalent to the A.P.O in France. Committed to using photography as a political tool to realize social change, it folded in 1951 after having been listed as a subversive organization by the House Un-American Activities Committee.[14]

Steiner was probably responsible for the introduction of Model's work to the Photo League.[15] Model became associated with it during a period when the events of the Second World War were influencing its direction and political concerns. It was a time of ideals and strong sentiments, as expressed in the titles of projects such as *War Comes to the American People* and the exhibition *New York at War*. She was a member when the shift from leftist journalism to documentary photography under Sid Grossman and Sol Libsohn had already occurred. Berenice Abbott and Elizabeth McCausland, both staunch supporters of Model, were actively associated with the executive at this time. Model respected and was close to Berenice Abbott; she also formed lasting friendships with other Photo Leaguers, including Marion Palfi, another European immigrant. Martin Magner, married to Palfi in 1955, described them as being very similar in temperament: "opinionated and never afraid to fight for their beliefs".[16] While Model recognized the League's commitment to the photograph as a social document, she avoided any such categorization for her own work. When asked whether she would define herself as a documentary photographer, her typical answer was that she did not understand the meaning of the term.[17]

If the Photo League espoused documentary, it nonetheless gave her a venue for her experimental work, and provided her with a critical framework and focus in the period of the early to mid-forties. Both the *Running Legs* and the *Reflections* series represented major stylistic and content changes for Model. She herself

believed them to be important bodies of work, and related them to her fascination
with glamour in America. About six photographs from each series appeared in her
first one-person exhibition, held at the Photo League in May and June 1941. The
exploration of new material, a departure from a representation of her subjects as
sculptural and self-contained entities to an expanded vocabulary of fluid, shifting
elements, is proof of her openness to experimentation, a credo she later impressed
upon her students.

Model's exhibition of 1941 included forty works, of which roughly one-third
were given over to European work, and the rest to imagery from her brief time in
New York: a series of twelve images captioned *Dispossessed*, possibly using Lower
East Side subject matter, a half dozen images from *Running Legs*, an equal number
from *Reflections*, and photographs of Valeska Gert.

The response to the exhibition, described in a notice in the League's *Photo
Notes* as "one of the most provocative",[18] by other Photo Leaguers was positive, as
was the reaction to her Friday night talk on 13 June 1941:

Miss Model spoke of her experiences and problems in working, both here and in her native
France [sic]. This branched into a very interesting discussion of methods of work, with almost
everyone present participating.[19]

An excerpt of McCausland's review for the *Springfield Sunday Union and
Republican*[20] was published in *Photo Notes*. "This, she said, "is the main production
of a photographer who had to leave France, leaving behind most of her negatives."[21]
McCausland understood Model to be an intuitive and emotional artist, whose chief
difficulty in adjusting to America was in the apprehension of new physical spaces,
forms, and phenomena: "The light was different. The width of the streets, the
straight façades, the height, created a milieu alien to her knowledge."[22] It was also
precisely this difference that had inspired Model to depart in style and subject
matter from her earlier work. In McCausland's view, her response to the changed
environment was to dematerialize it:

When she began to make photographs in the United States . . . A kind of abstractionism
developed. Shadowy faces and shapes seen in plate glass windows, blurred feet and legs hastening
past, a twilight world dimly seen by the camera.[23]

This time, McCausland's understanding of the work is evident as she situates
Model's contribution within the wider context of the prevailing photographic
aesthetic. She correctly identifies the work, with its radical angles and clear com-
mitment to experimentation, as a challenge to current orthodoxies about the nature
of the photographic image. The challenge extends beyond choice of subject matter,
in McCausland's view; she sees Model's primitive technical control as providing
an antidote to the current fascination with technique to the detriment of content.
Finally, in locating the importance of Model's work as lying outside of consider-
ations of medium, while at the same time observing its reliance on the medium,
McCausland commends it in both its general and its specific message.[24]

The Photo League not only provided a very tangible source of support for Model's photography, but through its commitment to teaching also contributed to her eventual development as a teacher. She and Evsa attended Sid Grossman's private classes, held in his home during the period 1949 to 1950, when he was under surveillance for alleged subversive activities[25]; this was remarked upon as being also a gesture of support for him.

From late 1948 to early 1949, partly as an act of defiance against the increasingly repressive political climate, a retrospective exhibition of the Photo Leaguers' work, comprising three hundred prints by obscure as well as noted photographers, was held at their quarters on East Tenth Street. Sadly, it was the last major public manifestation of their collective activity. Model was represented in the catalogue for this exhibition by *They Honor Their Sons*. A review in *U.S. Camera* stated that "Lisette Model's penetrating photographs strip affectations and baubles from the wealthy, make no pretence of hiding the misery of the poor. Some of her feelings constantly come through the mechanical devices of photography, to make her pictures as personal as spoken words."[26]

HARPER'S BAZAAR

Coney Island, New York's populist equivalent to the Promenade des Anglais, was the first assignment Model received from *Harper's Bazaar*. It was initiated by a phone call from the art director, Alexey Brodovitch. Of the resultant photographs, the large exuberant female bather standing in a semi-crouched position was the image that most pleased Model and evidently Brodovitch as well, as it was the one selected to illustrate the article "How Coney Island Got That Way".[27] The caption was "Coney Island Today, the Bathing Paradise of Billions – where fun is still on a gigantic scale." In the magazine, *Coney Island Bather* (pl. 88) faced left instead of right, perhaps a design decision by Brodovitch. Appearing in *Harper's Bazaar*, a publication largely devoted to illustrating the virtues of being svelte, it took on an outrageous quality. The Coney Island bather captured the imagination of at least one other New York photo editor, as *U.S. Camera* published the reclining version in October 1942, and the standing one in 1943.

However, contrary to Brodovitch's expectation, and although Model made submissions to them, magazines such as *Life* were not interested in Model's photographs. The only magazine that continued to respond to her work over time was *Harper's Bazaar*. Although Model's association with *Harper's* was dictated largely by her need to earn a living, there is no doubt that she found the magazine's philosophy at that time to be sympathetic to her own ideas about photojournalism. She was strongly supported by the principal movers and shakers of the editorial staff – Carmel Snow, Alexey Brodovitch, and Dorothy Wheelock (fig. 67), each of whom responded to her work in different ways. For Brodovitch, it was the originality of her vision that was attractive, and for Snow, who sought to make of *Harper's Bazaar* a magazine that looked at fashion within the context of international interests and ideas, it was her ability to produce strong, emotional images about everyday life. Dorothy Wheelock, described by Snow as "the stirring stick" of *Harper's Bazaar*,

"To-day admission is fifteen cents and another fifteen is charged to view Professor Heckler's Flea Circus. A unique show . . . mirrors . . . ; peep shows . . . ; Zanger the mystic . . . ; Dancing Girls; and a line-up of freaks, including Lionel the lion-headed man; Eko and Iko — Ambassadors from Mars; the Half Man-Half Woman; and a two-headed child!"
— Charles G. Shaw.[30]

"Imagine Albert-Alberta, a creature half man and half woman, seductive as a nightmare, a veritable French psychological novel, but symmetrical, flirtatiously revealing a powdered perfumed sequined female left breast with a rugged muscular hairy male right hand while our mouths fell open in disbelief."
— Diane Arbus.[31]

"I like to think that the inspiration I got from my European experiences was reflected in the magazine I edited. Certainly, those experiences were pictured by the photographers I always took with me. And when Brodovitch or I encountered brilliant photographers abroad . . . we were quick to allow them pages in Harper's Bazaar." — Carmel Snow.[32]

"I saw a fresh, new conception of layout technique that struck me like a revelation: pages that bled beautifully cropped photographs, typography and design that were bold and arresting. Within ten minutes I had asked Brodovitch to have cocktails with me, and that evening I signed him to a provisional contract as art director."
— Carmel Snow.[34]

"Alexey Brodovitch, art director of Harper's Bazaar, gave courses in photographic creativity. His principle of teaching was: 'Never show me anything I have ever seen before.' What a destructive and unhelpful concept! How can it help a photographer be more original if he says to himself, standing before his subject, 'Now I must be original'." — Ralph Steiner.[35]

"I adopted the custom I used throughout my life at the Bazaar of 'putting the book on the floor' — laying out photostats of every page in the coming issue so I could see it as a whole and mull over it while I sat at my desk. My photographers have told me that it was a chilling experience to watch their masterpieces walked over by everyone who came in to see me, but since these were photostats it didn't do the masterpieces any harm." — Carmel Snow.[36]

"My photographs were such a contradiction to the elegance of the magazine that Brodovitch, the extravagant art director, put them in for that reason alone." — Lisette Model.[38]

"Brodovitch introduced many artists to the Bazaar: Tchelitchew, Dufy . . . Topolski – Chagall – Noguchi – Ben Shahn. He reproduced Picasso, Matisse, Braque, Brancusi, Giacometti, Pollock As he tells his distinguished pupils (the leading photographers today have studied with him), 'In commercial photography your original style lasts five years. You must be alert for new visions and techniques.'"
— Carmel Snow.[39]

started her career in the editorial department as acting fiction editor during the absence of Mary Louise Aswell, and moved on to become theatre editor. Responsible also for personality features, she was, in Model's view, the most adventurous member of the editorial staff: it was Wheelock who was intrigued by what McCausland has described as Model's "subconscious revolt from rules". She was attracted by the "strangeness" of her vision." [28] It was she who encouraged Model to photograph Hubert's on Forty-second Street,[29] "a throw-back to old Fourteenth Street. When Fourteenth Street teemed with glamour and laughs and dime museums, too." [30] It was here that Model photographed the "half man-half woman", otherwise known as Albert-Alberta (fig. 68, pl. 27).[31]

Brodovitch (fig. 69) and Snow were unusual individuals. They favoured originality and an open, risk-taking approach.[32] When Carmel Snow become editor-in-chief of Harper's in 1932, she decided that the work of photographer Baron de Meyer, "was beginning to look dated",[33] and set about implementing changes. Her meeting with Brodovitch can be attributed to Ralph Steiner's intervention. As a photographer of shoes and other objects for the accessory pages of the magazine in the early thirties, he had encountered Brodovitch, who was newly arrived from Europe where he had worked as a magazine and stage designer. Steiner introduced him to Snow[34] as an individual dedicated to originality, and she hired him as Art Director. As a team, they brought a new image to Harper's Bazaar, thus distinguishing it from the dry predictability of Vogue.[35] The magazine came to bear Snow's personal stamp not only in management technique but also in the choice of its look. She "personally oversaw the final layout of each issue".[36] Similarly, as Snow expressed it, under Brodovitch's eye "Munkacsi's exciting photographs of girls running or jumping began to have the freedom of layout that they needed – they were no longer boxed in frames".[37]

An extraordinary aspect of Harper's Bazaar was that, although a magazine directed toward fashion-conscious women, it often published subject matter that did not fit with conventional notions of fashion. It almost made anti-fashion fashionable.[38] Images by George Grosz appeared,[39] as did photo essays on people who were disadvantaged, including features on settlement houses and on blindness, for which Model provided the photographs. A criticism levelled against them at the time was that the photographs published in Harper's were more like snapshots than artworks. Model was aware that the editors were going out on a limb for work such as hers, saying, "I don't know how she [Snow] did it. It was very daring for them to have me in Harper's Bazaar." [40]

Brodovitch is generally credited with being the force behind Model's years of work for Harper's.[41] Recognising in Model an audacious spirit with a good eye, it was he who talked Snow into taking her on as a regular photographer. This was precipitated by an early meeting in 1940 of Model and Brodovitch, again through Steiner. Brodovitch was anxious to use new talent and also to assist European refugee photographers whose work he found promising – such as Model, Roman Vishniac and, at the end of the decade, Robert Frank. In addition to giving them assignments, he would send them to Dorothy Wheelock for use on the theatre and nightclub beats. Wheelock, who became a personal friend of Lisette and Evas, to

the point of giving them the use of her house at Oyster Bay Cove for vacations starting in 1950, recalls that Lisette's manner was very quiet and unassuming and that, above all, she would not push herself.[42]

Although one might question his sensitivity toward the particular qualities of her images, Model respected Brodovitch enormously as a designer: "Brodovitch, without any doubt, was the best layout man America had. Positive and negative, superb and impossible. Just the way I like it."[43] He presented her work using a variety of layouts. One was a seemingly random ordering of the photographs in a fan-like composite, reminiscent of a deck of cards thrown casually onto a table. Another was a full collage treatment, where the edges and indeed the integrity of the individual images were indistinguishable. Occasionally he illustrated them in a straight full-frame layout. Sometimes the edges were bordered with brilliant red, as in *Home Is the Sailor*, a technique that Model herself used when mounting her photographs. She placed them either on a bright green, blue, or red board, or on a newsprint background. Brodovitch took great license with cropping, guttering, and bleeding images to the edge, all treatments which thwarted any attempt to read the image as a single entity.

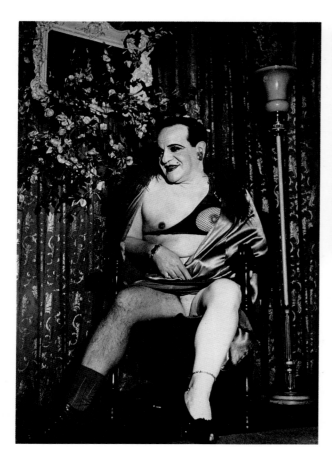

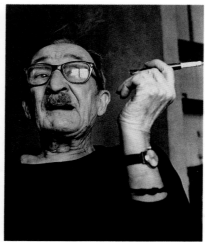

fig. 68
Lisette Model
Albert-Alberta New York c. 1945
Gelatin silver
34.2 × 23 cm
National Gallery of Canada
(29057)

fig. 69
Marc Kaczmarek
Alexey Brodovitch 1966
Gelatin silver
24 × 19.2 cm
Collection Marc Kaczmarek, New York

While Brodovitch's approach might have repulsed photographers attracted to the photograph as a self-contained coherent structure and statement, for Model it would have been in keeping with some of the European magazine layouts. Indeed, her own technique of manipulating her images through cropping, tilting her enlarging easel, and other devices to maximize dramatic expression and emphasize the graphic character of the image was not antithetical to a use of the photograph as a unit within a larger design concept. Brodovitch's insistence on newness, a feature that some have defined as being obsessive to the point of flaw, would also have appealed to Model, who was likewise capable of carrying her own devotion to originality to the extreme of inflicting creative paralysis upon herself.

It is tempting but misleading to view Model as a vulnerable genius who fell apart when photographing on assignment. There is no question that she felt more comfortable with free rein to photograph what she saw fitting, a condition of employment with a regular contract or salary which she tried unsuccessfully to negotiate with *Harper's Bazaar.* Yet she produced some excellent work on assignment, and a number of the images were published: the now iconic *Coney Island Bather* images, several *Nick's* and *Circus* photographs, and the image of the single leg with the American flag in the background. Other memorable assignment include photographs for the articles "To the Blind, Truly the Light Is Sweet," "Hot Horn Gabriel," "Sunday Fathers with Their Children," "The Settlements Still Pioneer," "New Faces on Broadway and Vine Street," "The Greatest Show on Earth," "Opera à la Carte," "New York," "Once an Actor," and "Sammy's on the Bowery." Because Model manipulated her images so heavily through cropping and enlarging, it is difficult to imagine what she might have done with negatives she did not print. Certainly, like most photographers, Model was not happy with restraints. The assignment process was not readily compatible with her way of working:

> Then *Harper's* gave me an assignment; but in the assignment I did not see anything that I wanted, though I did my damnedest. But I did very few things that I liked.[44]

However, she had to earn a living, and she herself did not view photojournalism as a corrupted form of artistic expression. This is borne out by her emphasis on it in her teaching notebooks, which were assembled after she had ceased to be dependent upon it for her livelihood.

Murray Hill Hotel, International Refugee Organization Auction, and *Westminster Kennel Club Dog Show* are three important and, from the point of view of intention, mysterious bodies of work from 1944 to 1948 for which negatives and some prints are still extant. Murray Hill was a residential hotel that fronted Park Avenue between Fortieth and Forty-first streets. In 1947 it was demolished to make way for an office tower. Described once as the "crowning glory of the elegant 1890s," with "red and white marble floors, carmine plush, gilt framed mirrors and rococo walls and ceilings,"[45] it was patronized by writers, presidents, and celebrities. When Model photographed it possibly as early as 1944, little had changed; some of the original furniture from 1884 still remained. Model's photographs of the residents are portraits of an age past, such as the Victorian-looking widow in sharp profile (pl. 151).

Others, such as one of an old woman on the edge of her chair blinded by Model's flash and clutching her mayonnaise bottle, are more despairing images and suggest decay and death.

The photographs of dogs and sometimes their owners taken on 12 and 13 February 1946 at the Madison Square Garden Westminster Kennel Club's Dog Show (pls. 6, 31, 145) constitute a body of work brought to a state of completion and never published. Similarly, her photographs of celebrities, such as James Mason at the International Refugee Organization Auction, seem to have been produced for reasons external to her own interest. Some are stamped for publication in *Harper's Bazaar*, but apparently never appeared in that magazine or in any other.

As personalities, photographer and friend of Lisette David Vestal saw Brodovitch and Model as sharing a strong irrational streak. They were, as he put it, both perfectly capable of entertaining simultaneously contradictory ideas without the least hesitation. Although Model insisted on instructing her students in technical matters, tales of her innocence in this domain as a *Harper's Bazaar* photographer are legion. It is to their credit that neither Snow nor Brodovitch appeared to be in the least alarmed at this. They not only accepted it but, one might conclude, indulged it. Carmel Snow, accompanying Lisette on an assignment where the subject, familiar with photography, told Model "You're doing that wrong", quickly retorted, "Let her make her own mistakes." [46] In later years, Brodovitch would always follow up an enquiry after Lisette's well-being with the question, "Is she still taking photographs without film?" [47]

Brodovitch's loyalty to Model is illustrated by his insistence on retaining her as a *Harper's Bazaar* photographer despite pressure from Weegee to hire him in her place. As told by Model, "Weegee said: 'You have worked enough with Lisette Model. Now throw her out and take me.' So Brodovitch threw him out. And he went to *Vogue* magazine and *Vogue* took him. He was a very good photographer – very interesting." [48]

The few attempts that Model made at producing fashion photographs indicate that this was not a subject that brought out the best of her talents. The woodenness of the poses and their repetition of existing fashion photography formulae indicate that the problem was not simply a technical block but rather a subject with which she could find no possible connection. Although she continued to take a shot at fashion photography from time to time, with less than satisfactory results, there is no evidence to suggest that she was ever hired with this as an assumed strength. It was also evident, however, that she aspired at one time to receive fashion assignments from *Harper's Bazaar*. In 1948 she received a letter from Snow:

> I am sending you a cheque for $100 for the work and time you put into the fashion pages. They were not quite right, but please – I beg of you – don't feel discouraged as I feel sure we will be able somehow or other to get good fashion work from you. [Frances] McFadden believes this as much as I do, and while I am in Europe, will give you an assignment again. [49]

The reason why Model may have felt the necessity to rechannel her work for *Harper's* in the direction of fashion may lie with a letter she had received from Snow

Carmel Snow's letters to Model over this period throw light on both the support she received from her principal employer, and her difficulties.

"We shall be delighted to guarantee you a minimum of 24 pages in the coming year." – 28 June 1945.

"I would like to make the following proposition to you – that I continue my present arrangement with you through the month of September. This will mean that you have two months in San Francisco and California completely unhampered by advertising work or editorial requests from me. Under these ideal conditions; I feel sure you will send me some wonderful pages. I hope and believe you know how much I love your work, but before tying myself up for an entire year, I must feel sure that under these new working conditions I am going to get such pages for *Harper's Bazaar* to justify my renewal of your contract."
– 24 May 1946.

"Dorothy Wheelock tells me my letter has upset you
"I know you wish to work on a non-assignment basis, because you feel you do your best work in this way. I think you are probably right, but I also feel that this new arrangement should have a trial of two months before I sign a contract with you. I will be most happy to then renew our arrangement Again let me tell you how much I love your work, and how much I believe in it."
– 10 June 1946.

"Frances tells me that you are not happy to prolong your contract for two months. All I can beg of you is to permit me to see the photographs which you will be doing on your own, as I feel quite certain they will be right for the *Bazaar*."
– 17 June 1946.[51]

some two years earlier. For all Snow's openness, there was a limit to what she and the magazine were willing to accept of an unorthodox vision:

> While I don't want to limit you in any way, at the same time I want to caution you not to show too many exaggerated, grotesque types. We can use such features every now and then in the *Bazaar* but not often.[50]

It was Randolph Hearst's conservatism that determined the bottom line when it came to the content of the magazine. Although never stated as written policy, anything that did not mirror middle White America was hard to get published. When Dorothy Wheelock wanted to illustrate a review of a Broadway play with a portrait of a Black actor, for example, it was made known to her that, while nothing existed on paper that disallowed this, it would be difficult to do. Model's photographs of Black dancer Pearl Primus likewise went further than Hearst could handle.

In the spring of 1946, around the time of the letter from Snow, the issue of assignments and of Model's contractual relationship with *Harper's* – she was never a fulltime staff photographer – came to a head. The breakdown appears to have resulted from different expectations, and it produced a correspondence between Snow and Model attempting to settle the problems.[51] It seems that the unconditional renewal of her contract, which she had so much hoped for, did not materialize; little of her work appears in the magazine after this date.

In spite of this, and of a later public falling out over sponsorship of her photographs for a book on jazz, Model always talked of Snow with respect, and thought they got on well together because "she knew photography as well as Brodovitch".[52]

It was well known among their friends that the Models lived on next to nothing. The lack of revenues from her property holdings in Italy, inaccessible for the duration of the war, made living modestly not only a choice – which it was, in part – but a necessity. During the war, they diverted small amounts of money from their earnings to help Félicie and Olga, who were often close to starving in Europe. The interest that *Harper's Bazaar* showed in Model's work was thus of great importance to Model. The remuneration she received from it constituted their major source of income. There were years when *Harper's* published her work every month, but this was not always the case, and the absence of a consistent source of revenue was cause for concern. Nonetheless, Model felt that *Harper's* was sensitive to her interests and, although some of the assignments were pedestrian and there were taboo subjects,[53] they gave her work that drew on subjects she had already showed an interest in, such as blind people.[54]

When Model approached other publishers they backed off instantly,[55] feeling that her caustic wit unleashed on American life and mores would be a bit too much. According to Model, they said, "If it were Europe and these photographs were European photographs and we needed them, we would publish them, but not in America." Photographer Paul Strand's comment was, "You cannot photograph America that way."[56] There were also subjects Model photographed that could have been published in *Harper's Bazaar* and were not, such as the characters from the Forty-second Street flea circus. Even before the heydays of *Harper's Bazaar* were

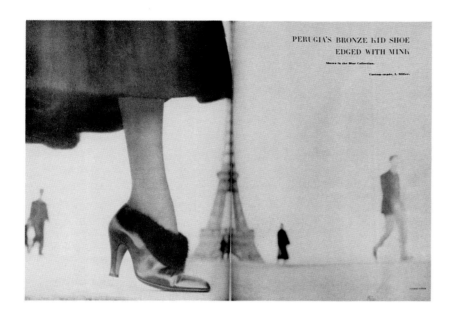

fig. 70
*Perugia's Bronze Kid Shoe Edged
with Mink* in *Harper's Bazaar*,
October 1948, p. 160–61
Photograph by Richard Avedon
National Library of Canada, Ottawa
(NL 16676)

Model claimed that she did a great deal for *Harper's* that was not published because it was "too much for [its audience] to digest.... Hearst did not like pictures of Black people, for instance."[53]

"I have just seen your 'Blind' pictures and I think they are magnificent. Would you drop in and see the ones I have selected – each one a full page for the *Bazaar*." – Carmel Snow to Lisette Model, 26 May 1944.[54]

"No other publications wanted me. They just couldn't see these pictures and other pictures published. They said, it's wonderful but we cannot use this. *Life* couldn't use me, *Look* couldn't use me.... they always believed I would come out with these kind of pictures that they didn't want." – Lisette Model.[55]

over, Model's involvement with the magazine had decreased dramatically. She only had two assignments published in the 1950s: "A Note on Blindness", written by Aldous Huxley, and "Pagan Rome". The photographs of Cartier-Bresson and Brassaï were being increasingly used by the magazine. And yet, some of her images left a lasting impression. The elegance of her *Running Legs* had not gone unnoticed in the fashion world: Richard Avedon's (fig. 70) and Karen Radkai's single leg images testify to this.

Taken as a whole, Model's association with the magazine, which lasted over a period of fourteen years, starting in 1941 and ending in 1955, was unusual in the world of conservative fashion publishing. The work that she published in it was not, with few exceptions, an attempt to compromise her style towards traditional fashion photography. Some of her most vital American photographs appeared in *Harper's*, including the *Coney Island Bather*s; and those from *Lighthouse, Blind Workshop; Sammy's; Circus; Running Legs;* and *Reflections*. The range of imagery over this period is finally a fair representation of her work.

The end of Model's regular involvement with *Harper's Bazaar* and the commencement of her teaching at the New School in 1951 not surprisingly coincided fairly closely, although as late as November of 1954 Dorothy Wheelock notes in a letter to Model that Brodovitch would like to see her Venezuelan photographs and wishes to remind her that she has never showed him her Italian photographs. Wheelock ends the letter on an affectionately chiding note: "You always make the point that the magazines do not use your work but you forget you haven't let us see anything new in several years. This is the word."[57]

It is generally accepted that the most important years of *Harper's Bazaar* came to a close in 1957 when Carmel Snow retired. Brodovitch had already left, and Dorothy Wheelock was to follow in short order. There was nothing left to attract Lisette to the publication.[58] Her last two magazine assignments were done for *Vogue* and *Cosmopolitan*, respectively.[59]

The newspaper *PM*, as Art Editor Ralph Steiner described it,

> ...was like no other since Gutenberg first set type. In the late thirties, the Sunday editor, William McCleery, persuaded me to edit two or three pages of photographs each Sunday and to write the captions.... The pages were intended to draw the attention of the general public to unusual photographers and what they were saying in their work. Their pictorial essays had as subjects everything from what was happening in the world to how photographers saw people.[60]

The reception of the *Promenade des Anglais* portraits in the United States in mid-January of 1941, when seven of them were published in *PM's Weekly*, including

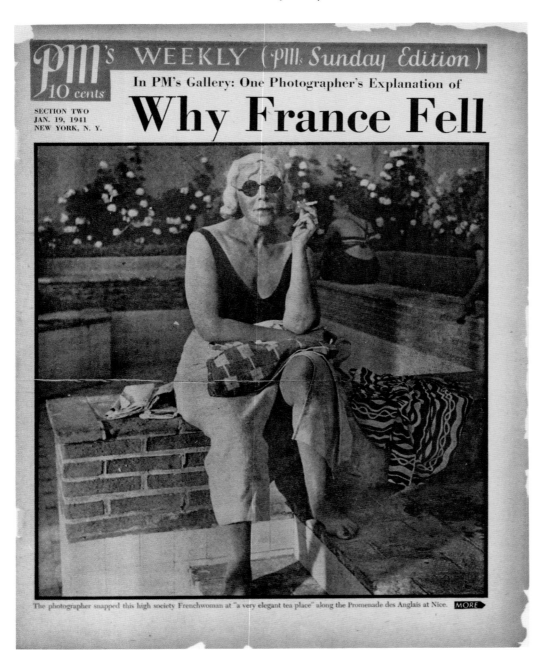

PM's WEEKLY (*PM's Sunday Edition*)

10 cents

SECTION TWO
JAN. 19, 1941
NEW YORK, N. Y.

In PM's Gallery: One Photographer's Explanation of

Why France Fell

The photographer snapped this high society Frenchwoman at "a very elegant tea place" along the Promenade des Anglais at Nice. **MORE**

fig. 71
**Cover of *PM's Weekly*,
Section Two, 19 January 1941
Photograph by Lisette Model**

"Some of her photographs, when they were published in the picture gallery of *PM*, created quite a furor among photographers."
– *Photo Notes.*[61]

Model denied having provided the captions for *PM's Weekly*.[63]

Model later denied this, pointing out that not all the people photographed were French; many were foreigners, including Russians. Her views on the interpretation of her own work changed radically between age forty and age seventy-five to eighty, when she gave the majority of interviews.[64]

one as the cover, was overwhelming.[61] In Europe, despite the serious manner in which they had been treated in *Regards*, they were also considered by many people to be amusing. Ralph Steiner, recognizing the exceptional qualities of Model's vision, but also evidently casting about for some – in this instance photographic – answers to the question "Why war?", presented them as a major feature. Were it not for the inclusion of one hapless subject – the market vendor – who appears under the caption *Underprivileged*, the entire group might have been read as a photographic manifestation of the seven deadly sins.

The feature is entitled "Why France Fell",[62] and Model's photograph of a seated woman wearing sunglasses and sunbathing appears on the issue's cover (fig. 71). The language of the captions is extreme. Any possibility of the reader being amused by the wit and audacity of the photographer is eliminated by the sternness of the presentation. The captions, supplied by the photographer in part,[63] vibrate with moral indignation and self-righteousness: the woman who turns her head away from the photographer, represents *Boredom*. Although described later by Model on several occasions as a native of Brooklyn, at one point she also said she was "a very French type – money and good family for generations. Since Nice is a resort, presumably she went there to enjoy herself."[64]

The market vendor, actually part of a series of images that show some hamming with a fellow vendor about, in all likelihood, the photogenic or phallic qualities of a zucchini, is entitled *Underprivileged*. Its expanded and accurate, but somewhat heavy-handed and didactic caption directs the reader to "Contrast this photo of a poor, uneducated woman with the front-page picture This shows the other side of the French social system."[65] The illustration of a pamphleteer is captioned *Greed:* "All sorts of people went to Nice. This fellow, who asked the photographer to take his picture, was distributing Socialist leaflets."[66] It was, in fact, taken in Paris.

In retrospect, Model saw herself as being shocked by the literal interpretation of these photographs in the United States, prompted perhaps by the outraged reaction of the French Embassy in New York when representatives first saw them, especially those from the *Promenade des Anglais* series. This is one example of a certain quality of naivete on the part of Model towards her own work. She apparently didn't realize the impact the photographs would have on some viewers and, in fact, as in this case, sometimes modified her own appreciation of her work according to audience reaction. Yet the critical content of the accompanying captions for the *Promenade des Anglais* subjects in the *PM* presentation and in the *Regards* story is, in essence, the same. The major difference is that, in France, the criticism was self-directed.

Elizabeth McCausland reinforced the reading of the photographs as not so much depictions of grotesques, but social criticism. In her view, the photographs served as important documents that would inform and presumably warn future generations. Praising Model for confronting "real life", she charged the subjects, in whose faces she perceived "a history of waste and social decay, fit for the scalpel of a Balzac", with frittering away their lives while trapped in the "ennui of existence". She compared the series not with the work of a painter or printmaker, but with D.W. Griffith's 1929 film *Orphans of the Storm*, an epic set in the time of the French Revolution.[67]

Photographing the West 1946–1949 CHAPTER SIX

In the fall of 1944, two letters to Lisette, dated 16 October and 3 November, bore respectively disturbing and tragic news. From Germaine Krull-Ivens, war correspondent and photographer for the French army and close friend of Félicie Seybert, the first letter notified her that her brother and his wife had been deported to Germany, and that her mother was in poor health. She asked Lisette to send news of herself to Olga and Félicie and, since they were without money or food, wrote that any assistance she and Evsa could provide would be timely. In order to make communication with her family easier, Germaine suggested Lisette address correspondence to her. In the second letter she wrote:

> Dear Madam: I am very sorry indeed to have the sad duty of informing you ... that your mother – who was a great friend of mine – died 21 October in Nice; she suffered from a cancer in the chest that reached her throat and she died of suffocation; fortunately her heart failed quite soon and she did not suffer much; she is buried in her uncle's vault in Nice in the spot she loved so well. Also, a card from an "Arbeitslager" somewhere in Germany provided some news of your brother. This is the first news from him since he was deported six months ago ...[1]

The news must have been all the more upsetting for Lisette because communication between herself and her family had by this time broken down completely as a result of the war. It is not surprising that, when she was asked years later about the death of her mother, she had suppressed the date and circumstances in her memory.[2] At this point the Models were able to survive economically, although with little left over after the rent was paid. Perhaps almost as an act of penance for the relative ease of her own life compared to that of her family in Europe, or as a way of attempting to sort out the terrible contradictions of the war years, she focussed on the subject of people being entertained and eating in restaurants (Asti's, Gallagher's, the St Regis, and Hotel Pierre) in 1944 and 1945. In the summer of 1944, both Models became naturalized U.S. citizens.

The intense schedule of exhibiting and publishing had continued uninterrupted by world events. Not only was Model extremely active in photographing, publishing her work in *Harper's Bazaar* and exhibiting it at the Photo League, but she travelled, first to Chicago in 1943, where The Art Institute of Chicago exhibited

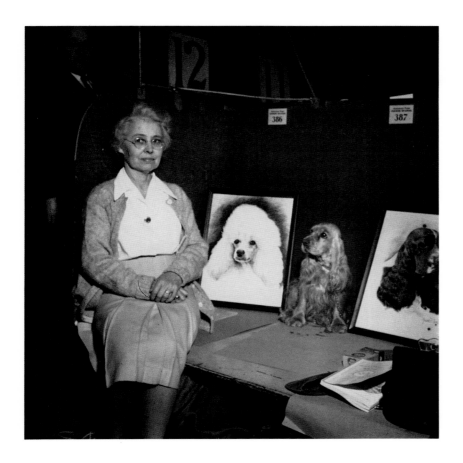

fig. 72
Lisette Model
Westminster Kennel Club Dog Show
New York 12 or 13 February 1946
Full frame enlargement by Justin Wonnacott
from original negative, 1989

Photographs by Lisette Model from 24 September to 17 November.[3] In April of the same year she made a trip to Washington, where she met Edward Steichen for the first time.

Lisette's *Nick's* and *Sammy's* photographs, in an 11 × 14 inch (27.9 × 35.5 cm) format, which was considered large, were in the Museum of Modern Art exhibition *New Workers 1* early in 1944. A series of forums on photography was organized by the Museum to accompany it, the first of which, *Standards of Photographic Criticism*, featured John Adam Knight (whose review of the show in the *New York Post* had attacked Model for picturing teenagers under the seemingly corrupting influence of jazz[4]), Bruce Downes of the *Brooklyn Citizen*, and Elizabeth McCausland. McCausland's summation of the event reveals something about the popularly held view of photography at the time:

> There is always the old bromide to the effect that critics should be photographers, painters, sculptors or whatever. The writer's experience with artists has been, as a matter of fact, that artists never have any hesitation in plunging into literature on occasion. However, jests aside, the ideas put forward were somewhat at variance. One point of view held that no good photographs exist or ever existed; another that there are no good critics of photography; while the audience seemed to be well packed with a claque which was "all agin" social content in photography. The writer, taking high moral tone, simply went to a hundred years of photography for precedents.[5]

In the spring of 1945, Model's work appeared in an exhibition curated by Berenice Abbott at the New School. Among the other photographers were André Kertész, Barbara Morgan, Martin Munkacsi, Walter Rosenblum, Gjon Mili, and W. Eugene Smith. In November, she photographed the pianist Ray Lev, who was in New York for a performance at Carnegie Hall. Model's extraordinary portraits of dogs, often double portraits with their owners (pls. 6, 31, 145, fig. 72), were produced in the winter of 1946.

fig. 73
**Installation of *Photographs by Lisette Model*,
California Palace of the
Legion of Honor August 1946**

"Dear Lizette, you cannot imagine my disappointment when I discovered that you had really vanished. If it had not been that I got so bad a cold that it seemed like flu, I would have seen you at the Labor School party the Sat. night of the week you were gone.... I cannot bear to think that I have seen you for the first and last time and shall be keeping it in my mind, that you will come again – I hope that your husband teaches here next summer and then you will come too..."
– Imogen Cunningham.[6]

Jermayne MacAgy was the curator of an installation of Aaron Siskind's photographs at the Palace of the Legion of Honor in 1949, where she introduced rocks and barbed wire as referents to his subject matter into the exhibition.[8]

SAN FRANCISCO

In the summer of 1946, Lisette and Evsa visited California for the first time. The trip had been precipitated by a meeting in New York in the winter or early spring of that year with Douglas MacAgy, Director of the California School of Fine Arts (CSFA), and his wife, Jermayne MacAgy, then an instructor at the California Palace of the Legion of Honor. MacAgy, an individual respected for his foresighted administration of the school – he lent strong support to the establishment of the photography department in 1946 – had invited Evsa to teach a special course in textile design with a commercial application for painters during the summer session. With his work being exhibited regularly in New York and once in Chicago, interest in it was generally increasing; Harriet Janis, for example, produced a small publication in 1945, *Evsa Model's American City*. On 15 June, Evsa, Lisette, and a close friend, painter Pauline Schubart, travelled by Pullman tourist class to San Francisco. Their accommodation was the Leavenworth Street house of Robert Howard and Adeline Kent, both sculptors and instructors at the School of Fine Arts.

The Photography Department of CSFA, established by Ansel Adams in 1946, although small was the nexus of a vibrant group of west coast photographers, and it did not take Lisette long to form warm and strong ties with various of its members. Ansel was the one photographer in the circle whom she had certainly met previously in New York. Friendships evolved with photographers Imogen Cunningham,[6] Ansel and Virginia Adams, Minor White, Pirkle Jones, and Ruth Marion Baruch. Although she photographed Dorothea Lange[7] and Edward Weston, she did not come to enjoy the same ongoing relationship with them as she did with the others. She and Evsa occasionally attended the regular gatherings at the Adams's home, and Lisette began a brief correspondence with Imogen, and one of longer duration but sporadic nature with Minor White (whom she may also have encountered earlier in New York when he was there from the fall of 1945 to the summer of 1946).

Jermayne MacAgy organized an exhibition of Lisette's photographs in August of that year at the California Palace of the Legion of Honor.[8] Simply entitled *Photographs by Lisette Model*,[9] it provided an overview of the work she had done up until that time,[10] including images from the *Promenade des Anglais* series and from New York. The photographs that were selected in newspaper reviews to illustrate the exhibition were *Fashion Show, Hotel Pierre* (pl. 128) and *Man with Pamphlets* (pl. 37).[11] Pirkle Jones recalls the show as being very powerful. The 11 × 14 inch (27.9 × 35.5 cm) prints were glossy and labelled by means of a title typed onto a piece of torn newsprint and then tacked to the photograph. Large swatches of coloured paint highlighted the presence of each print against the wall (fig. 73).[12] A press release described the exhibition as:

Photographs of people from the Riviera, from the Bowery, from the sidewalks of New York Lisette Model has an international reputation for her unusual and truly remarkable photographs. She is on the photographic staff of the magazine, *Harper's Bazaar*. She does not, however, take the usual fashion photographs, but subjects such as the circus, window reflections,

fig. 74
Lisette Model
Robert and Peter Oppenheimer
San Francisco 1946
Full frame enlargement
by Justin Wonnacott from
original negative, 1989

fig. 75
Lisette Model
Imogen Cunningham
San Francisco 1946
Full frame enlargement
by Justin Wonnacott from
original negative, 1989

fig. 76
Dorothea Lange and Ansel Adams,
California School of Fine Arts 1949?

"Small, exotic Lisette Model, with her tangle of silvery hair, her dulcet voice, her eyes that are sometimes blue and sometimes agate, is as interesting a personality as her photographs are art." – *San Francisco Chronicle*.[14]

people on the streets; these are now run as special features in the magazine. She is now in San Francisco photographing people connected with the art world.[13]

The impact of this work upon a community that first and foremost judged the worth of a photographic image by its "print quality" was noteworthy. Despite its often awkward technical realisation, it was received with great respect by Adams, Lange (fig. 76), White, and Weston. They recognised that her work, like her personality,[14] was visceral and charged with emotion – exactly what was required to counterbalance the more contained spirit and technical orientation of their group.

The project of photographing people connected with the art world was undertaken by Model entirely on her own initiative. The only encouragement that *Harper's* had offered her was that they would be delighted to see what she produced, but they gave no guarantee that the material would be published. Model deviated only slightly from her initial concept – a pantheon of San Francisco art world personalities – by including one or two business tycoons and nuclear physicist Robert Oppenheimer. Published in *Harper's Bazaar* in February of 1947 under the title "The Intellectual Climate of San Francisco", the portraits of Oppenheimer, Roger Sessions, Robinson Jeffers, Salvador Dalí, and Darius Milhaud are generally stiff and uninspired. More complex and engaging are the images that Model had rejected, showing Oppenheimer and his small son (fig. 74), and, a particularly tender portrait, Sessions holding his daughter. Model, however, dismissed these photographs as "snapshots", and recalls the sitting with Dalí as having been a disaster.[15] Yet the portraits of the Edward Weston (pl. 157), Imogen Cunningham (fig. 75), Ansel Adams, and Dorothea Lange (pl. 147) possess a vitality largely due, no doubt, to the photographer's greater sense of connectedness to the subjects. Like the attempts at fashion photography, however, these images again seem to have been made at a time when she was feeling vulnerable about her ability to survive economically and to do so within terms that would appeal to her major employer, *Harper's Bazaar*. It

was becoming increasingly difficult for her to conceive of producing the imagery she felt deeply about while seeing *Harper's* as a significant outlet for it.

As well, she photographed streetscapes and façades. In fact, her interest in architectural subject matter evolved to the degree that she admitted to wanting to return to San Francisco to work concentratedly on this subject.

On this first trip to California, Model exchanged a group of forty prints for the loan of one of Adams's exposure metres, an act of hers he considered more than generous.[16] The transaction resulted out of a photography excursion that must have involved a fair amount of banter between Adams and Model over the use of instrumentation versus intuition in obtaining correct exposures. Model claimed to have resisted owning a light meter until she started to teach. She enjoyed recounting an incident that occurred in 1949 when she returned to San Francisco. With the sub-theme being the triumph of the innocent, primitive photographer over the master photographer-cum-technical wizard, Model described an occasion on which she and Adams photographed one another without the use of a light meter, and she successfully gauged the appropriate exposure time before he did:

> I remember that Ansel Adams took a picture of me in San Francisco with the first Polaroid camera . . . took one picture wrong, and then the next picture wrong and then the third, and then he said, well, without a light meter – and then I said, well, Ansel, what kind of a lens do you have, and then I said I would expose it this way. They always thought I didn't have any technique, but I had a lot of sense.[17]

There were also other occasions on which they photographed each other (figs. 77, 78).

It is difficult to imagine how two photographers so divergent in choice of subject matter and aesthetic expression enjoyed a relationship of such strong mutual support throughout their lifetimes. Model would call upon Adams twice for support for her Guggenheim applications, and was clearly relieved when a misunderstanding that arose over the curious fate of the prints she had given him was resolved.[18]

On returning to New York, Model resumed a slower-paced schedule of exhibitions and assignments. Shortly after their arrival home to their apartment on Grove Street, Evsa's brother-in-law Moise died, and his sister Luba and nephew Constantine left New York for Millbrae, California. In 1947, Evsa was reunited briefly with his two sisters when Mania Zimmerman came to New York from China for a short visit.[19] In 1948, Lisette's brother, Salvatór, who had presumably died some years earlier in a concentration camp, was legally declared dead.

Along with her own personal work, her work for *Harper's Bazaar*, and the teaching she had now begun to undertake, Model entertained the idea of publishing a book of photographs. The subject of the book was to be New York, its people, and their environment. It was to be an interpretive look at the city without, as she expressed it, "emphasis on factual or sociological aspects".[20] In the fall of 1948, the Newhalls encouraged her to apply for a Guggenheim grant, and she wrote Ansel Adams asking him to sponsor her.[21] Adams's recommendation, mailed to Model early in December, read as follows:

fig. 77
Ansel Adams
Lisette Model 1946

fig. 78
Lisette Model
Ansel Adams 1946
Gelatin silver
34.8 × 26.8 cm

I have always admired the photography of Lisette Model. In it I find a power and penetration of thought and emotion rare in these times when the intellectual or sociological approaches to art often submerge the simpler human qualities of the world and the truths of spiritual expression. Model's work does not stand on the success of any one of her photographs or on the success of a specific group of photographs or "period" of her creative life. The sum of her conscientious efforts over many years does, however, constitute one of the major contributions to the creative photography of our time. As her perceptions and philosophy do not often coincide with the popular conceptions of "documentary" photography, and as her frank revelations of human character and environment are honest to the point of ruthless and tragic symbolism, she has not received the recognition she so deeply deserved.

Perhaps Daumier and Model have much in common. Her magnificent series of Riviera types, her more recent photographs in the Bowery, and the extraordinary experimental impressions of the city in which she employs the difficult device of reflections in large mercantile windows, clearly indicate great creative gifts. She fails – as most artists fail – when attempting expression without conviction. Her equipment – mental, emotional and mechanical – does not include adjustment to commercial assignments, and I consider this in her case a definite advantage. An occasional defeat in some shallow assignment has only sharpened her determination to employ her camera in recording the deeper currents of humanity. I am in accord with all the elements of her project as submitted to the foundation.[22]

Adams demonstrated an understanding of the requisite balance between technique and expression in Model's work, writing that "her mechanical techniques are reduced to an absolute minimum, in fact were she to elaborate thereon it is possible that the fire of spontaneity might be dimmed".[23] He alluded also to the potential use of the photographs in a book, which he felt was crucial to the evaluation of her application, because the book would "serve to bring to focus many divergent rays of urgent creative intention".[24]

The recipient of the Guggenheim for photography for that year was Homer Page.[25]

RENO, NEVADA

On 16 June 1949, Lisette and Evsa again set off for the West. This time, Lisette had been given an assignment to document the women who resided at dude ranches in Nevada for six weeks with the intention of qualifying for residency and then filing for quick divorce under the recently passed state laws. Model had been selected by John Morris, Picture Editor of *Ladies' Home Journal*, to illustrate the documentary series "How America Lives". Says Morris:

I tried to pick the photographer who would be the most perceptive in dealing with that particular kind of family.

The Journal would always send an advance scout, usually an editor named Ruth Matthews, who would interview two or three "candidates" for the kind of family chosen for that month – a young housewife, an auto worker, a lawyer, etc. In this case it was decided to focus on a family who kept a guest ranch where prospective divorcées stayed under Nevada's (then) residence requirement.[26]

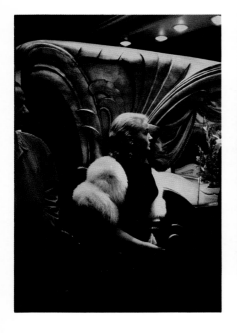

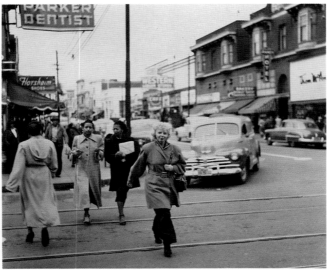

fig. 79
Robert Frank, American (b. Switzerland, 1924)
Movie Premiere – Hollywood 1955 or 1956
Gelatin silver, printed 1968
30.6 × 20.6 cm
National Gallery of Canada (21851)

While the editor's intention had been to follow the divorcées at the Lazy A Bar Guest Ranch owned by the Winnes, Lisette erroneously arrived at The Bundy's Guest House, owned by Gus Bundy, and proceeded to document the women who were waiting out the residence requirement there. When the error was identified, she quickly moved on to the Winnes and proceeded to fulfil her assignment. By this time she was working consistently with both her Rolleiflex and her Leica, and produced a substantial body of negatives in both formats.

As unlikely as it may seem for such an urban photographer, in this small Nevada desert town surrounded by horses, divorcées, and rodeos, Model found people and places that fired her imagination. While the divorcées may not apparently have held promise visually as "Model types", the mood of these women, mirrored in their veiled, intensely inward expressions, attracted her. In the same way that musicians and blind people respond to stimuli that an outsider can only try to imagine – and Model was strongly attracted to these subjects – so these women seemed to live in some impenetrable interior reality that lay far beyond the reach of the camera. What the camera could record was this mystery.

Another and perhaps unforseen attraction in Nevada for Model was the gambling casinos, reminding her of the resorts of the French Riviera. In a body of photographs similar in spirit to Henri Cartier-Bresson's documentation of Harold's, a famous Reno gambling casino, which had been published a year earlier in *Harper's Bazaar*, Model responded to the people lost in a mood of speculation as they gambled and dreamed. It was not the glamour of gambling that drew her attention, but its more squalid side, the pursuit of ephemeral excitement: a gamble, sad and futile, taken by people who had started out with little to lose. Without necessarily being fully conscious of it, she was looking at the reverse side of American energy and optimism, was seeing a society driven by the belief that everyone was entitled to their hopes and dreams, and that, if there were no guarantees, the right to pursue them was, at least, inalienable. Model produced in Reno a vignette of the United States which, although less comprehensively conceived, is not unlike Robert Frank's iconoclastic vision in *The Americans* (fig. 79).

Sometime in mid to late August, her assignment completed,[27] she left Nevada with Evsa and headed for California, to stay with Luba and Constantine, now settled in Millbrae.

"Minor White and Lisette were wonderful together. She admired his work very much, but she didn't approve of the esoteric part [alluding to later work, perhaps]. [She] felt that it was misleading for the students. I did not agree with her." – Nata Piaskowski.[29]

While they were in California, at first unknown to the Models, their landlord was in the process of illegally evicting them from their Grove Street apartment. Evsa and Lisette had by this time become sufficiently well-known and loved in New York for this event not to pass by unnoted. It became a *cause célèbre* in their absence and ignorance. As reported in both the *New York Times* and the *New York Herald*, the landlord was found to have acted without justification and without the due process of the law.[28] Friends, neighbors, and professional associates Dorothy Wheelock and John Morris came to the rescue of the Models' belongings, which had been tossed out on the sidewalk. They had Evsa's paintings safely stored in the Charles Street Gallery, and defended their tenancy. By the time the Models had been contacted, the eviction and the consequent legal action had all but come and gone.

CALIFORNIA SCHOOL OF FINE ARTS

The sequence of events that resulted in Model becoming a visiting instructor at the California School of Fine Arts remains a little murky. Although Lisette did not teach at CSFA on the first visit in 1946, the contacts she made with the members of the San Francisco photography community clearly made it possible for her to do so as a respected photographer and potentially dynamic educator when she returned there some three years later. Minor White, who had joined the staff of CSFA in 1946, arriving in San Francisco just weeks after the Models, was to become a friend with whom she enjoyed a long but reputedly competitive relationship.

The essence of the discussions between these two individuals, who were both to leave such a lasting impact on photography through their images, their personal aesthetic philosophies, and their teaching might never be known in detail, but at least a glimpse is obtained through their correspondence with one another and with their acquaintances. Those who knew them both commented on the fact that they enjoyed an ongoing dialogue about photographic pedagogy and mysticism, but entertained different ideas on the reading of photographs.[29]

At this stage they enjoyed a relationship based on strong mutual respect and support. In a letter to the Newhalls written in August of that year, White reports, for example, on an evening recently passed with Model listening to her views on the "miniature aesthetic", and reflecting on the meaning and relevance of "equivalences" and "equivalents". White perceptively comments that "Model is even more 'Equivalent' in her approach in using people as visible revelations of herself."[30]

The competitiveness that photographer David Vestal observed in their later relationship[31] may have been one reason why Model always maintained it was Ansel who gave her her first teaching opportunity, when in fact it appears to have been Minor White. Another may have been an incident that occurred three years later, when Minor criticized the content of an article Lisette published on photography in the *New York Times*, leaving her with some residual feelings of anger towards him.

As Model remembers it, it was at Adams's invitation that she came to teach, and it was all quite spontaneous. There is every reason to believe her introduction

fig. 82
Lisette Model
Ansel Adams and students
San Francisco 1949
Full frame enlargement
by Justin Wonnacott from
original negative, 1989

to teaching at CSFA was as informal as she always maintained, since no correspondence regarding job offers is extant.

When Lisette and Evsa arrived in San Francisco in late August of 1949, Ansel Adams was at the train station to greet them. Besides discussing her failed attempt to receive the Guggenheim award for which he had sponsored her, she recalled that he also asked whether she would be interested in "taking over" his classes for the duration of the fall term, when he would be away. Her recollection of her initiation is humorously self-deprecating. To Adams's "job offer" she alleged she answered:

> My dear, what I know of photography I can say in two and a half minutes, and he said, "You have nothing to fear. They have fifty photographs of yours in the school," – which belonged to him – "they know your work. You go in, try it out, and if you don't like it, just walk out." So I walked in, sat down with a student, and unfortunately it came out that I could do it! Unfortunately for my photography, because it took me over in such a big way. But I had to make a living. Then the New School for Social Research wanted me immediately.[32]

Engaged to teach only for a couple of weeks, she ended up staying until at least November as a "Special instructor in documentary photography"[33] in the Department of Photography. Imogen Cunningham and Edward Weston were also visiting instructors. As it turned out, it was as a guest instructor in "Photography 2", a class of Minor White's, who was running the department, that she taught. The students in her class that semester included Bob Hollingsworth, Benjamin Chin, Charlie Wong, and Nata Piaskowski.[34] She was responsible primarily for a group of advanced photography students, on whose behalf she requested permission to photograph circuses at the Cow Palace.[35] Totally in line with how she would later conduct her classes at the New School, she did not confine her students to the classroom, but took them to photograph in various parts of the city (fig. 80), including Union Square, the Mission and Fillmore districts, the parks, and the horse races. In this way, not only did she exercise some influence on the choice of subject matter of Minor White's students, but it is highly likely that she had some impact also on his own work (fig. 81).

Photographic historian Peter C. Bunnell observes that "a fascinating and important aspect" of White's San Francisco imagery is "how it demonstrates White's commitment to photographing, not simply as an activity but as a basis for gaining knowledge and understanding. We know the world – and ourselves – by the use we make of the world. Influenced by the work of Lisette Model, whom he had brought to the California School of Fine Arts to teach in 1949, and by Cartier-Bresson's work, which he admired, White sought on the city streets the living, sometimes comedic, sometimes frightful, reality of the urban world in which he lived."[36]

According to Nata Piaskowski, the students in this class had had prior experience only with large-format cameras, and Model's instruction launched many of them into the use of the "minicam", as it was then called.[37] Model, who remained open to learning from her students until the end of her life, was on her side anxious to pick up the rudiments of large-format technique. White recalled her "trying out a 4 × 5 while here".[38]

fig. 83
Lisette Model
San Francisco 1949
Gelatin silver
27.4 × 34.7 cm
J. Paul Getty Museum,
Malibu (84.XM.153.9)

In 1950 Nancy Newhall wrote her, "Minor says that you did a superb job directing his kids in photographing the Negro district in San Francisco. Did you do anything there yourself?"[39]

Model does not in fact appear to have done any photography in this area herself. However serious her involvement with the Photo League and her interest in the work of socially committed artists like Grosz and Heartfield, the Black districts of Fillmore and Mission, destabilized by housing and unemployment crises, were not subjects that attracted her. She seems mainly to have photographed people in parks around Union Square, experimental views of San Francisco streets (fig. 83), and street façades, in 35 mm. She also photographed Ansel Adams and his students (fig. 82). The total of her extant negatives from this period is not great. It is interesting to speculate what might have happened had she not become involved with teaching at this point, and also if she had received the Guggenheim grant for which she had applied that year. Reflecting on the amount of creative energy she channelled from her own work once she began teaching, Model observed:

> I had to make a living and I found out unfortunately maybe that I could do it [teaching]. If I would not have been able to do it I would have photographed a lot more and not been teaching. Once I had the experience in San Francisco, the New School immediately took me, and then I had an enormous amount of teaching – two classes in the New School, two classes in my studio, two classes of painting in Evsa's studio – private students and small groups. And that went on and on. That was the only way I could make a living.[40]

Model's disappointment with the failure of her Guggenheim application, and her need to make a commitment to teaching because of increasing financial difficulties compounded her growing feeling of professional uncertainty. Although her work was still being recognized, through publications such as Beaumont Newhall's *The History of Photography* (which appeared in 1949), and presentations such as the Museum of Modern Art's circulating exhibition of fifteen of her works in the *Leading Photographers* series (which toured until 1954), her sense of unease about her status as a photographer persisted.[41]

I have often been asked what I want to prove by my photographs.

The answer is, I don't want to prove anything, they prove to me and I am the one who gets the lesson.[1]

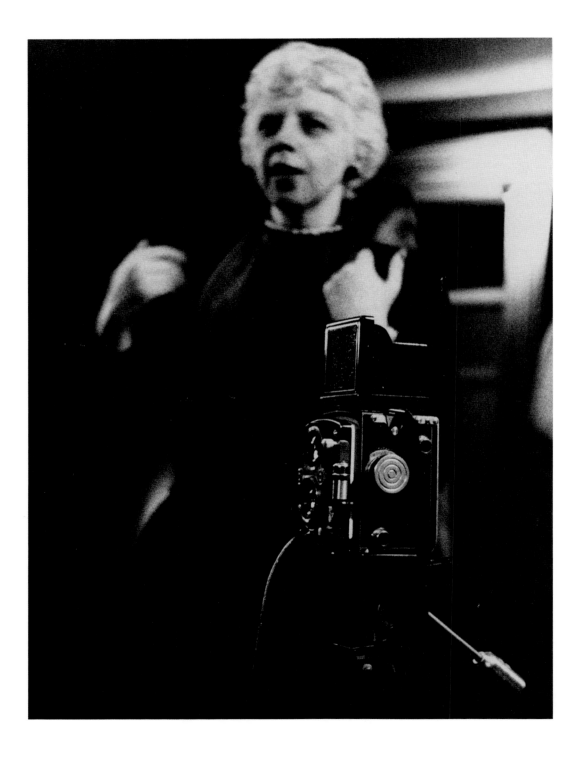

fig. 84
Ray Jacobs
Lisette Model 1953
Gelatin silver
35.1 × 26.4 cm

Model always maintained that her own practice of photography was undertaken for heuristic rather than aesthetic reasons. When she started teaching in 1949, Model had already established herself as a powerful and uncompromising photographer. Her strengths as an educator extended beyond her professional standing and included personal qualities such as a deep interest in all areas of creative endeavour and a passionate concern for people (fig. 84). For Model, any experience of the world or act of creation divorced from these connections to life was incomplete. Blunt and forthright in her manner, and totally unintimidated by current theoretical orthodoxies of thought, she addressed her students in a clear, strong, and personal voice, leaving no doubt as to where she stood on any issue. Even had she possessed conventional academic credentials, they might well have been rendered irrelevant in the light of her particular brand of subjective wisdom. The influence she had on students was generally powerful and positive, although certainly not everyone who crossed the threshold of her classroom was won over to her views or methodology.

Model frequently expressed surprise at how she "fell" into teaching and only when "it was too late"[2] found out she was good at it. Although she described her first encounter with teaching at CSFA as serendipitous, she returned to New York determined to do more of it. In 1950, in line with this intention, she participated in a symposium at the Museum of Modern Art on the topic "What Is Modern Photography?", organized by Edward Steichen.[3]

She also wanted to learn from those who were reputed to be lively and forceful teachers, and it was in this spirit that she and Evsa attended the private classes of Sid Grossman in 1950. In one of these sessions she summarized her approach to both photography and teaching:

The great authority is the picture itself. It isn't the public ... it isn't the editor, it isn't the teacher The picture is the greatest symptom and the most precise, the one that doesn't lie. I have never been afraid to show my pictures or not to show my pictures – even to get a lousy criticism. To me, the camera is the instrument I am asking a question with. I don't know myself what the answer will be. When I want to discover something, when I want to get an answer in this world which I don't understand because nobody does, then I take the camera, and I find out what strikes me. And this thing that strikes me I photograph, and that is in one way or another the answer.... the photograph proves it to me.[4]

A short while after the symposium, she was asked by Jacob Deschin to commit her thoughts about photography and teaching to paper. Deschin's column in the *New York Times* was everyone's source of news on photography, and the channel for presentations of the current critical positions. In "Pictures as Art"[5] Model objected to a reliance on the term "creative photography" to describe serious or superior picture-making in the medium:

Music, poetry are supposed to be creative or they are nothing. The very use of the term creative when applied to photography is therefore discriminatory, implying a difference that does not exist. If one is convinced that photography is art, which it undoubtedly is, then it must be creative.[6]

Brodovitch's class met at the studio of Paul and Karen Radkai, both photographers for *Harper's Bazaar*. The course was described as: "Photo Reportage, photo story, fashion photography, photo illustration, experimental photography ..." [9]

Josef Breitenbach taught two courses, "Photography as Document and Self-Expression" and "Creative Possibilities in Photography".[10]

The negatives are of a piece of crumpled paper. A teaching technique used by Brodovitch was to "crumple a piece of paper and throw it onto the center of the table, challenging those around it to 'give me a report on this object' ".
– Andy Grundberg.[11]

She went on to attack those who refer to themselves as creative or experimental photographers. In her perception, work thus described was derivative and did not address the full potential of the medium, but reduced the photographic image to surface pattern. She was equally vociferous about Pictorialist photography, insisting that it drew too heavily on the aesthetics of other media and "makes photography artificial".[7]

When the article appeared, students passed it on to Minor White. Always ready for a good gloves-off argument about photography, he immediately wrote Model a letter strongly protesting certain of her views. For him, there was nothing in the least inappropriate in the use of the term creative to distinguish non-commercial from commercial photographers, and he described her thinking as illogical and wrong-headed.[8] Model's response to his criticism revealed a surprising vulnerability. Instead of rising to the occasion with a feisty counterattack, she retreated – an indication of a slowly swelling mood of insecurity and depression, some of which arose out of the serious economic uncertainty that blighted her life in the fifties.

THE NEW SCHOOL

However, within just months of joining the faculty at the New School for Social Research at 66 West Twelfth Street in the spring of 1951, Model was fully into the fray. A staunch defender of the photographic medium, she nevertheless argued against any special status for it and fought for public recognition of it as a medium of creative expression equal to and no different than all others.

When Model became a part-time faculty member, Alexey Brodovitch,[9] Josef Breitenbach,[10] Charles Leirens, and Berenice Abbott were all teaching courses that covered a range from magazine photography, photography with the miniature camera, and photography as self-expression, to advanced workshops. On the music faculty was Edward Steuermann, Model's old piano teacher from her Vienna days, Henry Cowell, a friend whose wife studied photography with Model, Roger Sessions, whom she had photographed with his family in San Francisco, and Felix Greissle, the husband of her dear friend Trudi.

It is possible that Model attended or perhaps periodically taught Brodovitch's class. In her archive there are 35 mm negatives marked "Brodovitch's class".[11] Brodovitch insisted on originality and inventiveness in his teaching. For him, experimentation was a primary creative force and one he encouraged in his students above all else.[12] Like Lisette, he believed in experiential teaching situations, and gave his courses in a studio off the school premises, stressing the application of the work to the commercial environment.

Berenice Abbott taught one class for beginners, "Fundamentals of Photographic Practice and Theory", in which students were encouraged to master "first things first".[13] Proficiency in technical areas was developed and students had their work analysed in class discussions. In 1959, Marion Palfi taught a course entitled "Social Uses of Photography". The friendship between her and Model, two strong-minded women photographers, was to endure up until Palfi's death in 1978.

The faculty included James Harvey Robinson, Charles A. Beard, John Dewey, Wesley Clair Mitchell, Elsie Clews Parsons, Thorstein Veblen, Emily James Putnam, Graham Wallas, and Harold Laski.[14]

"Any kind of American art that could not compete on equal terms with European Art was not worth bothering with." – Clement Greenberg.

"One painted to the world or not at all."
– Arthur C. Danto.

"Speaking in 1945, on the subject of Europe's collapse and the immigration of many notable European composers to the United States, Roger Sessions argued that the old contrast between 'native American' art and 'European' art had been rendered moot by events.... Instead of being a province of Paris, or even an imitator of Paris, New York in the 1940s became Paris. And the assimilation of the culture of Paris was crucially important for what happened in New York." – Thomas Bender.[17]

In "The Function of the Small Camera in Photography Today" students attended ten two-hour evening sessions, and five field trips, held on either a Saturday or a Sunday.[18]

Founded on the principle that knowledge should be accessible to all people regardless of social class, and favouring a broadly based humanistic education over specialization, the New School – originally known as the Free School of Political Science – was established in 1919 by several professors from Columbia University seeking alternative means and aims for education.[14] Not appreciated for its liberal orientation, the faculty and program was castigated by Columbia President Nicholas Murray Butler as a "little bunch of disgruntled liberals setting up a tiny fly-by-night radical counterfeit of education".[15] Housed in a "self-consciously modern building" built in 1931, Thomas Bender described it in his study of intellectual life in New York as being "a major center of modernist experimentation" in the late twenties and thirties.[16]

When Model began teaching there in the early fifties, the United States was in the grip of McCarthyism. The New School remained, nonetheless, very much oriented toward the fulfilment of community needs. Even then, ten years after the mass migration of European Jews, it had a significantly high quotient of European refugees on staff. As Bender points out, the tremendous influence that European artists and intellectuals had upon the substance and expression of both ideas and artistic experimentation in the thirties and early forties in that city altered the United States' perception of its role within the international context.[17]

Model taught two courses in the first session: "The Function of the Small Camera in Photography Today" and "Photographing New York and Its People".[18] Her course description for the first, published in the calendar for 1951, encapsulates her approach to photography:

> Photography is the art of the split second. Speed, the fundamental condition of our present day activities, is its power. The photographer works fast within the second he has to see, to select and to act. The small camera is his ideal tool. Its art value is enhanced by qualities which have been variously described as journalistic, documentary, candid: it is a means of detecting and revealing the reality surrounding us.
>
> The course stresses the importance of learning to see photographically, and of completing the photographic image in the dark room by enlarging. Its aim is to give the student the use of an instrument with which to develop his own potentialities and style.

The course Model had taught in San Francisco in the fall of 1949 had also emphasized the small camera. Despite her experiments there with a larger camera, Model herself worked exclusively with a 35 mm camera and 2 1/4 inch (5.7 cm) camera. She finally favoured the 35 mm for its "intimate" quality.[19] At that time, she and Minor White had exchanged ideas about teaching and established a relationship based on a mutual interest in education and photography. The dialogue continued throughout their friendship and was sustained by a shared interest in the psychological or psychoanalytical interpretation of photographic images. In correspondence dating from 1961 White describes a recent experiment to her:

> Just finished reading 28 papers by students who had been assigned to work with and analyze and write down reactions to a photograph of their own choosing. Several looked at them for long

fig. 85
John Gossage
Lisette Model and student 1961?
Collection John Gossage, Washington

periods of concentration. The boy who is being psychoanalysed treated the photo as a mirror of himself and went haywire – purely neurotic symptoms; but so obvious that even he realized it on the spot. But others saw deeply into a photo for the first time. Reading these papers with your conversation in mind I was watching for the detrimental effects. Conclude that at the BEGINNING of a training of the intuition, long periods of concentration are useful. Not as something to be done always but for the early stages of getting students who think that they know all about a photo in a glance to realize that they missed almost everything.[20]

A significant difference between her approach to teaching and Minor's is that he used photographs, often his own, as the basis for his teaching. He would often make them specifically for this purpose.[21] As far as her own work was concerned, Model never taught by example. To do this would have required a certain objectification of her material, a process she was reluctant to undertake. In 1971 she had this to say about it:

When it comes to show [ing] and talk [ing] about my own photographs, I so far have refused, feeling that one sees less clearly one's own work one would have to see oneself from many different angles and distances, all sides. It would be almost impossible.[22]

Instead, she brought in books of other photographers whose work she admired to stimulate discussion, such as August Sander and later Josef Koudelka.

Although Model never used her own work in teaching, she did draw on its subject matter. "Photographing New York and Its People", for example, was based on field trips during which "students and instructor work together to photograph the city, its people, its different sections, i.e., the East Side, the financial district, Rockefeller Center, etc."[23] In the winter she would take her students to the Metropolitan Museum, excursions which could be viewed as a contradiction of her philosophy that the making of art should be a response to the world and not an imitation of other images. They were, however, conducted in a spirit of true enquiry: in addition to asking students to observe the people visiting the museum, she challenged them to respond to the paintings and sculptures through an appreciation of their role and place in history, but not by emulation in their own work. Most of her workshops included trips to these places, as well as to Coney Island and Central Park (fig. 85). While encouraging her students to photograph on such occasions, she herself did not.

In structuring her courses, Model followed a relatively routine approach, assigning to her students at the basic level the learning of technique – "the handling of the tools". Here she would point out that "photography starts with the projection of the photographer, his understanding of life and himself into the picture. What we are concerned with is not ... [a] good or bad print, but the print for what is unintended to be conveyed".[24] In other words, she wanted them to discover the unexpected. This directing of her students' thinking about photography as an experience of disclosure rather than foreclosure was to strongly influence Diane Arbus's relationship to the medium (see chapter 9).

In the advanced workshop, which she took over from Abbott in 1960, she

fig. 86
David Vestal, American (b. 1924)
55 Grove Street, New York 1951
Gelatin silver
26.4 × 33.3 cm

Other subjects on the assignment list were: "Photograph something never done before; Close and Far; Light; Explore Perspective; An unconventional face; Self-portrait; Instant (Speed); Abstract; Sequence; Nature in New York." – Teaching Notebook.[27]

"Lisette Model, one of America's leading documentary photographers and formerly an instructor at the California School of Fine Arts, is organizing a class to start in February. Her course on "The Small Camera and Its Function in Today's Photography" will be given 8 to 10 p.m., twelve Tuesdays, for $50. Write her at 55 Grove Street or telephone Chelsea 2-4626." – *New York Times*.[28]

hoped to bring students to an understanding of photography within the larger framework of its contemporary uses, as well as within the history of art.[25] Compared to other visual media, she emphasized that photography was the product of a very specific development in science and technology, and thus seeing, feeling, and understanding expressed through it would be linked to an industrial/post-industrial perspective.[26]

For twenty years the program followed the same lines with little variation, and Model's courses concerned themselves with much the same principles. In 1976 she was still giving assignments that corresponded to subjects that had absorbed her interest some thirty-five years earlier, such as "Animals (Zoo, People and Pets); Groups of People, Crowds; Statues; Objects unanimated; Museums; Traffic vibs. of big City; Wall Street Skyscrapers".[27]

The expansion of the photography program in the mid-1970s echoed the burgeoning of the photography market. The staff, and consequently the range of approaches to photography, greatly increased beyond the more documentary focus of earlier years. Philippe Halsman taught a "Psychological Portraiture" course. Ken Heyman and George Tice also came on staff, respectively teaching "The Intimate Moment" and "Making the Fine Photographic Print". Around 1977, Master Workshops were introduced and Model was assigned to two for Advanced Photographers. She continued to teach at the New School until her death in 1983.

PRIVATE CLASSES

Exactly when Lisette and Evsa started to hold private classes is difficult to determine. It is possible that they lived on Lisette's personal income until 1941. When that had been dissipated, they were able to exist on her modest fees from work for *Harper's Bazaar* until around 1945, when assignments started to taper off. It would seem to have been about this time that Evsa began to conduct his workshops in painting and painting theory, which Lisette attended and participated in as a student, in the Grove Street apartment (fig. 86). Among the people who studied with him at some point were Leon Levinstein, Harper and Eve Brown, Jane and Manny Greer, and, for a brief while, Henrietta Brackman and Dee Knapp. Some six years later, in 1951, Lisette began her private classes.[28]

Helen Gee, who opened New York's first photography gallery – a combination coffee house and gallery, the Limelight – was among her first students. Model was not, however, Gee's first photography teacher. Gee had taken a New School course oriented to magazine photographers and given by Alexey Brodovitch in Paul Radkai's studio. Finding that this was not what she wanted, Gee started to study under Dan Weiner; it was there that she learned of the work of Lisette Model. In response to a notice in Jacob Deschin's column announcing Lisette's private classes, Gee paid her first visit to the Grove Street apartment one Sunday morning. In addition to Gee, there were about six other students in the group. Gee described Model as a "dynamic personality. Warm and kind ... always difficult but inspirational. She was a catalyst. That was the best part of Lisette – she could really fire people. She really gave and she really inspired".[29]

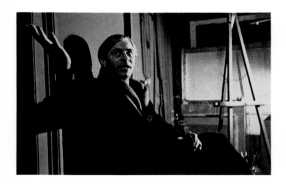

fig. 87
Ray Jacobs
Evsa Model 1953
Gelatin silver
23.5 × 35.1 cm

fig. 88
Ray Jacobs
Grove Street Studio 1953

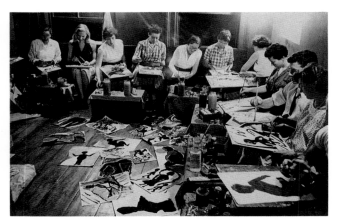

When the Models moved away from 55 Grove Street in late 1953 or early 1954 to 247 West Thirteenth Street, where they were to live until 1958, they continued to teach from their apartment, as they would when they later moved to 137 Seventh Avenue South. Some students studied with both Evsa and Lisette, like Manny Greer, Harry Lapow, and Leon Levinstein, and in some instances there were couples with each partner studying with either one or the other of the Models – for example, Ray Jacobs studied with her and Eleanor Jacobs with him. In many respects they operated as a team, basing their pedagogy on the play element in art (fig. 88), as well as on the philosophy of art which sees it as a means to self-knowledge (fig. 87).

TECHNIQUES AND PHILOSOPHY

Perhaps the strongest influence on Model's teaching was Arnold Schönberg. Not only had she studied with him and been exposed to his ideas about art, but she had been profoundly affected by his personal credo and philosophy of education. It was said of Schönberg's teaching that he brought freshness to old ideas and had an ability to embrace the complex and the abstract along with the mundane:

> On the one hand the force of naive perception, which can do without the help of tradition and which forces him to reformulate everything, from the smallest everyday matters of life to the highest human and artistic questions, and to make it live anew; on the other hand the power of communicating his personal evaluation of these matters in a convincing way. Out of these two basic forces of his personality derives the miracle of his way of teaching, his unique effect on his pupils. All the artistic rules which seem dry in old text-books and from the lips of bad teachers appear in his lessons to have been born at that moment from an immediate perception, or else they suddenly appear in a new light which brings them to life, quite apart from the totally new insight which his personal approach always opens up. In this manner every stage of his teaching becomes an experience for his pupil, and really sinks into his personality.[30]

Schönberg was a natural pedagogue, instructing and opening people's eyes and minds in every possible situation. He also engendered love and respect for creative achievement. His grandson Hermann Greissle recalls walking with him, Anton von Webern, and Alban Berg through the streets of Mödling, when Arnold tapped him gently on the back and instructed him to take off his cap, saying, "Don't you know we are passing the house of Beethoven?"[31] He encouraged students to question the established conventions that governed their discipline, and

urged them to go against the grain and be abrasive in order to truly learn. Similarly, Model's quest as a teacher was to help students find their own vision and learn to use the camera as an instrument of detection.[32]

The Schwarzwald School, with its experimental program, had also impressed her deeply, and left its mark on her as a teacher.

A contemporary influence on the development of her philosophy and pedagogical outlook was the writing of Berenice Abbott. Her respect for Abbott, who had published the intelligent and very complete book *A Guide to Better Photography*, dates back to the early forties. Shortly after starting at the New School in 1951, for example, Model and Abbott organized a joint exhibition of their students' work,[33] manifesting the spirit of collaboration and strong mutual respect that marked their friendship throughout their lives.

The final, and perhaps most significant, influence upon her teaching was her students.

Model's teaching was at a far remove from the rigid instruction of the Austrian Gymnasium of her childhood. Rather than downplaying her lack of formal education, Model used it to dramatic advantage by making it the basis of her introduction to new classes. One student, Lisa Clifford, recalls Model's breezy and decidedly unconventional opening remarks: "She first warns that she has never taken a class in photography and she has never learned a thing from any photograph she has seen."[34] Right from the beginning, Model made sure her students knew she abhorred imitation:

> Most photographs are driven by routine – this tells us something about our civilization – tells us about the way we are educated and influenced – this convention stops us from seeing the means to react with our body and mind.[35]

While she acknowledged that photographers could learn from one another's work, great care should be taken to ensure that the images made were "one's own life inspiration [and] not images of other people's lives", or the "accumulated knowledge of other people's pictures", which would be sure to be "still-born".[36] She exhorted them to heed the advice of Picasso and Schönberg not to be impressed by what others do; love it, but do not imitate.

What was said of Sid Grossman's teaching methodology in 1961 could also have been said of Model:

> His life was full of challenge and conflict, and his manner of teaching was to create challenge and conflict for his students, defining their goals and inspiring them to strive in those directions. He was merciless in his criticism of work that appeared to be pedestrian or showed a lack of creative effort.[37]

Students tended to respond to Grossman's teaching with either enthusiasm or antipathy.[38] Model's strongly expressed criticisms and views as a teacher sometimes also had an alienating effect on students whose work was quieter and less directed toward subjective experience. They often felt cast aside. Others, like

Eva Rubinstein, who were not sympathetic to Lisette's confrontational approach to photography or teaching, nevertheless conceded that her strength and depth of involvement gave them something substantial against which they could define themselves.

The impact of Model's teachings about the nature of images and the subjective impulses of image-making on the course of contemporary photography has been exceptional. Beyond her tremendous influence on the work of her best-known student, Diane Arbus, many other photographers whose images we see in the pages of fashion magazines and art periodicals, on the walls of commercial galleries and museums, and in exhibition catalogues and photography publications have been greatly affected by her tutelage. What is common to the work of many of these photographers is independence of vision. Bruce Cratsley's *Foot and Shadow, Metropolitan Museum (for Lisette)* (fig. 89) is a direct tribute to the impact that Model had on him as an image-maker and as a student, but the message goes beyond this to explore the limits of an intense, personal experience of darkness and perhaps despair. This probing beyond the familiar is what Model would have respected.

In fact, the work of her students is so diverse in character that one is struck with how little it appears to have in common. Yet her presence is often felt in the images of her students, sometimes as directly as in Marie-Claire Montanari's *Asian Mannequin in Bloomingdale's Window* (fig. 90). Sometimes it is in the passionate commitment to the human subject, as in the work of Eva Rubinstein (fig. 92), Peter Hujar, or Larry Fink (fig. 91) – images that capture basic human communion in arrangements of gesture and shape that cannot help but remind us of some of Model's photographs of people in groups. Fascinated by the subject of couples relating psychologically and physically, Model's photographs from the forties present them not romantically, but as entwined entities, body parts disconnected and limbs mysteriously emerging and disappearing like double-headed mythological beings. She did not show this work, and yet Arlene Collins's photograph of a young couple at the Princeton Cotillion (fig. 93), while not as steamily sexual as Model's couples, is full of the same atmosphere of strange physical merging and ambiguity. Similarly, Model's sense of theatre and of pushing the limits personally and formally is at the foundation of the best of Bruce Weber's portraits (fig. 94). Areas she tentatively, privately, and finally unsuccessfully explored in the fifties, such as photographing at night or recording the cultures of Venezuelan Indians, were the focus of students who passed through her hands much later, in the sixties and seventies – John Gossage in his exploration of Berlin at night, and Rosalind Solomon, a student whose work greatly impressed her, in her photographs of Central and South American Indians (fig. 95).

Model's students were generally accepting of her often ruthless criticism of their work, and found fault less with her manner than with her inability to relate to work that came from a completely different sensibility. "Expressive photography is an image of life," [39] she declared. "You never go out to make good photographs. That's death. You go out to make photographs of something." [40] When it came to the examination of the photographic medium in the cold light of a critical framework with which she was unfamiliar, Model was quick to anger. *On Photography,* Susan Sontag's book, offended her deeply. Rubinstein remembers her sitting at

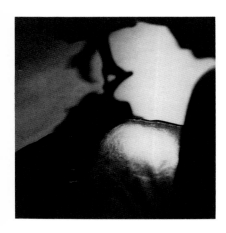

fig. 89
Bruce Cratsley
Foot and Shadow, Metropolitan Museum (for Lisette) **1976**
Gelatin silver
Collection Bruce Cratsley, New York

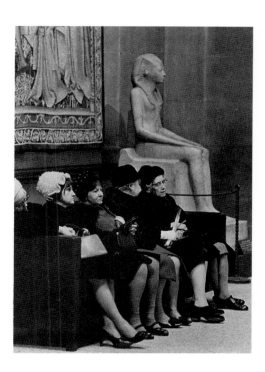

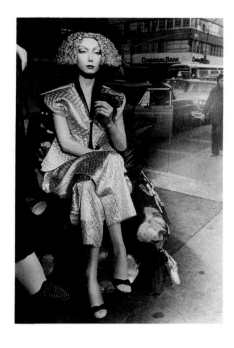

fig. 90
Marie-Claire Montanari
Asian Mannequin in Bloomingdale's Window 1980
Gelatin silver
Collection Marie-Claire Montanari, New York

fig. 91
Larry Fink, American (b. 1941)
Pat Sabatine's 8th Birthday Party 1977
Gelatin silver
Collection Larry Fink, Martin's Creek

fig. 92
Eva Rubinstein (b. 1933)
*Five Women and Statue,
Metropolitan Museum,
New York* 1969
Gelatin silver
Collection Eva Rubinstein, New York

fig. 93
Arlene Collins
*Young Couple No. 1, Princeton,
New Jersey, Cotillion* 1988
Gelatin silver
Collection Arlene Collins, Toronto
© Arlene Collins, 1988

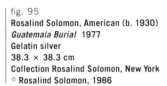

fig. 94
Bruce Weber, American
Isabella and Vigo, Malibu,
California 1987
Gelatin silver
Collection Bruce Weber, New York

fig. 95
Rosalind Solomon, American (b. 1930)
Guatemala Burial 1977
Gelatin silver
38.3 × 38.3 cm
Collection Rosalind Solomon, New York
© Rosalind Solomon, 1986

a party reading it page by page and finally slamming it closed with a "this woman knows everything and understands nothing".[41] If Model can be seen as lacking a certain objectivity in relation to her chosen medium, she was not alone. Sid Grossman told his students:

> If your photography is an act of living you will discover very wonderful and heart-warming concepts: very wonderful ideas about the direction of your life. You will discover great possibilities for enriching yourself.[42]

What Model saw in many of her students, and what troubled her most, was a lukewarmness – not so much a paralysis of will as of imagination. If she charged them with the task of rejecting presumptions, she saw her role as being that of a catalyst, and as bringing her students to a level of critical judgment where they would be able to openly evaluate one another's work in class. In doing this, she took an approach learned in Schönberg's composition seminar, where he encouraged his pupils to "discuss and criticize each other's scores before coming to him – to cultivate the same uncompromising honesty of judgment he used with himself and towards them."[43] Model brought a similar fresh perception to her students, not only of the world around her but also of the human capacity to create and grow. It was this quality as much as her knowledge and appreciation of the photographic medium that made her an exceptional teacher. Lisa Clifford recreates the lively, confrontational environment of a Model class:

> We see we have been invited to banter our philosophies and clash our personal visions. Through the chaos, an accented voice asks, "Don't you all see what these pictures have in common?" Everyone is puzzled, they reach again for their perceptions, and the soft voice speaks to the photographer, "Darling, are you steady?" Then, as if it cannot be seen any other way: "These pictures are all mediocre! And that is because they are of mediocre things. We cannot see talent in lukewarm subjects. Subject matter is of vast importance I cannot stress this enough. You must have a great feeling for these things, you must find a subject matter that you have much interest in and passion for (interest and passion do not cost one cent), then, with work, you can develop your talent. It is easy to develop a love for what you see. Does anyone disagree?"[44]

At another time, she questioned, "How, in this multitude of objects, subjects, space, light, and movement is the photographer to select and organize? By sensing, feeling, understanding consciously and unconsciously the significance of life around us and in connection with us ... [using] every tool in photography to translate this living image [into] a photographic image".[45]

Some of the contradictions that plague our comprehension of all representational systems and the photographic medium in particular remained unresolved also for Model. An Expressionist, she encouraged her students to use the camera to express their emotions. She urged students to understand the symbolic nature of art and the limits of its fictions: the world and its objects should always be differentiated from their depiction. The world was a stage and people the raw data for the expression of a generalised mood or the weaving of a tale; the image produced was not necessarily one's feelings about the subject. Still, she would always point out that images are "the only ... measure [by which] to understand disappeared cultures and generations",[46] and encourage students "always to express the actual state of human understanding of the world and life".[47]

Her strengths as a teacher combined an intuitive understanding of individuals and of the degree to which their work was a true reflection of their concerns, with an ability to judge the structure and effectiveness of an image. The key to her approach to her students was her conviction that talent is God-given, but everybody can learn to see:

> All depends on how much interest a person has in a specific medium, and how much effort he is willing to expend in achieving whatever goal in life and in [making] contact with himself. [When he] understands himself for what he really is, then he can use the medium.[48]

This was not all that different from Arnold Schönberg's demystification of the concept, who, when asked by a man if he had talent, stressed that the amount of time and love lavished upon the chosen discipline is the measure of the existence or absence of talent.[49]

In short, the basic principles that governed Model's teaching were that a student should aspire to freshness and honesty of vision, and to independence and originality, and that aesthetics and expression must not be dictated by technique. She shared contemporary artist Jackson Pollock's view that "Technique is just a means of arriving at a statement".[50]

THE TEACHING NOTEBOOKS

Twenty-nine extant teaching notebooks contain Model's plans for the courses she was teaching at the New School. Undated, but seeming to run consecutively from the fifties through to 1982, their form and content suggest that they were an *aide-mémoire* rather than prepared scripts. Not systematically ordered, but random jottings, the contents range from technical notes on the optics of the eye and the physical properties of light to lists of key figures and works in the history of art and photography. Interspersed with lively doodles and personal notations, these

nevertheless provide the reader with a glimpse of the concerns and thoughts of an influential educator about photographic imagery. The individual notebooks seem repetitious and random initially, but a reading of them as a group reveals the structure and basic principles by which she taught. Her note-taking on one subject, at least, proved to be incremental: observations on the relationship between subject matter, composition, and the limitations of the rectangle and square of the viewfinder, which appear to be cryptic in a given notebook, are often clarified in another.

Comments and statements do appear, albeit rarely, that relate directly to her own work. Most significant are those on her selection of subject and her manipulation of the negative. These demonstrate the degree to which her work was really about interpretive picture-making and Expressionism, and the extent to which it departed from the American documentary tradition. To quote one entry:

> – not the document the physical appearance or social statement – it goes far beyond – it goes beyond into another plane like words can become poetry – but whatever it is – whatever the subject it always is the photographer in relation to his subject and the subject means what? to the photographer – it is not possible to say – How I am to discover my subject matter – what it takes is interest, passion and endless patien[ce] – What's the hurry? You have a lifetime.[51]

Her selection of subject matter was an intuitive and emotional response to people and the world around her. She expressed it as working by attraction – "like by a magnet".[52] She chose her human types because of their facial character: "I feel that these are people of great strength and vitality – whose life experience is not held back but comes strongly to the surface of their bodies and expression."[53] Other photographers, she noted, are more contemplative about their choice of subject matter: "other photographers think about it, plan, and then start to work".[54] Here she cited Arbus, Cartier-Bresson, Palfi, Jacob Riis, Lange, and Walker Evans.[55]

Children's art is the instructional example that she turned to repeatedly to make the point that art is an exploration and discovery of the world, and not an application of things already known. She shared this view with Evsa, who would often teach from a rocking chair surrounded by his paintings. Gently encouraging, he would urge his students to recover their sense of childhood wonder and freshness through a return to a primal experience of the world. This concept of a vision formed out of an "innocent" perception is picked up in Model's teaching notebooks where she writes that, the more elemental and basic, the more advanced the art: "Often we find this quality in children's [art], and then again, but very rarely, the same innocence in real artists."[56]

In her own work, Model saw the initial image as a departure point. She reinforced this in her teaching when she discussed the use of the enlarger as another way of seeing the image. Here it could be viewed as an entity, in detail, and transformed by cropping.[57] She referred to looking through the enlarger as an act of contemplation, in which the photographer "can change not only what he missed but what the taking of the picture cannot produce, for instance, action".[58] Both the flopping of the negative[59] and the tilting of the image in the enlarger were seen by

fig. 96
Lisette Model
Sammy's **New York**
between 1940 and 1944
Full frame enlargement
by Justin Wonnacott from
original negative, 1989

her as introducing other possibilities to the photograph. She encouraged students to place their negatives in the enlarger and discover the ways in which the image could be altered according to what they wished to express. She used to say that the enlarger was her best teacher.[60] Her singer at Sammy's bar, which she printed both tilted and untilted, is an illustration of this point (pl. 111, fig. 96).

In the more psychological realm, she reveals in the notebooks the areas in which she herself had to overcome anxiety and fear – "seeing is the result of working not talking" – and alludes to the need to train oneself "against fear – against routine".[61]

Model taught very little technical material, but recorded copious notes and explanations on the physical properties of light, film, emulsion, and other photographic elements. She traced in her notebooks the transformation of the external visual stimulus into a mental image. "The eye," she observed, "is an organ and the camera is a mechanism. The image is mechanical until the nerve endings lead it to the brain and make it a mental image"[62] – a description of the complex neural-optical system that might be found lacking by a neuro-physiologist, but that offered a simple and effective way to locate for a student of photography the nexus of subject matter, the centre of sensory intelligence, and the ways in which they might connect should the student remain fully alive to the world.

In the same way that she pictured the nervous system as the central linking feature that fires mental and finally photographic images into being, she viewed the photographer's truth to self and "connectedness to life"[63] as the pivotal centre for the making of images that are affecting and powerful.

Model constantly observed in her notebooks that rules and regulations are contradictory to art and that the only dignified and productive response to them is to rebel. "Your task," she wrote, "is to do away with presumptions."[64]

Probably the most illuminating of these writings, ones which reveal her unorthodox ideas and also shed light on the process behind the making of her own works, are those that deal with the concept of composition and its dynamics. Composition was something intuitive which came with the subject matter and by looking through the lens or the enlarger. Model's ideas about photography were very much in synchrony with Abbott's. When Model wrote, "We do not fabricate composition – composition is what you feel about a subject – understanding and attitude brings [about] the organization",[65] and, "you do it this or that way not for better effect but because it says more",[66] she was essentially paraphrasing Abbott's "Composition . . . is a method of creating meaning."[67]

Model championed the cause of photography, but never saw it as an isolated phenomenon, preferring to address it within the larger, more meaningful scope of all image-making. In spite of photography's specific characteristics, it had, in her view, important roots in a long history. If they were discussing photographic portraits, she made her students aware, for example, of the evolution of the portrait from prehistoric art onwards. Images had always had both a symbolic life and an historical relevance within the cultures that produced them, and photography, she observed, as an image-making process made a specific contribution to our modern age. What she referred to as the "magic of the image" or the "phenomenon of the

fig. 97
Jon Pearce
Lisette Model lecturing at the
Comfort Gallery, Haverford College
4 March 1983
Collection Jon Pearce, New York

image"[68] was its collective power. The photograph possessed a "life of its own" and an ability to "project certain thoughts unexpectedly on the viewer". We "invest properties in images – life and death – fecundity",[69] and these images, in turn, become part of the memory of a given culture.

If the freshness and brilliance of Model's perceptions when expressed spontaneously as she viewed her students' photographs and interacted with them is missing from the teaching notebooks, they are important for what they reveal of a pedagogical vision that was humane and essentially based on common sense. From the impressionistic note-taking, interspersed with technical data, that comprises these volumes, and from the numerous first-hand accounts of students, both institutional and private, a picture emerges of a philosophy of teaching that was both personally and empirically grounded. She built it up somewhat randomly on a dialectic of seemingly opposite ideas that would merge into one truth. For example, on the question of aesthetics versus technique: "[It is] more important to study aesthetics than mechanics",[70] and "technique can disconnect [the] photographer from his medium,"[71] she wrote. Yet she was opposed to the idea that with freedom came sloppiness of craft, and proposed that one "master technique in order to be free of it".[72] In other words, she was renowned for her provocative and confrontational manner as a teacher, but in fact took a very balanced approach.

The existence of the notebooks belies to a degree her insistence that she taught without prior preparation, although there is no doubt that she relied on the spontaneous interaction she enjoyed with her classes for much of the direction of her teaching. It may come as a surprise to many of her students that she equipped herself through the notebooks with technical information and other references that might not have come to her readily, or that she seldom drew upon in class, but it is an indication of how earnestly she took her professional responsibilities.

THE LEGEND

Lisette Model's commitment to teaching – both private and institutional – was serious and inspired. By the last decade of her life, already into her third decade of teaching, her reputation as a lively and outstanding instructor of photography had become legendary.

The last public lecture she gave was on 4 March 1983, three weeks before she died. Invited by William Earle Williams, the director, to the Comfort Gallery at Haverford College, she talked to students and public surrounded by an exhibition which, in addition to her own, included the photographs of Diane Arbus and Weegee (fig. 97). Generously sharing information about her work, her students, and her years of teaching, she was in full swing, and although one detected a slight fatigue in her voice, in no way did she sound ready to stop. Her manner was as it had always been, strongly opinionated, often self-deprecating, sometimes vitriolic, and marked by an unfailingly sharp sense of humour.

The question was put to her: "Have you ever regretted teaching?" A slight pause, and then the reply:

128

Never. There is too much in it. One learns a great deal, and one isn't self-centred, and one sees the work of others, which is very important at certain times – that you don't only see your work but what happens in the field. And also, the kinds of relationships I've had with students who became my best friends. There is nothing I can regret. On the contrary, ... I love it.[73]

We are surrounded by thousands of images everywhere.

Most of these are invisible to us because we are blinded by routine.

By pointing the lens at something I am asking a question,

and the photograph sometimes is the answer. [1]

fig. 98
Lisette Model
Times Square New York c. 1954
Gelatin silver
33.2 × 21.2 cm
J. Paul Getty Museum,
Malibu (84.XM.153.3)

What had Lisette Model learned by 1950 after a decade of taking some three thousand photographs in America? The questions she was formulating during those years centred around a simple query: Who are we – all of us? And how do we live – in what kind of physical and psychological environment?, she seemed to be asking as she turned her lens to store windows and reflections. Her responses – records of her experience as a woman, as a European immigrant, and as a naturalized American – came in the form of a collection of rapidly produced images: Lower East Side personalities, pedestrians on Fifth Avenue, celebrity portraits in New York and San Francisco, and the *Running Legs* series.

Yet often the questions, like the answers, were not always immediately apparent even to Lisette herself, working as she did by instinct. Some were scarcely formulated when she moved on to the next subject of exploration. Others, like those embodied in the reflections and store window photographs, simply provoked more questions. She became an interrogating mobile landmark in New York City, described as "the one you would always see walking up and down, photographing Fifth Avenue".[2]

The period 1950 to 1958 seems to have been a difficult one for Model because of frustration from aborted projects, personal confusion, and depression. For a number of reasons, process took over from the finished product, and few of her window images made after 1950 were ever printed (fig. 99). Friends noticed an anger and bitterness in her that surfaced repeatedly.[3] Her book project, entitled "New York, Its People and Its Environment" in her Guggenheim application of 1949, which would have provided her with an important milestone for self-evaluation in her photographic career, had not been realized. Neither was her new project of a book of jazz photographs. No longer celebrated as an exotic refugee photographer, she learned of the transitory nature of fame.

Another factor that put a dampener on her photographic activity was the climate of intimidation created by Senator Joseph McCarthy's witch-hunt for Communists and suspected Communists

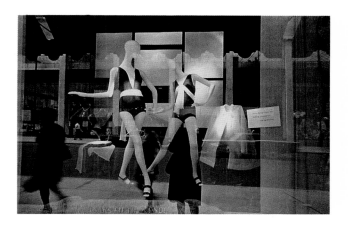

fig. 99
Lisette Model
Window New York c. 1951
Full frame enlargement
by Justin Wonnacott from
original negative, 1989

under the legal guise of the House Un-American Activities Committee. This could conceivably have been what prompted her to turn away from more contentious human subject matter to sculptural forms.

"It was terrible. You didn't know *what* to photograph"[4] was Model's comment on the inhibiting effect of McCarthy's campaign. In September of 1953, while in Europe, Model was the subject of a surreptitious investigation. Her neighbour, a man named Downie, and the local Armenian grocer were both questioned about her activities by unidentified individuals presumably in search of evidence of leftist connections.[5] The nasty and powerful wave of anti-intellectual terrorism[6] that encouraged individuals to report on activities of friends and foes alike seemed to have reinforced Lisette's mood of general depression.[7]

She responded by experimentation, which for her was also the putting into practice of something she encouraged in her students. Hints of this evolution had already emerged in work done in 1949 in San Francisco, for example in her combining of two frames of a negative to make one image, or in her maximizing of the grain of an image through a grossly enlarged negative. In the fifties, she virtually stopped using her Rolleiflex and adopted the 35 mm Leica almost exclusively. The photographs that resulted from Model's trips to Europe in 1953

The Photo League, itself on the list of suspect organizations, disbanded. Agencies granting support to artists, and any persons or institutions that expressed progressive or liberal views were also targeted as suspect.[6]

During this period of uncertainty and personal introspection, she became friendly with a couple who were involved with family counselling and personal therapy, Willard and Margo Beecher.[7]

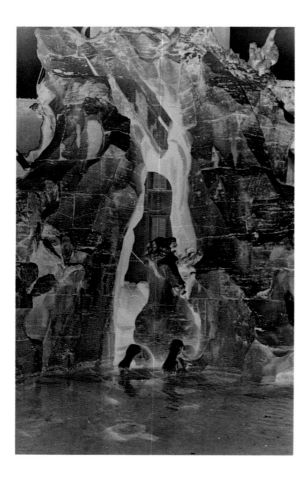

A print which shows the black and white tonalities reversed to give a negative image can be made by placing a photograph in contact with photographic paper and exposing it for an extended amount of time; or by using a positive internegative, that is, a positive transparency made from the original negative, to produce a final negative print.[8]

and Venezuela in 1954 show her following a new direction, photographing new subject matter, and attempting, less successfully, to use new techniques.

However, the few prints she made from this body of work also indicate that she did not fully explore it. Her attempts to challenge her own approach and break a pattern that she might have perceived as developing into predictability never evolved beyond experiments. There were roughly three primary areas in which she played with new approaches: subject matter, light, and composition. Whereas the phenomenon of light in her earlier work had been largely descriptive or lyrical, it became a more pronounced feature in several of her images from Italy, almost a subject in itself. Intrigued also by the absence of light, she was drawn to photograph under low lighting conditions: at twilight in Caracas, Venezuela, and in Manhattan at night (fig. 98). She discovered interesting qualities in the negative print, and produced a number of images using positive internegatives[8] from her photographs taken in Italy, some of which were published under the title *Pagan Rome*, the fountain at Piazza Navona being one such example (fig. 100). But these never seemed to evolve beyond the point of being an interesting exercise in the reversal of light values.

In subject matter, instead of focussing, as before, almost exclusively on human subjects, she expanded her repertoire to include sculptures, fountains, and buildings. In composition, she substituted a dumb angle viewpoint (an angle selected for its naive or non-pictorial character) for the complex, highly theatrical composition of earlier photographs. She printed a number of these experimental images, in varying sizes but mainly in 9 × 11 inch (22.8 × 27.9 cm) and up to 16 × 20 inch (40.4 × 50.6 cm) formats, from a relatively much larger number of negatives. Within this group there are images which, in subject choice, compositional treatment, and printing, differ so radically from her earlier work as to be virtually unidentifiable as being from her hand.

Unfortunately, she never seemed to have had the time or the motivation to take these explorations further. In interviews she alluded to the fact that the demands of earning a living for two people during this time were onerous. Experimentation is nourished by a sense of play. It is possible that this phase of her career failed to bring fully realized new work into existence because play had been such an insignificant part of her life: "Someone once said to me, Lisette, you have an undeveloped sense of play. It is true that in childhood there was not much of it."[9]

These experiments were unsuccessful, not simply because they broke so radically with the aesthetic of her earlier images, but because they were never taken to a point of resolution.

HARD TIMES

While middle-America was swept up in post-war prosperity, indulging in a prefabricated heaven of suburban ranch houses supplied with every convenience, affordable or not, in station wagons and bomb shelters, the Models were struggling to make ends meet. Their aspirations had always been different, their belief in freedom and individualism tough and clear. They lived frugally, with only the necessary possessions to make a life of creativity and reflection possible. Lisette's clothes were basic black with appliqués of Evsa's design in constructivist shapes of primary-colour felt. But in 1950 even this spartan way of life was threatened, so reduced were their employment opportunities.

The pace of the early and mid-forties had been frenetic for the Models. By 1948, it had begun to slow. Evsa's exhibition at the Janis Gallery that year (fig. 101) had not been a financial success, leaving him embittered and reluctant to show his work in commercial galleries again. He was also not convinced about the worth of public institutions, and would remark, "This looks as if it should be hanging in the Museum of Modern Art!" if he wished to pass a negative judgment on his students' work. The number of assignments that Lisette either received from publications or that were approved after submission was diminishing.

In spite of all of this, the book project was still very much on her mind. In 1950 she wrote to Minor White:

> Everything is very interesting but there is no food. I have gotten one very wonderful thing, $100 worth of material at Willoby's (store). Steichen gave it to me instead of the Guggenheim. And when we will have a solution [for] what we are going to live on I start my book.[10]

Financial difficulties were exacerbated by a debilitating health problem that kept her inactive for most of the winter of 1950: "I was sick with a sacroiliac condition for months [and] could not move."[11] At this period she had one private student, and otherwise devoted time to reading up on technical issues in photography.[12]

fig. 101
Lisette Model at Evsa Model Exhibition, Janis Gallery 1948

Out and about again in the spring of 1950, Lisette showed her photographs to agencies and magazines in the hope of soliciting assignments. Acting upon a suggestion by Ansel Adams, she called on the photographs agency Magnum with her work and received a disappointing response: "They gave my photos one look and walked out. . . . I have since tried every magazine."[13]

That summer brought a psychological if not a financial break for them – an opportunity to spend some time away from New York at a country retreat – and her mood lightened. Dorothy Wheelock Edson and her husband Wesley gave the Models the use of their cottage at Oyster Bay Cove for a month. Here Lisette experimented in a modest way with her choice of imagery and her way of seeing. She photographed the natural landscape, specifically trees. She also made studies of objects from different angles and under different lighting conditions and sometimes using different lenses. Before leaving, Model had shown Minor White's photographs, which he had sent her with the intention of gaining some exposure for and response to his work in New York, to John Morris, Steichen, and Brodovitch. She wrote Minor:

> I am still on a vacation at a beautiful place in Long Island where an Editor of *Harper's* has given us her house for 4 weeks – lucky for once – Before I left I showed your photos to Brodovitch; he simply *adored* them! – found them very interesting and wants to see more of your work; it was quite a success. Then I showed them to Steichen: he said I should tell you he thinks them very interesting – And he

meant it. When I come back they go to *Ladies' Home Journal*, Photo League, etc. What happens with the next series? I think you should send it to me – I had one assignment for *Harper's* and have started my own work in the country. If the bombs don't come down soon and I have some jobs I shall consider myself very lucky. How about you? I hope your depression is gone, I hope you come soon to N.Y. to meet all the people who have seen your fotos. How is the school? I would love to hear from you.[14]

Called upon to participate in the Museum of Modern Art symposium, "What Is Modern Photography", held on 20 October 1950, she there made her often repeated statement about the camera as an "instrument of detection". This was a period in which some of the issues examined and discussed by Photo League members were appearing before wider national audiences through symposia and conferences and becoming the subject of published debate.[15] A year after the symposium, in October 1951, a conference took place at Aspen, Colorado. Here Frederick Sommer, Dorothea Lange, Minor White, Nancy and Beaumont Newhall, Berenice Abbott, Ansel Adams, and other luminaries of the photography world discussed many topics and, specifically, grappled for a definition of documentary photography. Lange defined it as "closely related to time and change". The word "communication" was often employed with a prescriptive intent. Implicit in communication was a desire to make pictures "meaningful". Also, the validity of categories such as "experimental" and "abstract" in photography was questioned by White, as was the practice of evaluating photographs that might be so described against the perceived strengths of "straight photography".[16]

The launching of *Aperture*, a magazine of serious critical writing on the subject of photography, occurred in April 1952, with the issue in which Minor White published his article on the minicam, "Exploratory Camera: A Rationale for the Miniature Camera".[17] According to Minor, much of his thinking had been stimulated by discussions with Model in her capacity as visiting lecturer in San Francisco in 1949. Lisette, receiving an advance account of the contents of the article, responded to Minor's statement of indebtedness with characteristic contrariness:

Concerning your article, I remember I could not recogniz[e] anything I had said – But why can't you send it to me? I would be very interested to read it anyway – I agree with you. Whenever one says something and somebody else interprets it in his own way, one can no more identify it with oneself. However my last experience with the *Times* was such that I am a burnt child. I don't put my name under anything without reading it. I am organizing 2 new courses, am painting, but not photographing on my book because of no funds and no publisher.[18]

Intense as the climate for the critical evaluation of photography may have been, Lisette appeared by mid-1950 to have made few gains in placing her photographs in magazines. Neither had she received any assignments of any impact. In November of that year, *Flair* rejected her work. While she photographed personalities during this period who should have been considered solid journalistic subjects, such as authors Georges Simenon and Dylan Thomas (pl. 155),[19] the portraits do not appear to have made it into print. In the field of magazine photojournalism, 35 mm work was generally becoming more accepted and editors were increasingly adopting the role of initiators of assignments. Henrietta Brackman, a photographers' agent, found that the climate of the fifties was very different from that of the forties, allowing the photographer less freedom to create independent assignments. It had now become routine for magazines to assign specific subjects and to balk at any deviation. Under these circumstances, it was more difficult to find work for Model, both because she would rather have worked on speculation, and because she did not always follow instructions for assignments as the editors might have wished.

In January of 1951, in addition to teaching at the New School, which involved at least one and most often two workshops, Lisette was also teaching privately out of her home and assisting in Evsa's classes, which he continued throughout the fifties.

Charles Pratt, a photographer whose landscape photographs had illustrated two of Rachel Carson's books on the natural environment,[20] was one of the first to study with her privately, and a student in the first class she taught at the New School.[21]

From 1951 to 1952, her work was also featured in two exhibitions at the Museum of Modern Art: *Twelve Photographers*, and one offering photographs for sale as Christmas gifts. Accompanying Aldous Huxley's "A Note on Blindness" in the July 1951 issue of *Harper's Bazaar* was one photograph from the *Lighthouse, Blind Workshop* series, taken some seven years earlier.

Looking for a way of earning money, Lisette even considered becoming a researcher for *Ladies' Home Journal*,[22] or working as a journalist for the *New York Post*. While, as she put it, she and Evsa were "by no means dead", they found that, by having to continually worry about how they would be able to cover the next month's rent, they had fallen into a situation where "we lose time and energy instead of producing".[23]

THE LIMELIGHT

On the non-commercial side of photography, debate about the nature of the medium was intensifying, and alternate venues were being established for the viewing of photography, albeit modest in scale.

Lisette was one of the star performers at the Limelight Gallery, a coffee house-cum-gallery that opened in May of 1954. Located near Sheridan Square at 91 Seventh Avenue South, once the site of a nightclub, it was owned by Helen Gee. It was enthusiastically described in the press as "Bohemia neatly done up in white brick, with black and white lanterns, small tables, and loads of room" (fig. 102). Behind the coffee shop was an "attractive art gallery where the work of a serious photographer or other artist is displayed".[24] Limelight fulfilled two important needs – it provided an informal venue where photographers could socialize, and it was a place where they could exhibit their work in an environment that isolated photographs as visual statements worthy of solemn contemplation. The style in

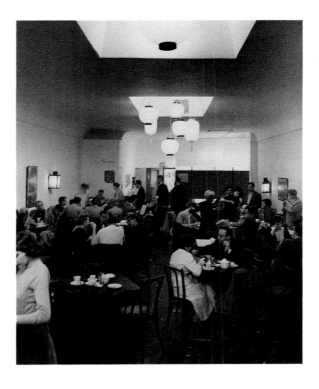

fig. 102
Arthur Lavine
Limelight Gallery New York 1954
Collection Arthur Lavine, New York

which the photographs were presented was recalled by Peter C. Bunnell:

> The photographs, often in a bleed mounted borderless style, were hung sympathetically and with clarity by Helen herself. There were a few exceptions when the photographer was allowed to hang his own work or even, as in the case with Bert Stern, he was allowed to paint the walls gray. But the white walls, the crisp lighting, and the unaffected installations were the hallmark of Limelight.[25]

In December of the opening year, Gee mounted the exhibition *Great Photographers*, designed to promote the purchase of photographs as Christmas gifts.[26] Along with work by Abbott, Adams, Édouard Boubat, Bill Brandt, Brassaï, Manuel Alvarez-Bravo, Robert Frank, and others, Model's *Woman with Veil* (pl. 10) appeared on the bright white wall in the flush-mounted style alluded to above.[27]

Pratt was a great supporter of Model, arranging to help her out with printing supplies when her funds were low, and bequeathing her money when he died.[21]

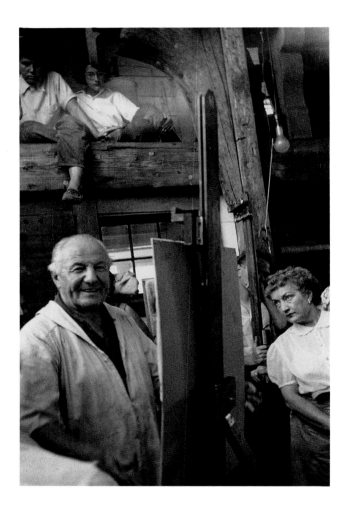

fig. 103
Lisette Model
Hans Hofmann Provincetown 1952
Full frame enlargement
by Justin Wonnacott from
original negative, 1989

Gee recalls Model, along with Frank and Deschin, as having been among the greatest supporters of Limelight, while Bunnell remembers Lisette and Minor holding court there:

It seems to me that I was first taken to Limelight in 1957 by Minor White, and I suspect it was to see the *Lyrical and Accurate* exhibition he had originally organized for Eastman House. I can recall the place and the people. One of those whom we met was Lisette Model, who, every time I see her now, causes me to remember that first encounter. She was all intensity and challenge and she had quite a contrasting personality to Minor's. Limelight was a meeting place and a socializing force for all photographers regardless of orientation.[28]

JAZZ PERFORMERS

A project to produce a book of her photographs of jazz musicians, accompanied by the poems of Langston Hughes and a critical text by Rudi Blesch, dominated Lisette's interest and energy outside of teaching during the period 1952 to 1956. It evolved out of work she had done through the forties in nightclubs and on jazz beats, producing photographs eloquently praised by W. Eugene Smith (although damned by John Adam Knight), as well as portraits of Harry James, Eddie Condon, Bunk Johnson, and Gene Krupa.

Resigned to the fact that her New York project was not going to find support, for the moment anyway, she considered a new book. She enjoyed listening to the music, and became excited about the prospect of photographing more of both its performers, and the festivals which were organized during this period. The Models' personal finances were in such a serious state of depletion, however, that she could not begin to entertain the idea of publication without assistance.

In the late forties, Model had struck up a friendship with photographers' agent Henrietta Brackman, who had taken a few painting classes with Evsa. In the early fifties, Brackman represented Dan Weiner, Fons Ianelli, and Garry Winogrand. When, in August of 1952,[29] the Models

left New York for a two-week vacation in Province-town, continuing their tradition of the forties, Brackman accompanied them.

It was there that, in addition to visiting the Hans Hofmann School (the activities of which she again documented extensively, as well as Hofmann himself [fig. 103]), Model and Brackman conceived the idea of the book on jazz. From Provincetown, Brackman went to Music Inn in Lenox, Massa-chusetts, where this plan appeared to her to be even more feasible. This was a period when several influential books of photographs appeared, includ-ing Cartier-Bresson's *The Decisive Moment* (1952), a book Model liked very much. While collabora-tions between photographers and writers or poets were certainly not new, they were experiencing a revival. Roy DeCarava's and Langston Hughes's book *The Sweet Fly Paper of Life* was one such exam-ple. Not only was Model attracted to the ambience around the jazz music world, but she was also impressed by the writings of Hughes, a poet and authority on jazz music (in the early 1960s she regularly clipped his newspaper columns). The project would have brought together her two great interests: music and photography. According to Brackman, Hughes and Blesch were interested, and all that remained was to find publishers or backers for the book.

In the following five to six years, Lisette persisted with the idea, producing close to eight hundred negatives of jazz musicians and their audiences at Music Inn, the Newport Jazz Festival, the New York Jazz Festivals at Downing Stadium on Randall's Island (1956–1961 and 1966–1970), and at Central Plaza. The summer of 1954 was the opening year at Newport, and Model was there to photograph musicians Dizzy Gillespie and George Lewis; the Modern Jazz Quartet; and personalities Elaine Guthrie and Lewis Lorillard, Richard Gilder, and John Hammond; as well as audiences and parties.[30]

Model photographed jazz concerts and per-formers repetitiously, as though mesmerized. Taken from a viewpoint that was almost unvarying, she produced a large number of negatives. Finally, her prints are reduced to simple silhouettes edged with a nervous outline of light and strongly cropped. Intense and moody, the images portray musicians oblivious to the visible world, responding to the rhythms of internal experience (pls. 168–71, 173, 175–77). Photographs of the audience in rainy weather at Newport intensify the feeling (pl. 178).

She was not alone in her attraction to jazz. Many other photographers were equally moved by this subject at the time, including W. Eugene Smith, Aaron Siskind, Weegee, and James Van Der Zee. Some musicians, such as Dizzy Gillespie, even took up the camera themselves.

In order to gain access to places, she obtained the help of her old friend at *Harper's Bazaar* Dorothy Wheelock, in the form of a "To Whom It May Con-cern" letter: "Lisette Model, the bearer of this letter, is working on a book of jazz photographs. *Harper's Bazaar* will publish some of the photo-graphs from time to time. I would deeply appreciate any assistance you can give her in expediting matters in your club."[31]

To find a source for financing the project, she turned to Carmel Snow, who sent her to see Helena Rubinstein. In spite of initial encouragement, she received nothing but a long silence from Rubin-stein. Finally, anxious to know where the project stood, Model spoke to her son Roy Titus Horace, who informed her of a letter from Snow to Rubin-stein, discouraging any support of the project because of Model's political beliefs.[32]

As well, Brackman's business was thriving, and she found herself too preoccupied with the photographers she represented to pursue funding for the book single-mindedly. Nonetheless, al-though they had never had a formal agreement, Brackman periodically tried to place Model's work or find her magazine assignments in which she had expressed an interest, such as further work for the *Ladies' Home Journal* series "How America Lives". Lisette depended on Henrietta to write letters and make contacts for her. When Brackman left New York for Haiti in 1955 for a two-year period to try her hand at writing, Model kept on with the book despite the lack of funding. The failure to assemble

"In the summer of 1956, despite driving summer rain, jazz proved once again to be a powerful draw. Record crowds totalling over 25,000, almost all white, gathered at Freebody Park to hear performances by Count Basie, Charles Mingus, Louis Armstrong, Sarah Vaughan, Dave Brubeck, Toshiko Akiyoshi, Ella Fitzgerald, the Modern Jazz Quartet, Teddy Wilson, Bud Shank, and Duke Ellington. . . . Near the conclusion of the festival, when the tenor saxophonist Paul Gonsalves of the Duke Ellington Orchestra launched into a marathon solo of twenty-seven choruses, a blond woman leaped up in a private box and began to gyrate to the music, and the audience of seven thousand was soon moving almost as one."
— Arnold Rampersad.[30]

The gist of the letter which Carmel Snow had sent to Rubinstein, according to Model, was advice against the funding of the project because of Model's left-wing views.[32]

fig. 104
Lisette Model
Billie Holiday New York 1959
Gelatin silver
20.5 × 34 cm

During the fifties she retreated from photographing people as a subject. She photographed a few on the street in Europe, but these images are more picturesque and less confrontational.[35]

money for the project, however, brought tension to their friendship for a while.[33]

The last jazz photographs she took were of Billie Holiday. Although it is impossible to precisely date all her negatives of jazz performers and concerts, their making appears to have been largely confined to the fifties. The image that concludes this body of work is a 1959 death portrait of Holiday. Model had photographed her on several occasions, attracted no doubt by the intense, reckless, and finally tragic nature of her life. These earlier photographs, however, seem tepid, lacking in the passion that must have inspired the photographer to first be there. Approaching her subject again, this time in her coffin, Model set herself in opposition to the twentieth century photojournalistic image of death as violent, terrifying, and anonymous. Rather, her photograph (fig. 104) seems to spring from a combination of tenderness and an almost childlike sense of curiosity.

EUROPE

Because their financial resources were so depleted, Lisette decided to investigate the sale of an Italian property of which she was still part-owner. She left New York on 15 June 1953, seemingly in the com-

pany of one of her students.[34] This trip, which virtually used up all their savings, took her away from New York for five months altogether: one and a half months spent in France, and the rest in Italy, including two trips of several weeks each to Rome.

Arriving in Paris, she remained there until late June and photographed flea markets, Montmartre, Parc-Royal, and the Luxembourg Gardens. In a mood of nostalgia rather than creative inspiration, she photographed the building on Lalande where she and Evsa had last lived before leaving for the United States.

From Paris, she went south close to the Spanish border to a small spa village, Vernet-les-Bains. There she photographed the carved figures that adorn the capitals of the columns in the interior of a cathedral, a new subject for Model. She returned also to her old theme of photographing people out on the sidewalks (fig. 105).[35]

Prades, a village not far from Vernet-les-Bains, was another of her stops. In addition to photographing people, she documented the interior of the de Monfreid home in Prades, its owner, and its contents, including a painting and a sculpture by Gauguin. In Avignon, she photographed the sculpture of Racine, and, again, people in the town square. Her images from Nice followed the same theme of people in public places, particularly in parks. There is nothing to indicate that she retraced her steps along the Promenade des Anglais as Alexey Brodovitch had suggested she might do as a possible assignment for *Harper's Bazaar*.

At the end of July she departed for Italy, travelling via Switzerland and arriving in Milan on 30 August 1953. Little of her time there appears to have been devoted to photography, as she was involved in negotiating the sale of shared family properties.[36] Although she did take photographs in Ponza, a small island off Naples where she stayed for approximately two weeks at the end of August, and in Trento in mid-October (fig. 106), it was really in Rome that she gave her serious attention to photographing.

Both trips to Rome, where she stayed each time at the Hotel Senato, together yielded a total of

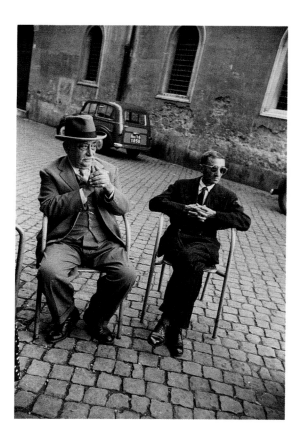

fig. 105
Lisette Model
Rome 1953
Proof print

fig. 106
Lisette Model
House Façade Trento 1953
Proof print

some one thousand 35 mm negatives. She continued to explore the now familiar theme of people in public places, but her attraction to monumental architecture and sculpture clearly dominated. This body of photographs has a deceptive simplicity. It seems at first to be no more than a record of the sights of the city, popular with photographers since the invention of the medium: the Colosseum, the Forum, the Baths of Caracalla, St. Peter's, the Pantheon, the Piazza d'Espagna, the Campidoglio, the Villa d'Este, Villa Borghese, and Villa Adrianne, the Trevi fountain, and the Palatino, Romano, and Capitoline museums. On close examination, these images of buildings, sculptures, and mosaics from Roman pagan mythology and the Renaissance become her vehicle for the expression of strong internal feelings, the antithesis, in fact, of the ex-

troverted imagery of the *Promenade des Anglais* and the *Lower East Side* series. For the most part, they describe a sense of the transience of all things (figs. 107, 109). Here, she concentrates more on the formal properties of the subjects and produces images that are more contained by their environments (fig. 108). Death, fecundity, and power emerge as principle concerns.

As well, by selecting the great monuments and icons from the past as subjects, Model passes comment on the power and pervasiveness of imagery itself in all cultures, a subject she frequently alluded to in her teaching notebooks.[37] Certainly the sculptural forms and the lyrical quality of light illuminating them attracted her, but she was most interested in the manner in which we have chosen, throughout history, to record our image of ourselves, or

fig. 107
Lisette Model
Rome **1953**
Full frame enlargement
by Justin Wonnacott from
original negative, 1989

fig. 108
Lisette Model
Rome **1953**
Full frame enlargement
by Justin Wonnacott from
original negative, 1989

fig. 109
Lisette Model
Rome **1953**
Proof print

fig. 110
Lisette Model
Caracas 1954
Gelatin silver
23.4 × 34.5 cm

"the image of our image".[38] This preoccupation with classical symbols of death, maternity, and heroism was part of her exploration of the theme of glamour.

Reflecting on this period of her work, Model recalled how she discovered the monuments, statues in the streets, and objects in the museums, and declared that she "forgot about the people of Rome forever".[39]

VENEZUELA

If the answers that Model sought through her photographs were not always as revealing for her as they might have been, the questions at least took on clarity and shape in the mid-fifties. The experience of Venezuela, a culture in which rapid technological developments were threatening the survival of the indigenous people, produced images of monstrous-looking oil derricks, box-like highrises, pumps, and pipelines looming over or carving into a landscape still part jungle. This encounter with cultural difference had the effect of unsettling her rather than inspiring her to make great photographs, but it did provide her with the distance she required to place the work she had done up until then into perspective. It permitted her to consolidate her free-floating thoughts about her own culture, and to see links between diverse bodies of imagery.

It was becoming clear to Model that the visual expressions of a culture simultaneously shape and reflect it, and that the plethora of images we each provide for ourselves name and direct our experiences in the world. To the extent that she saw photography as contributing to this state of image saturation, she recognized the role that her own work played.

She left New York for Caracas on 12 August and returned on 10 October 1954.[40] While a major attraction of the visit was seeing her sister, Olga, who was now living there, she explained in press interviews that the primary purpose of her trip, undertaken on the invitation of the Venezuelan government,[41] was to photograph the cultural monuments, the streets, and the architecture of the country.

She was received as an "American journalist... in Zulia to organize an exhibition on life in Venezuela".[42] In interviews, Model gave her views on photography, lamenting its absence in Venezuela and expressing plans to publish and exhibit the work she had done there. She was accompanied during the trip by Merida de Valera, a Venezuelan poet and journalist, who acted as an interpreter and guide. A friendship developed between the two women, inspiring de Valera to compose a sonnet in her honour.

In Caracas, Model photographed government figures,[43] attempting, it would seem, to make some kind of official portraits; the University of Venezuela; public monuments and architecture; and the surrounding, surreal landscape of oil derricks, pipelines, and pumps. Her pictures taken at twilight, with the lights of the city dimly illuminating the pedestrians and the traffic, seemed to best present the feeling of strangeness that the city evoked in her (fig. 110).

What she photographed when she left Caracas for the Maracaibo region to "complete an already abundant collection... on Venezuelan themes"[44] was a complete contrast. Accompanied by Catherine Hill, American President of the Maracaibo Fine Arts Center (of which she attended the inauguration), she photographed the Maracaibo Indian people. Taking predominantly women in stark landscapes and in the surroundings of their villages for subject matter, the body of negatives that she made of the inhabitants around the area of Lake

"In Caracas I photographed for the government. I couldn't do much for myself because I had a car and a chauffeur and they brought me around where they wanted to."
– Lisette Model.[41]

fig. 111
Lisette Model
Maracaibo Woman
Venezuela 1954
Gelatin silver
27.3 × 34.5 cm

Hayworth, and relates it to American culture as well as classical ideals of female beauty. He notes, "The enormous distribution supplied by photographic and printing technology has made the goddess practically omnipresent", and describes the commercial exploitation of this phenomenon:

> Several of the country's largest industries are devoted to helping them [women] attain this desire [to be as much like her as their physical limitations will permit], the theoretical end product of which would be the emergence of an abstract, mechanical, ideal woman, endlessly repeated like the car that issues from the end of the production line, differing from others of its kind only in such minor features as color and optional extras.[46]

Interestingly, the first page of the article is illustrated by a photograph of a headless Roman sculpture of Aphrodite (fig. 112). It is similar to the images Model selected to record in the museums of Rome in 1953 (fig. 113).

In 1964, spurred on by Diane Arbus, Model applied again for a Guggenheim grant.[47] Of all Model's students, Arbus was the one whose photographs would become the most influential force in mid-twentieth century photography. Their professional relationship was marked by strong mutual support, with both providing encouragement and references for one another when it came to finding economic means to survive as photographers. The application included a statement, prepared with the assistance of Arbus, that outlined the subject of her grant as "Glamour: The Image of Our Image",[48] a sub-theme under the larger thesis "Photographic studies of the social and artistic history of our time".

> We are glamored daily. Anyone can buy it everywhere and anywhere but no one can be sure of it. It is both artificial and profound. It is our most precious export: the real American Dream. You cannot have beauty, success and happiness without it.
>
> Its origins are sacred and no one is immune. Marilyn Monroe died of it. A Christmas tree in our landscape shines with it. Costumes and decoration, fun and games, crime and theater, politics and religion follow where it leads.

Both the Italian and Venezuelan material were published eventually. Neither *Harper's Bazaar* nor *Vogue* did justice to it.[45]

She was ready to work again, but was reluctant to apply for another Guggenheim and suffer possible rejection. However, Diane Arbus went to the Foundation and requested Model be invited to apply. Shortly after, Model received a letter:
> Miss Diane Arbus has suggested to us that you may wish to make application for a Guggenheim Fellowship, and accordingly we send you herewith a statement concerning our Fellowships and a set of application forms.

Arbus's action had the desired effect. Lisette wrote to Ansel Adams asking for his support in recommending her for a Fellowship. She expressed the wish to become active again, explaining that she had been producing "non-printed negatives in the last 4 summers only."[47]

Maracaibo represent her work at its most illustrational or documentary. The few prints she produced from this group of negatives, however, seem tentative or muted (fig. 111). The assured viewpoint and passion, always so strongly present in her other work, is replaced by a more gentle, but finally uncertain, vision.

The subject she seemed to have connected with most deeply was the work and studio of the painter Armando Reverón. Unfortunately, Reverón had died on 17 August, and she never met him. The studio, however, was occupied by the woman with whom he had lived, and the life-size dolls they had made together. Not only the image of a studio in a jungle, but the representations of nature – paintings on the walls of birds in cages – attracted her.[45]

"THE IMAGE OF OUR IMAGE"

Model always claimed to have come to understand the meaning of the word glamour only after she returned from Venezuela. In fact, while she might not have perceived the common underlying thrust of these separate bodies of work, her investigations into glamour go back to the forties to her photographs of windows with mannequin representations of women. Her interest in how the perception of women and of their role in society was affected by notions of glamour was demonstrated in 1947 when she clipped and preserved an article by Winthrop Sargeant from *Life*. In it, he describes the idolisation by American men and women of Rita

I want to follow this Pied Piper too; to photograph America's self-portrait a million times projected and reflected, to make the image of our image.[49]

While the project could be described as ambitious, undertakings of such scope were certainly not new to photography. The medium itself seems to encourage large-scale ambitions. As early as 1858, French photographer Charles Nègre, wishing to document the traces of mankind, had proposed to Napoleon III that he photograph all the "significant artifacts of the history of civilization".[50] In 1910, August Sander began his extraordinary series of photographs: a massive typological documentation of the German people that had originated from a small group of twelve archetypal photographs of German peasants. In contrast to the heroic proportions of these two projects, Model's proposed study was more limited in scope, being firmly rooted in contemporary culture and its myth-making images. Nor was Model the first photographer to be attracted to the subject of America, as several Guggenheim applications prior to hers demonstrate.[51]

A letter from the Guggenheim Foundation dated 17 March 1965 informed Lisette she had been awarded a Fellowship: $5,000 for a period of twelve months, commencing in May of that year.

She made plans to visit Los Angeles and Las Vegas, and also to make a return trip to Italy, but it wasn't until sometime after May 1966 that Model in fact followed her Pied Piper to the west coast, leaving Evsa in New York. In July she was in Los Angeles, where she stayed with Marion Palfi and Martin Magner and visited with a New York friend from the forties, Celia Rogers.[52]

She photographed rehearsals in the studio that Magner, a theatre director, shared with actress Hope Summers. Hollywood, where she spent six weeks, she found to be a disappointment, her image of it having being formed by a reality of some thirty years earlier.[53] However, her project was also a study of anti-glamour, so she photographed Phyllis Diller, who parodies in her performances the notion of the ideal woman.

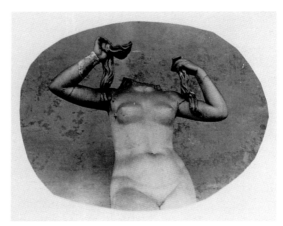

fig. 112
From "The Cult of the Love Goddess in America," *Life*, 10 November 1947, p. 81

"In Hollywood I didn't find anything. I said, where is Hollywood? Right where you are. You are thirty years late. I spent a month, six weeks, but I didn't find anything." — Lisette Model.[53]

fig. 113
Lisette Model
Rome 1953
Gelatin silver
13.2 × 16.1 cm (irregular)

fig. 114
Lisette Model
Beatrice Wood Ojai 1966
Full frame enlargement
by Justin Wonnacott from
original negative, 1989

Las Vegas, the glamour capital of America, was her other destination on this trip. Between there and Los Angeles, Model travelled to smaller centres in California photographing subjects that apparently had nothing to do with her glamour project. One of the stops she made was in the Ojai Valley to photograph the unconventional actress, artist, and mystic Beatrice Wood (fig. 114), who was associated with the artist Marcel Duchamp.

Las Vegas is a city of appropriation and possibility. The architect Robert Venturi described visiting there in the mid-sixties as akin to visiting Rome in the late nineteen-forties:

> Las Vegas is to the strip what Rome is to the Piazza Each city is an archetype rather than a prototype, an exaggerated example from which to derive lessons for the typical. Each city vividly superimposes elements of a supranational scale on the local fabric: churches in the religious capital, casinos and signs in the entertainment capital. These cause violent juxtapositions of use and scale in both cities.
>
> The Las Vegas casino is a combination form. The complex program of Caesar's Palace – one of the grandest – includes gambling, dining and banqueting rooms, nightclubs and auditoria, stores and a complete hotel. It is also a combination of styles. The front colonnade is San Pietro-Bernini in plan but Yamasaki in vocabulary and scale, . . . the blue and gold mosaic work is Early Christian tomb of Galla Placidia . . . Gian de Bologna's *Rape of the Sabine Women* and statues of Venus and David, with slight anatomical exaggerations, grace the area around the porte-cochere. Almost bisecting a Venus is an Avis . . . [54]

Model was in Las Vegas for about one month. There is evidence to suggest that in this "message city", as Umberto Eco described it,[55] she found herself overwhelmed: she focussed primarily on the strippers and performers with their silicone-implanted breasts, the forest of neon signs (fig. 115), and the wedding chapels ("Then there were these fantastic churches . . ."[56] [fig. 116]). Given her approach, Model would not have arrived there with the intention of realizing a specific plan, but rather of making discoveries about the place and its human environment. Despite the sense of claustrophobia and tackiness that the photographs she took project – street signs that appear to induce a hallucinatory state and stages with seedy lighting – Model, in all likelihood, had no intention of passing either a profound or trite value judgment on this environment. Both she and Evsa had a strong interest in vernacular culture, one that could easily have encompassed the wedding chapels and the neon signage. The interiors of casinos were an attraction, as they had been in Reno some seventeen years earlier, but turned out to be inaccessible in Las Vegas. She could not obtain permission this time to take photographs:

> They threw me out from one casino to another It doesn't pay for them to have you . . . if I could have photographed the gambling places in Las Vegas, I could have done things.[57]

The United States in the 1960s was perpetually in a state of crisis, from the assassination of President John F. Kennedy and race riots, to the continuation of the Cold War and the country's entrance into the Vietnam war. Sociologists, artists, and writers examined the nature of American culture and its symbols. Part of what appealed to Model about Las Vegas was the collage of imagery, which appropriated venerated images from the past, copied them in plastic, and assembled them randomly within a blaze of neon. For someone raised in a sober European cultural climate where the past, in spite of wars and economic collapses, was a firm and immutable presence, Las Vegas, with its vulgar and iconoclastic vernacular, was irresistibly attractive.

After her stay in Las Vegas, Model travelled to and photographed an abandoned gold mining town.

Late in October 1967, she left for Italy to re-address the subjects she had explored fourteen years earlier. Letters of introduction had been prepared for her by John Szarkowski, the curator of photographs at the Museum of Modern Art, to the directors and curators in charge of the Italian museums Museo Nazionale di Villa Giulia, Musei Capitolini, and Museo Nazionale Romano.

Dee Knapp, her friend and protégée, who was on holiday in Rome at the time, met Model by chance on the Piazza Navona. She recalled that Model seemed to be very excited by the work that she was about to undertake[58]:

I was not satisfied with [the earlier work in Rome], so with the Guggenheim I wanted to go back, and I was unbelievably lucky. I had friends over there – owners of galleries ... who said to me, are you crazy, to go into museums and photograph the stuff everyone has seen and everyone has photographed? I will direct you to private collections first, and they have millions of things much better than in any museum they are in Sicily and in Naples and near Florence, and they are hidden in caves. There are caves where there are huge statues of pre-Roman mothers with five or six children. Things completely unknown. There are catacombs that people have never been in and we are going to let you in...[59]

Ill health, however, forced Model to discontinue her stay and return to New York, where she was treated, successfully, for uterine cancer.[60]

fig. 115
Lisette Model
Las Vegas 1966
Full frame enlargement by Justin Wonnacott from original negative, 1989

fig. 116
Lisette Model
Las Vegas 1966
Full frame enlargement by Justin Wonnacott from original negative, 1989

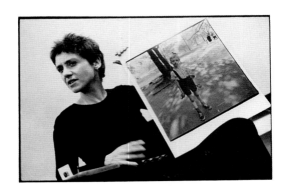

fig. 117
Stephen Frank, American
Diane Arbus Providence, Rhode Island 1970
Gelatin silver
22.5 × 33 cm
Collection Stephen Frank

If Model's photographs exerted a powerful influence over a generation of photographers, Diane Arbus's photographs, which took a major element of Model's vision and pushed it to a logical conclusion, have probably had an even greater influence. Not only is it true that the effect of the work of Arbus on photographers has outweighed our understanding of it, and that her photographs changed the character of the medium, but it is also true that the mere fact of her images being present in the world has adjusted our collective self-image.

As a teacher, Lisette Model encouraged many serious photographers. Diane Arbus studied with Model around 1957,[1] when her reputation as an outstanding educator, both for private classes and at the New School, was already established. Before this, Arbus had studied briefly with Abbott in 1941, and with Brodovitch in the mid-fifties. According to her husband, Allan Arbus, neither of these experiences "clicked",[2] but after three sessions with Model she had become a photographer: "There was no more hemming and hawing." It was "as if she was ready to be a photographer and just needed a release – Model provided that release."[3] This would seem to reflect Model's assessment of her role in the development of Arbus's photography. She attempted to put distance between her own subject matter and that of her student, and she was emphatic about the independent nature of Arbus's vision, insisting that she never showed the younger photographer her work, and that what she might have seen on her own was limited.

APPROACHES: PARTICULAR RISKS

"Everybody has that thing where they need to look one way but they come out looking another way."[4] The photographs of both Arbus and Model confront subject matter that has traditionally been considered extreme or outside the social pale. While never resolving the conundrum of whether the appearance one presents to the world is a mask or a face, their images at least raise the question. Model's *Woman with Veil* (pl. 10) and Arbus's *Girl in a shiny dress, N.Y.C. 1967* (fig. 118) are images that fix themselves upon the mind, vividly presented subjects who are not so much mocking parodies of themselves as of a socially agreed upon cosmetic defence against aging, truth, death, or, simply, what we really look like. The subjects of the photographs carry the approved ritual of grooming to a length which becomes, paradoxically, an act of social defiance. Either refusing or not knowing where to to draw the line, they become the focus of extraordinary attention.

It was a similar cultivation of the extreme that formed the nexus of Valeska Gert's performances, a pushing out beyond the accepted limits: through exaggerated make-up, clothing, and movements, and strange and primal sounds. Model's and Arbus's visual performances are not unlike Gert's, once described as an itching to "burst in on all the sweetness" by bringing to our attention "those people dismissed by [the bourgeois] – whores, procuresses, cast-offs, those who had slipped".[5] The photographers both made images to break the spell that middle-class society had spun around itself, that of a charmed world, a world aspiring to be "normal" and perfect in all respects. Their works subvert an unwritten rule operating at the core of our culture: that one tampers with the hierarchy of social

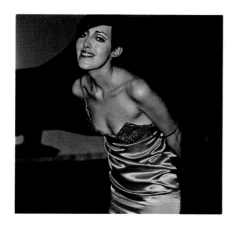

fig. 118
Diane Arbus,
American (1923–1971)
Girl in a shiny dress, N.Y.C. 1967
Gelatin silver
36.1 × 36.5 cm
National Gallery of Canada
(20667)
Copyright © Estate of
Diane Arbus 1972

"The Happy, Happy, Happy
Nelsons" (*Esquire*, June
1971) – Ozzie and Harriet
Nelson and Rick and Dave
Nelson and their families –
were photographed by
Arbus, for example.[7]

values at one's peril. As a code affecting women's behaviour, in particular, it has often been tragically effective in producing respectful and obedient passivity.

Both Model and Arbus reject in their photographs the familiar presentation of our society as a homogenous culture with glamour-driven ideals and norms, and insist it is neither a complete nor an accurate reflection of reality. For questioning the standard perception of the world, they both provoked censure and accusations of going too far.

As has already been shown, Model was intrigued by the role the concept of glamour plays in shaping everything from economics to human values. Taking a different but related approach, Arbus was appointed to a Guggenheim fellowship in 1963 "for photographic studies of American rites, manners and customs."[6] Ironically, she was herself subject matter for *Glamour* magazine in 1947, along with her husband Allan, and she alone in 1951. When she became a photographer working on assignment, she contributed to its dissemination by photographing "glamorous" families.[7] Yet the persuasive power of the American dream was lost on her. As she put it, "I wasn't a child with tremendous yearnings. I didn't worship heroes."[8]

Model and Arbus shared a similar stance; their respective visions were, in essence, of a recovery and a discovery of the world for themselves. They were each attracted to the risks that people took, and to the conquest of their own fears. In the execution of their images, both worked with a consciousness of the visual traditions of their time but, when compelled by their inner visions, rejected accepted practice.

Model drew from the values and techniques of European art in the thirties. She employed satire and expressed her concerns in broad, open gestures, sacrificing, if necessary, the details of a specific moment. Her images, vigorous and visceral, suggest anecdote through truncation and exaggeration, dramatic diagonals, and strongly silhouetted forms. She manipulated these elements in such a way that the prints with their grainy surface often appear crude. They read strongly as a whole, inviting a response to the theatre of the visual event.

Arbus, on the other hand, was profoundly a part of the North American empirical tradition that one writer has described as the "need to grasp reality, to ascertain the physical *thereness* of things".[9] Her photographs visually allude to the luminist and limner legacy of American painting in their expression of light and form, and to the critical discourse that had already developed around photography when she started to work. Tight, rendered with pristine clarity and the kind of attention to detail found in the daguerreotype process, her photographs have the sharpness and textural distinctions of an earlier generation of photographers from the States, such as Paul Strand, Ansel Adams, Walker Evans, and Edward Weston.

The worlds in which Model and Arbus came of age were very different. When Model left France for the United States, Adolf Hitler's imperialism dominated the daily news; Europe was on the threshold of the second major war of the century. Artists, writers, and social commentators responded to the social and economic chaos, the menacing leadership, with satire and a characteristically European sense of the absurd. While Model's photographs were influenced by the European humanist tradition, it is equally important to recall that she became a photographer when photojournalism was considered an exciting, even glamorous, profession, with power to affect the course of political events, and that she was clearly attracted to it. Her anecdotal approach and her vocabulary of generalized forms must be understood in relation to photojournalism of that period.

European humanism was based on the idea of a complex but shared human condition; a capacity to believe that there is such a thing as a universal experience of human suffering and joy. Model's empathetic nature embraced these ideals:

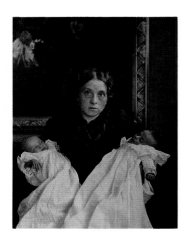

Most people are terribly afraid to take pictures of people because, so-called, they are invading their privacy. Isn't it rather that, when we see a drunk lying on the street, we feel that that is him but it can't happen to me? Or somebody who is a cripple ... or somebody very poor, or somebody ugly, or somebody extremely beautiful? Instead of feeling that the difference between one human being and the other is very small, and what happens in people's lives is approximately the same. Where is the great secret? ... What one is, everybody is Because tomorrow morning I can be there – which happened during the war all the time. Then one *has* to feel As long as I have the feeling, "this is me," I can do it.[10]

For Diane Arbus, raised in the context of the American philosophy of individualism, and a child of both the Depression and the Second World War, the differences in human experiences were more relevant, and bitterly apparent. Model's statement contrasts dramatically with the sense of particularity expressed by Arbus when she said that "it's impossible to get out of your skin into somebody else's", and "somebody else's tragedy is not the same as your own."[11] For Arbus, it was the infinitely distinctive permutations of human identity and experience that were important. She saw her role as a chronicler of this variety and believed that, without her photographs, it would remain invisible and unacknowledged. Interestingly, however, it was from Model that she learned how to use the particular to explore larger truths: "It was my teacher who finally made it clear to me that, the more specific you are, the more general it'll be."[12]

The differences between the work of Arbus and Model seem, finally, to be more significant than the similarities. For Model, the world was a stage, and she brought to photography a sense of gesture, emphasis, and generalization in order to make strong, moving, visual theatre. Her search for types – not unlike a casting director – also links her activity to theatre: "I am always very attracted to certain types – which are not always the same because they do not exist anymore ... even in Paris and Nice ... only in New York can I find very strong personalities."[13]

For Arbus, the world was intensely and inescapably real. Her trauma was her inability to imagine her surroundings any differently from what they appeared to be in gritty fact. The details of the commonplace were what excited her, not fantasy or aberration: "If you scrutinize reality closely enough, if in some way you really, really get to it, it becomes fantastic."[14] Her portraits, tight, precise, revealing, almost hermetically sealed, shocked and provoked for their intimate, persuasive, more-than-real presentation of the mundane. Her photographic technique was similar to that used in the sleek, seductive imagery of Madison Avenue, but it had a diametrically opposed message and purpose:

I wanted to see the difference between flesh and material, the densities of different kinds of things: air and water and shiny. So I gradually had to learn different techniques to make it come clear. I began to get terribly hyped on clarity.[15]

The work of August Sander struck a sympathetic chord for both women, providing them with a common historical precedent for their respective visions. While familiar with the work of Sander, Arbus's encounter with a large number of

"One of the things that disturbed Diane Arbus at the time of her death had to do with how misunderstood her work seemed to be, in the sense that it was thought of mainly in terms of the crudest subject identification with no self-reflection. In terms of the imitators of her photographs, these followers simply felt obliged to seek the bizarre in subject and secure a likeness on film." – Peter C. Bunnell.[18]

"For example, I have never photographed homosexuals. I have never photographed lesbians. I have never photographed freaks. [This] is not what I was interested in." – Lisette Model.[19]

Janet Beller: How did this picture come about? Model: *Harper's Bazaar*. Years later she [Diane Arbus] photographed that too. Beller: Same place? Model: Same person. *Harper's Bazaar* asked me to go to the Flea Circus on Forty-second Street, and I didn't find anything – people with one leg, and without arms – *that* I didn't want to photograph. And the fleas you can't photograph either. But there was this kind of person there, and he told the following story with all the proof, the letters and photos. He was a Parisian, he had been a woman until the age of thirty-five, with four children, and when the fourth child was born, he slowly but surely turned into a man he had still one female and one male breast. He was an incredibly fascinating kind of performer and actor, great intelligence *Harper's* of course never published that. Nobody published that.[23]

his images at the Museum of Modern Art in New York in early 1969 had a powerful effect, giving her, it appears, a confirmation of her direction and a revelation about the capacity of the medium to detail the reality of the human presence. She had come into the study room on a day when every table surface was covered with Sander photographs from the Museum's collection, in preparation for selection for an exhibition by photographer and curatorial intern Gary Metz. Peter C. Bunnell remembers that Diane Arbus looked very hard at all the photographs. They included three of circus performers, two of blind people – both subjects that had already engaged her, and the image *Mother in Joy and Sorrow*, Sander's extraordinary portrait of his wife and their twin infants, Sigrid and the deceased Otto (fig. 119). Arbus was deeply moved by what she saw; she remarked on the incredible clarity of the photographs, the way in which the figures seemed to spring from the paper.[16]

Model, instead of showing her own photographs to students, would introduce them to the work of photographers she admired, and among the books she brought into the classroom during this period was Sander's *Menschen Ohne Maske*. It is very likely that Model's interest had been rekindled by Arbus's excitement.[17]

SUBJECTS: RECOVERY AND DISCOVERY

Although it would be a mistake to respond to the work of these two photographers simply on the basis of "subject identification",[18] both Model and Arbus placed great importance on subject matter, testing both the capacity of the medium and the tolerance of its audience. Model thought that, if the issue of resemblance between her work and Arbus's had to be addressed at all, it existed only in the choice of subject matter and then only to some degree. Yet she went to great lengths to point out that there were certain Arbus subjects she had never photographed,[19] and she could have noted that the reverse was true. She conceded there was "something about the selection of extreme-looking people that is in common", adding that "certainly she didn't get it from me".[20]

A subject considered ethically difficult for photographers, for obvious reasons, is that of blind people. Typically, the photographs that Model made of the blind (pls. 13–15, 130–33) address the issue of truth and appearance, what Model liked to refer to as the hidden face and the mask. Arbus who photographed the blind Argentinian writer Jorge Luis Borges, perhaps referring to this idea, commented that the blind "can't fake their expressions. . . . They don't know what their expressions are, so there is no mask".[21]

In her photographs, Model touched on almost every volatile element that constitutes the nebulous, regulating force we know as "the norm": patriotism, gender identity, and genetic coding. Her photographs of a man at a war rally in New York in 1942 (pl. 23),[22] of transvestite Albert-Alberta at Hubert's Flea Circus (fig. 68, pl. 27),[23] of a dwarf (pl. 81), of Percy Pape, the circus "Living Skeleton" (pl. 24), illustrate her interest in people who were either firmly entrenched in a social order of some kind, or, by contrast, who were relegated to the margins of society.

After seeing *Coney Island Bather* in the Museum of Modern Art, Arbus wrote Model, "What a beautiful photograph that is."[24] What she found convincing

and moving about this image was her own appreciation of the fantastic as a quality neither extreme nor exotic, but embedded in the commonplace.

Photographs by Arbus of subjects similar to Model's (figs. 120–24) illustrate how different their visions were, in essence (pls. 23, 24, 27, 81).

Arbus's view of the fantastic was not unlike Thomas Mann's definition of the grotesque, written at the beginning of the twentieth century: "Something more than the truth, something real in the extreme, not something arbitrary, false, absurd, and contrary to reality."[25] As another writer on the concept, Geoffrey Galt Harpham, has noted, it is from the conventions and assumptions of a culture that the definition of the grotesque is drawn: "Culture does this by establishing conditions of order and coherence, especially by specifying which categories are logically or generically incompatible with which others."[26]

Model's and Arbus's photographs are both persistently associated with the grotesque, at least in the United States, although not necessarily elsewhere. In 1979, Model commented:

> This word grotesque, from the first moment I began to photograph, has of course been used very often When last year I came to Arles, and these pictures were seen over there ... – and there were Brazilians, South Americans, English, French, Italians, Germans, Austrians, Swedes – *never ever* was the word grotesque ... pronounced ... it didn't even dawn They found them human but never grotesque.[27]

The extreme sensitivity of both photographers toward what they saw as imitation of their work might have been partly territorial, but it also had something to do with being appalled at the short-circuiting of real experience and substitution of a world of images. Most significantly, it had to do with their consideration of the subject as the most important element in their photographs, "more complicated", as Arbus put it, than the picture itself:

> I do have a feeling for the print, but I don't have a holy feeling for it. I really think – what it is, is what it's about. I mean, it has to be *of* something. And what it's of is always more remarkable than what it is.[28]

TEACHER, STUDENT – FRIENDS

To see Arbus's photographs grow out of, depart from, and in the end eclipse her own could not have been easy for Model – particularily given the extent of her admiration for the work. On more than one occasion, Model made public her regard for Arbus as a student and as a photographer, noting the quality of her imagery and the degree of her commitment.[29] On the other hand, she sometimes made statements which sound negative or ambivalent, for example, when she alluded in interviews to Arbus's work as being pathological or neurotic. These contradictory statements seem, finally, to be an expression of Model's vulner-ability and confusion about how their careers meshed, and where they separated. They have to be considered in the light of a strong personal friendship, an extraordinary teacher-student relationship, and the difficult circumstances of Model's life, both professionally and financially, in the period after she met the younger woman.

When Arbus applied in 1962 to the Guggenheim Foundation for a fellowship, Model wrote her a supporting letter. She, in turn, kept her informed of the progress of the application, observing on the side the curiousness and anonymity of the institutional environment:

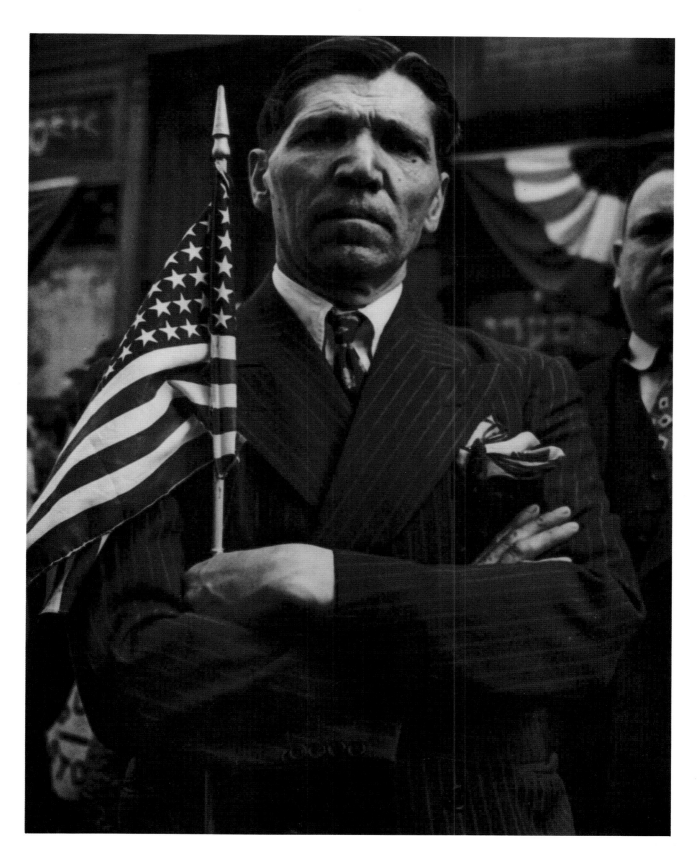

23 **War Rally** New York between 1941 and 17 November 1942

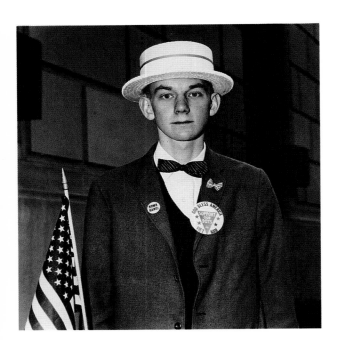

fig. 120
Diane Arbus, American (1923–1971)
Boy with a straw hat waiting to march
in a pro-war parade, N.Y.C. 1967
Gelatin silver
38.6 × 38.3 cm
National Gallery of Canada (20674)
Copyright © Estate of Diane Arbus 1971

fig. 121
Diane Arbus, American (1923–1971)
Mexican dwarf in his hotel room
in N.Y.C. 1970
Gelatin silver
38.2 × 36.9 cm
National Gallery of Canada (20675)
Copyright © Estate of Diane Arbus 1971

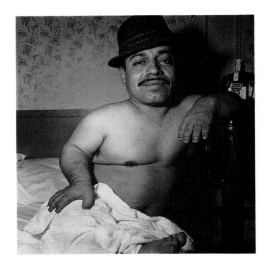

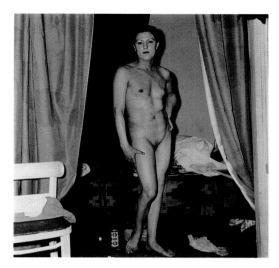 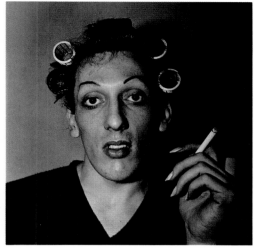

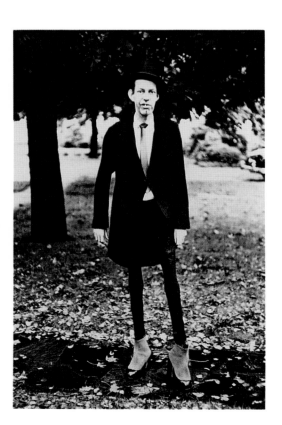

fig. 122
Diane Arbus, American (1923–1971)
Very thin man 1961
Gelatin silver
35.5 × 22.9 cm
The Chrysler Museum,
Norfolk, Virginia (80.222)
Purchased with funds provided by
Joyce and Robert Menschel
Copyright © Estate of Diane Arbus 1961

fig. 123
Diane Arbus, American (1923–1971)
A naked man being a woman, N.Y.C. 1968
Gelatin silver
36.3 × 37.4 cm
National Gallery of Canada (20669)
Copyright © Estate of Diane Arbus 1972

fig. 124
Diane Arbus, American (1923–1971)
A young man in curlers
at home on West 20th Street,
N.Y.C. 1966
Gelatin silver
39.2 × 38.3 cm
National Gallery of Canada (20679)
Copyright © Estate of Diane Arbus 1972

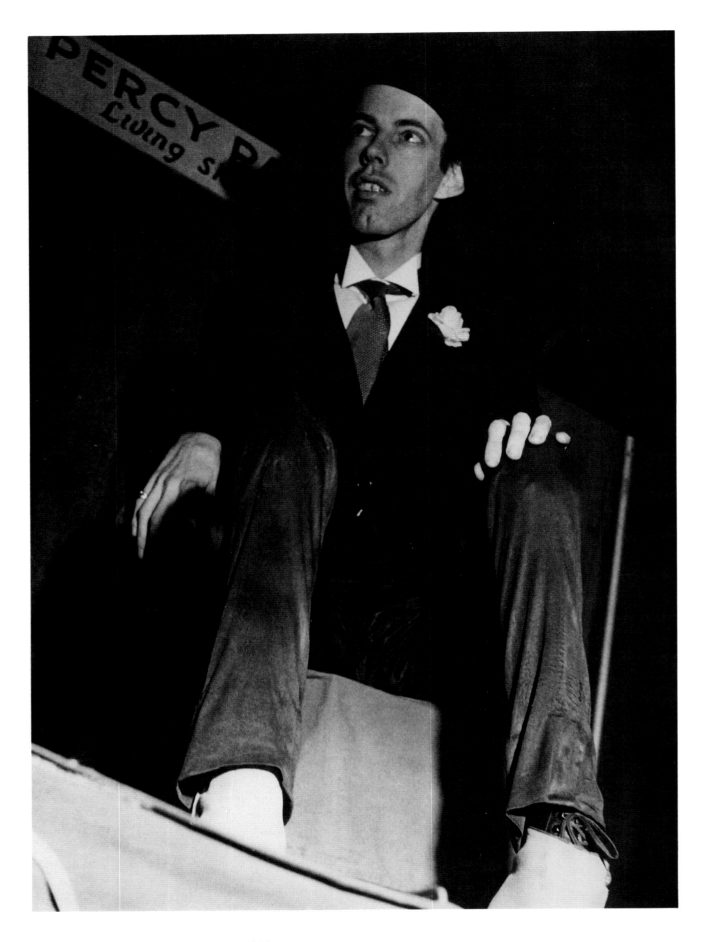

24 **Percy Pape, The Living Skeleton** New York 1945

> Dear Lisette, the G'gg'nh'm have summoned all photos and plan to keep them only until Jan 15 so I guess now is the time when they (whoever they are) make up their collective mind. I brought them there and it is so odd! Just a small series of offices like judgment day in a bad dream.[30]

As mentioned earlier, she also encouraged Model to apply for a Guggenheim Fellowship herself, and assisted her in the assembly of the submission.

Model was proud of Arbus. She wrote Ansel Adams about her exceptional student, and in 1964 proposed her for the Milwaukee *Invitational Exhibition 10: American Photographers 10* (March 1965). They also evidently discussed projects they were working on, such as Lisette's interest in photographing old people in October of 1968:

> Dear Lisette, To find mother Brown, the lady who was about 112 years old a few years ago ... call the Salvation Army red shield center... perhaps you could arrange to go to the next meeting and meet her.... Let me know if for any reason it does not work.[31]

In 1973, two years after Diane Arbus's death by suicide, an article on her photographs appeared in *Print Collector's Newsletter*. Impressed by the piece, Model contacted Peter C. Bunnell, who was the author, several months later, and proposed a meeting. On this occasion she confided her bewilderment over the death. In an effort to arrive at some comprehension of what had driven her to so prematurely end what appeared to be a life full of promise, Model gave Bunnell a synopsis of Arbus's life: "She had a good husband, children who loved her, and she was famous."[32] This was Model searching for light not only on the death of Arbus but also on the passage of her own life, wondering perhaps at the tenacity of her own will to survive.

Model enjoyed one-on-one relationships with people. Allan Arbus, a close observer of the two women together, confirmed that their relationship was intensely private. Nowhere is the sense of their unique friendship better expressed than in the note Arbus sent Model upon receipt of her Guggenheim Fellowship: "Dear Lisette, my father told me to thank you, but your eloquence is your own and your friendship is mine, so I cannot."[33]

Model's and Arbus's respective visions, as they applied to and disrupted the accepted order of their society, found both opposition and support. On the occasion of the Arbus retrospective at the Museum of Modern Art in 1972, John Szarkowski said her work brought a "freshness, a sense of starting anew, to photography"[34] – a statement which could equally have applied to Model's work some forty years earlier. The final results of their contributions are yet to be seen. There is no doubt, however, that both these outstanding women, confrontational, original, above all extraordinary, have had a powerful effect on the development of their medium of photography.

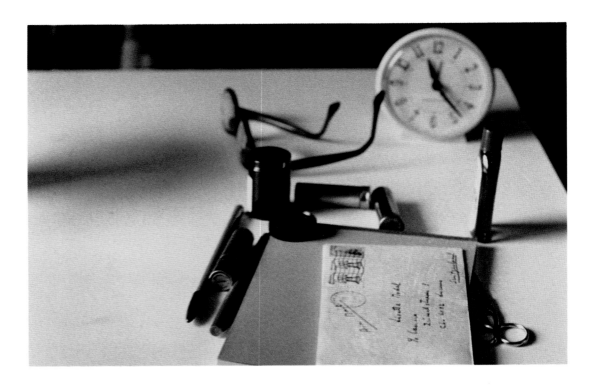

fig. 125
Lisette Model
Lucerne **1977**
Full frame enlargement
by Justin Wonnacott from
original negative, 1989

Very few prints were made at this time. Some were made from the Italian, Venezuelan, and jazz negatives of the fifties, but not from her reflections series. This was also true of material from the sixties, when she was photographing movies from television screens, shadows on the sidewalk, New York at night, and personalities as diverse as Phyllis Diller, Sammy Davis Jr, and Beatrice Wood.[2]

This imagery exists in negative form only except for a few prints from negatives taken in Venice in 1979 and France in 1980.[6]

For Lisette Model, the act of taking photographs during the last fifteen years of her life became more an experience of process than of production. Several hundred sheets of negatives and a smaller ratio of contact sheets in the estate testify to this fact. Why this should have been the case is mysterious. It should not be forgotten however that her general photographic productivity had already begun to decline in the early fifties when she started to teach at the New School. At this time she also began to produce fewer prints of her current work, preferring to make proofs, and even then only on occasion.[2] While there is good reason to believe that her economic situation and the tremendous amount of energy that she put into her teaching partly determined this, it seems to have reflected also a personal crisis of confidence.

Although she developed rheumatism in her hands in the late seventies[3] and became increasingly frail with age, the motivation to continue photographing was always present. In early 1970 she applied to the Ingram Merrill Foundation for a grant to undertake a "photographic study of the social and artistic history of modern times",[4] and was awarded $2,000. In March of 1973 she received a Creative Artists Public Service Program award for $2,500. If she had expended her energy or enthusiasm for photographing, there is no indication of this in interviews that she gave

156

I have always accepted things as they were, and I have a strong will to survive.

These two attributes would be my summing up.[1]

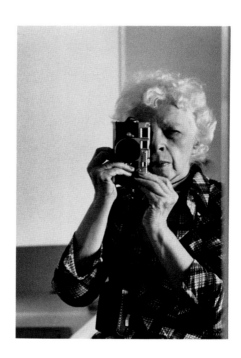

fig. 126
Lisette Model
Self-Portrait Lucerne 1977
Full frame enlargement
by Justin Wonnacott from
original negative, 1989

She went to Lucerne to work
with Allan Porter on the
issue of *Camera* dedicated
to her work.[8]

In Venice she photographed
people, architecture, and
gondolas extensively.[9]

in the late seventies. To the contrary, when reflecting on her "undeveloped sense of play", she remarked, "But now, with a camera in my hand, I am perfectly calm, unafraid, restless to get moving – and I never know what is going to happen next. And that is what play is all about, is it not?"[5]

From the seventies onward, Model seemed increasingly inspired to photograph when away from New York on one of her frequent teaching or lecturing trips. The fullest bodies of imagery[6] from this period are from Berkeley in the summer of 1973, where she photographed "hippies" and students[7]; Lucerne in the fall of 1977 (figs. 125, 127)[8]; Venice in September 1979 (fig. 128),[9] and France in the spring of 1982. On the latter trip, she returned to Nice after an absence of nearly thirty years (fig. 129). She stayed four weeks in a rented apartment and took photographs retracing her steps along the Promenade des Anglais, but did not find Nice a source of inspiration as she had forty-eight years before. According to her landlord, she no longer seemed to know her way around and behaved "as if she were here for first time".[10]

Old age was a subject in which she had expressed an interest to Diane Arbus in the late sixties, and which she explored in a startlingly thorough documentation of the La Verne Nursing Home in the seventies.[11] Model's coverage of the institution and its resident patients was exhaustive, but she made only a small number of proof prints, and those of one subject alone: a senile woman clutching a doll. The act of taking these photographs must be seen as a tough look at her own life. Conscious of her own aging, and the return to dependency that usually accompanies this process, a possible future that she would have had trouble reconciling herself to, but that was everywhere apparent in this institution, must have struck her as cruel and painful. Faced with difficult truths, the camera became again for her a tool of confrontation.

The remaining body of her work from this period includes images that deal with contemporary events, such as a "fat power" rally, and subjects in which she had always shown an interest, such as store windows, reflections, and street scenes.

Without Model's expressive cropping and dramatic reshaping of the negative images, this vast body of largely unprinted work remains somewhat mute to the viewer. The photographs that are a moving record of her last years, in spite of this, are her self-portraits and a series of portraits that she made of Evsa. Throughout her career, Lisette periodically recorded herself with her camera in a mirror (fig. 126), but never printed the results, thus making the process something of a private

fig. 127
Lisette Model
Window **Lucerne 1978**
Full frame enlargement
by Justin Wonnacott from
original negative, 1989

At some point she made a
contact sheet pairing these
images with a series of
images of a mannequin face.
The juxtaposition produces
the effect of the face as
a mask, suggesting that
photographing Evsa was
a process of acknowledging
to herself the full impact
of his condition.[12]

"Keeping the Legend Intact"
(*Infinity*, vol. 22, no. 1,
January 1973) was the first
of a number of interviews,
articles, and essays, to
which she refused to give her
consent for publication.[14]

accounting procedure. She also photographed Evsa in the same way, realizing only
a handful of the negatives in print form (fig. 130). The final depictions of Evsa do
not have the detachment of her self-portraits. Taken at close range, she recorded
the sculptural beauty of his features, but also the tragic fact of the debilitating
disease that left him without expression.[12]

In many respects, however, the last decade of Lisette Model's life seemed
a simple extension of her earlier activities, differing from the preceding three
decades only in intensity. She continued to make photographs and to teach both
institutionally (fig. 131) and privately, and the exposure of her work through
exhibitions and publications in fact increased from the fifties and sixties. Towards
the end of the sixties, with interest in photography burgeoning, there was a revival
in attention to the photographs she had made in the thirties and forties, that is, to
the ones she chose to place before the public eye. Throughout the seventies,
several photographers printed for her. Some did so on a more formal, contractual
basis, such as Richard Benson, Al Striano, Chuck Kelton, and occasionally Gerd
Sander (although he more often did it informally), and others on an informal basis,
such as Sol Lopes and Gary Schneider.

This was an important period of consolidation for Model, but one also strongly
marked by her reluctance to put any new work before the public.[13] Photographs
were rapidly becoming incorporated into the contemporary art market, and the term
"vintage photograph" had been coined and had taken on a particular economic
meaning. Thus, her insistence on exhibiting only early material neither represented
a serious threat to her reputation, nor undermined her prospects of being part of
the "photography boom". However, her desire to maintain control over both her
work and the dissemination of information about it was matched by her desire not
to be considered a "has been", but rather a working photographer. She responded
with outrage to commentaries that made the assumption, based on the absence of
exhibitions of recent material, that she had stopped photographing. Yet, to the
extent that she did not exhibit new work and refused to relinquish tight editorial
control of her earlier work, she contributed to the perpetuation of this belief. Also,
her role as an educator was increasingly more in evidence than her role as an active
photographer.

Another area of considerable ambivalence for her was her need to have her
role in the history of twentieth century photography acknowledged. She would no
sooner have told her story to an interviewer than she would promptly refuse to allow
it to be published. In 1975, for example, she took issue with the interpretation of
her work in the text of the catalogue accompanying the exhibition *Women of
Photography: An Historical Survey*. Some of her resistance was fuelled by her suspicion
of the sudden popularity of photography, and her sense of being crowded onto a
bandwagon in an undignified manner. Some came from her desire to have her story
told her way – a way that was, however, always self-contradictory. This attitude
prompted article titles such as "Keeping the Legend Intact",[14] and "Lisette Model:
Re-Emergence from Legend".[15] She began to earn a reputation as a difficult and
elusive figure. With characteristic contrariness, she enjoyed denying this.

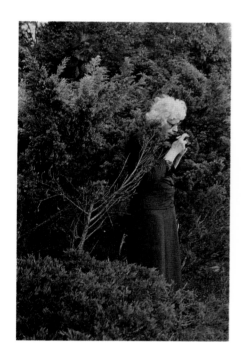

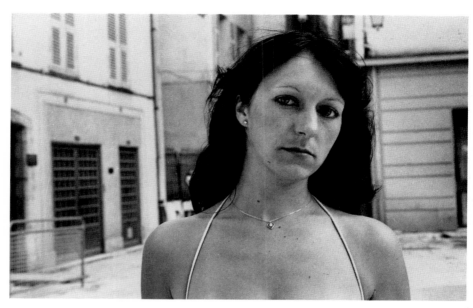

fig. 128
Nancy D'Antonio
Lisette Model, Venice – Taken
just off the vaporetto stop
en route to the Giardini exhibit 1979
Collection Nancy D'Antonio, New York

fig. 129
Lisette Model
Nice 1982
Full frame enlargement
by Justin Wonnacott from
original negative, 1989

fig. 130
Lisette Model
Evsa New York between 1970 and 1975
Full frame enlargement
by Justin Wonnacott from
original negative, 1989

Despite these difficulties, a number of projects that were monographic in approach did come to be realized in the seventies. In late 1977, *Camera* published an issue devoted to her work. The *Aperture* monograph, conceived in mid-1977, was launched in the fall of 1979.[16] The Center for Creative Photography dedicated an issue of their bulletin to their holdings of her material. An exhibition, *Lisette Model: A Retrospective*, showing one hundred and twenty-six modern prints of photographs dating predominantly from the 1930s and 1940s, was held at the New Orleans Museum of Art in the summer of 1981, and travelled to the Museum Folkwang in Essen, Germany, in the spring of 1982.

She gave a workshop at Berkeley in the continuing education department in 1973, and lectured at the International Center of Photography in the fall of 1977. In 1978 she was honoured, along with William Klein and Izis, at the *Rencontres Internationales de la Photographie* at Arles. In March 1979 she gave a workshop at the *Salone Internazionale di Cine Foto Ottica é Audiovisivi*, Milan, and one entitled "Personal Encounters" at *Venice '79* in the fall of that year. In the United States she lectured at the Pratt Institute in March 1978, the Boston Photographic Resource Center in 1979, and the Seattle Art Museum in 1979, among other venues.[17]

The portfolio was to be in an edition of seventy-five with an additional fifteen artist's proofs. Richard Benson was initially hired to print for Model, an arrangement that worked well for a brief period of time. However, his studio was outside of New York and, with Evsa's condition worsening, Model found the travel there onerous.[19]

Her photographs also reached an international audience during this period, largely as a result of the efforts of Gerd Sander, her dealer, and her work appeared in galleries such as Galerie Fiolet in Amsterdam, Viviane Esders in Paris, and the Ikona gallery in Venice, as well as in the Photographers Gallery, South Yarra, Australia. Just as the exhibiting of her work had become international, so Model's teaching was no longer confined to the New School and her apartment. She was invited to institutions in the United States and abroad to give lectures and workshops.[17] At the New School, changes to the course structure had been introduced and the program expanded with the arrival of Ben Fernandez as Chair of the Department of Photography in 1969. As a senior photographer, she presided over Master class workshops. A number of her students became close personal friends.

Several major projects and collaborations with gallery owners served to bring about a greater dissemination of her photographs. The Floating Foundation of Photography, a gallery and educational centre established in 1970 by Maggie Sherwood and moored in the Hudson River at the West Seventy-ninth Street Boat Basin, was a venue for her work regularly throughout the seventies.[18] Sometime in 1974 she made contact with Harry Lunn,[19] a Washington art dealer who had recently begun to handle photographs, through Helen Gee. An agreement was arrived at by Model and Lunn's gallery, Graphics International, to produce a portfolio of twelve of her photographs contained in an Evsa-designed case, with an introductory text by Berenice Abbott. By May of the following year, the portfolio selection was

fig. 133
**Lisette Model at Lee Friedlander exhibition,
Galerie Zabriskie Paris 1978
Owner unknown**

fig. 131
**Nancy D'Antonio
Lisette Model, Venice –
Review of student's photographs 1979
Collection Nancy D'Antonio, New York**

fig. 132
**Arnold Kramer
Interior, 137 Seventh Avenue South,
New York April 1983
Collection Arnold Kramer, Washington**

In December of 1975, Model wrote Lunn that she would not accept the prints by Richard Benson that she had initially received quite positively. In January 1977 Gerd Sander took over the printing, and by the summer the project was completed. She had instructed Sander to print "closed and dark", resulting in prints that are 16 x 20 inches (40.4 x 50.6 cm) in format, grainy, and with much more contrast than the vintage prints she herself had been responsible for printing.[20]

well underway. Within seven months, however, it had become bogged down by a dispute.[20]

In June of 1975 she had met Gerd Sander, a photographer, grandson of photographer August Sander, and future owner of the Sander Gallery in Washington, for the first time. In September and October of 1976 she had her first exhibition there, *Model Photographs*. Eight months later her images were exhibited at the Galerie Zabriskie in Paris, along with those of former students Rosalind Solomon and Diane Arbus.

In January of 1976, Evsa suffered a massive heart attack that left him requiring almost constant attention. His exit from the world was slow and painful. His financial dependence on Lisette had been there almost from the beginning of their close-to-forty-year partnership, but the emotional and physical dependency, which started in the late sixties when he stopped painting and his health had already begun to decline, must have required considerable adjustment on her part. On 19 October 1976, in the early hours of the morning, Evsa died. He was cremated the following day in St Michael's Cemetery and Crematorium.[21]

The period after Evsa's death was emotionally hard on Model. She continued to live in the basement apartment that had been home to them for the past twenty years (fig. 132), but scrawled across an envelope containing receipts a simple acknowledgment of his absence: "Lisette without Evsa".

She survived friends of the same generation like Alexey Brodovitch, and lived to experience the deaths of students to whom she felt deep attachments, such

as Diane Arbus[22] in 1971, and Charles Pratt[23] in 1976. In 1983, at 1:47 a.m. on 30 March, twenty-seven minutes after a final visit by her doctor, Lisette Model died in the New York Hospital. Until that final moment, her participation in life was complete and uncompromising.

THE LEGACY

Although the taking of photographs was still clearly of importance to her, the strongest sense of connectedness from the mid-seventies to the time of her death seems to have been between Model and her students. Her talent for contemplating and responding to photographic images certainly matched, if not overtook, her influence as a photographer in the latter years of her life (fig. 133). When we consider how alien she had found the process of regarding a single photograph some forty years earlier, it is remarkable that this ability to analyze images and perceive their connections to the photographer became such a pronounced strength. She became not only a capable critic, but something of a mentor. Particularly with other women photographers, her role went beyond that of instructor to that of constant sounding board and advisor. She took on private students, some paying, and others non-paying, such as Rosalind Solomon, who started studying with her in 1972, Elaine Ellman, Lynne Davies, Joan Roth, Marie-Claire Montanari, and Nancy Rudolph.

Model's vision as a photographer and as a teacher was recognized by two honorary awards. In New York on 4 June 1981, thirty years after she had started teaching at the New School for Social Research, she received, along with her friend of forty years, Berenice Abbott, an Honorary Doctorate from the institution. On 5 April 1982, she was awarded the Medal of the City of Paris.

These awards were a richly deserved recognition of a lifetime of influential work. What, exactly, was her contribution?

Primarily, Model brought a frank subjectivity and the expression of strong passions to a medium conventionally noted for its mechanical and seemingly neutral capacity to record information. She used the camera as a direct and accurate means to express emotion. Understanding the distinctive qualities of the photographic process, but never feeling enslaved or intimidated by it, she was quick to identify the ways in which it could serve her. Her preoccupation with the force and clarity of her message presided over the plethora of information the camera was capable of recording. Elizabeth McCausland identified a tension between Model's expressive impulses and the properties of the medium:

Lisette Model's intuitive approach to her work creates contradiction. Her emotional response to experience is immediate and direct. Yet she is harnessed to a method requiring the restraint of a complex technic. She strains at these bonds; for the camera is infinitely slower than feeling, and the lens far less selective than the mind's eye. Truly a dilemma.

For Lisette Model, personally, no doubt the dilemma is painful. In regard to photography, generally her case underlines the truth that photography's direct and definite character does not spell the end of its possibilities. Fascinated by precision, definition, minute rendering of detail,

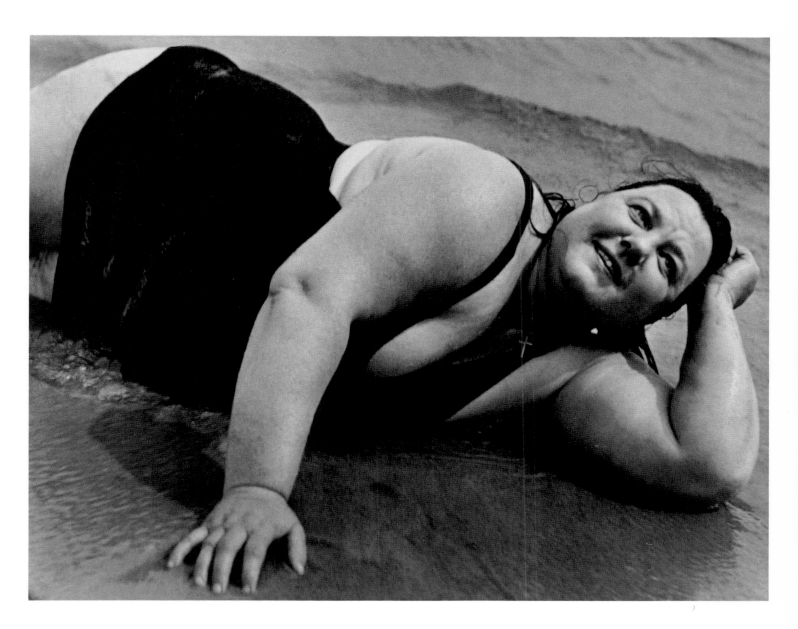

25 **Coney Island Bather** New York between 1939 and July 1941

we are likely to forget that photography may equally be an instrument for fantasy, a comment, a channel for emotion. Lisette Model's photographs seem superficially to fall into the category of anti-technic or impressionism.[24]

Model's "anti-technic" countered the indiscriminate, fact-collecting nature of the medium: she practised unabashed manipulation of the negative, cropping, tilting, burning, and dodging, suppressing extraneous details. Two images that were the result of such shaping have virtually acquired the status of icons: the two versions of *Coney Island Bather*. The subject was apparently as ebullient as she appears in the portraits: she urged Model to take her picture, and answered the sniggers of onlookers with, "What's wrong with you? Have you never seen a fat person before?" For Model, the portrait was a recognition of the whole person and not a polite evasion of any one aspect. In the recumbent version (pl. 25), the Rubenesque bulk of the bather structures the image, edging out all extraneous detail. This archetypal earth goddess lies by the sea with a defiant voluptuousness, her face radiant, indeed triumphant. Her fleshiness is fully expressed, as is the sensual contact of her hand with the water and her torso with the mud.

In "Camera Satire and Sympathy", McCausland implores her readers to look at Model's photographs, appreciate their acute subjectivity, and be conscious of their unorthodox nature:

Study them closely, and another moral emerges: that photographs may be as personal, intuitive, emotional, as the individual who makes them. In this kind of unconscious revolt from rules, Lisette Model broadens our conception of the medium's expressive qualities.[25]

Portraits are the images for which she became most celebrated, but her more abstract works, in which the human form is reduced to a blurred line or a truncated composite of dense shapes and reflected lights, as in *Running Legs* and *Reflections*, also extended the medium's expressive qualities. *Running Legs, Fifth Avenue* (pl. 26) is a radical treatment of a subject already unconventionally seen. It is authoritative in its sense of geometry, with the taut, light lines of the string, the crude blur denoting a hand, and the merging of legs and parcel to produce a dynamic silhouette that occupies three-quarters of the space.

Model approached the mundane in an unusual way, but she also introduced subjects considered taboo. We know from her notebooks that she understood the role that photographs, like other images, play in confirming or challenging social norms. Aware of their particularly canny ability to allude to and even symbolize reality, she made photographs that disturbed the significant number of rules and taboos that surrounded the medium when she began her career, some of which survive into our own time. Her powerful attractions and compulsions moved like an army of bulldozers over the terrain of neutral truths and social orthodoxies, giving form to images full of force, whether compassionate or satirical. *Albert-Alberta, Hubert's Forty-second Street Flea Circus* (pl. 27) is a bold portrait of an insouciant subject: male and female, smooth and hairy, coy and exhibitionist. This was the gritty stuff of legend that attracted Model. Brassaï's photographs of the demimonde

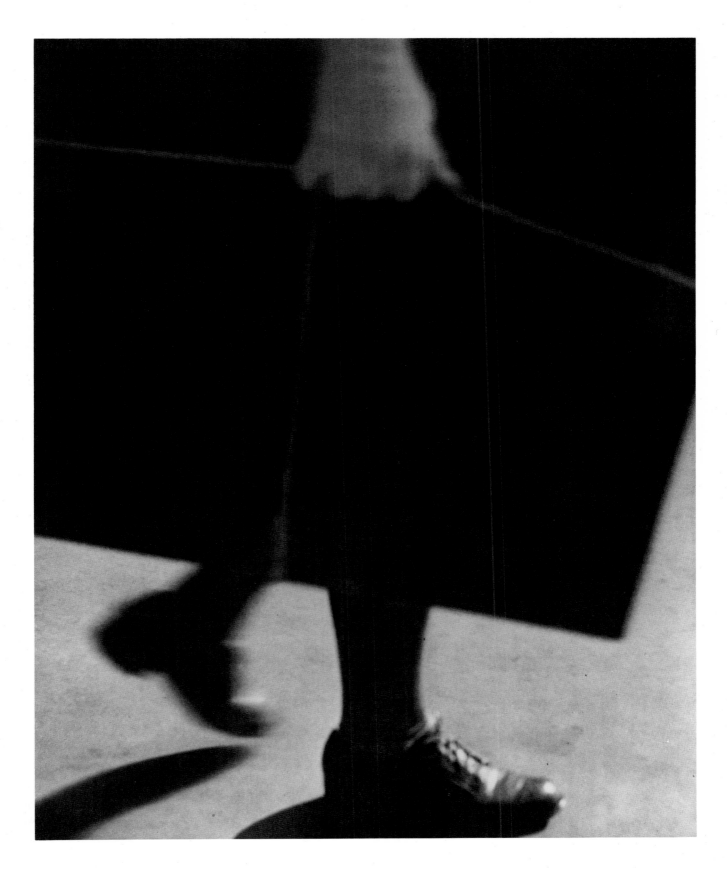

26 **Running Legs, Fifth Avenue** New York between 1940 and 1942

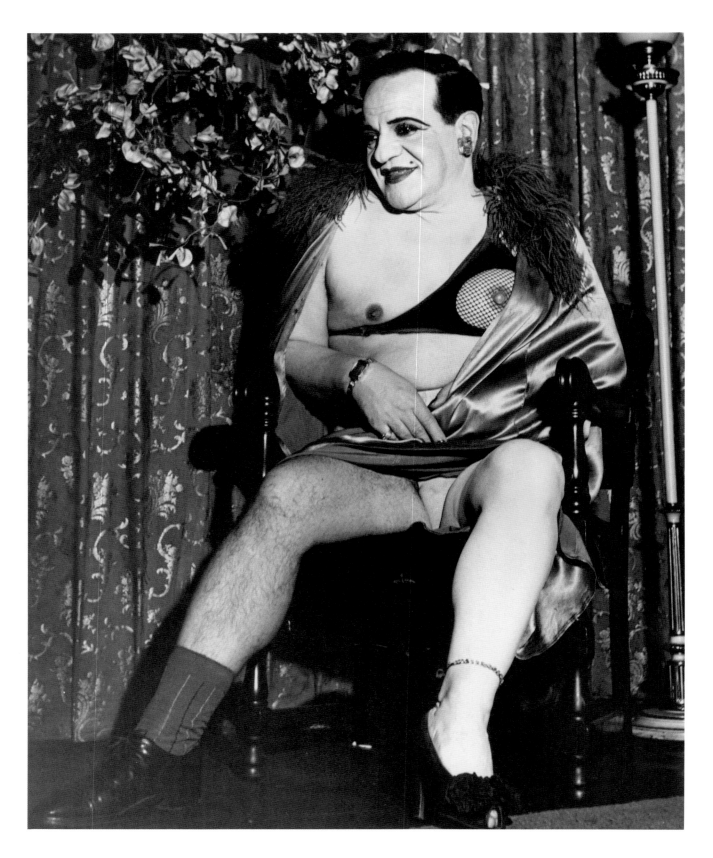

27 **Albert-Alberta, Hubert's Forty-second Street Flea Circus** New York c. 1945

are full of romance, perhaps even glamour. In contrast, Model photographed people like the female impersonators working, which also meant having fun and being rude, as if to excise them from the romantic context. Her portraits of those at the so-called margins of society are situated solidly in an environment that is particular and thus convincing. McCausland accurately observed that Model was "obsessed by the face of humanity", whether those "on the Riviera, among the rich amusing themselves at Monte Carlo and Juan-les-Pins, or . . . the homeless who sleep on hard stone benches along the Seine. . ."[26]

This obsession of hers was to transform the concept of the heroic portrait in photography. Subjects normally excluded from portraiture, subjects from whom viewers would most often avert their gaze – the blind, fat, derelict, deformed, and aged – were portrayed without condescension or pity. Only faces that bore the marks of the experience of life attracted Model. People usually considered common-place and without distinguishing merit became, in front of her lens, uncommon and heroic. Nor was it the mere fact of isolating the subject through the act of pho-tographing them that conferred a special importance. In the *Lower East Side* series, a dwarf stands on a sidewalk in partial shadow (pl. 28). Lozenges of light dapple the background façade of the Belmar Hotel on the Bowery, the open door, and the pavement. They also gently illuminate his stunted torso and face, spotlighting an expression of immense sadness. Yet, like Velasquez's subject in the painting *The Dwarf Francisco Lezcano*, he is quietly heroic: for all its implied gloominess, this is his territory and he occupies it with authority. Whatever the nature of his private pain, he has not anaesthetized himself to it.

In another image (pl. 29), a woman is photographed by Model ambiguously shielding her face. Her gesture, possibly an expression of fatigue, or perhaps a blocking from the gaze of the photographer or a protecting of herself from the light of the sun, is seen by Model as strong, elegant, and above all humanizing. Great emphasis has been placed on the legibility of the arm, on the wrist slightly thick-ened by arthritis, the capable hand. The image illustrates what McCausland correctly identified as an essentially photographic quality in her work, a "kind of reality or contemporaneity" that "could only be created with the camera."[27] Model understood the dramatic potential of light, and, just as she tilted, flopped, angled, changed focus, and otherwise radically manoeuvred her negatives and altered their original composition to arrive at an expression true to her view of the subject, so she exploited light and its absence to enhance her message. The light that falls upon the "Mayor of Delancey Street," as this subject was known, intensifies the taut, smooth, aging flesh, making her presence tangible. A powerful element in the formal coherence of the image, the arm is an expression of the subject's flesh-and-bone reality, her physical existence in the world.

Many of Model's most moving images are homages to human presence, in all its varied forms. These, for the most part, reiterate Canadian pianist Glenn Gould's romantic observation that it is better to have existed a little than never to have existed at all. But there are photographs by her that elucidate something less tan-gible, the interior moods, swings of feeling and thought, eruptions of imagination and memory, expectations and disappointments felt by us all.

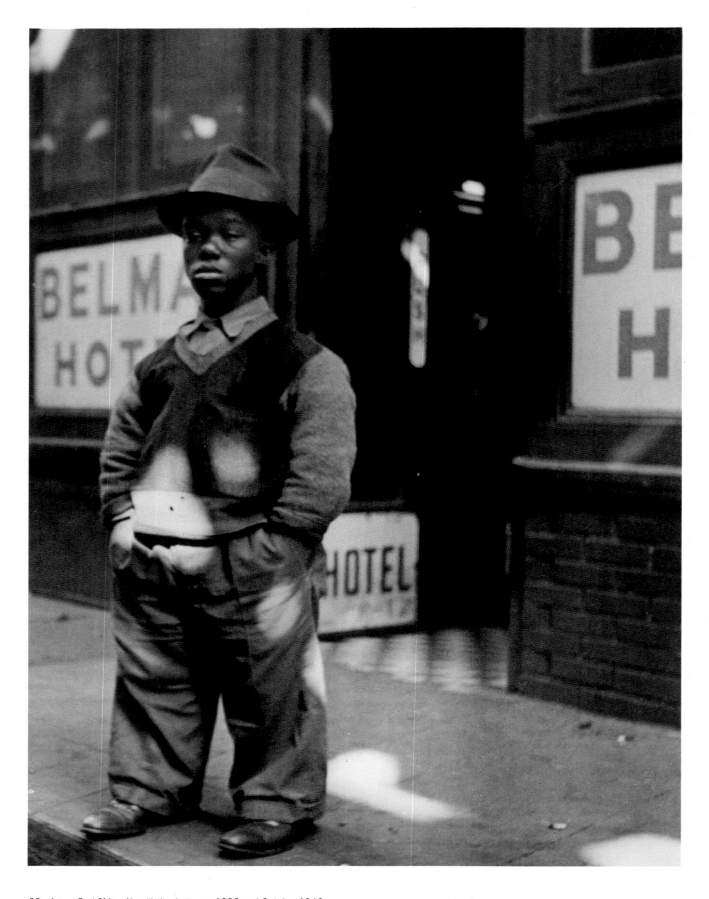

28 **Lower East Side** New York between 1939 and October 1942

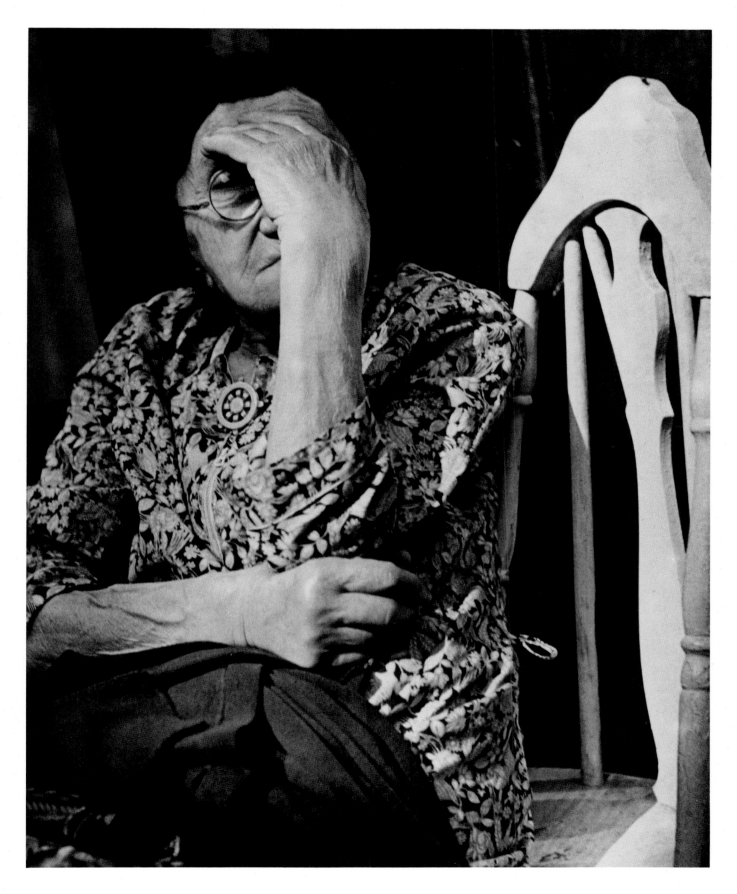

29 **Lower East Side** New York between 1939 and 1945

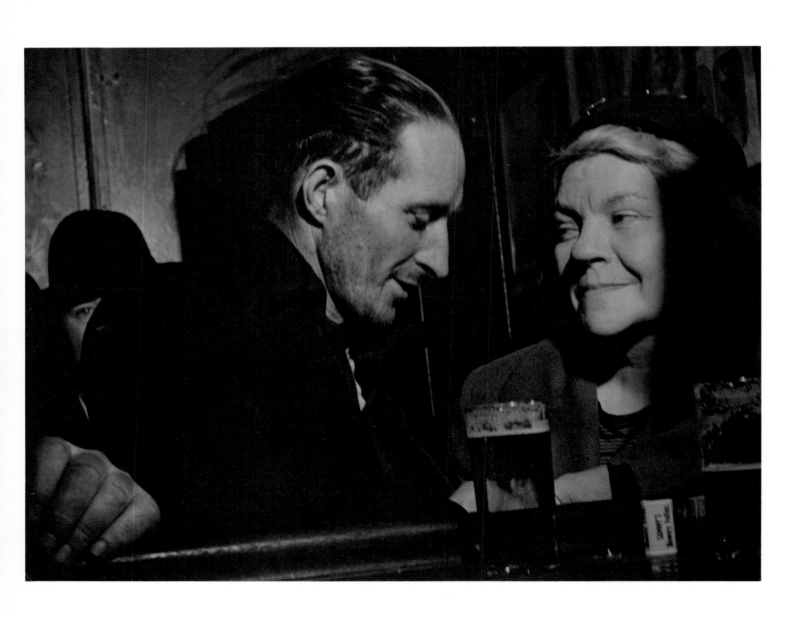

30 **Sammy's** New York between 1940 and 1944

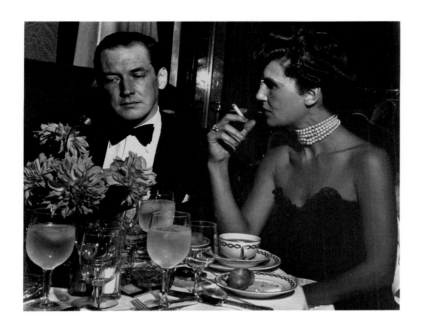

fig. 134
Lisette Model
St Regis Hotel New York c. 1945
Gelatin silver, printed 1981
50.8 × 60.9 cm

A sub-text in some images, these become the subject in others. In *Sammy's* (pl. 30), mood dominates. The empathetic human exchange that is taking place is the central point of the image. The portrait shows a man and a woman inextricably linked in a moment of communion. Light floods the woman's features, allowing Model to describe the "tenderness that this older woman feels for the younger man" [28] in visual terms.

A comparable drama is observed by Model in a completely different setting (fig. 134). Here the image is rich with ambiguity and psychological tension, stressed and adumbrated by passages of light and dark. Our attention is drawn to the melancholic, introspective mood that appears to encapsulate the man by the light passing over his features, flashing back from his starched dress shirt, and, finally, revealing eyes averted from his companion. By contrast, the expression of this person, whose classic and androgenous features, partly in deep shadow, are turned toward him, is harder to read.

Depiction of emotion, of conflict, fear, pain, and simply of the condition of being human was the linchpin of Model's vision. She believed that art should confront, challenge, and reveal, a fundamental motive in her photography that reflects her Viennese origins and her appreciation of the work of artists like Egon Schiele and George Grosz. Much has been made of her affinity for the human subject and her confirmation of the equality of all human beings through her photographs. Yet, one image in particular that seems to sum up her confrontational stance and her uncommon viewpoint is of animals. It is a portrait of two bull terriers confined to their adjacent stalls before being paraded before a panel of judges at a dog show (pl. 31). The one on the left looms forward out of the shadows of its box. We could

surmise that, a moment before the human with the strange instrument arrived, it too had been curled up in a fetal position in a corner, like its neighbour. Its expression – it has a melancholic look not unlike the man in the St Regis photograph – like its posture, is a confusing combination of vulnerability and contained aggression. In contrast, its companion remains nestled in the narrow far end of the box, aware of the intrusion but not prepared to act on it. Its posture is reminiscent of that of the man in the *Promenade des Anglais* series, who meets the photographer's eye with lethargy and wariness, conscious of the challenge of her presence but unwilling to respond or defend himself against it other than by an exchange of glances.

Notwithstanding, bull terriers are dangerous rather than decorative, which was the way Model liked her images to appear. Equally, they are short-haired and pink-eyed, more inclined to evoke feelings of revulsion than of attraction. A mental image of Model peering into their box, examining the primitive, naked-looking creatures and photographing them directly and from close up, recalls the photograph she once made of a young girl staring with raw curiosity at a plucked goose hanging in a window (fig. 64), and also experiencing, no doubt, a range of conflicting feelings.

One of the great and abiding qualities of Lisette Model's photographs is that they will always raise more questions than they answer. Her images provoke epic deliberations in the way that the title of a single painting by Gauguin's does: *Where do we come from? What are we? Where are we going?* Perhaps the last word[29] should be that of the critic who wrote most perceptively about Lisette Model's work, almost fifty years ago, Elizabeth McCausland:

Here is a woman who operates almost purely by intuition.

It is as if, in the camera, she had substituted her own uncovered nerves and emotions

for light-sensitive gelatin emulsion; as if experience had burned itself into her retina

as indelibly as the photographic image is embedded in silver particles.

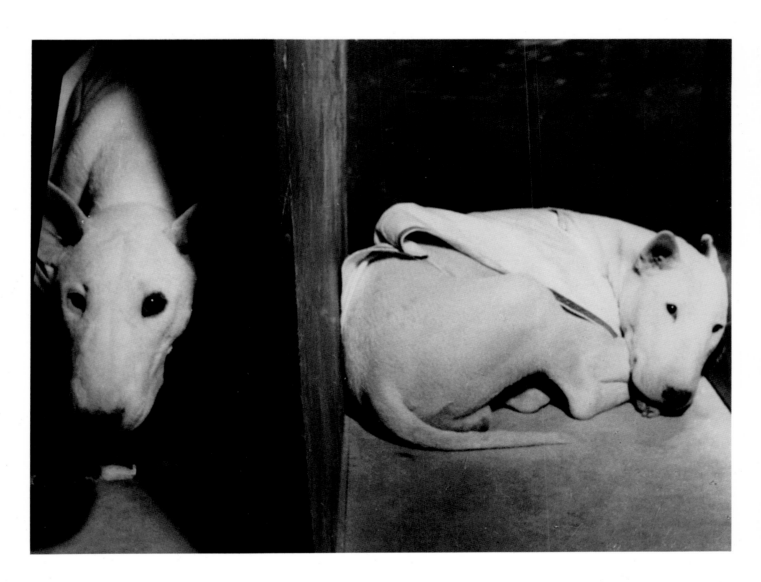

31 **Westminster Kennel Club Dog Show** New York February 1946

If I photographed animals, for instance, I would love them all, but I would photograph an enormous animal like an elephant, a rhinoceros, or a whale. All the other things are marvellous too, but I know this is what I would do. . . . I have noticed that when I photograph people in close-ups, I always take away everything in the background as much as possible. So I have come to the conclusion that there are huge biological forms that attract me. . . . Now if that is an explanation, I do not know. You mustn't forget that, all together, I have not photographed more than maybe twenty people who were large, fat, and voluminous.

— Lisette Model (Cooper / Hill)

32 **Vincennes Zoo** Paris between 1933 and 1938

33 **Vincennes Zoo** Paris between 1933 and 1938

34 **Vincennes Zoo** Paris between 1933 and 1938

35 **Vincennes Zoo** Paris between 1933 and 1938 36 **Vincennes Zoo** Paris between 1933 and 1938

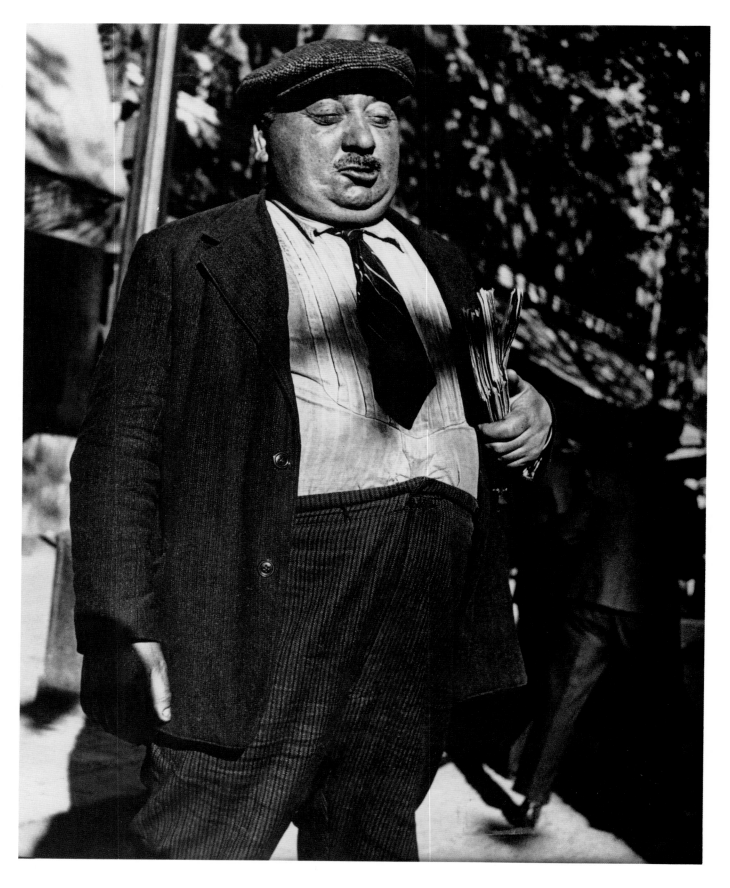

37 **Man with Pamphlets** Paris between 1933 and 1938

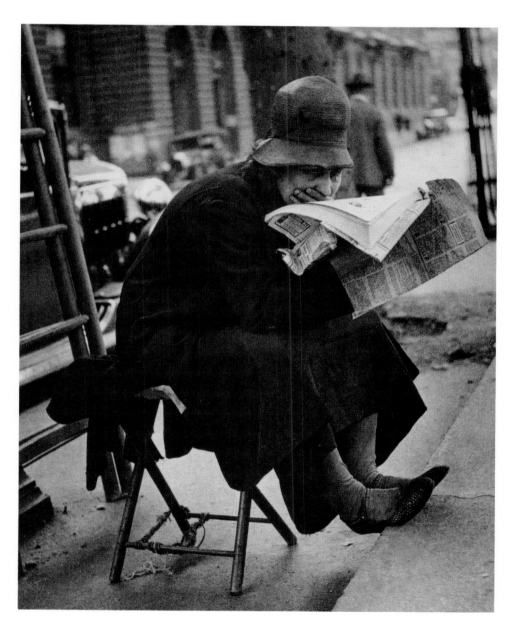

38 **Woman Reading** France between 1933 and 1938

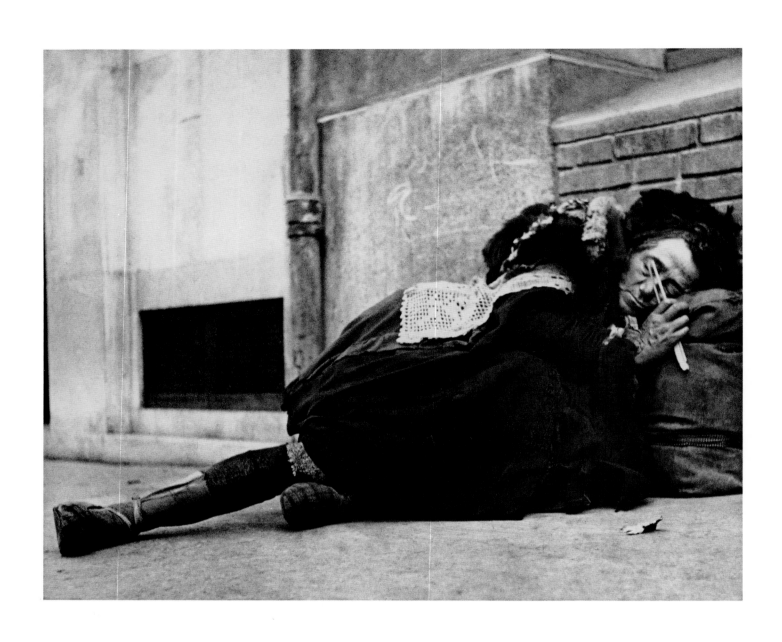

39 **Sleeping on Montparnasse** Paris between 1933 and 1938

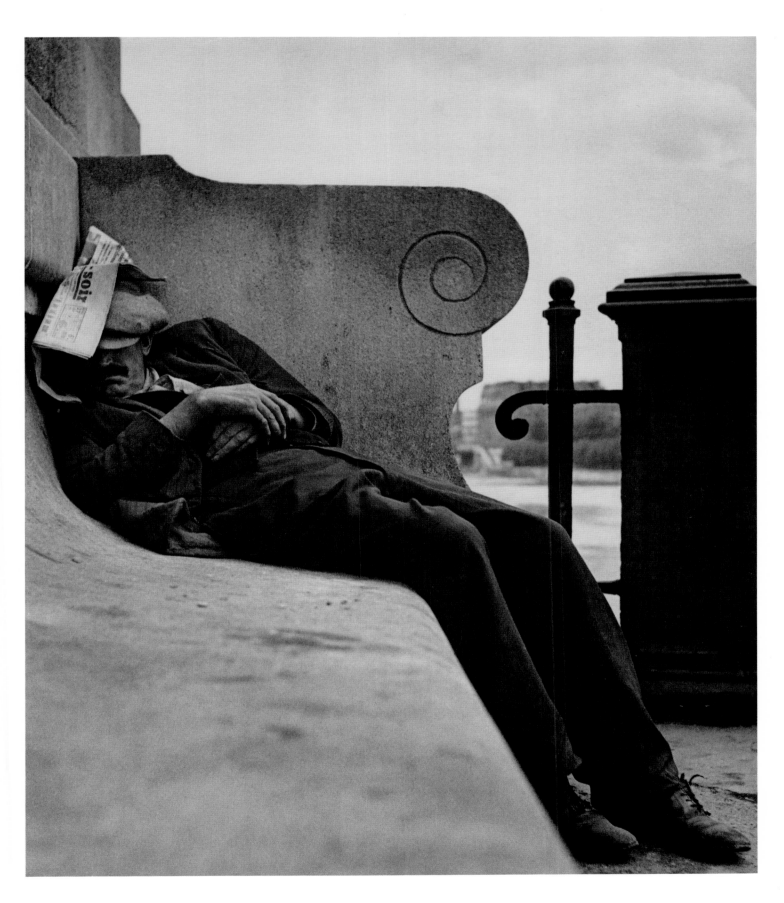

40 **Sleeping by the Seine** Paris between 1933 and 1938

41 **Young Man Asleep on Sidewalk** Paris between 1933 and 1938

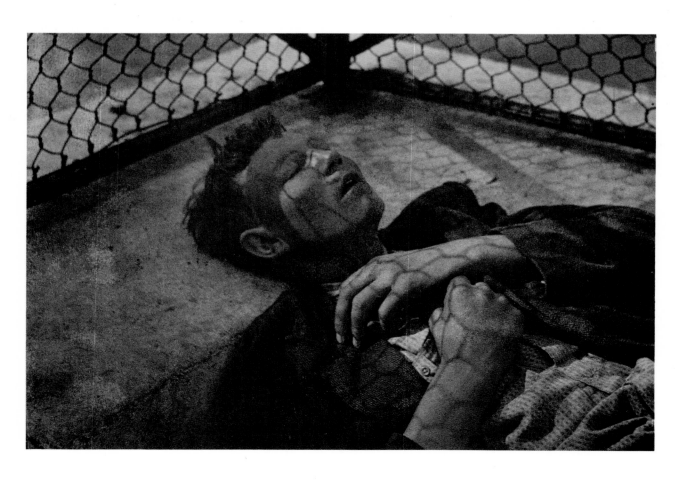

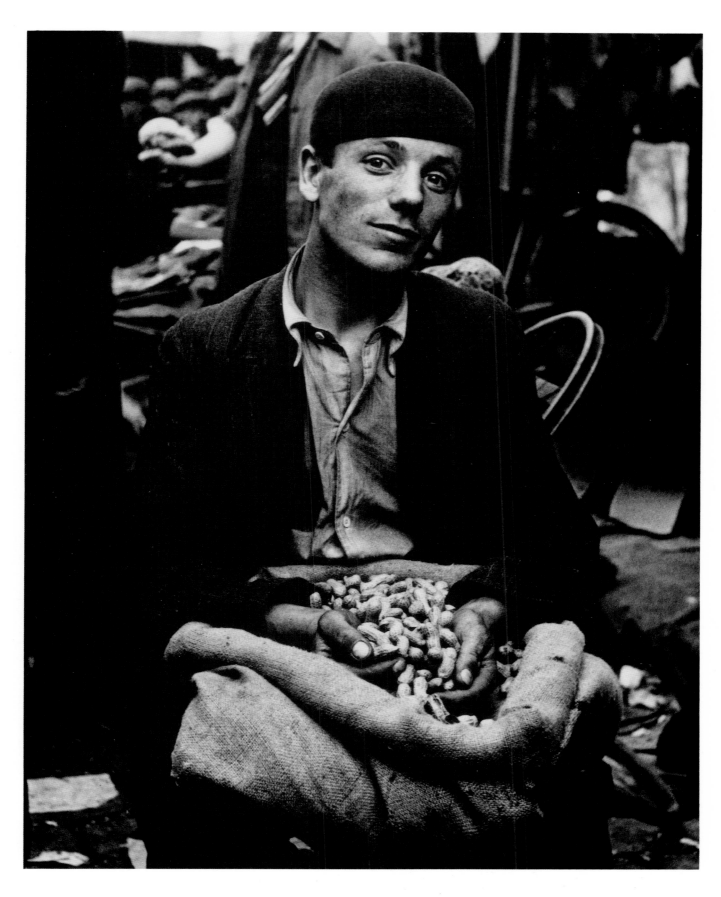

42 **Peanut Vendor** Nice between 1933 and 1938

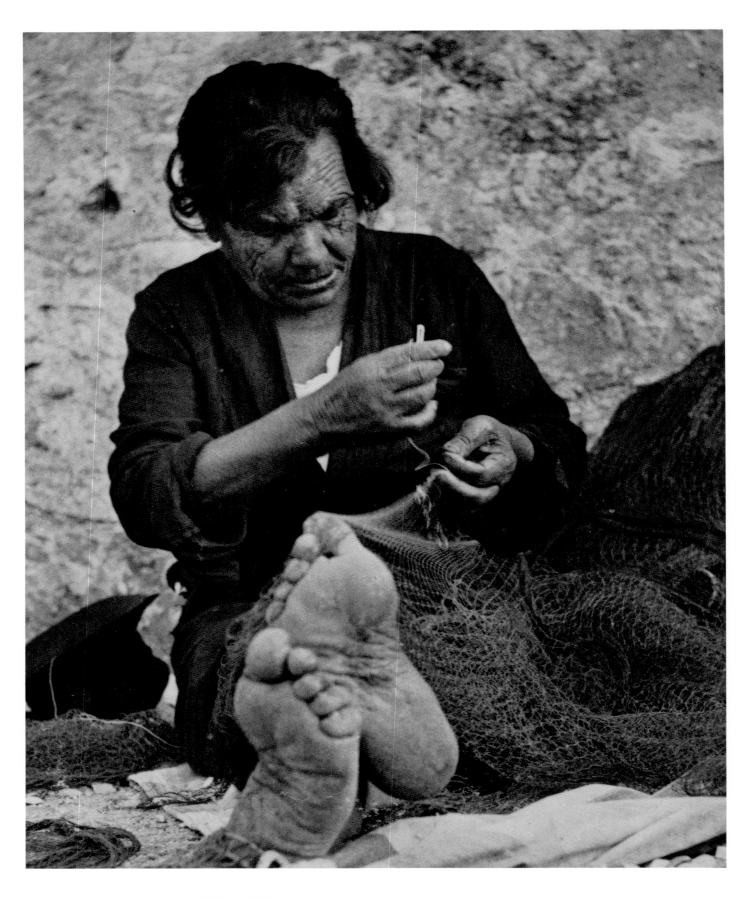

43 **Man Mending Net** Nice between 1933 and 1935

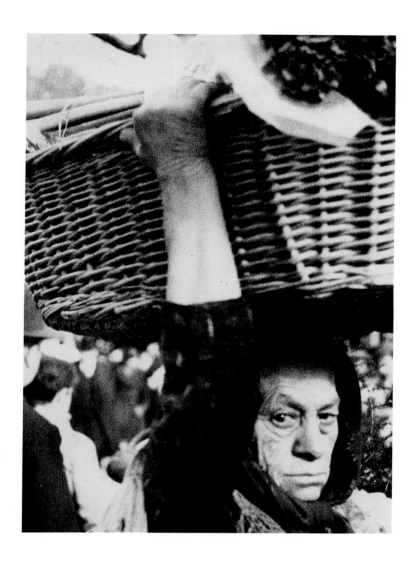

44 **Woman with Basket** Nice between 1933 and 1938

45 **Destitute Woman Seated on Bench** France between 1933 and 1938

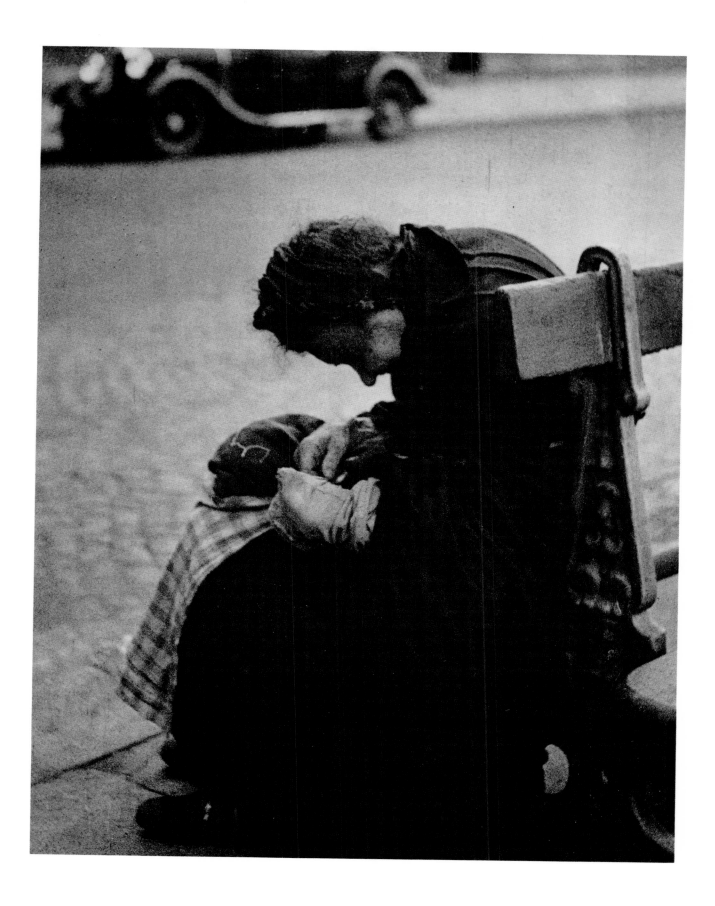

189

46 **Promenade des Anglais** Nice 1934?

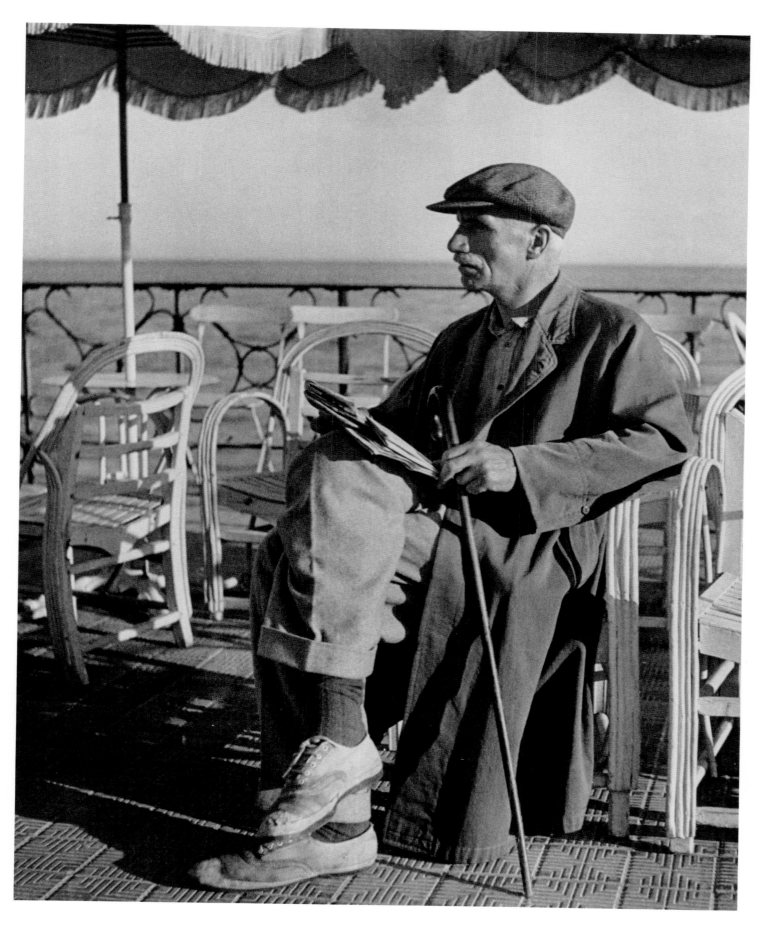

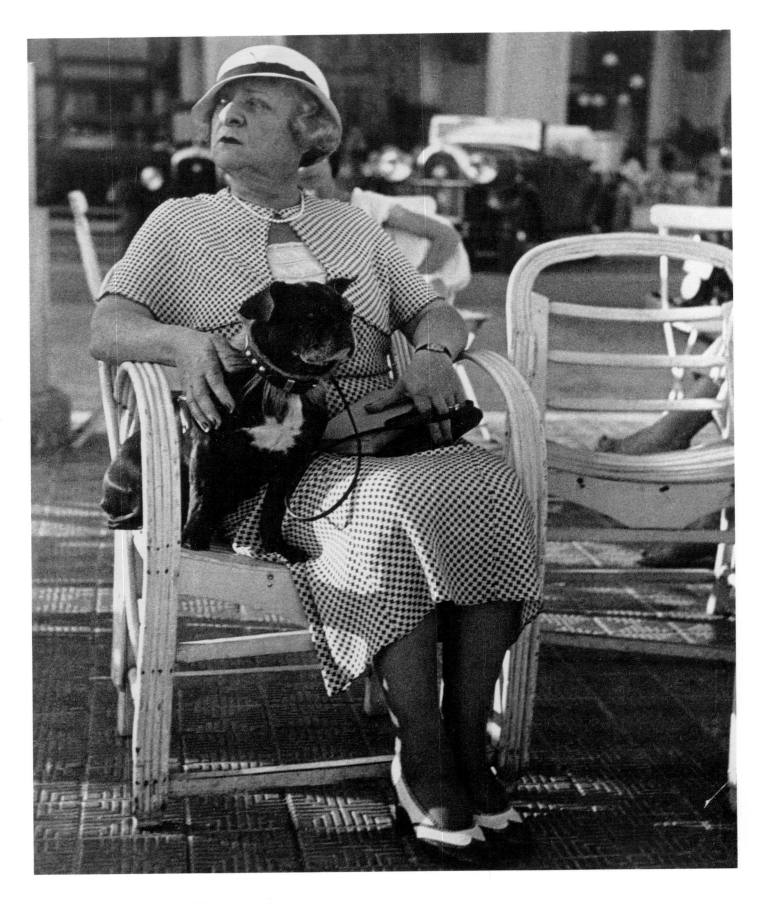

47 **Promenade des Anglais** Nice 1934?

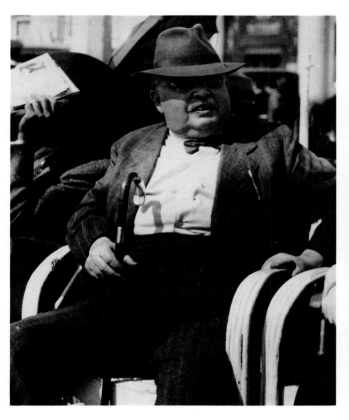

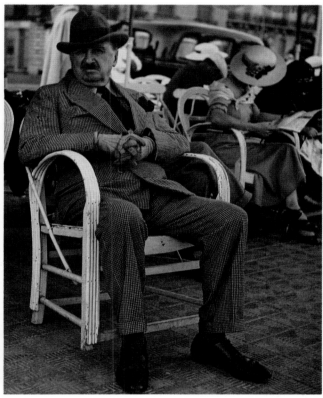

48 **Promenade des Anglais** Nice 1934?

49 **Promenade des Anglais** Nice 1934?

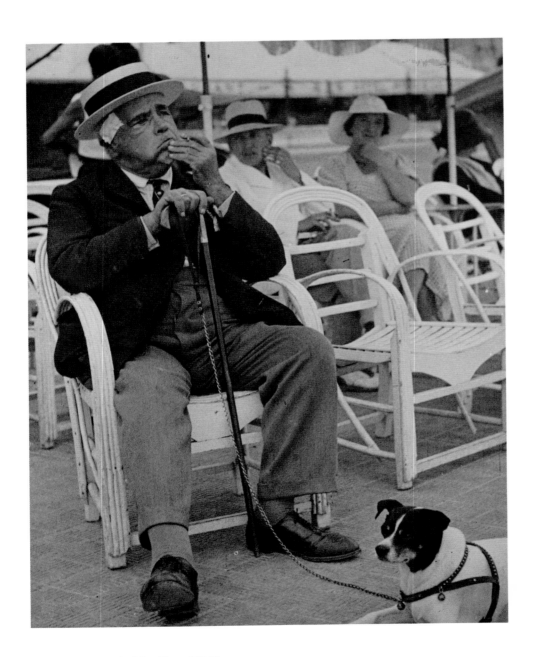

50 **Promenade des Anglais** Nice 1934?

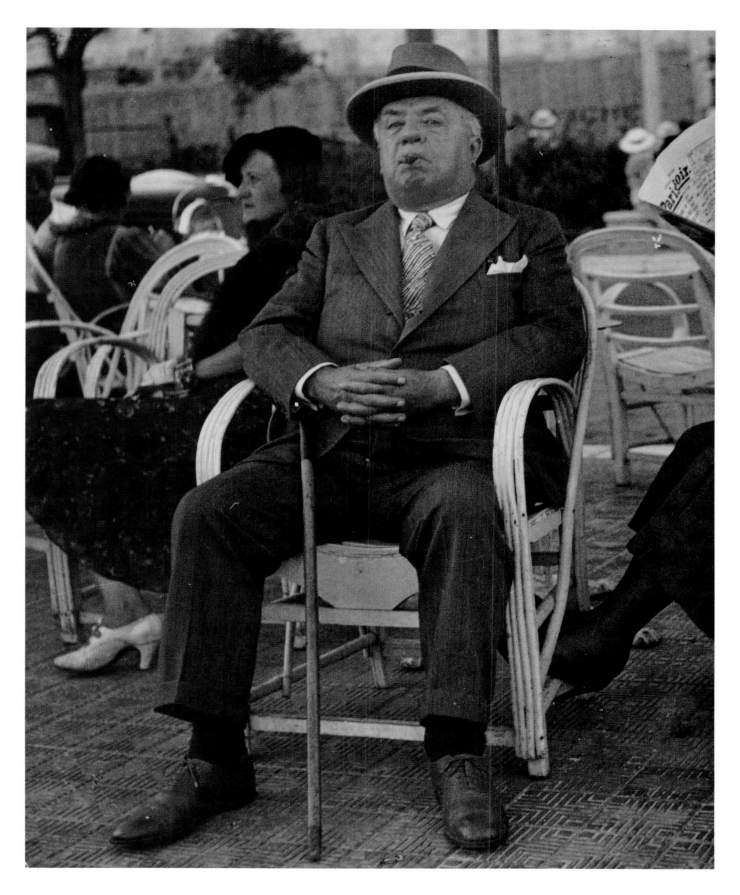

51 **Promenade des Anglais** Nice 2 September 1934

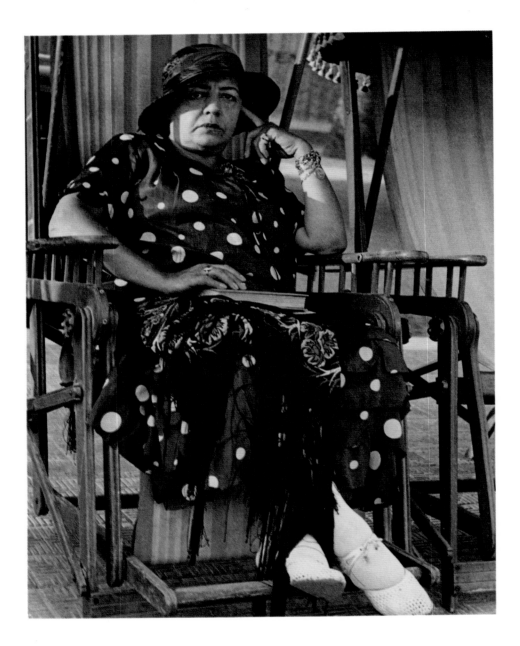

52 **Promenade des Anglais** Nice 1934?

53 **Promenade des Anglais** Nice 1934?

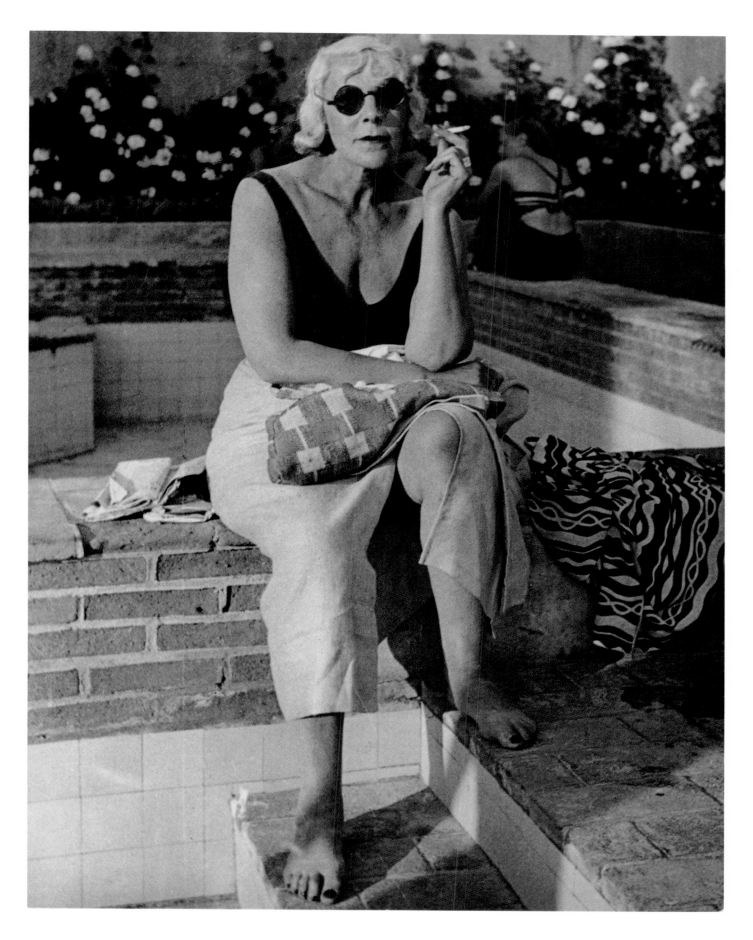

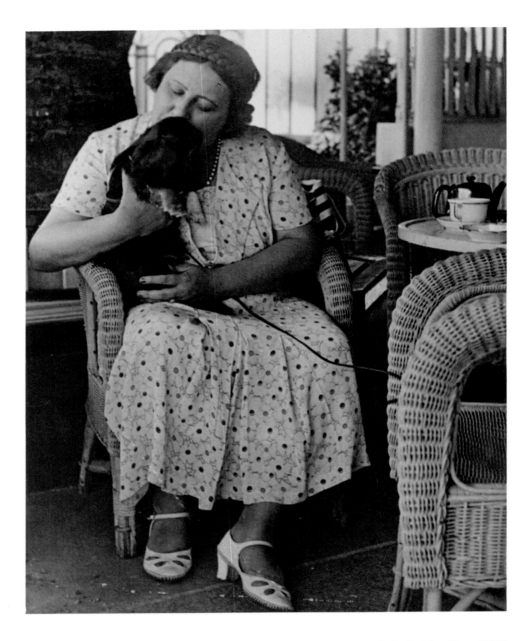

54 **Promenade des Anglais** Nice 1934? 55 **Promenade des Anglais** Nice 1934?

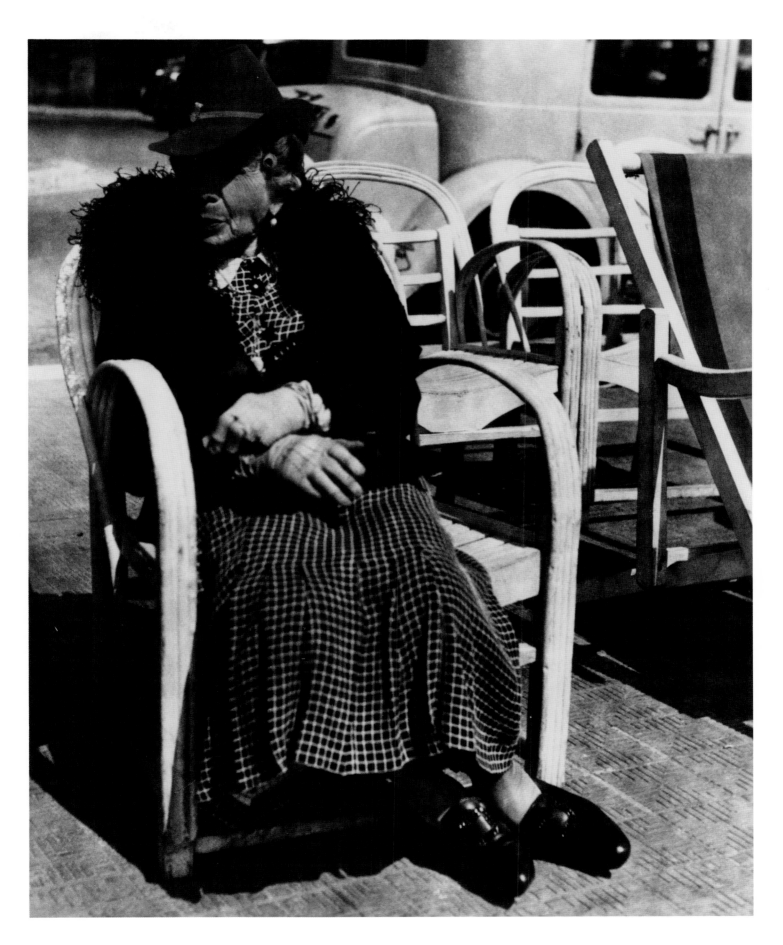

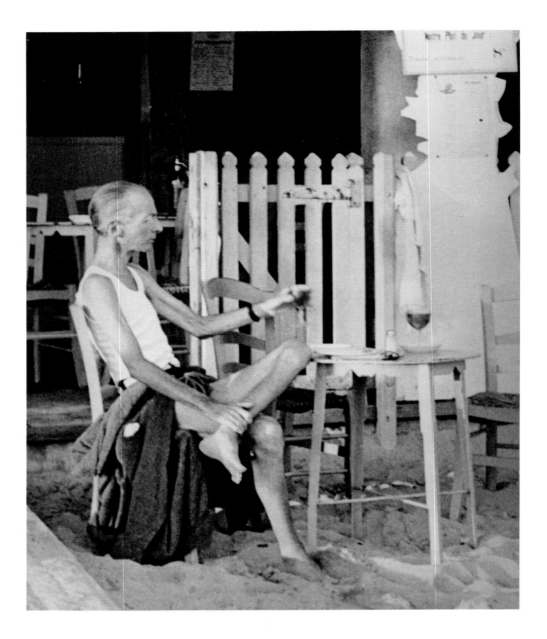

56　**French Riviera**　1934?

57　**French Riviera**　1934?

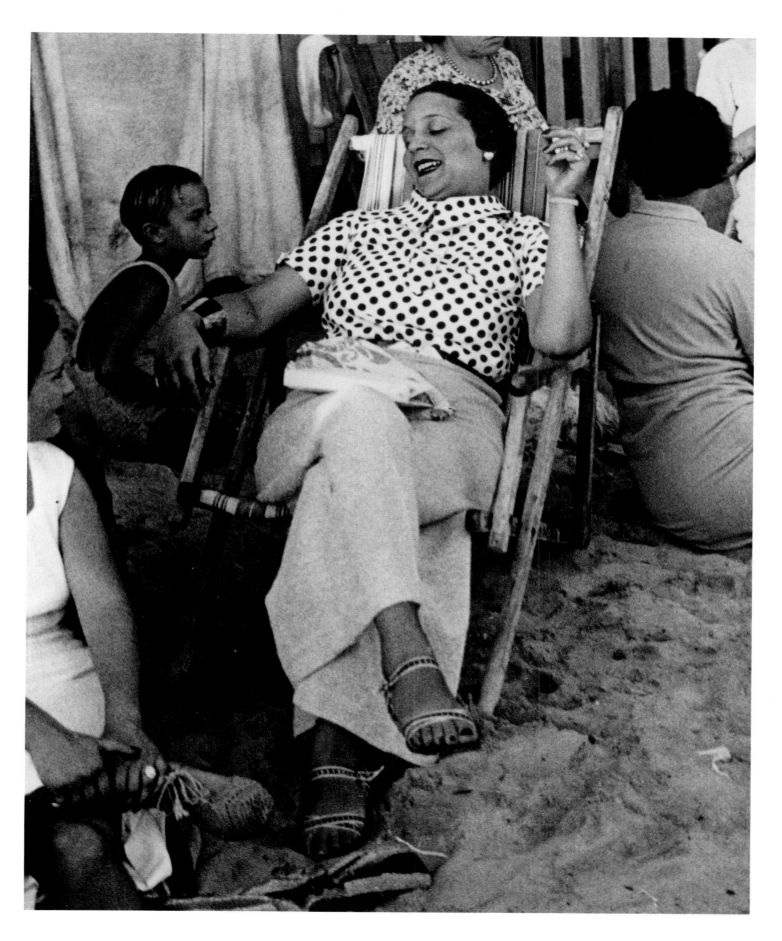

201

58 **Promenade des Anglais** Nice 1934?

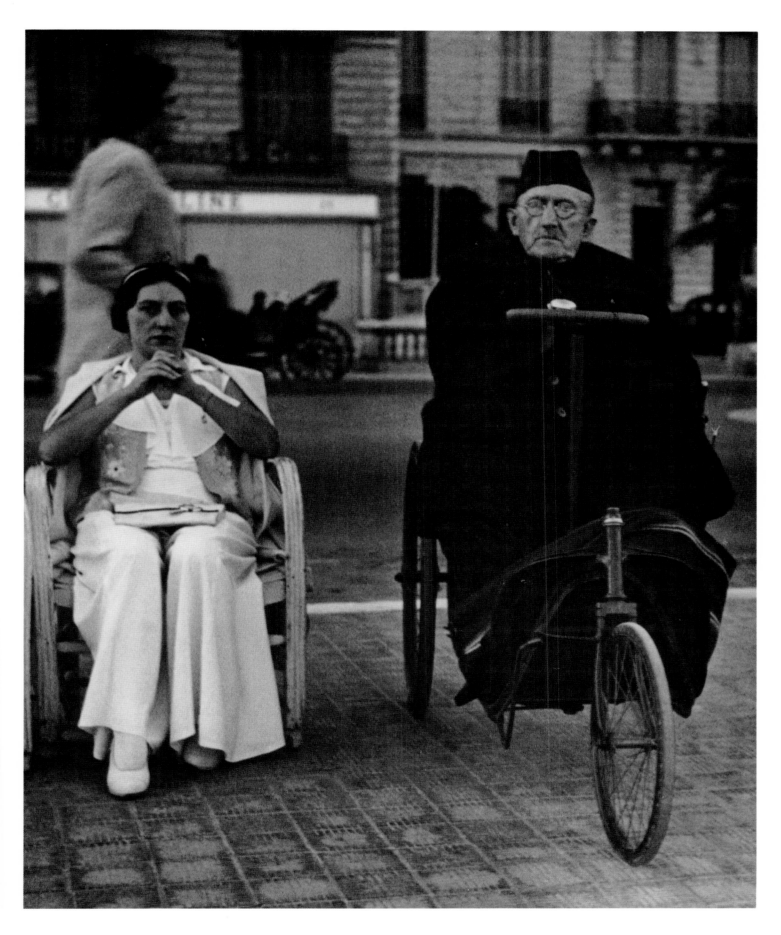

59 **First Reflection** New York between 1939 and October 1940

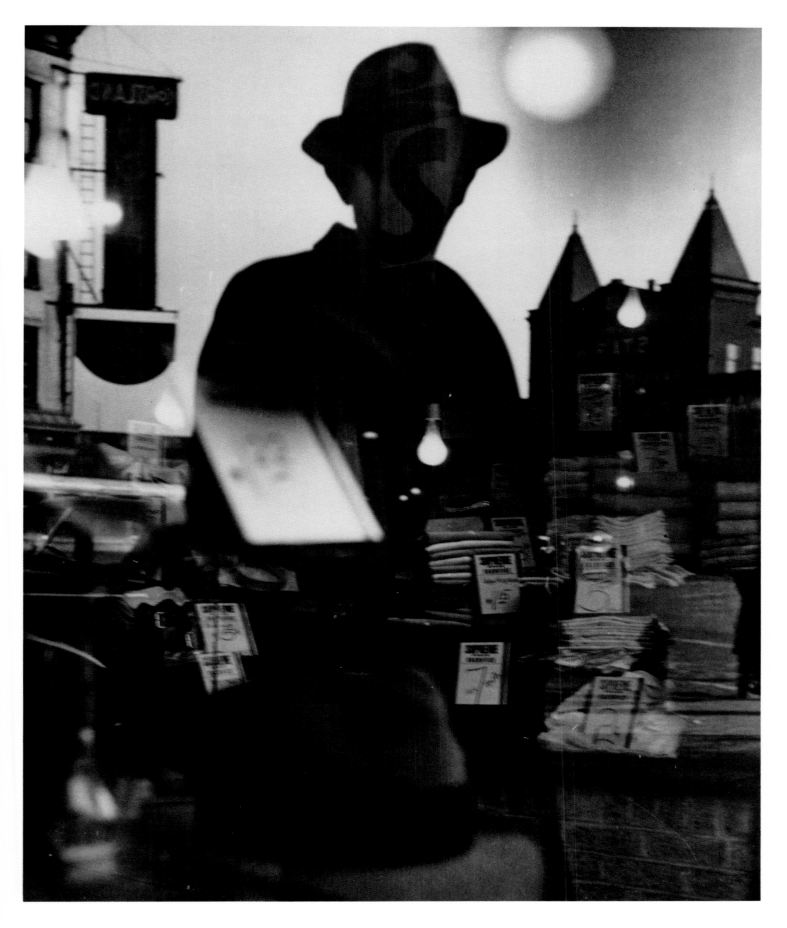

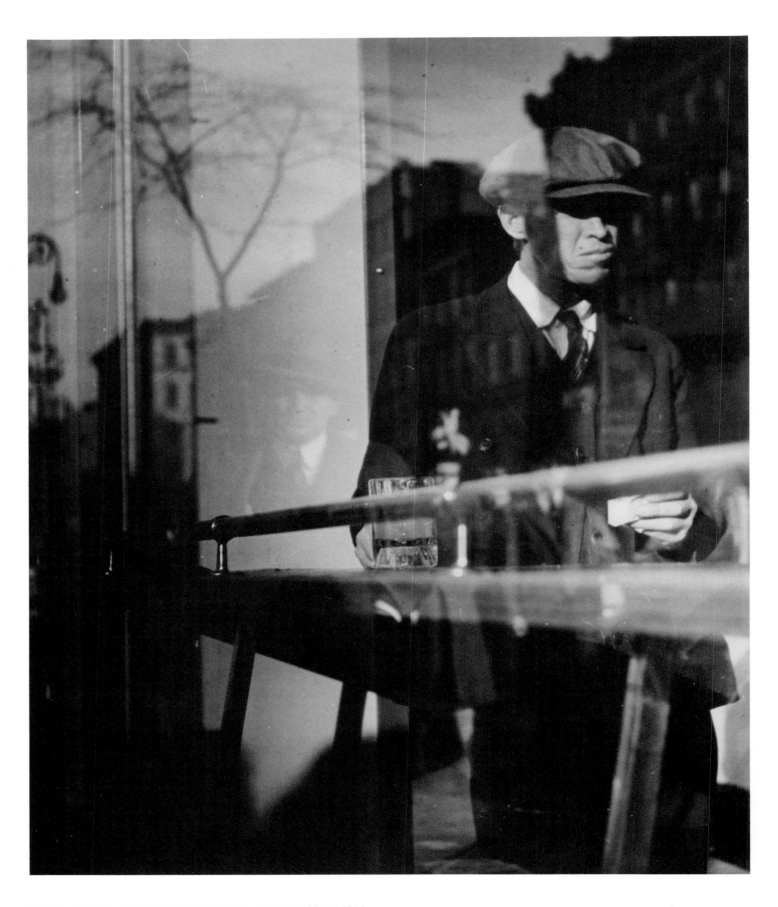

60 **Man in Restaurant, Delancey Street** New York between 1939 and 1945

61 **We Mourn Our Loss** New York 1945

62 **Chicken and Glamour** New York between 1939 and 1942

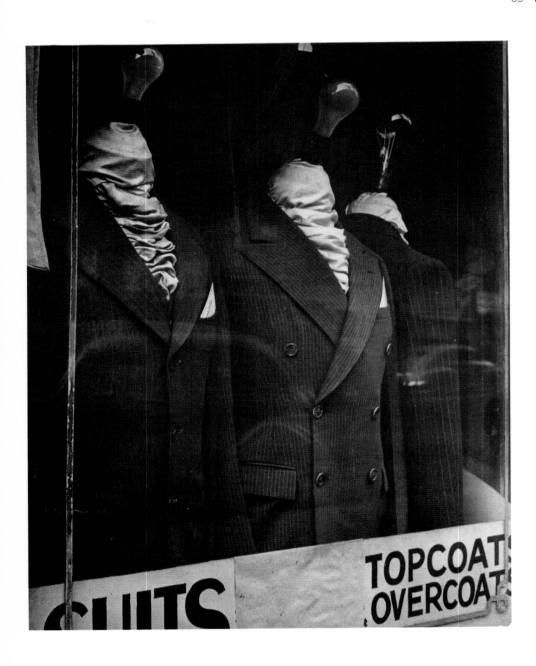

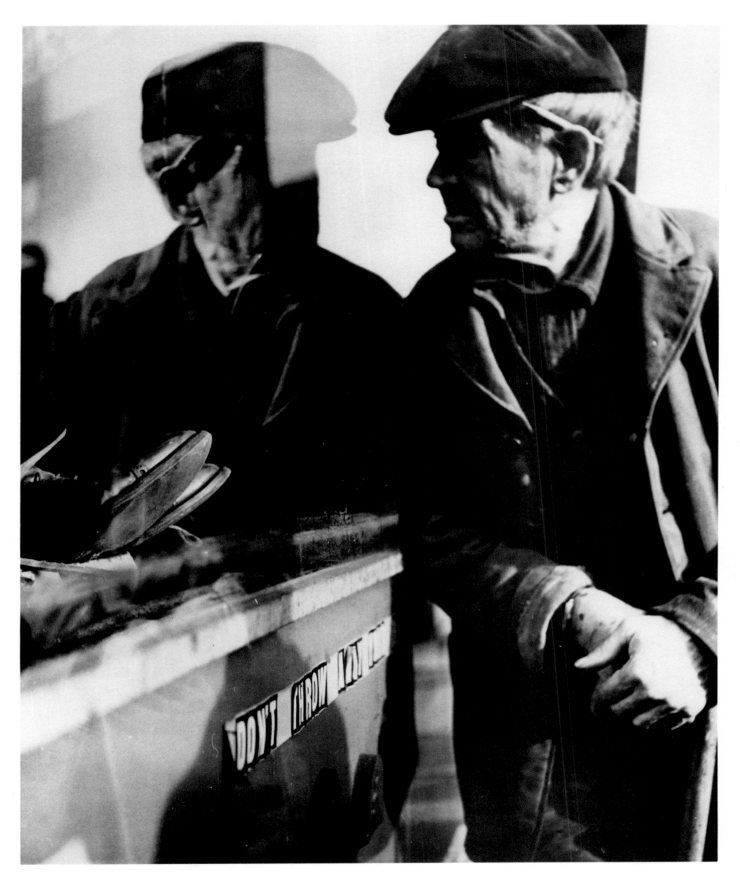

64 **Lower East Side** New York between 1939 and 1945

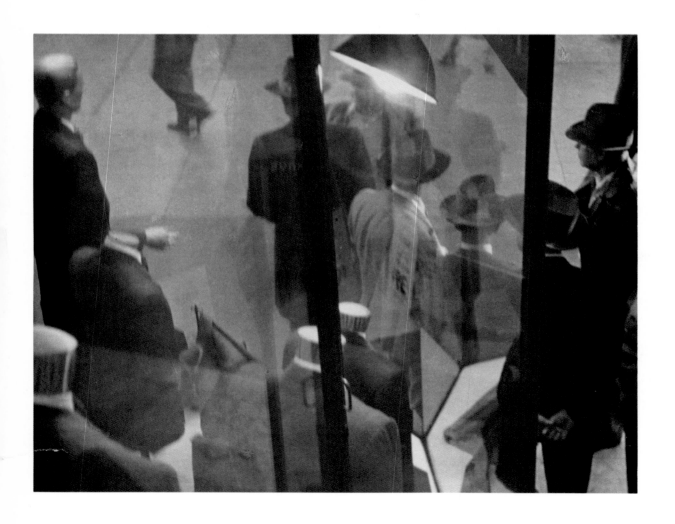

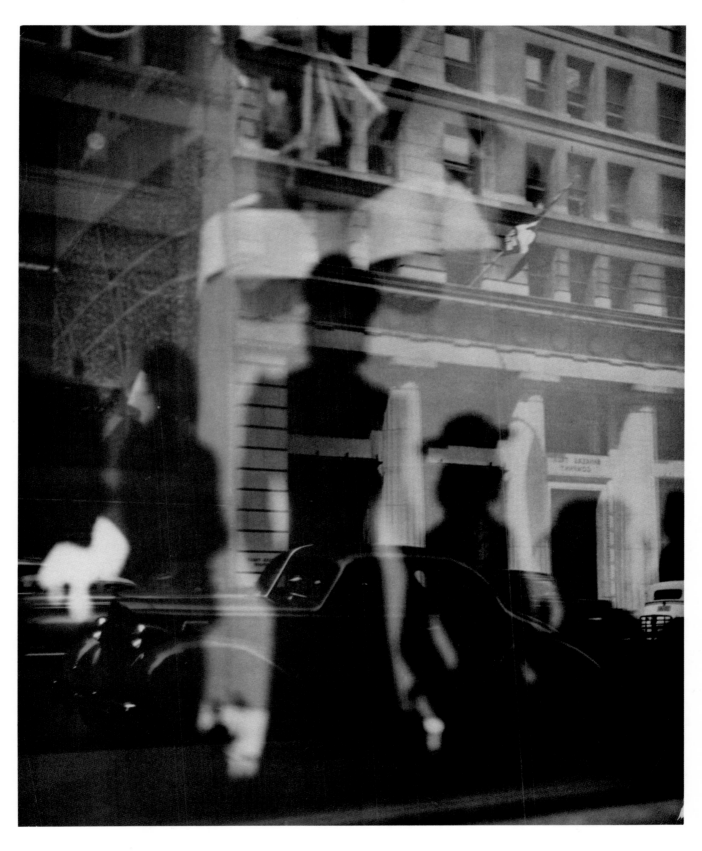

66 **Reflections, Rockefeller Center** New York c. 1945

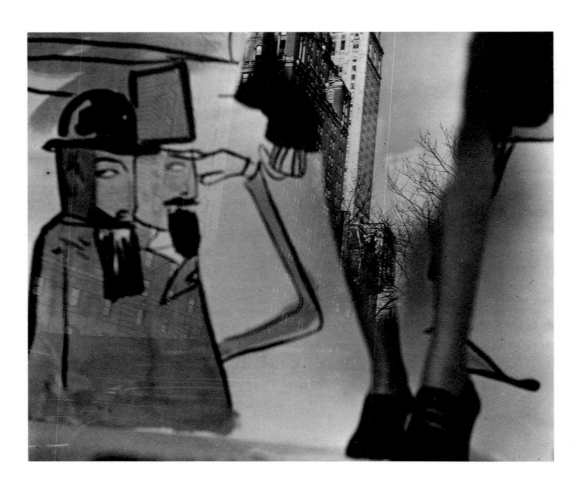

67 **Window, Bergdorf Goodman** New York between 1939 and 1945

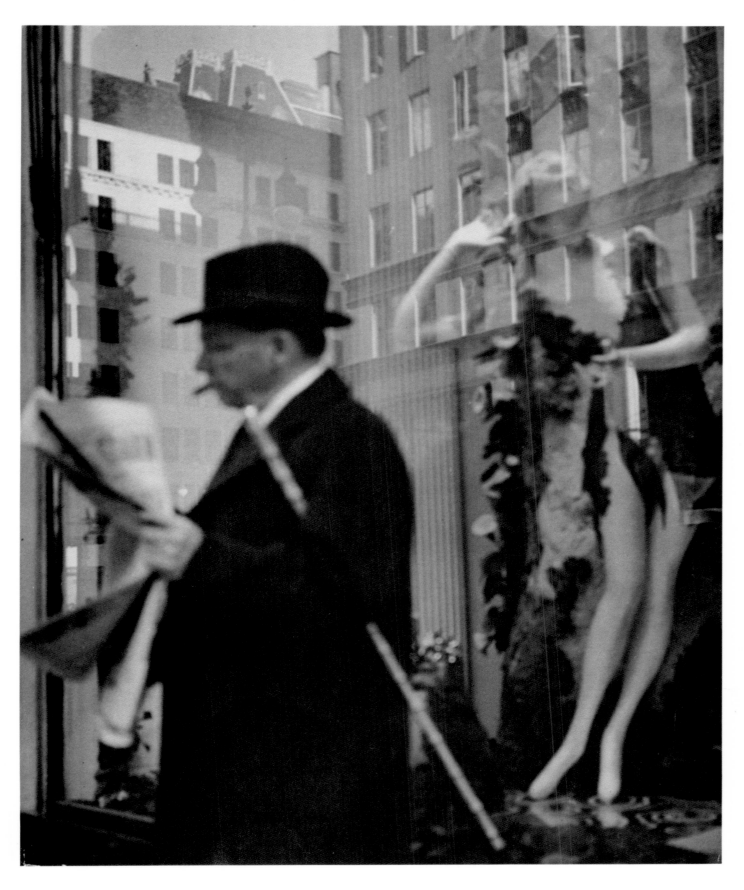

68 **Window, Bonwit Teller** *New York* between 1939 and 7 December 1940

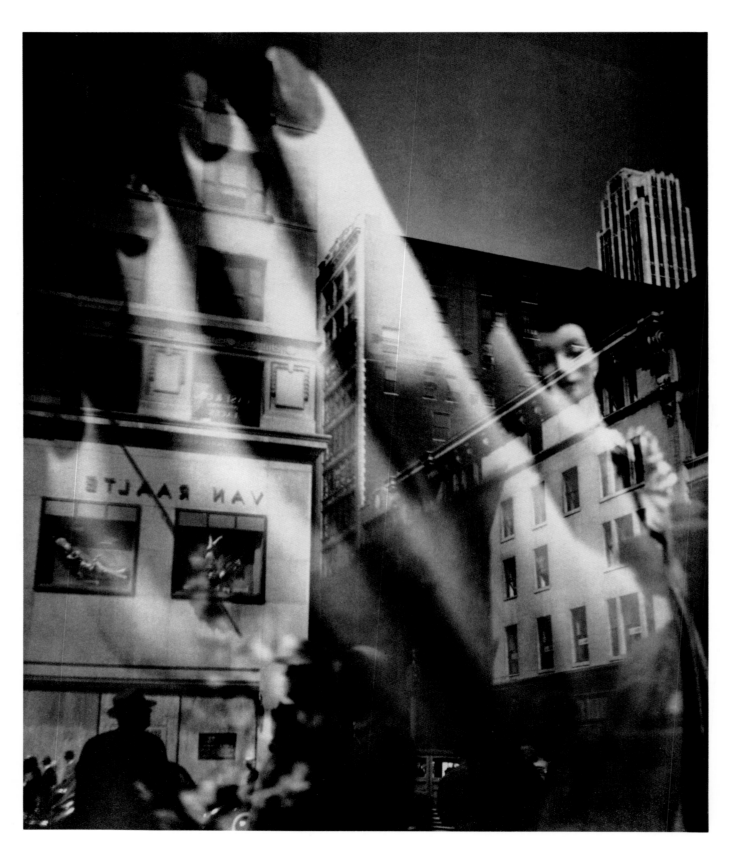

69 **Reflections** New York between 1939 and 1945

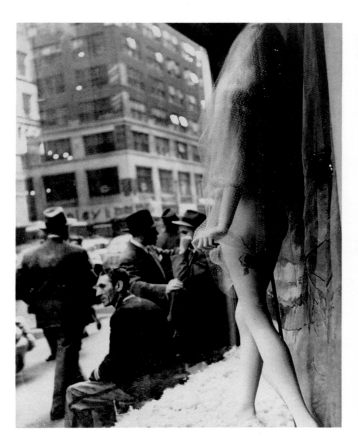

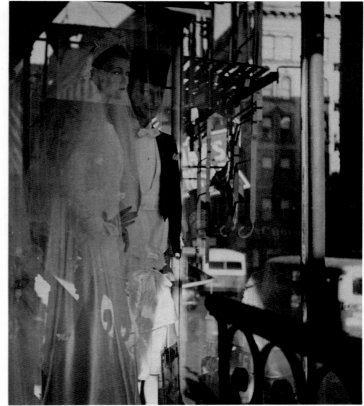

70 **Window** New York between 1939 and 1945

71 **Window, Bridal Couple** New York between 1939 and 1945

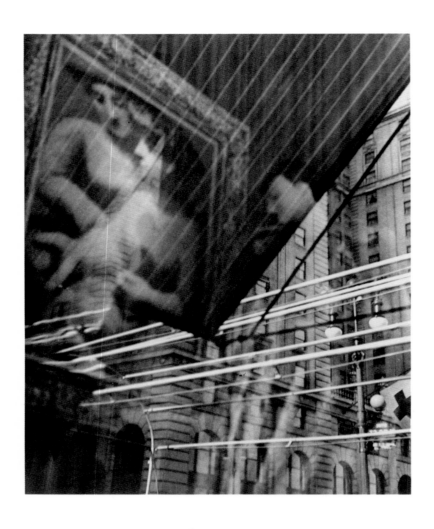

72 **Reflections, Fifty-seventh Street** New York between 1939 and 7 December 1940

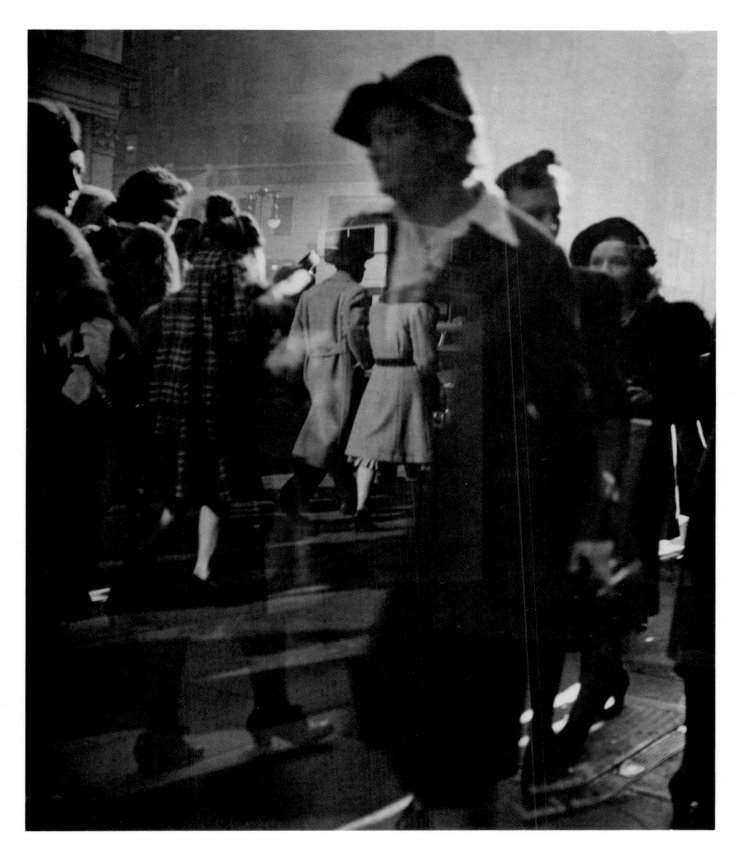

73 **Reflections** New York between 1940 and 1945

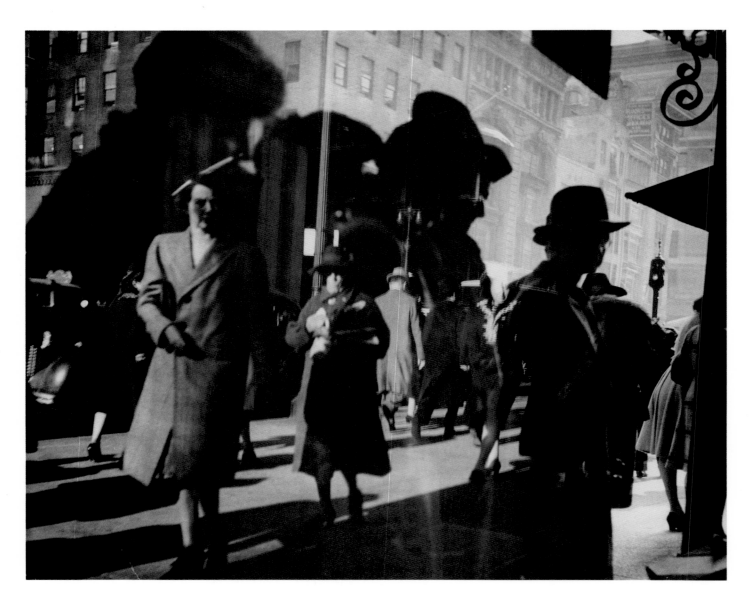

74 **Reflections** New York between 1939 and 1945

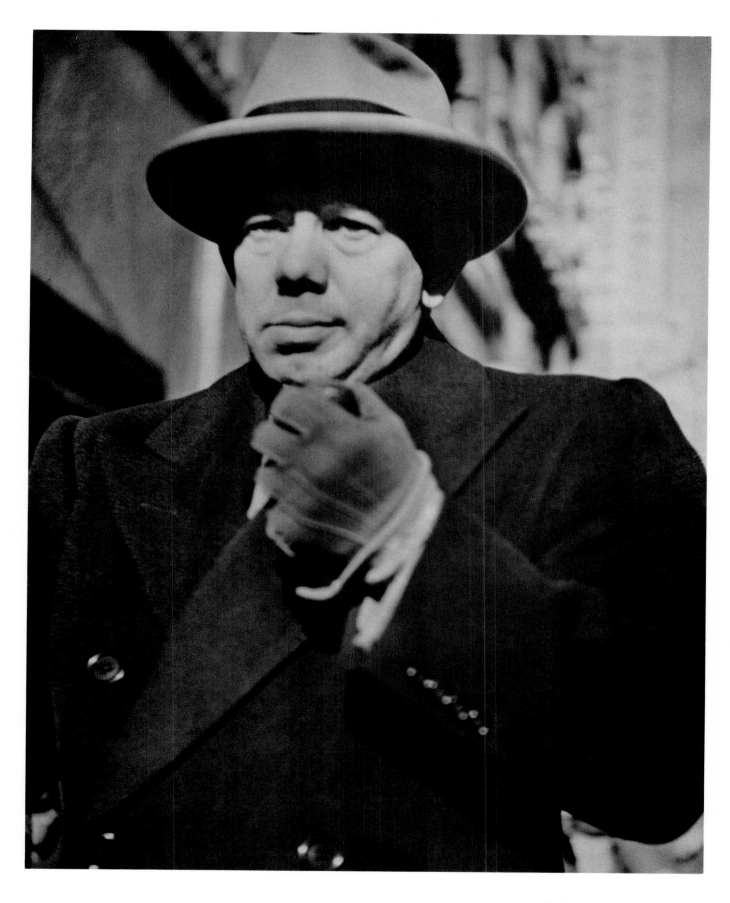

75 **Pedestrian** New York c. 1945

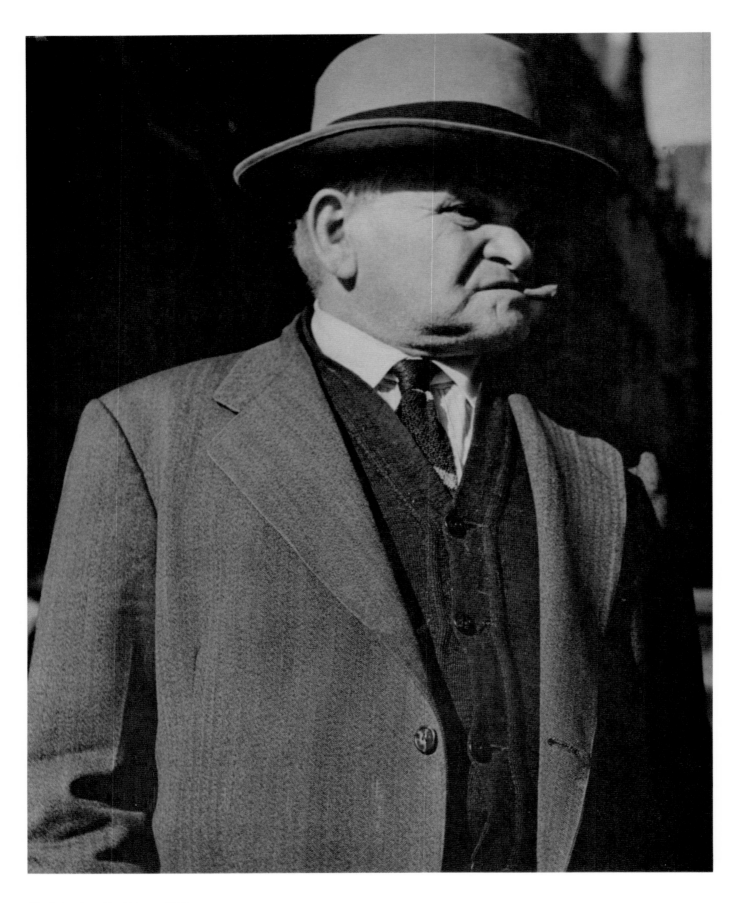

76 **Pedestrian** New York c. 1945

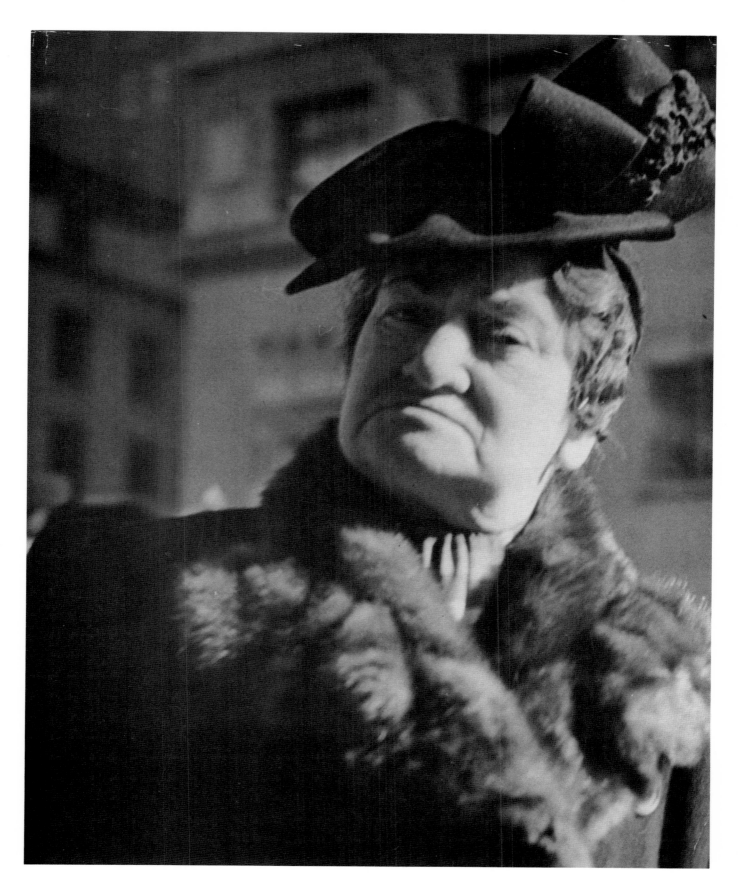

77 **Pedestrian** New York c. 1945

78 **Wall Street** New York between 1939 and 10 October 1941

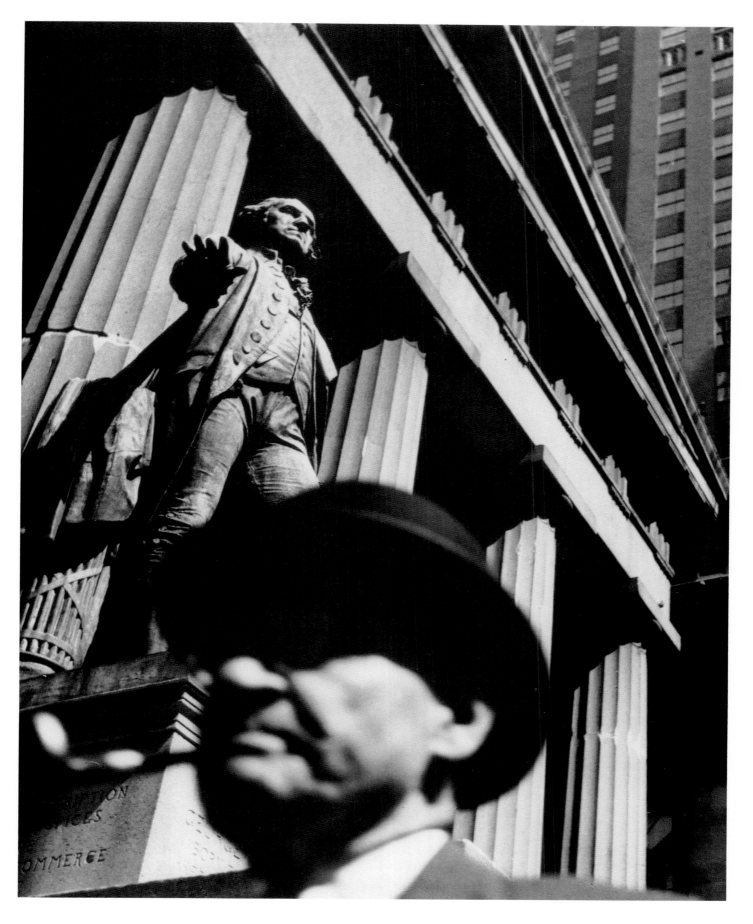

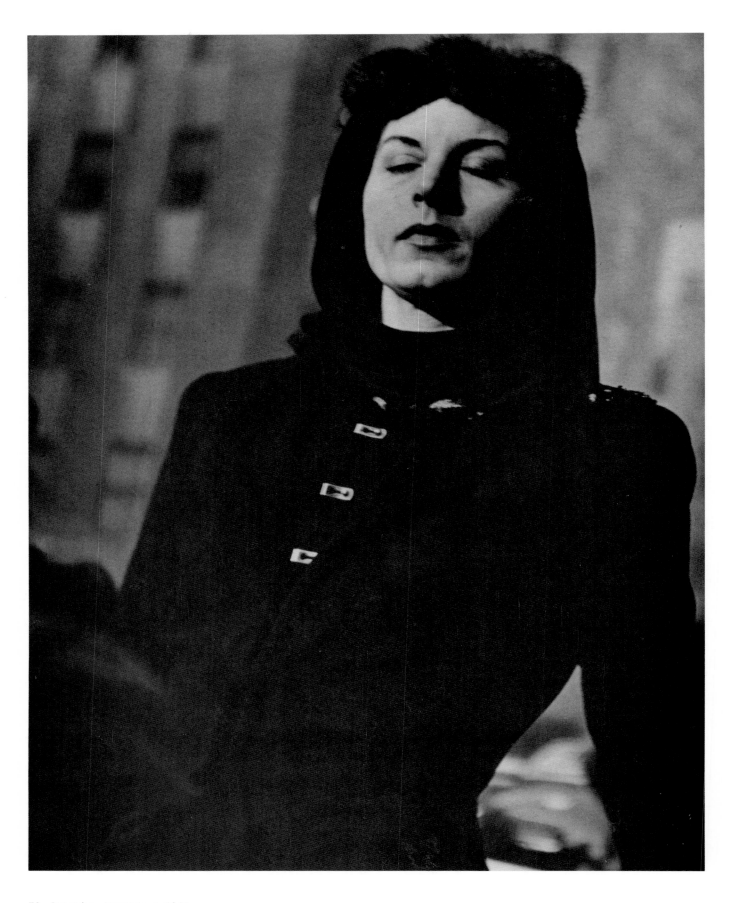

79 **Pedestrian** New York c. 1945

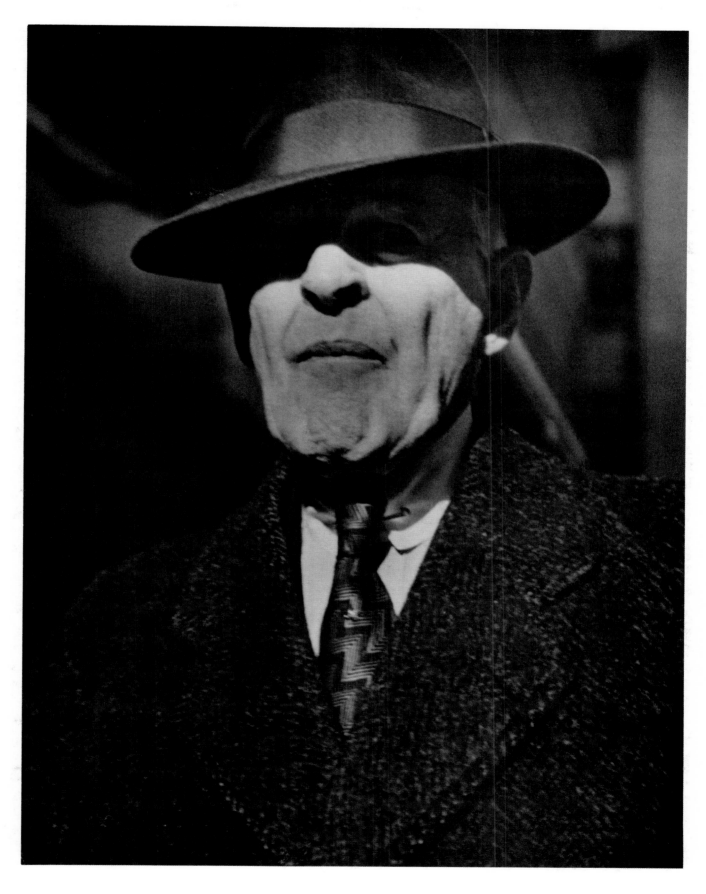

80 **Pedestrian** New York c. 1945

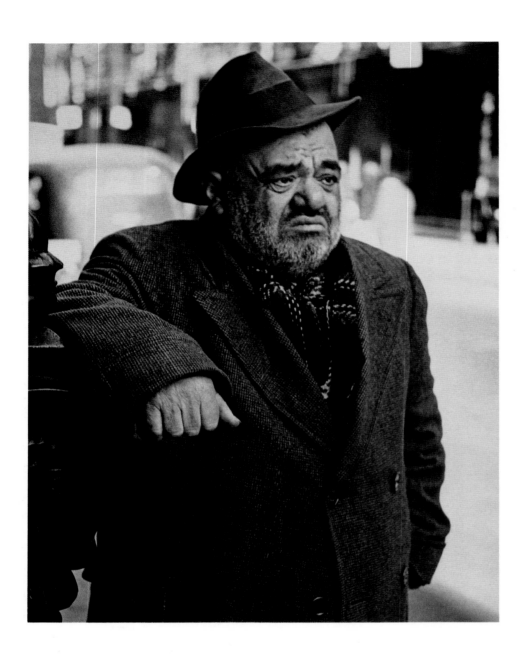

81 **Lower East Side** New York between 1939 and October 1942

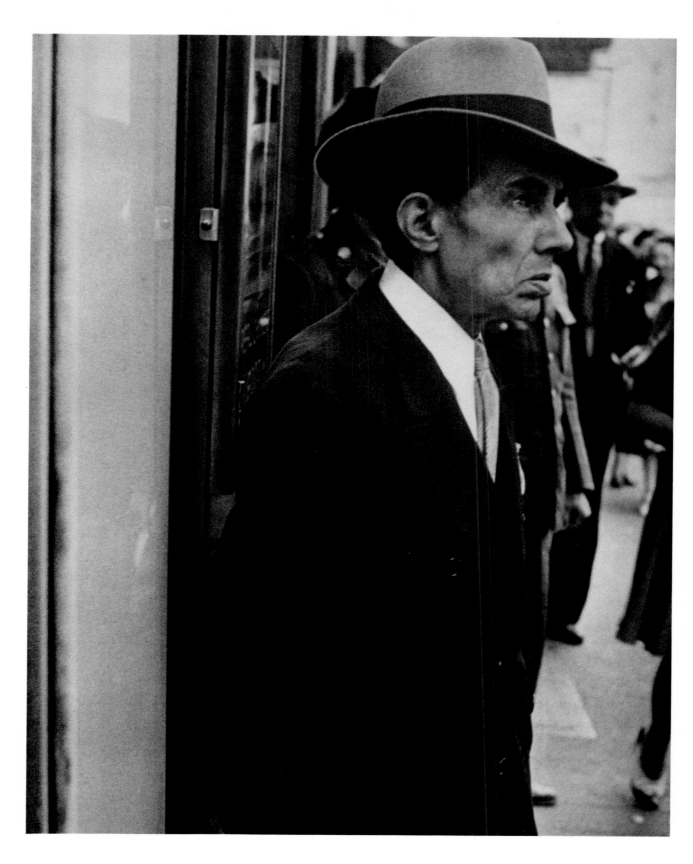

82 **New York** c. 1945

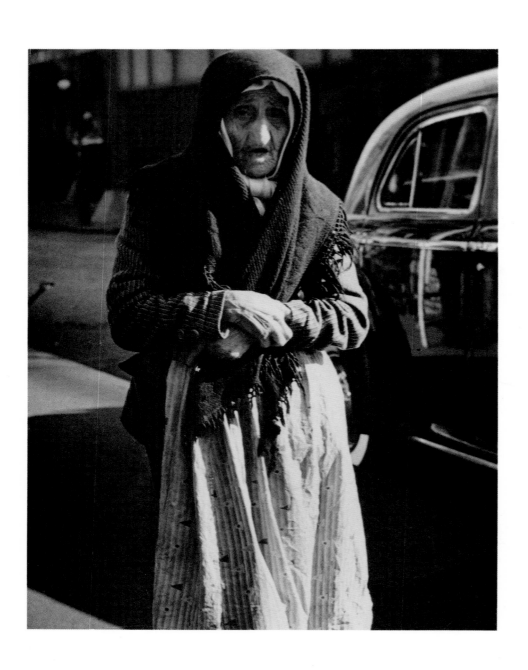

83 **Lower East Side** New York between 1939 and 1945

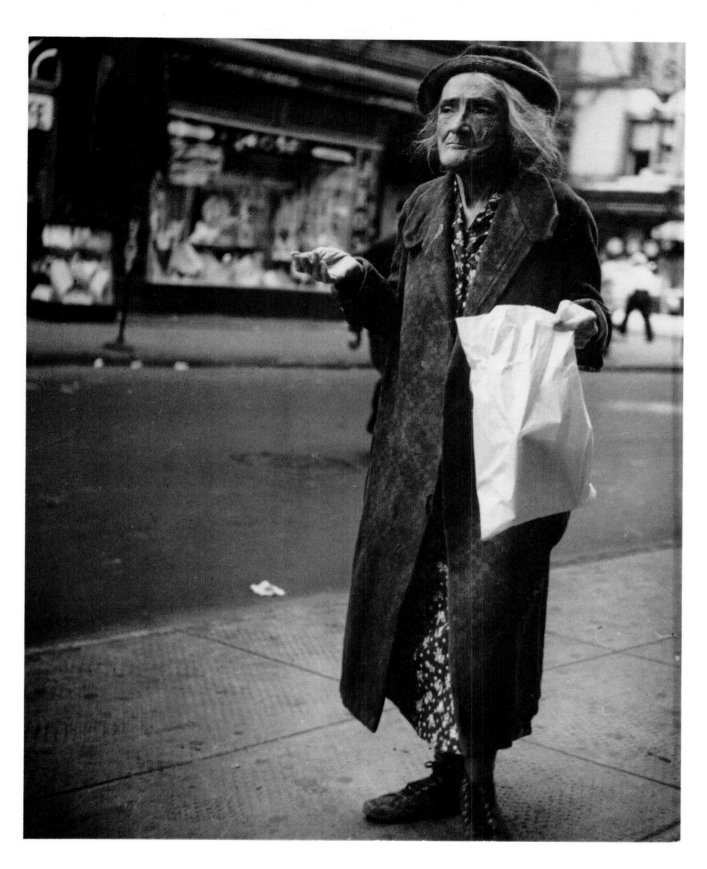

84 **Lower East Side** New York between 1939 and 1945

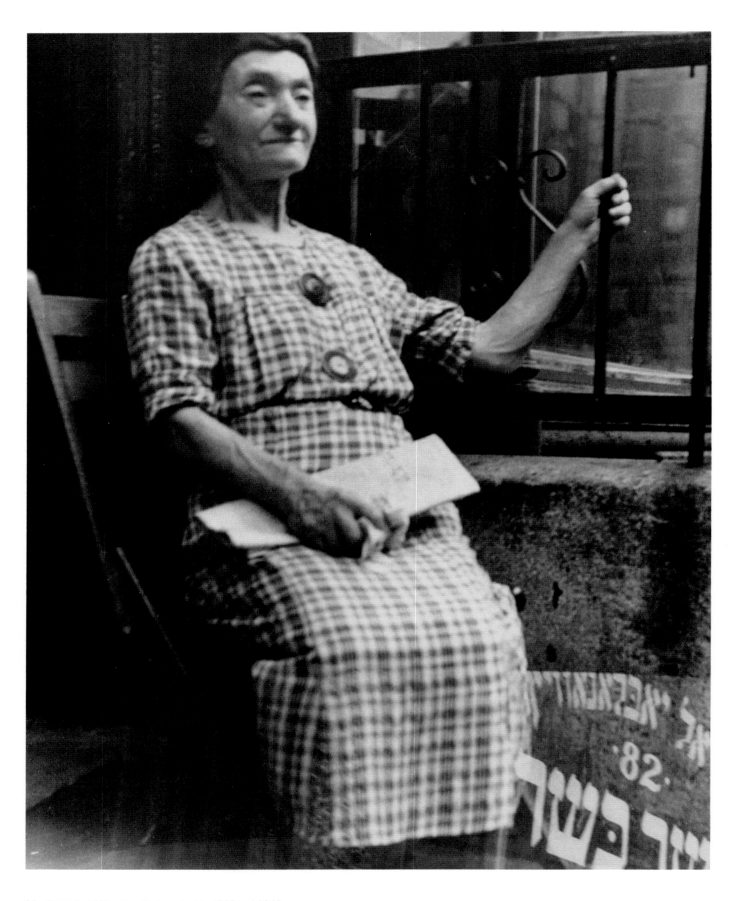

85 **Lower East Side** New York between 1939 and 1945

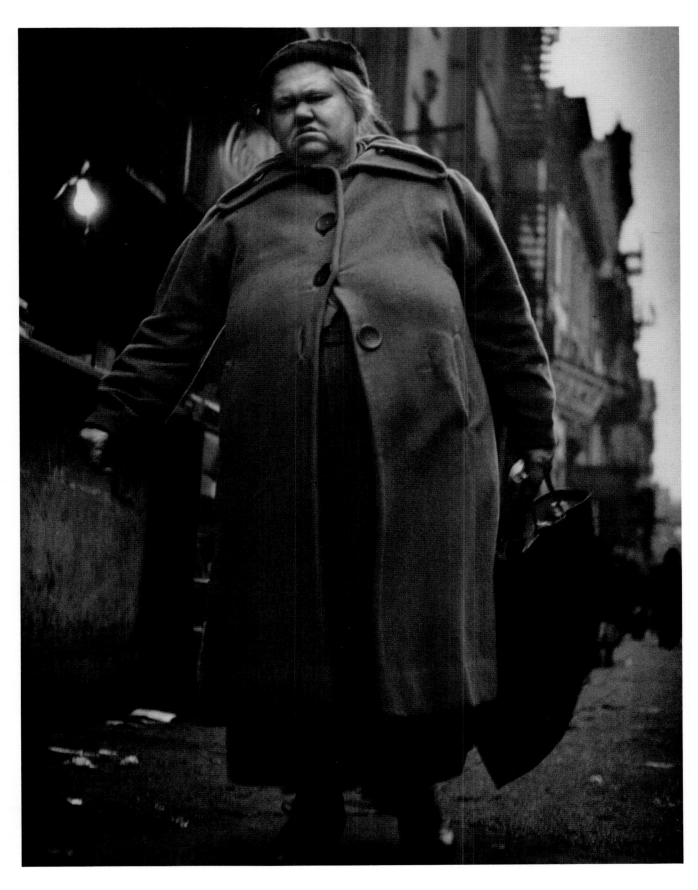

86 **Lower East Side** New York between 1939 and 1945

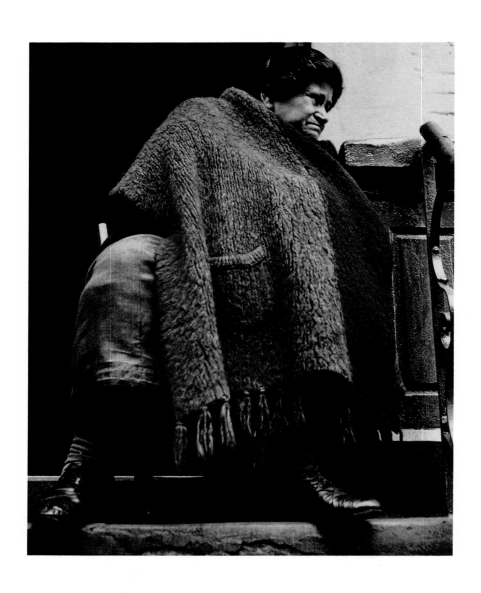

87 **Lower East Side** New York 1942?

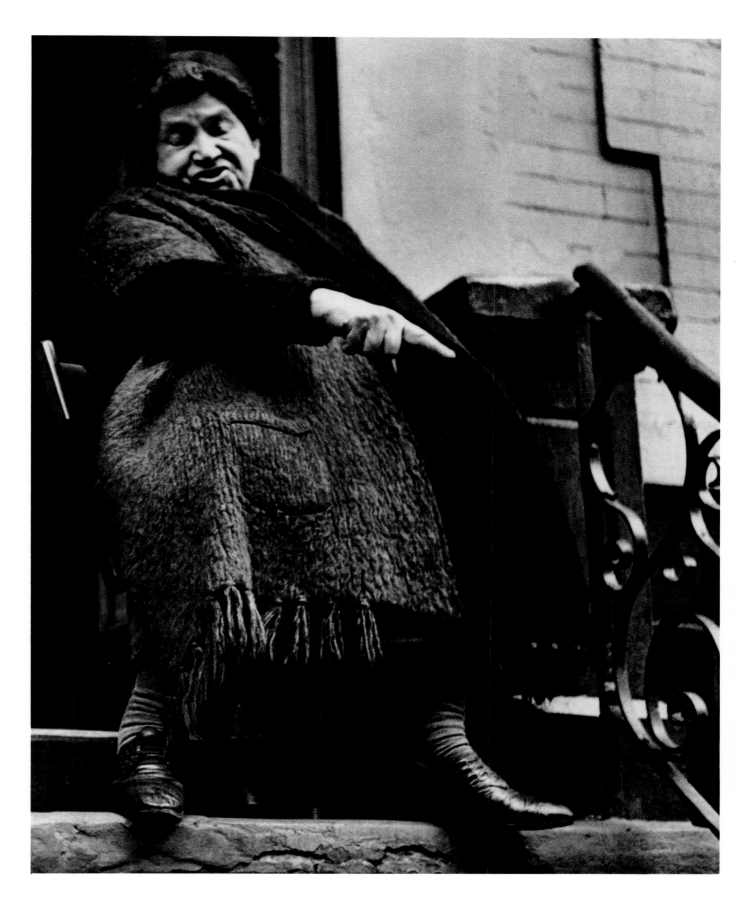

88 **Lower East Side** New York 1942?

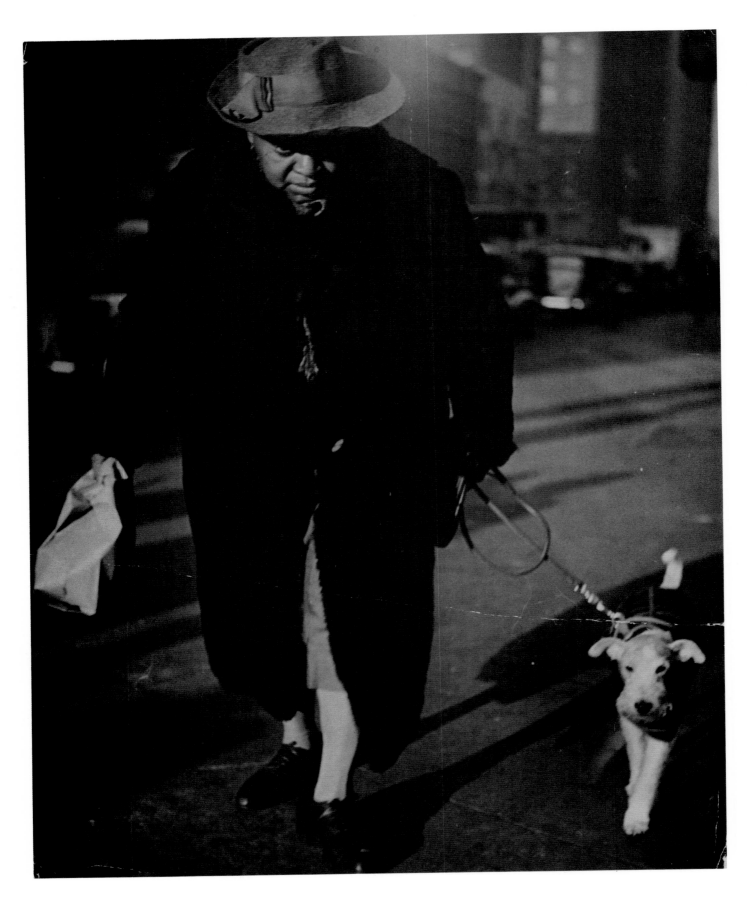

89 **Lower East Side** New York between 1939 and 1946

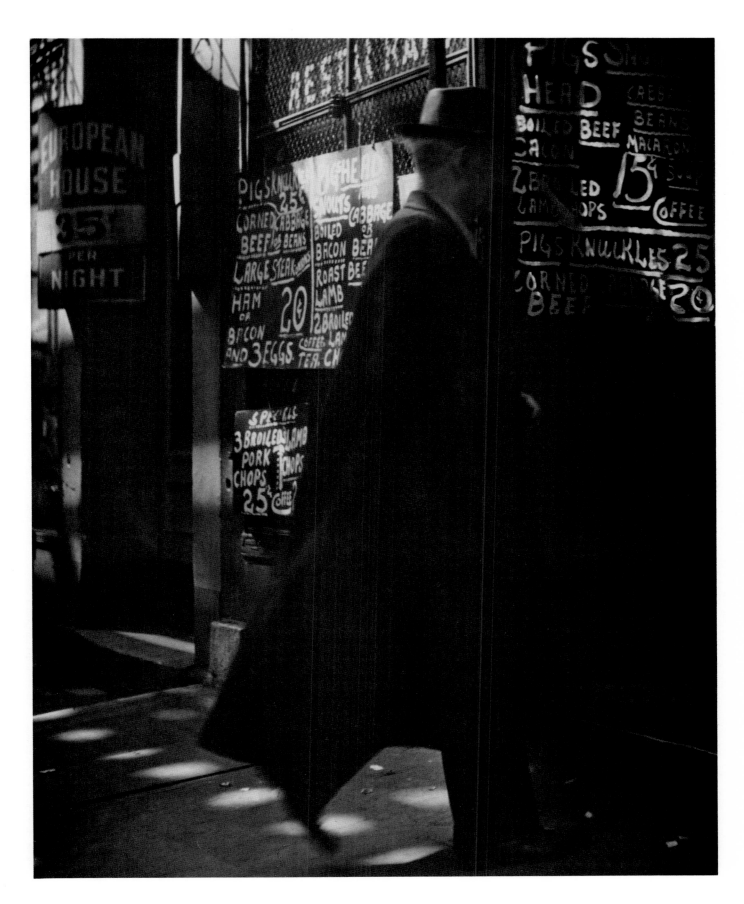

90 **Lower East Side** New York between 1939 and 1945

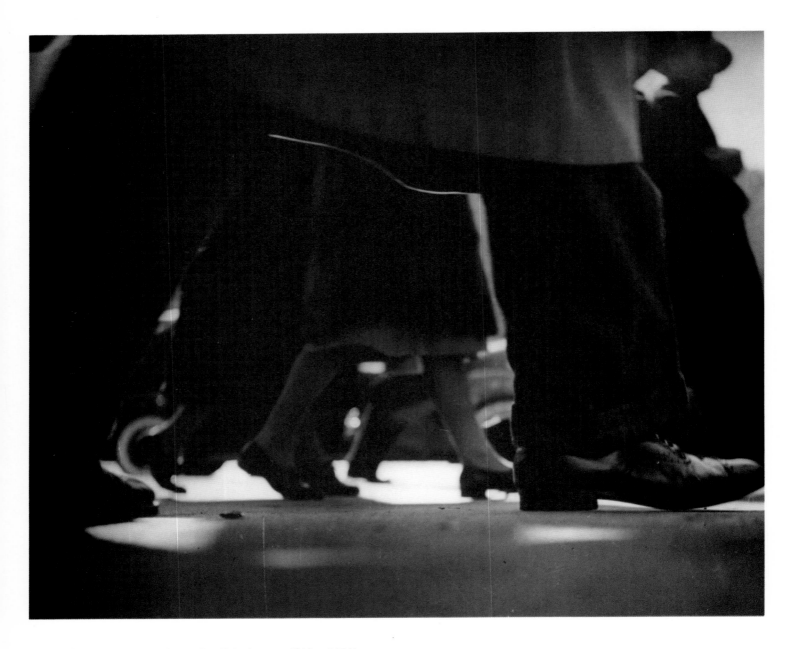

91 **Running Legs, Forty-second Street** New York between 1940 and 1941

92 **Running Legs** New York between 1940 and 1941

93 **Running Legs** New York between 1940 and 1941

94 **Running Legs** New York between 1940 and 1941

95 **Running Legs** New York between 1940 and 1941

96 **Running Legs** New York between 1940 and 1941

97 **Running Legs** New York between 1940 and 1941

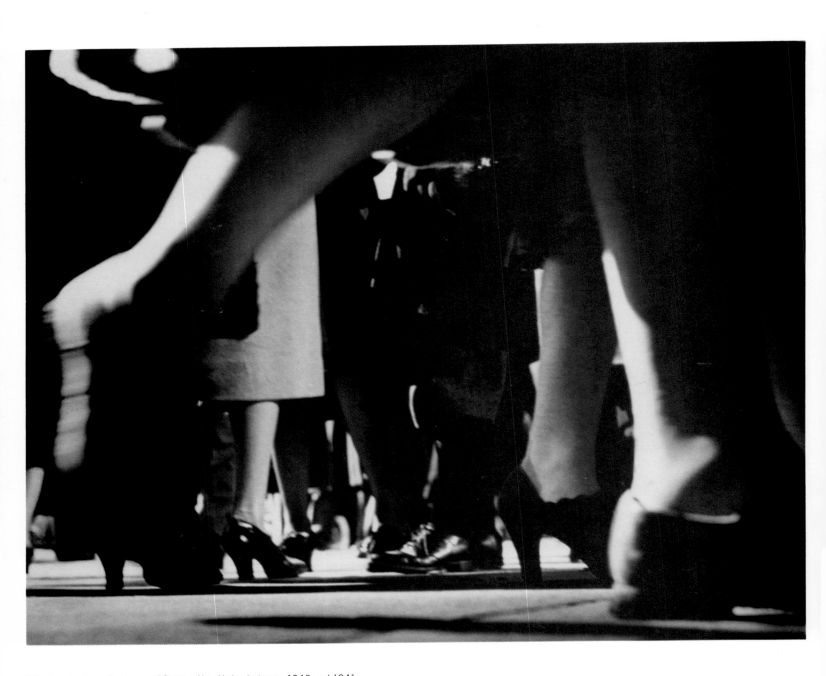

98 **Running Legs, Forty-second Street** New York between 1940 and 1941

 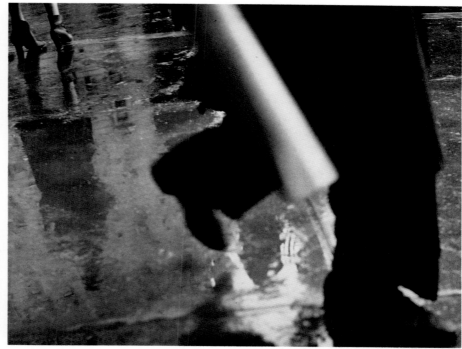

99 **Running Legs** New York between 1940 and 1941

100 **Running Legs** New York between 1940 and 1941

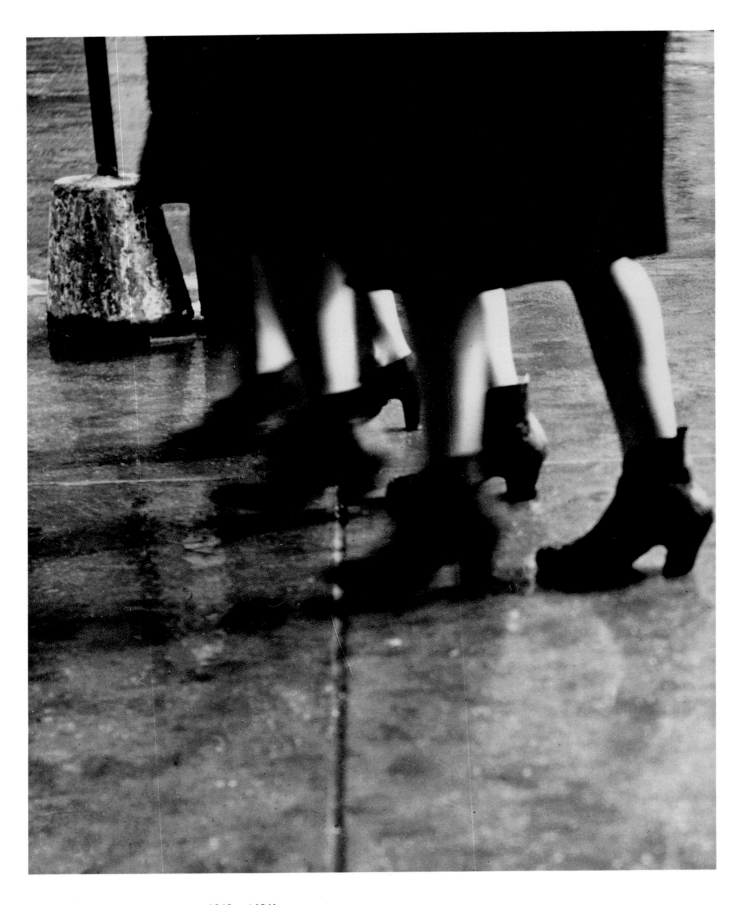

101 **Running Legs** New York between 1940 and 1941

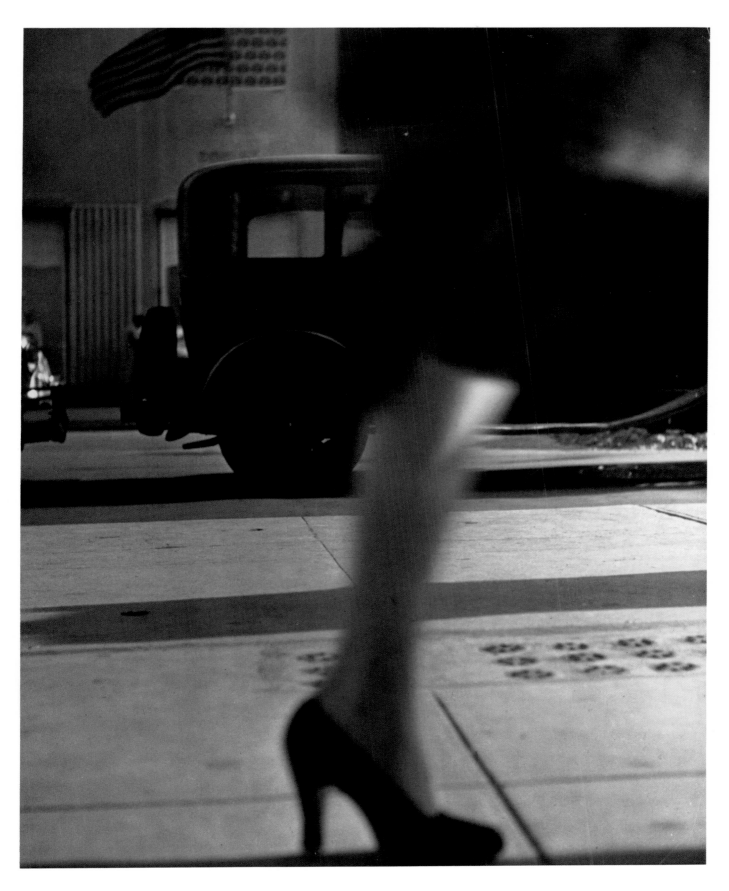

102 **Running Legs, Fifth Avenue** New York between 1940 and 1941

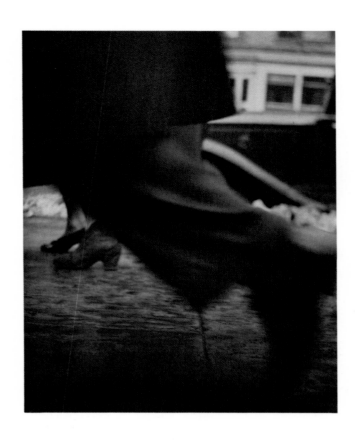

103 **Running Legs** New York between 1940 and 1941

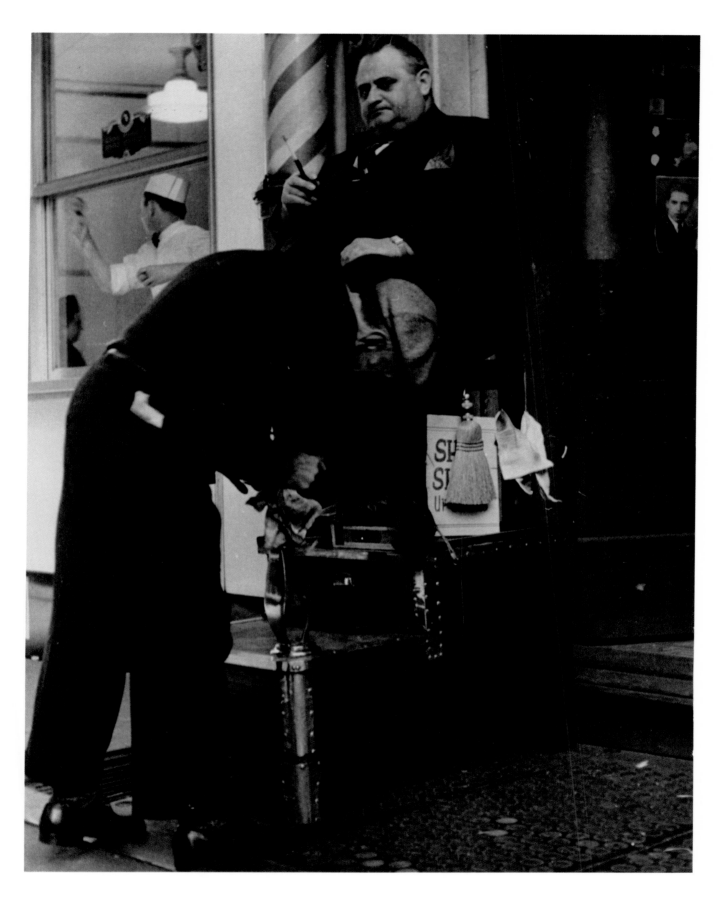

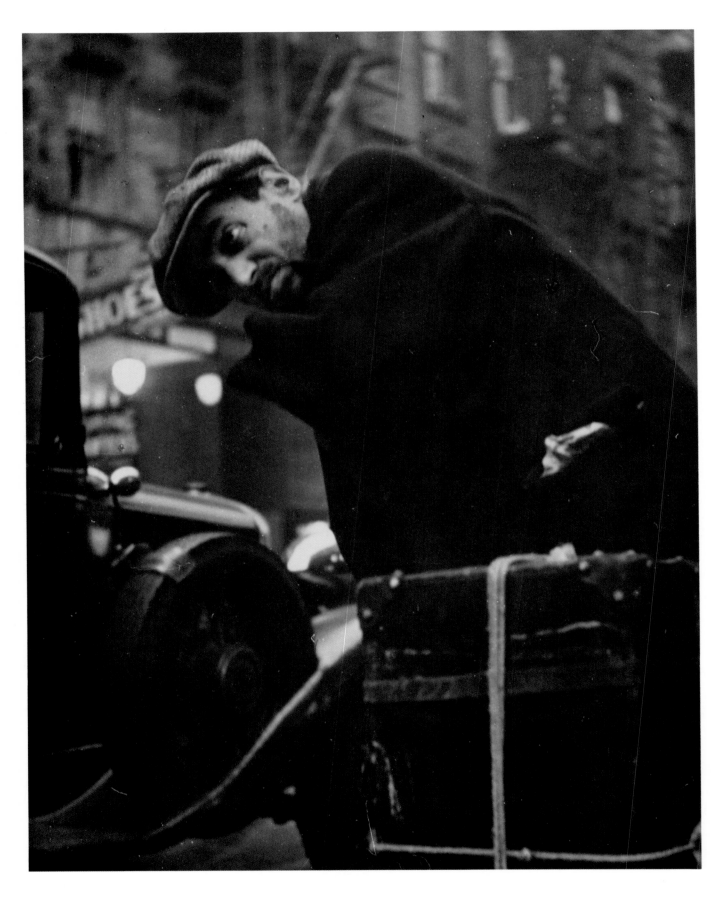

105　**Lower East Side**　New York　between 1939 and 1945

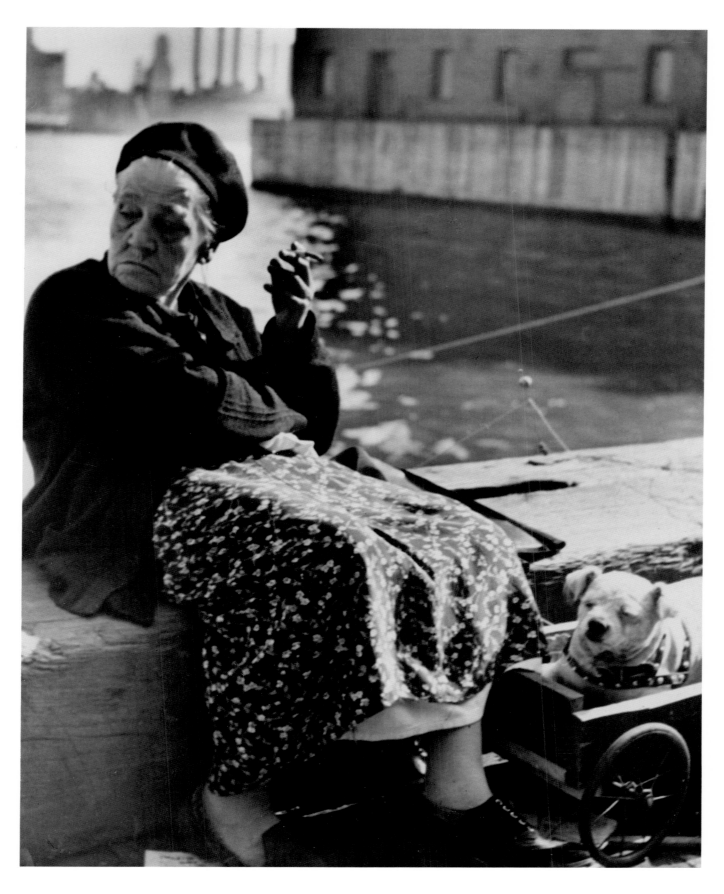

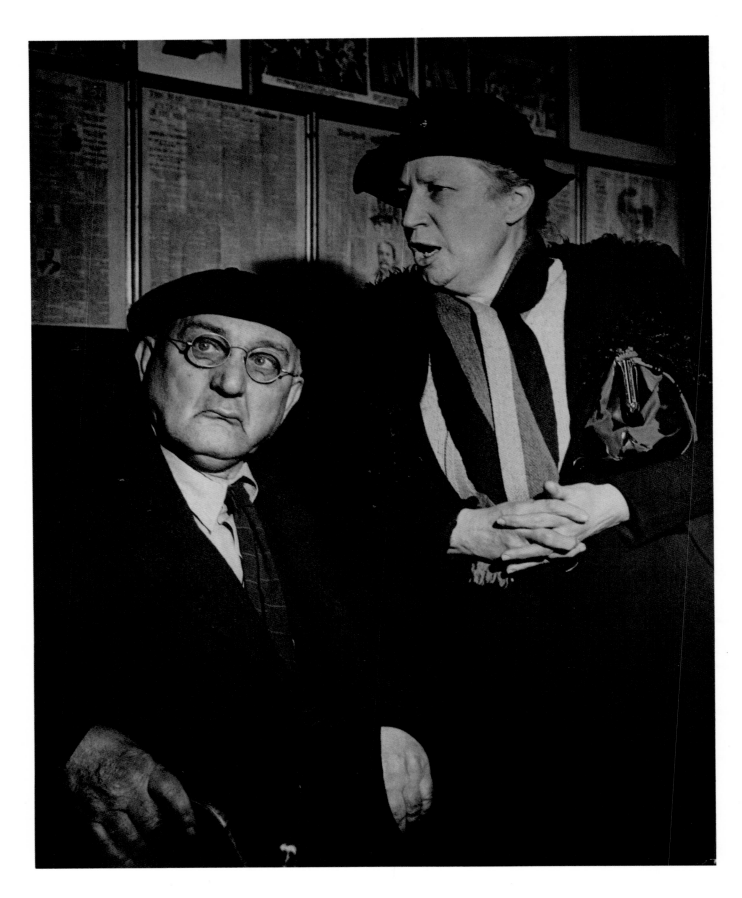

107 **Sammy's** New York between 1940 and 1944

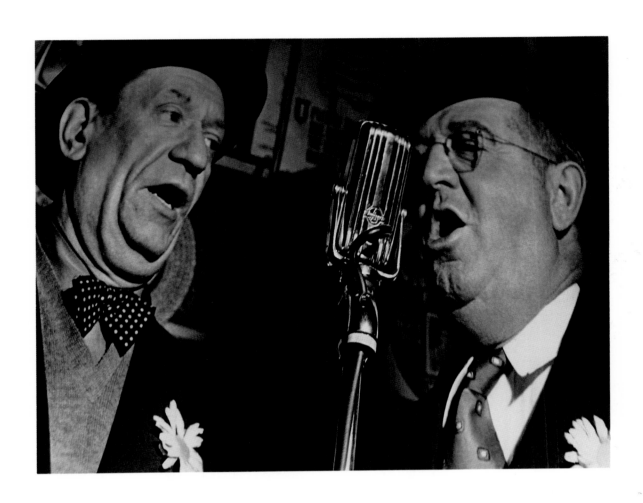

108　**Sammy's**　New York　between 1940 and 1944

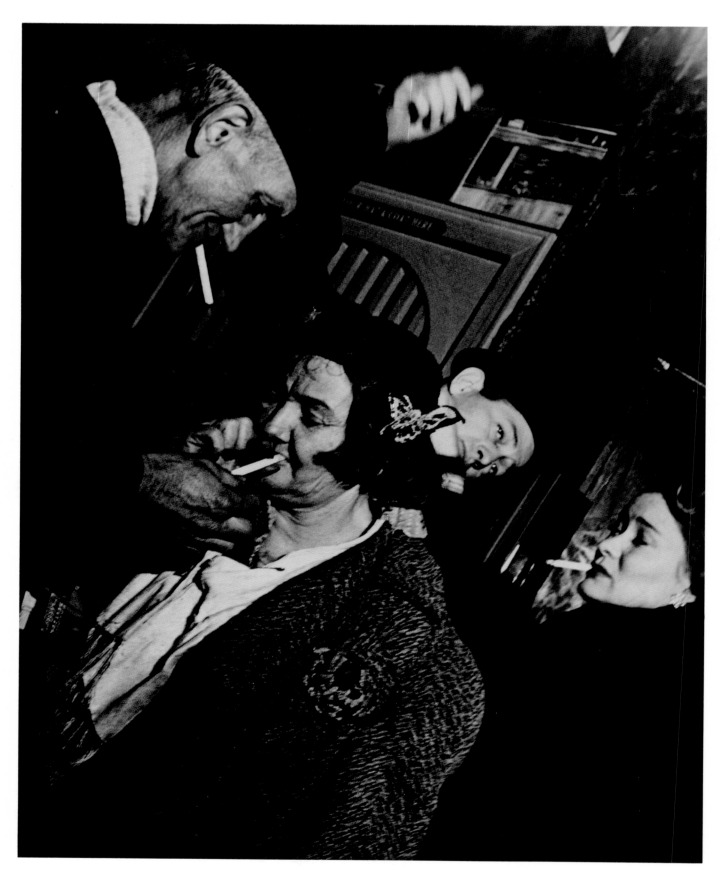

109 **Sammy's** New York between 1940 and 1944

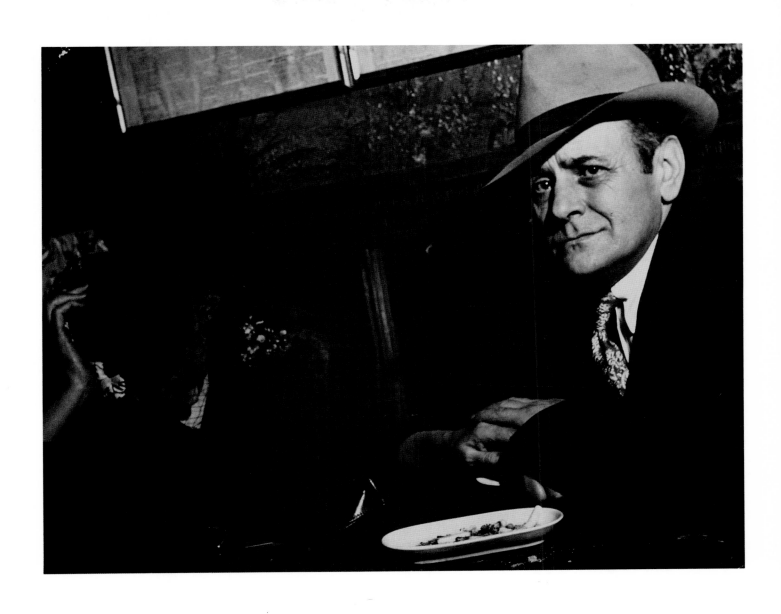

110 **Sammy's** New York between 1940 and 1944

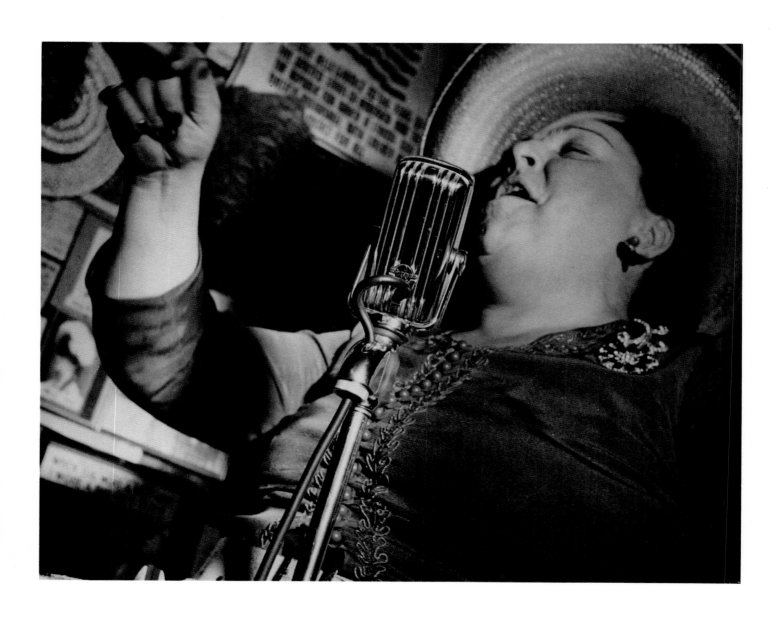

111 **Sammy's** New York between 1940 and 1944

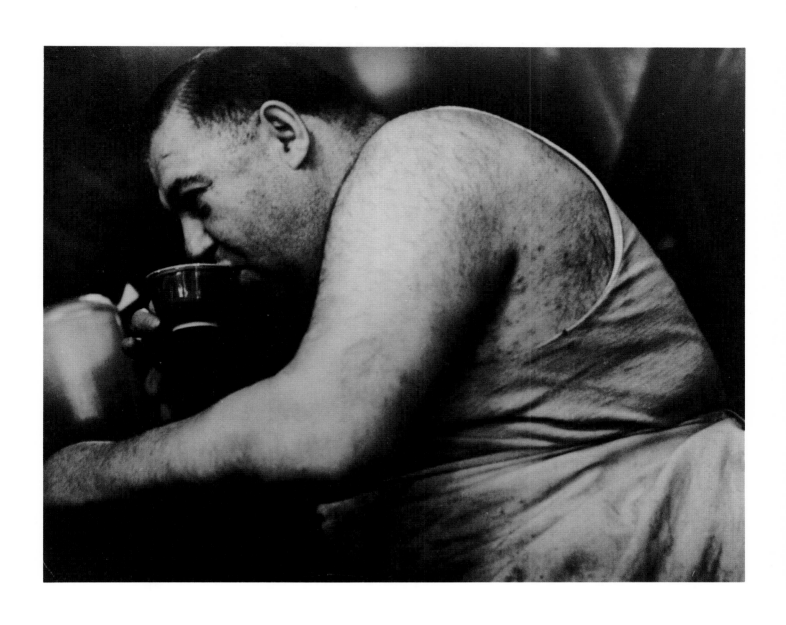

112 **Lower East Side** New York between 1939 and 1945

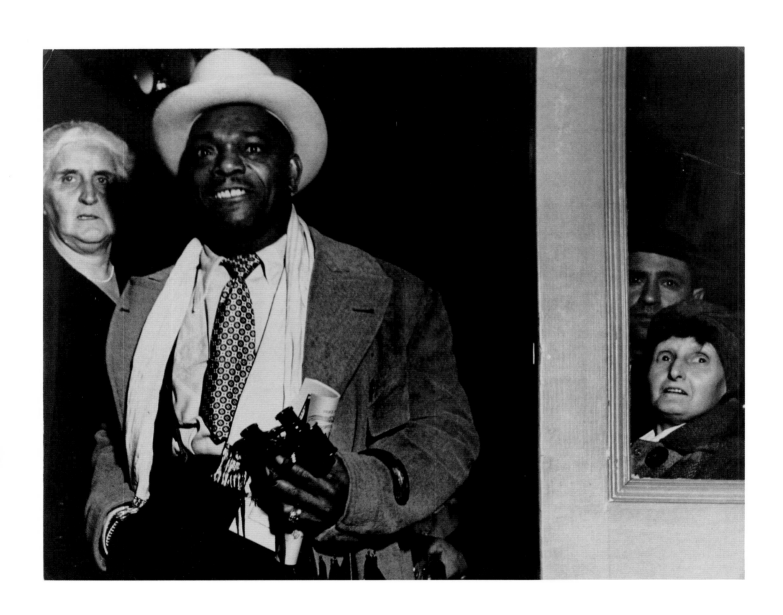

113 **Metropolitan Opera** New York 1943?

114 **Hanka Kelter** New York 1945?

115 **Nick's** New York between 1940 and August 1944

116 **Sammy's** New York between 1940 and 1944

117 **Female Impersonators** c. 1945

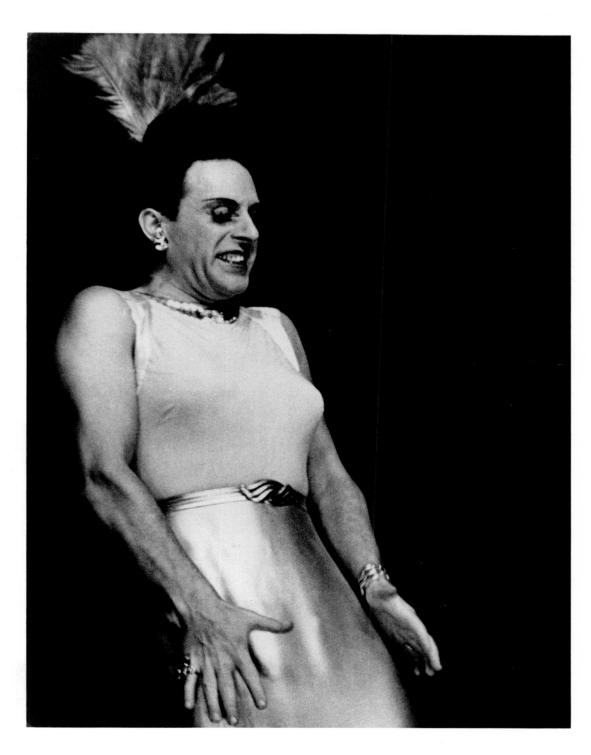

118 **Female Impersonator** c. 1945

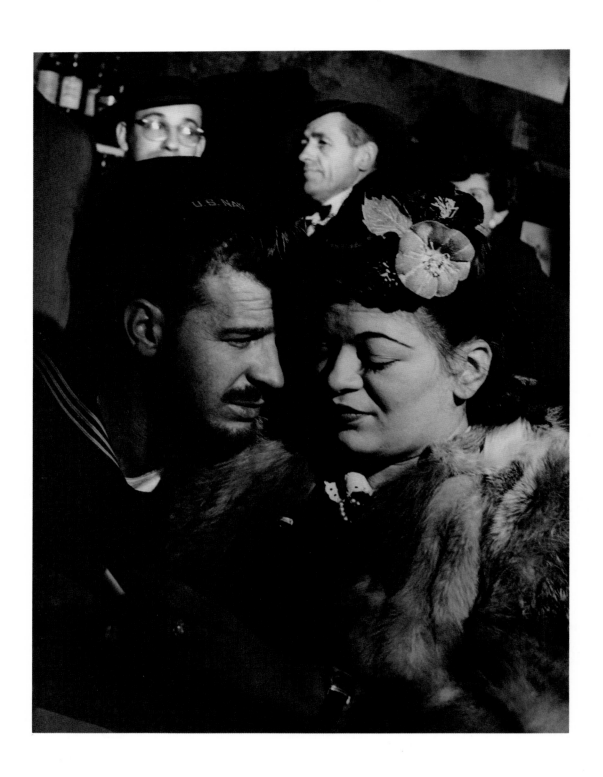

119 **Sammy's** New York between 1940 and 1944

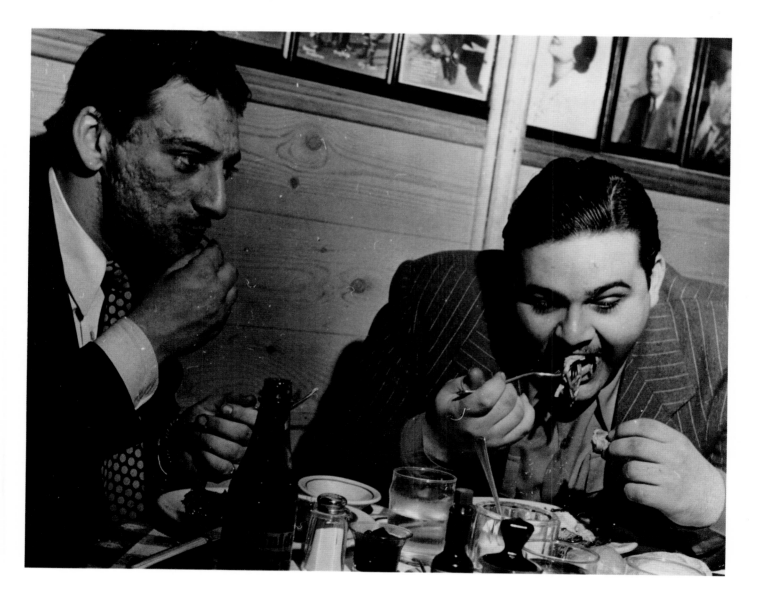

120 **Gallagher's** New York 1945

121 **Sammy's** New York between 1940 and 1944

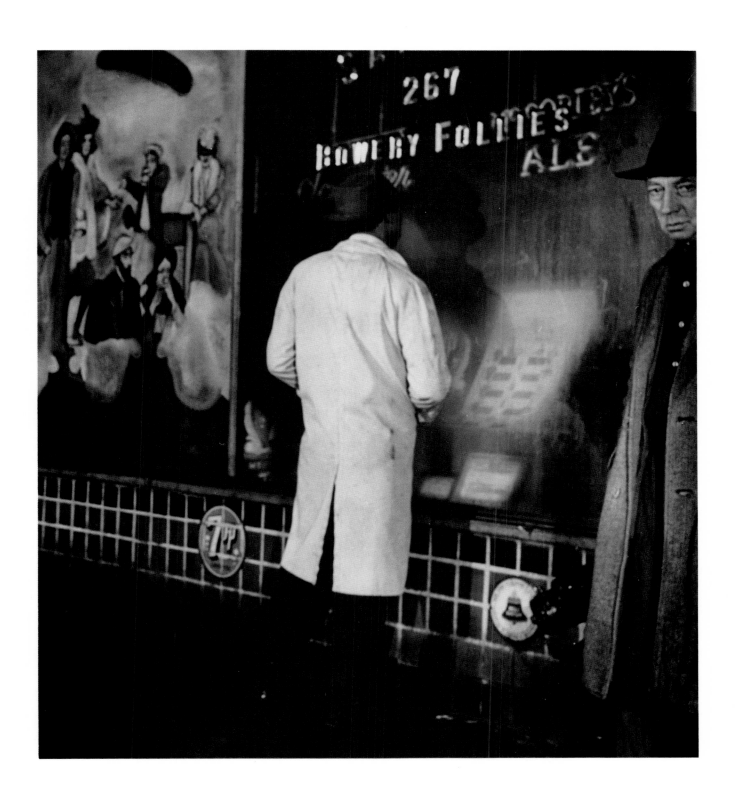

263

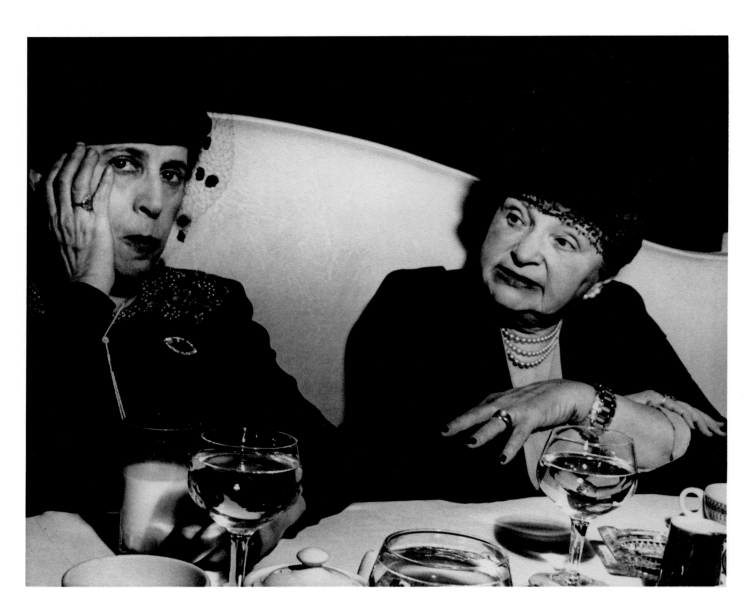

122 **Fashion Show, Hotel Pierre** New York between 1940 and 1946

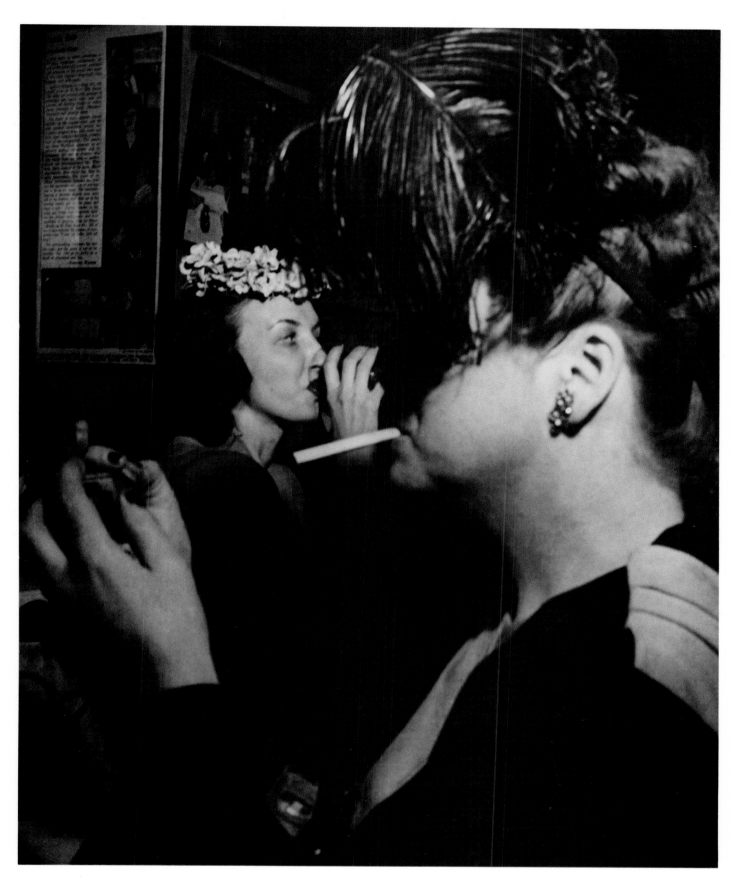

123 **Asti's** New York between 1945 and 1946

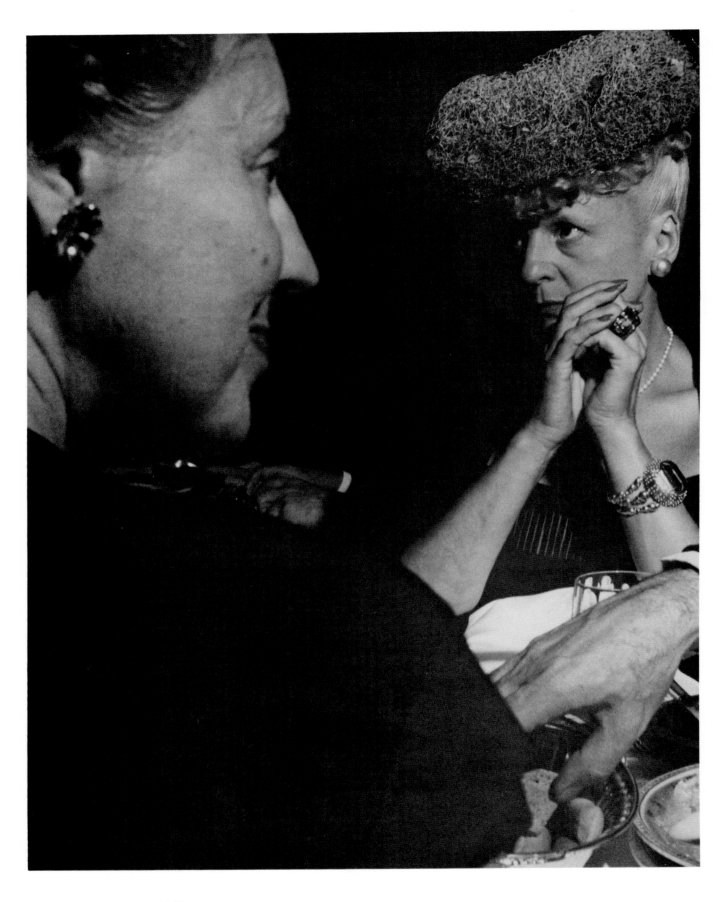

124 **Restaurant** New York 1945

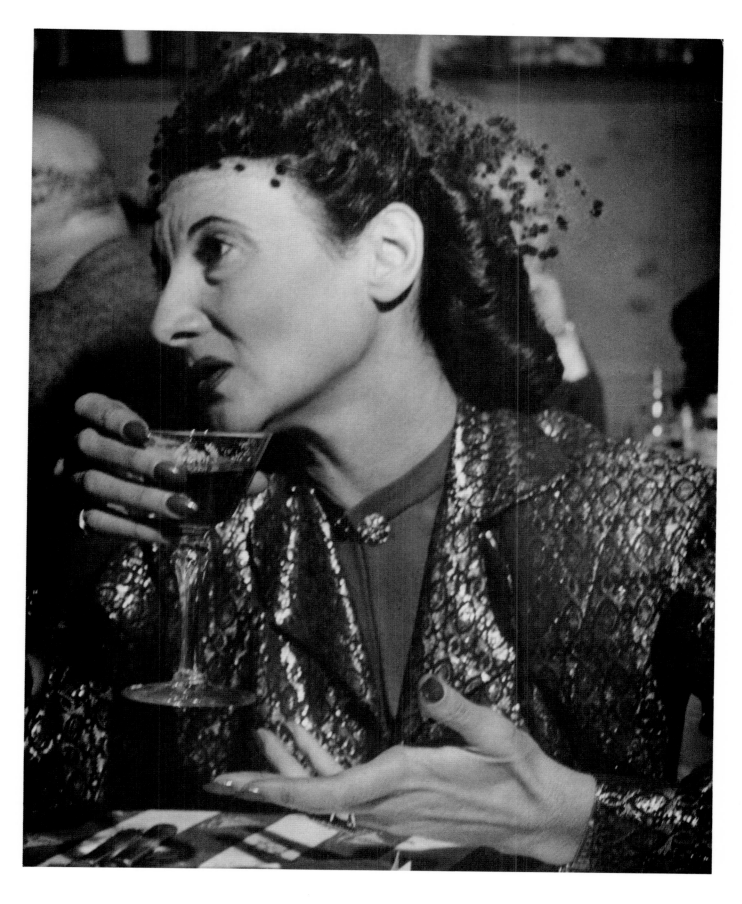

125 **Gallagher's** New York 1944

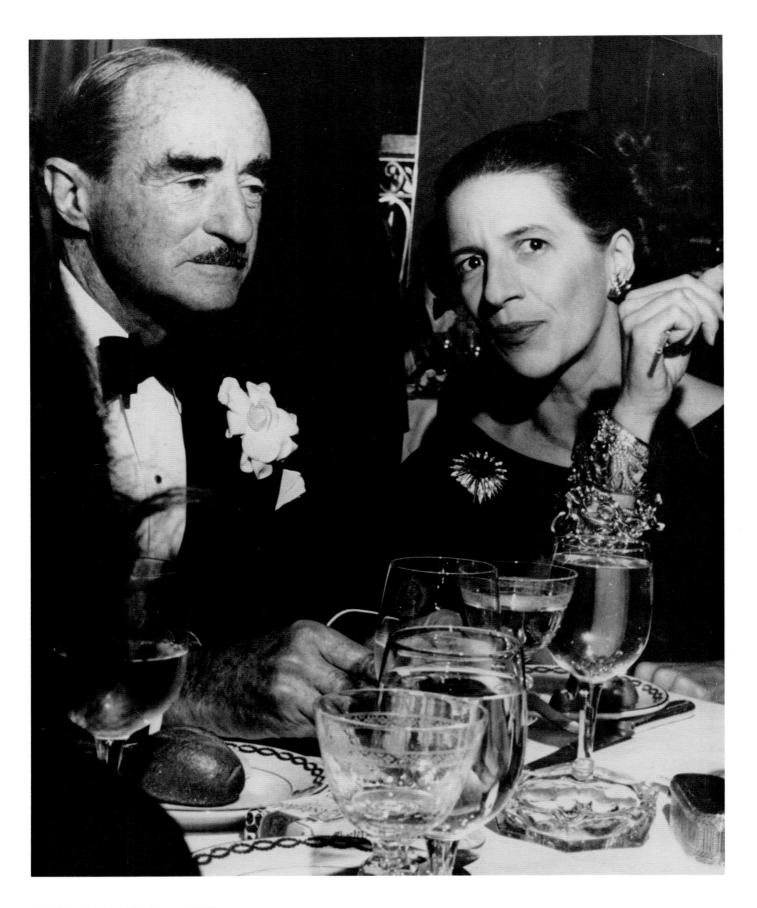

126 **Diana Vreeland** New York c. 1945

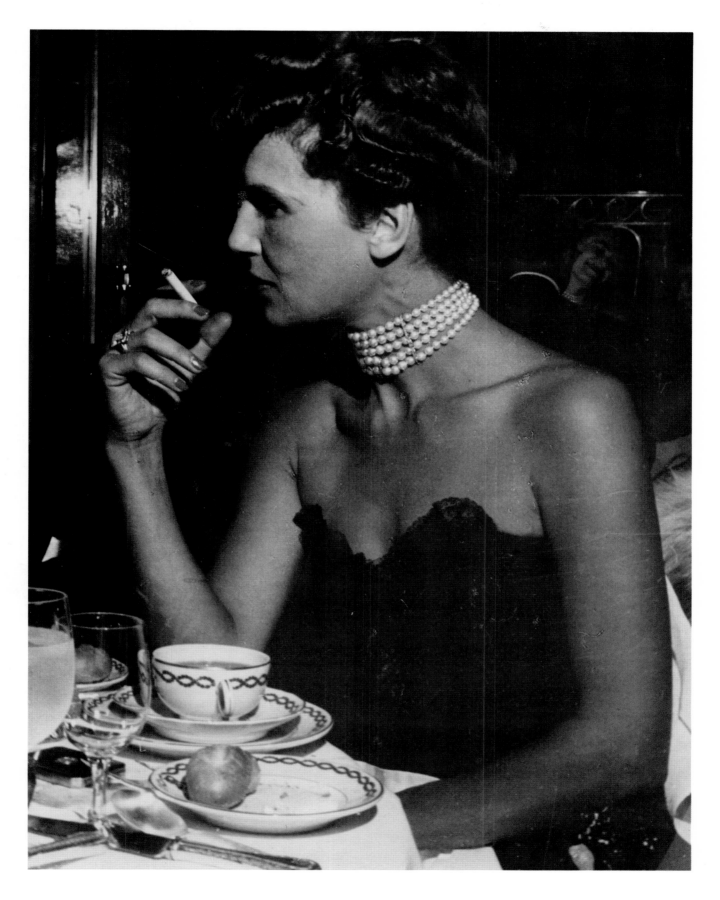

127 **St Regis Hotel** New York c. 1945

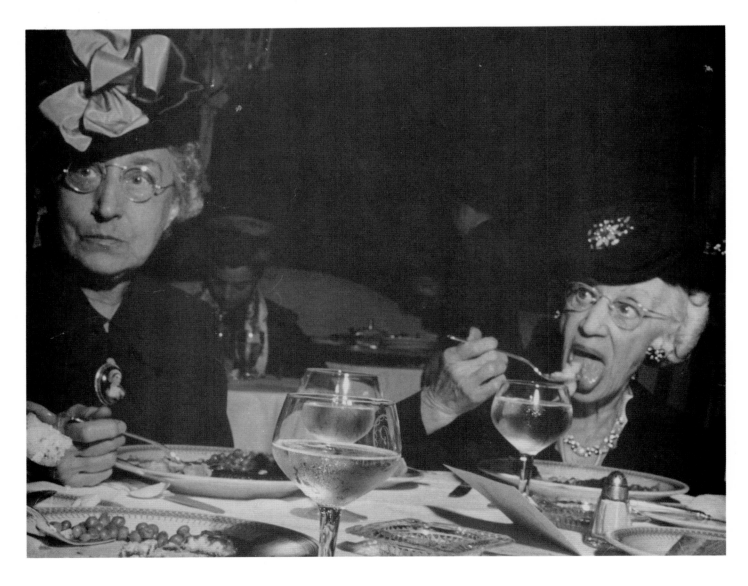

128 **Fashion Show, Hotel Pierre** New York between 1940 and 1946

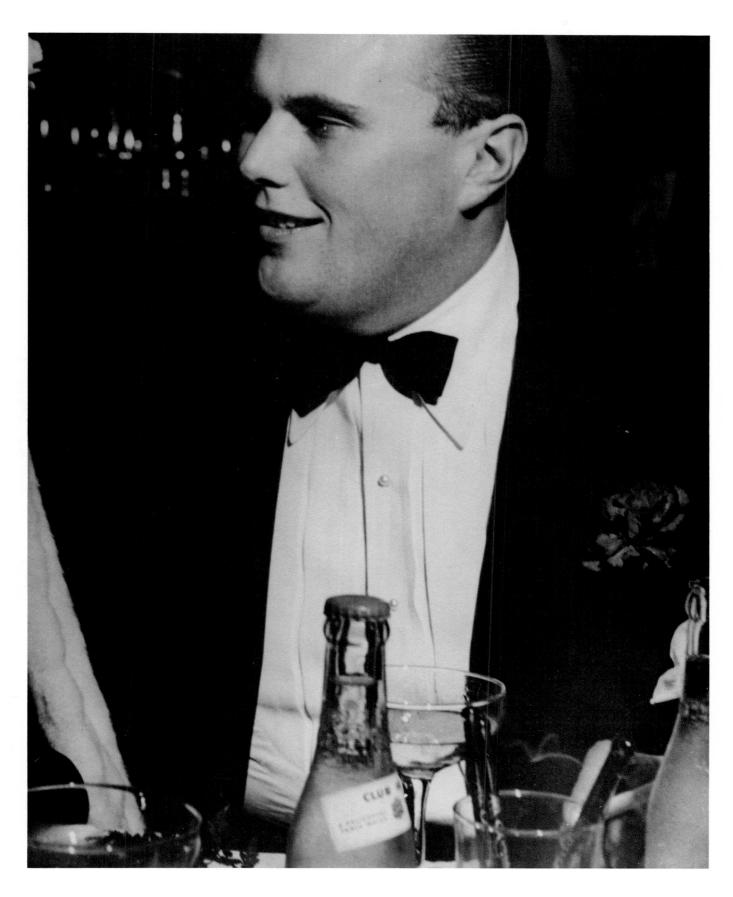

129 **St Regis Hotel** New York c. 1945

130 **Lighthouse, Blind Workshop** New York 1944

131 **Lighthouse, Blind Workshop** New York 1944

132 **Lighthouse, Blind Workshop** New York 1944

134 **Circus** New York 1945

135 **Circus** New York 1945

136 **Circus** New York 1945

137 **Circus** New York 1945

138 **Circus** New York 1945

139 **International Refugee Organization Auction** New York 1948

140 **International Refugee Organization Auction** New York 1948

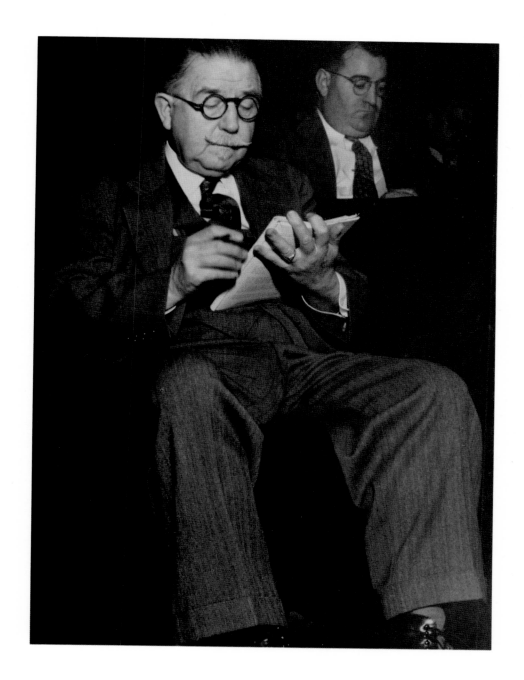

142 **International Refugee Organization Auction** New York 1948

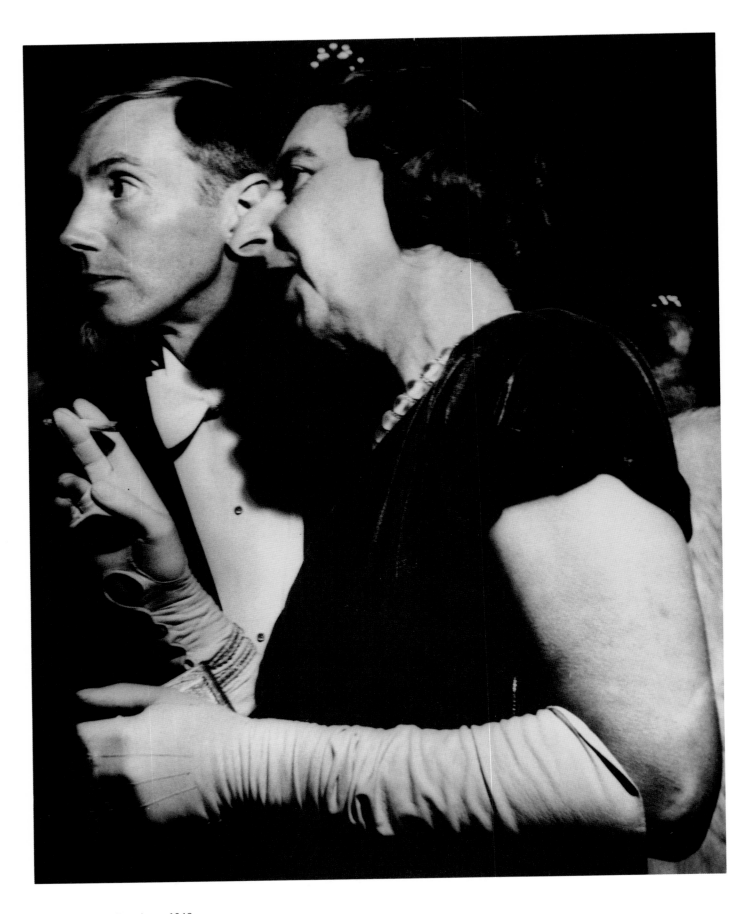

143 **Opera** San Francisco 1949

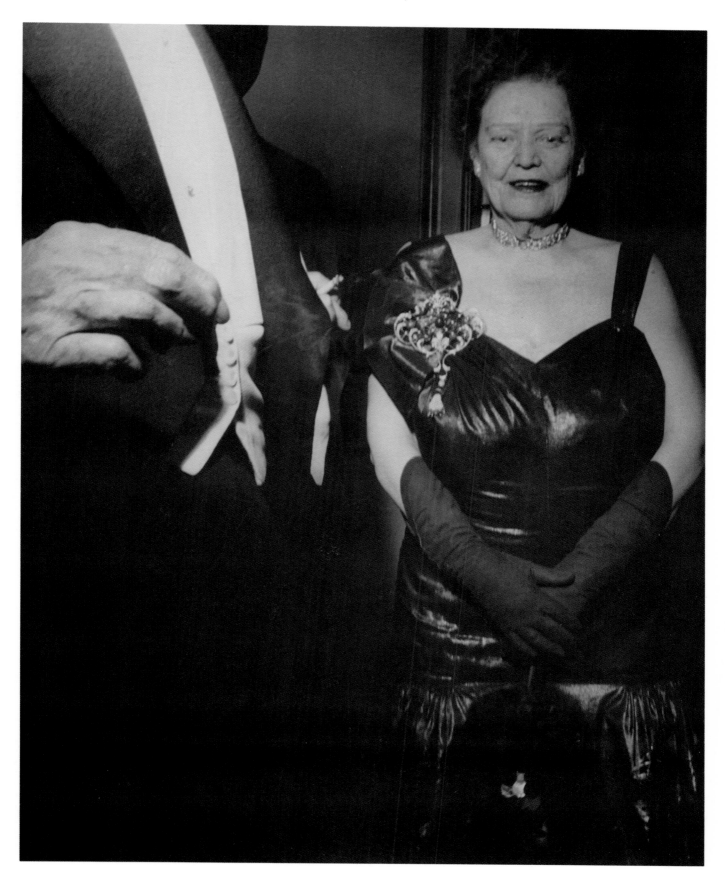

144 **Opera** San Francisco 1949

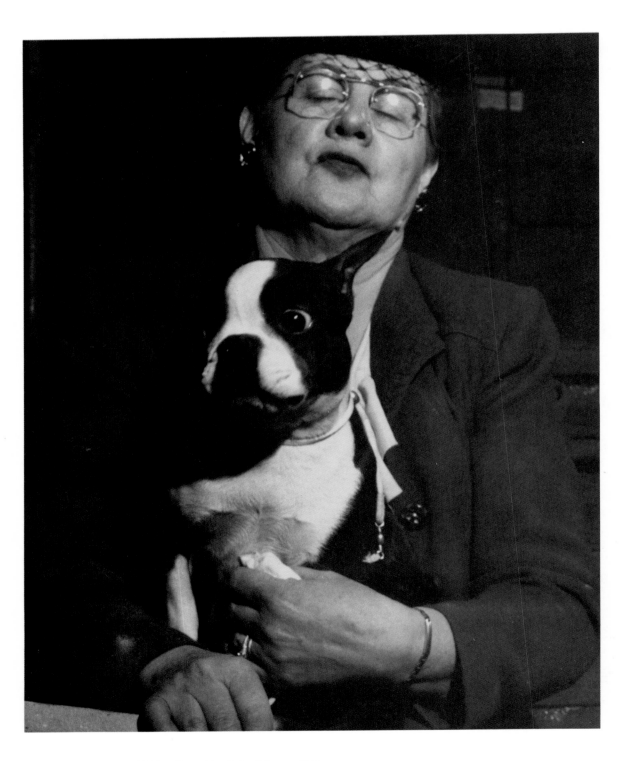

145 **Westminster Kennel Club Dog Show** New York February 1946

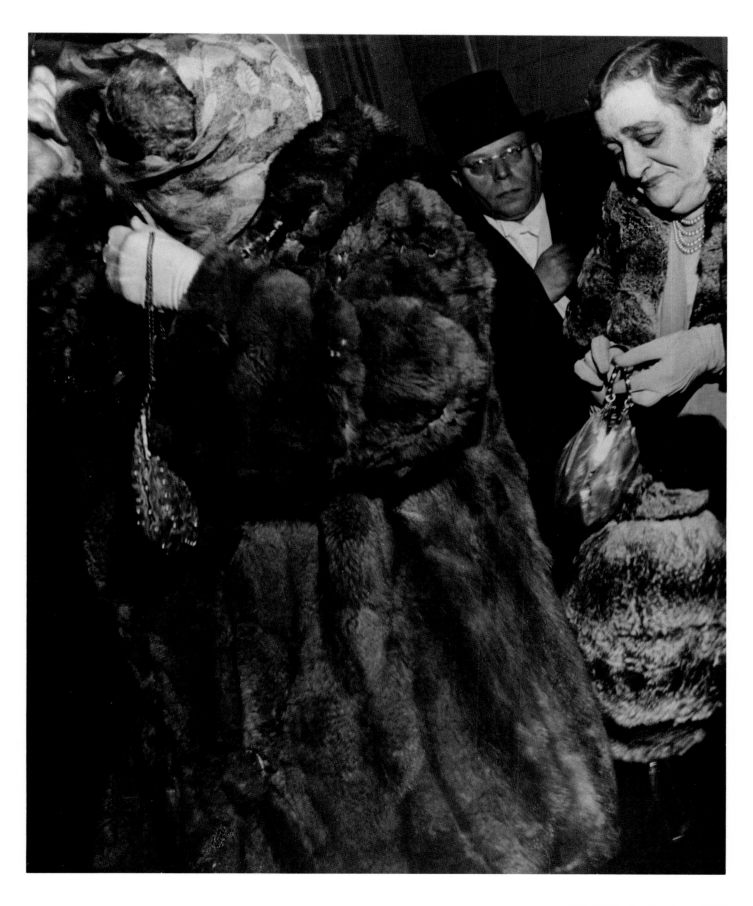

146 **Opera** San Francisco 1949

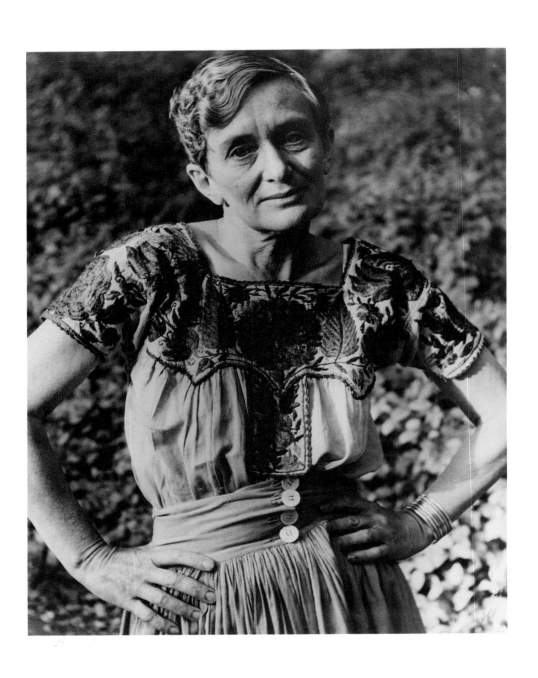

147 **Dorothea Lange** San Francisco 1946

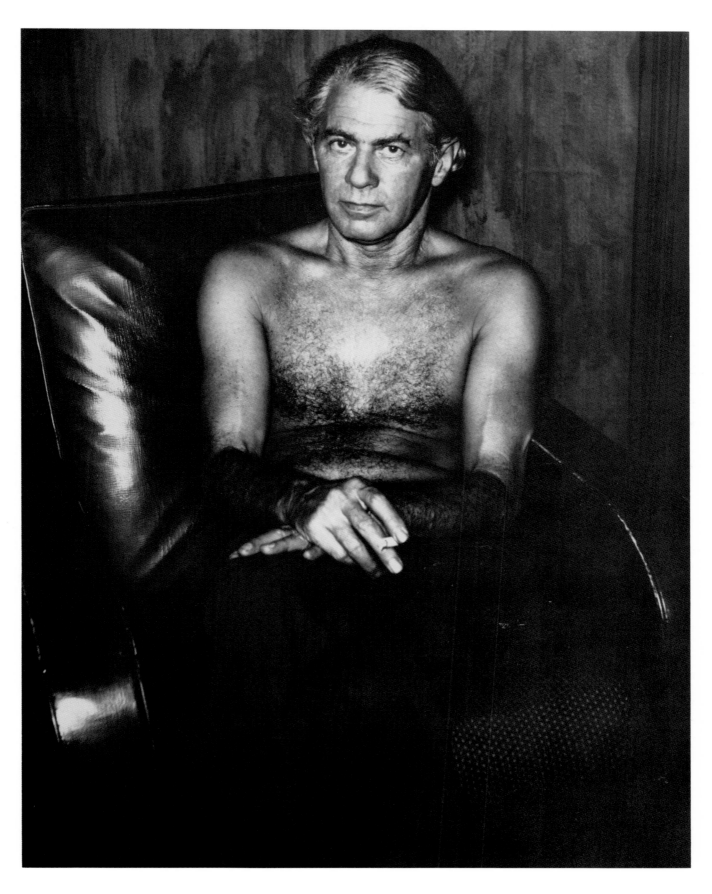

148 **Evsa Model** New York c. 1950

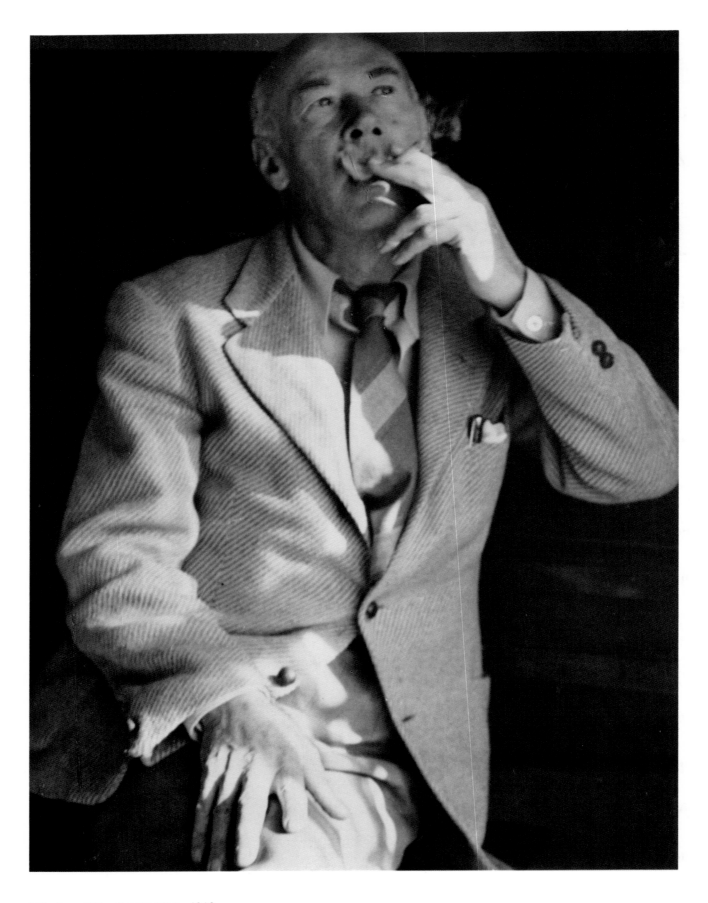

149 **Henry Miller** San Francisco 1946

150 **Frank Sinatra** New York between 1939 and 1944

151 **Murray Hill Hotel** New York between 1940 and 1947

152 **Murray Hill Hotel** New York between 1940 and 1947

153 **Murray Hill Hotel** New York between 1940 and 1947

154 **Murray Hill Hotel** New York between 1940 and 1947

155 **Dylan Thomas** New York probably 1953

156 **J. Robert Oppenheimer** San Francisco 1946

157 **Edward Weston** San Francisco 1946

158 **Reno** 1949

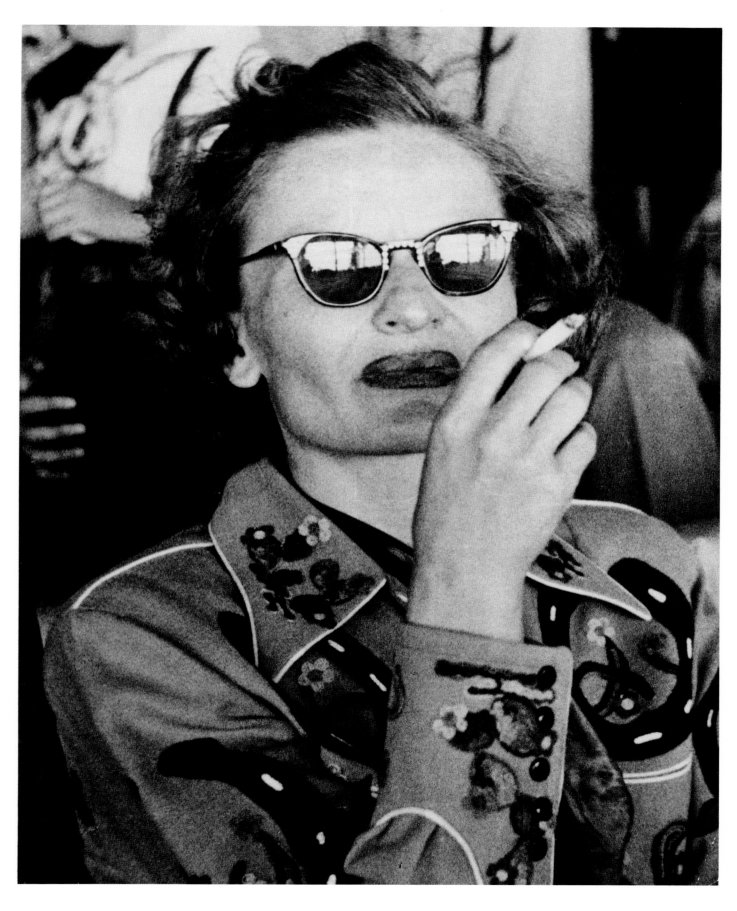

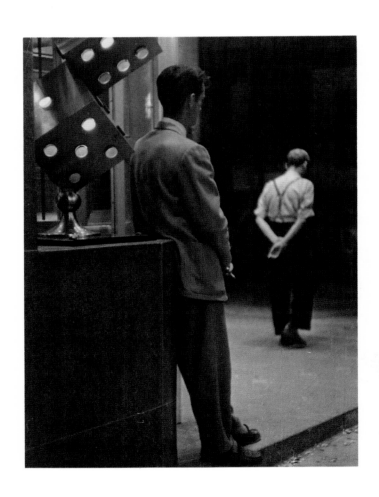

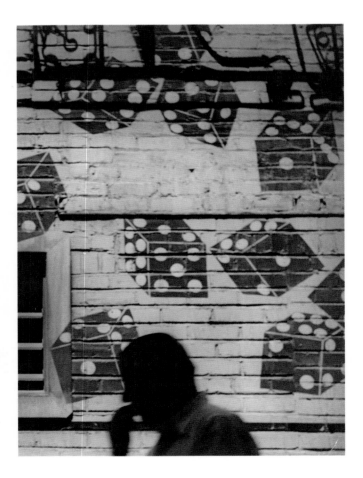

159 **Street at Night** Reno 1949

160 **Harold's** Reno 1949

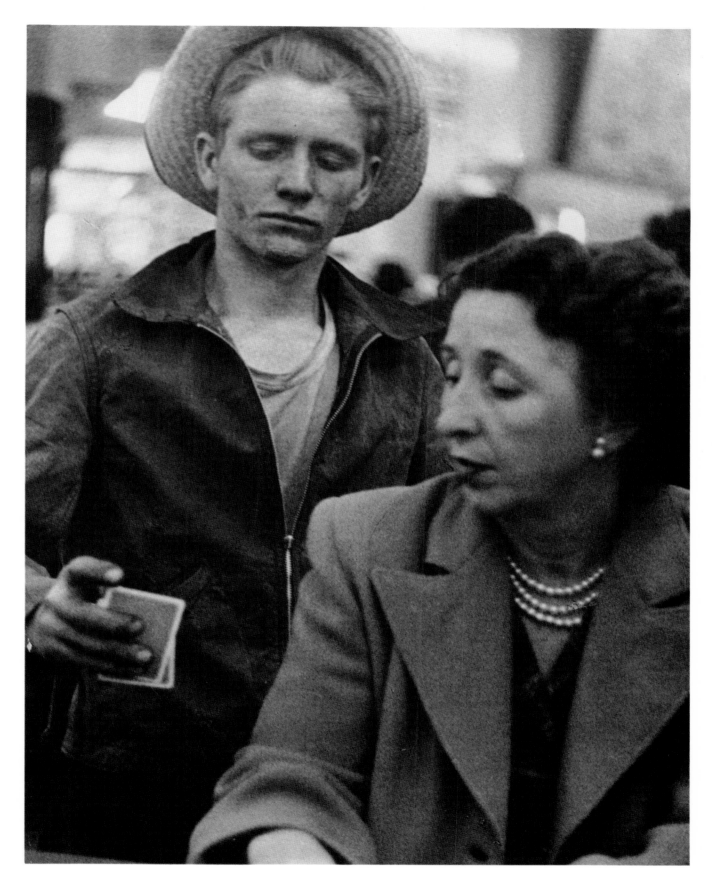

161 **Reno** 1949

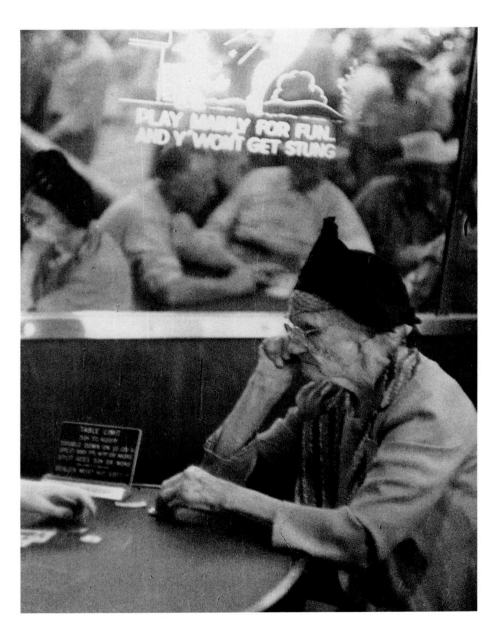

162 **Reno** 1949

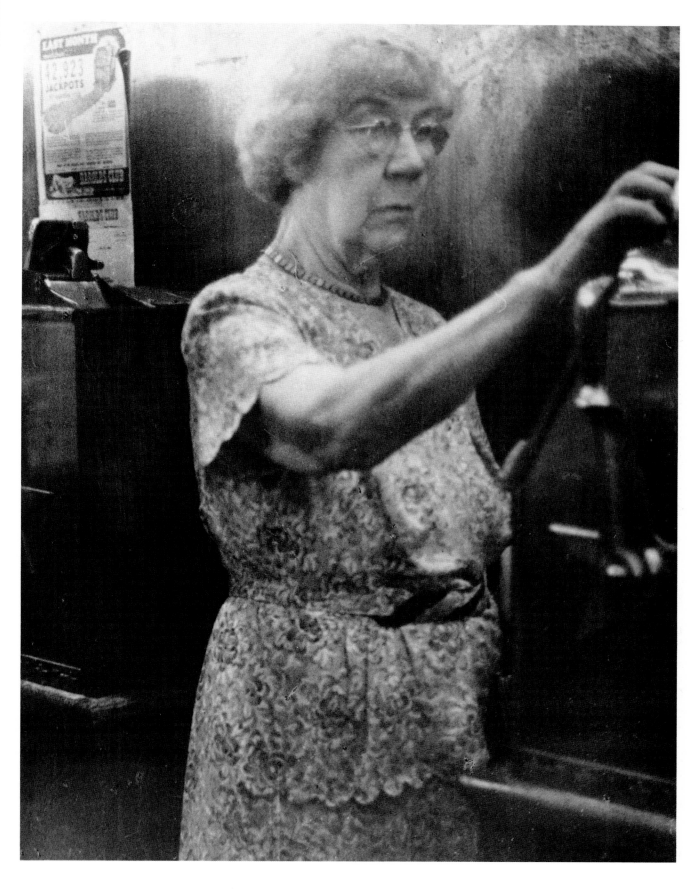

163 **Reno** 1949

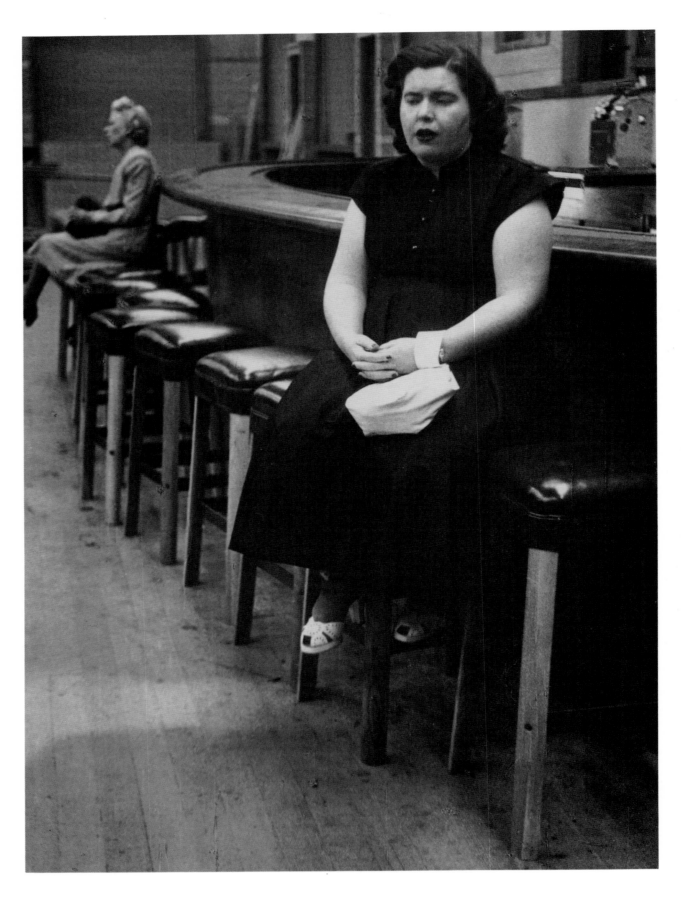

164 **Reno** 1949

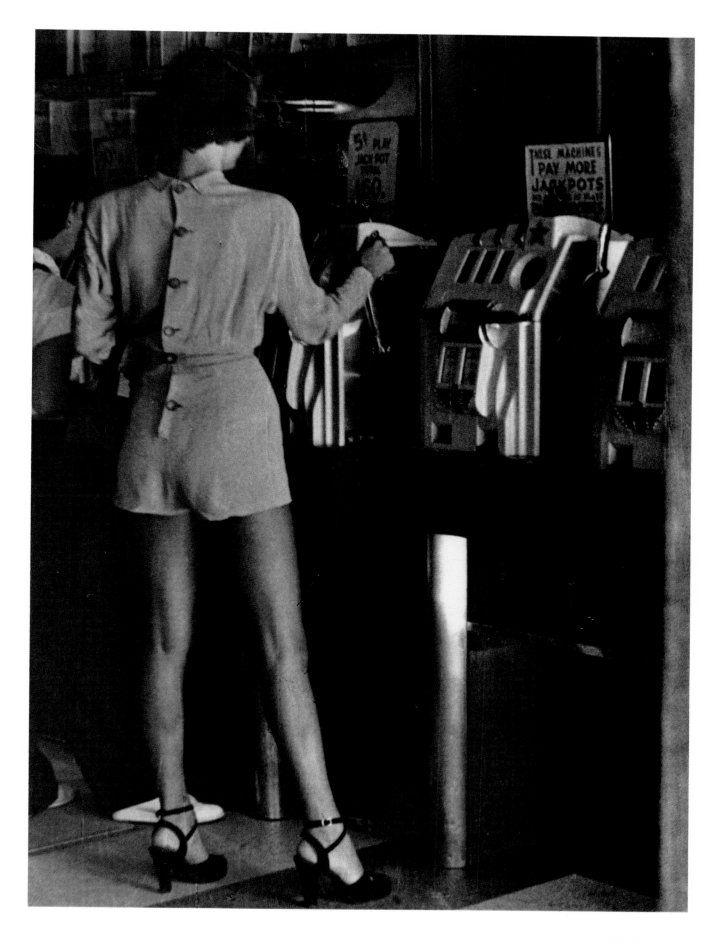

165 **Reno** 1949

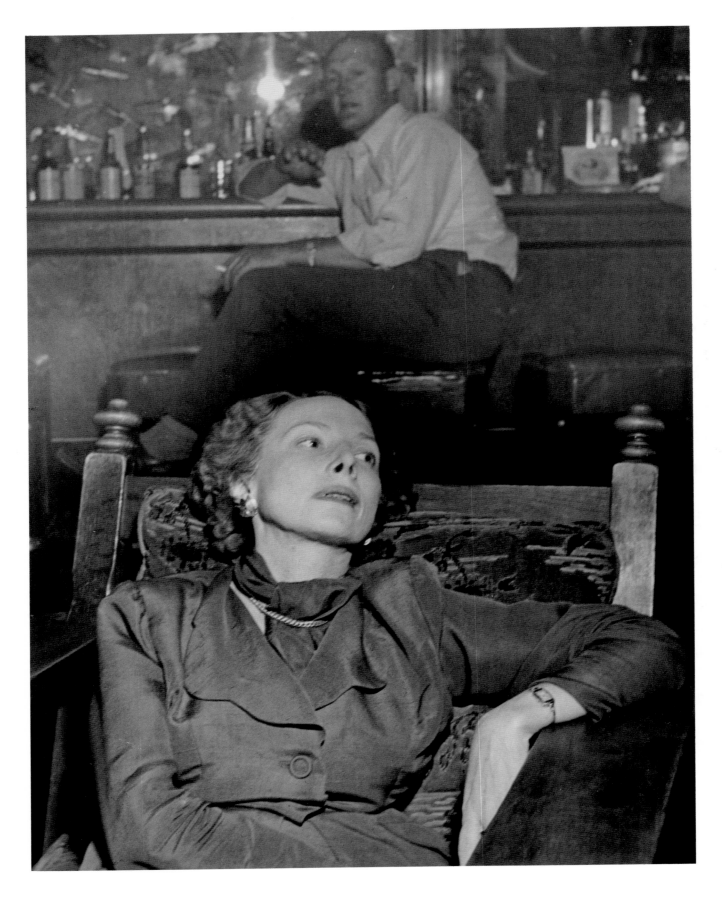

166 **Reno** 1949

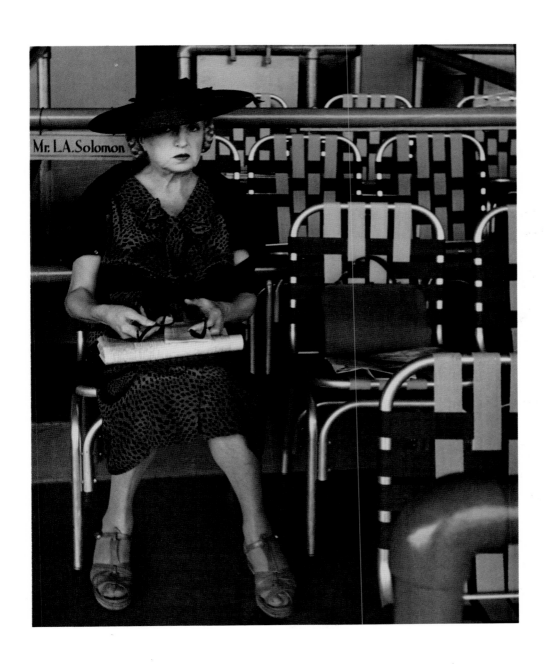

167 **Belmont Park** New York 1956

168　**Ella Fitzgerald**　c. 1954

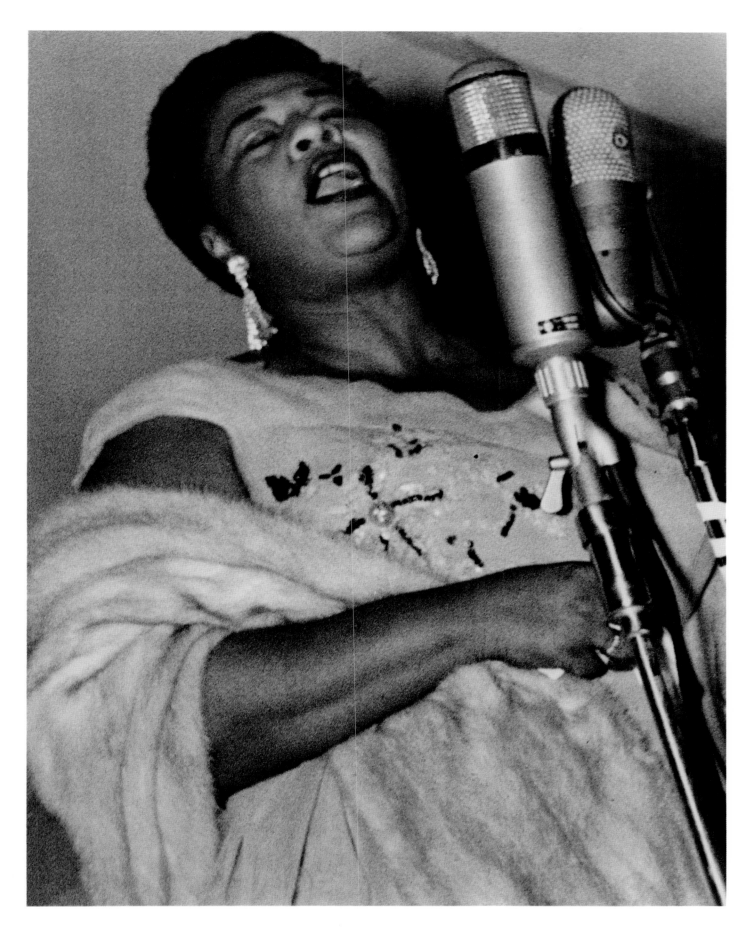

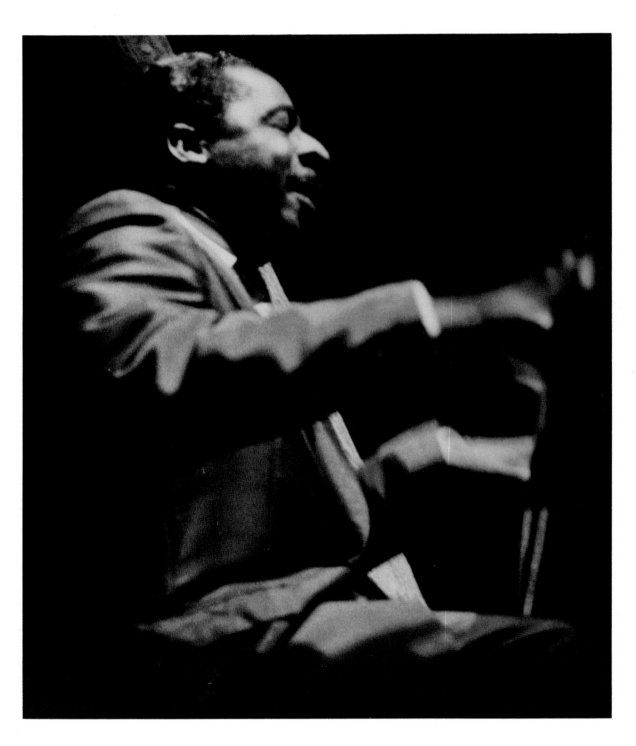

169　**Erroll Garner**　New York Jazz Festival　between 1956 and 1961

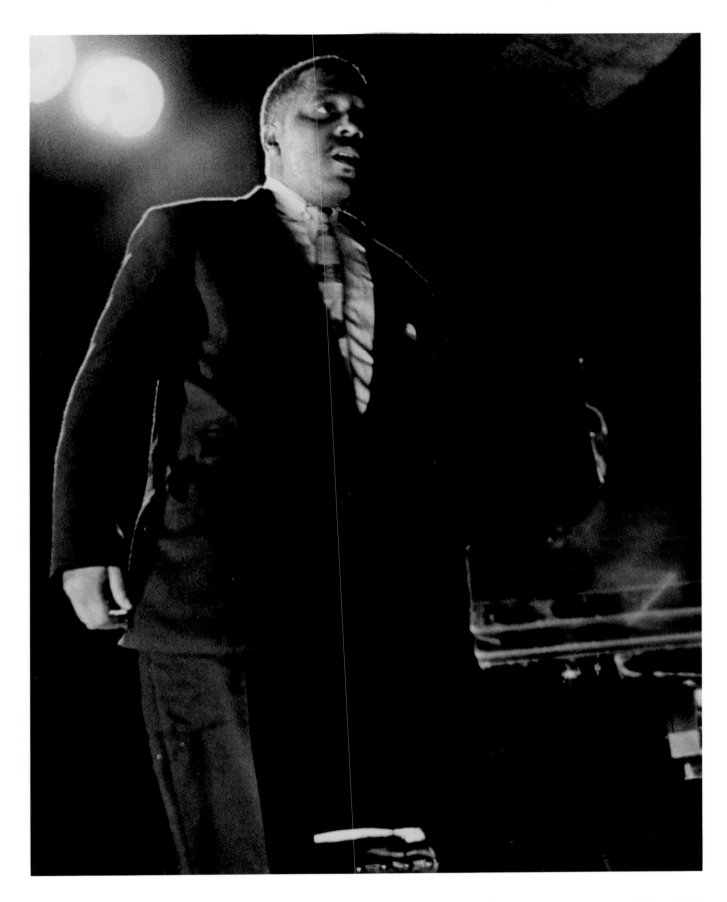

170 **Bud Powell** New York Jazz Festival between 1956 and 1958

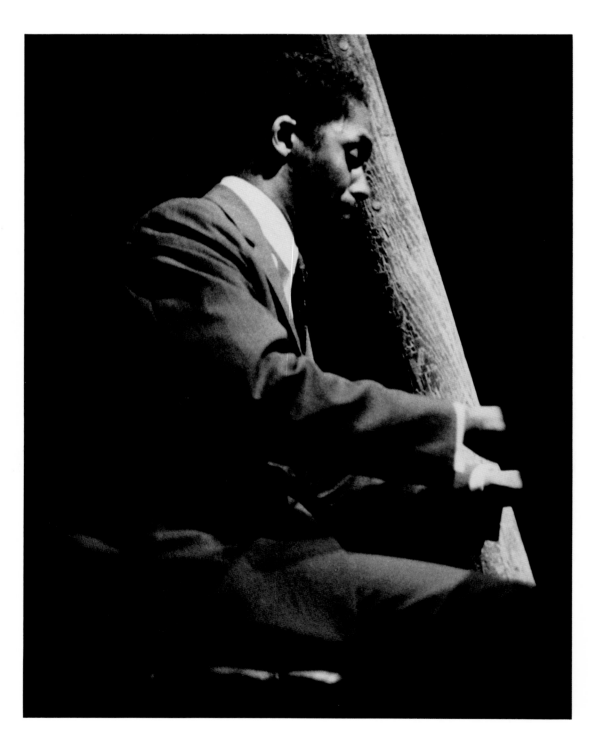

171 **John Lewis** New York Jazz Festival between 1956 and 1961

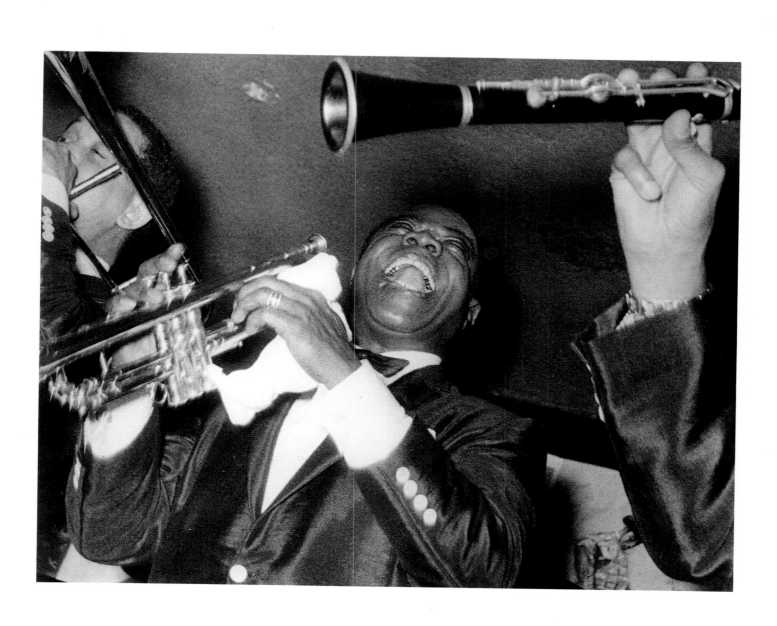

172 **Louis Armstrong** between 1954 and 1956

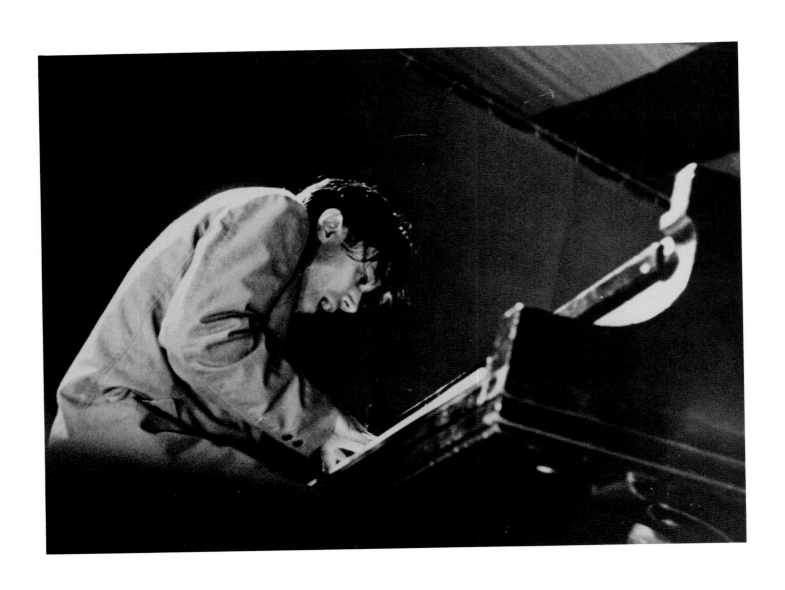

173 **Horace Silver** Newport Jazz Festival between 1954 and 1957

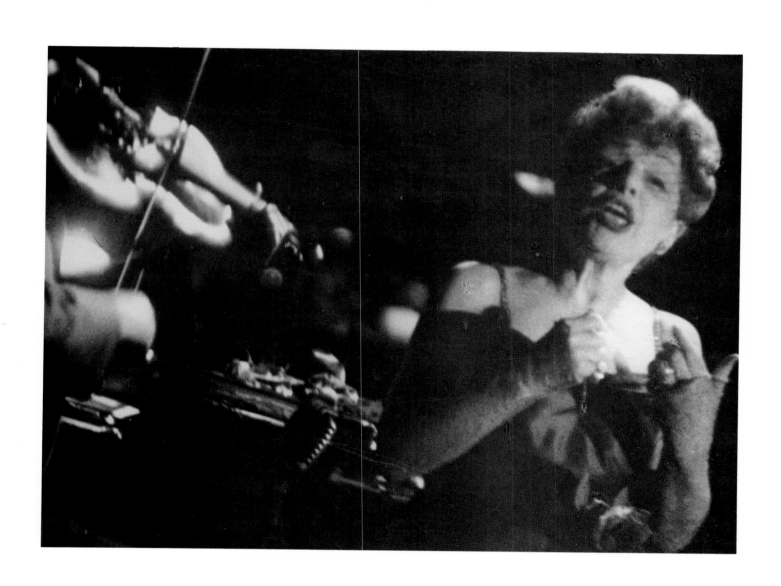

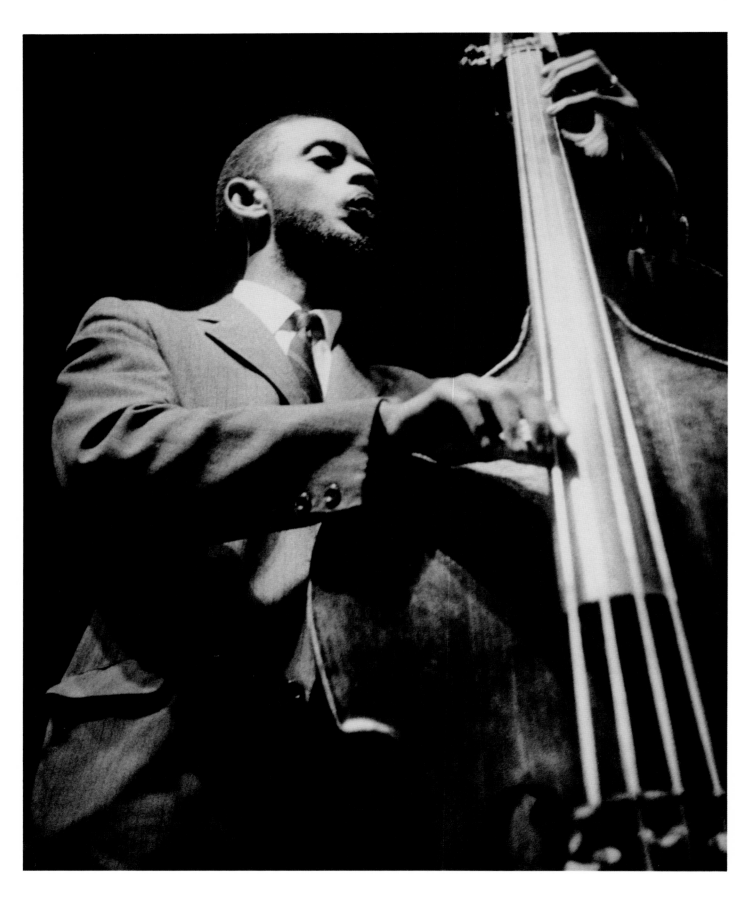

175 **Percy Heath** New York Jazz Festival between 1956 and 1961

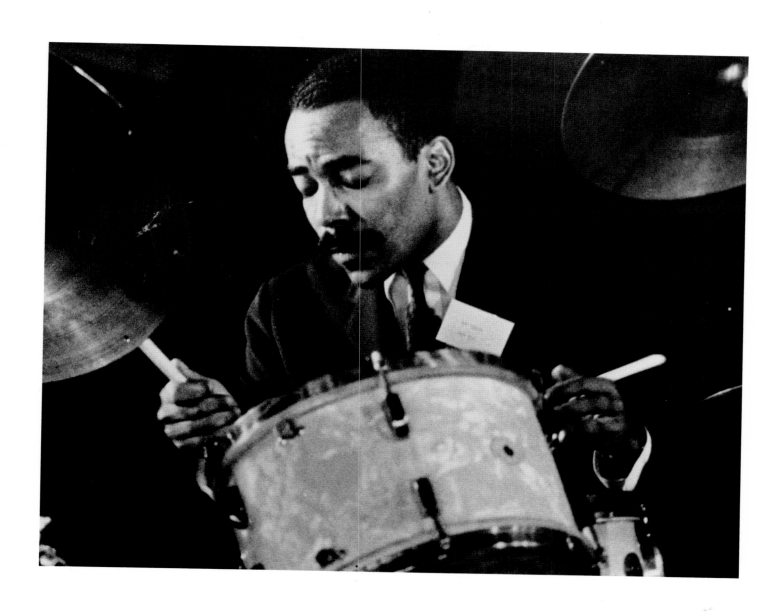

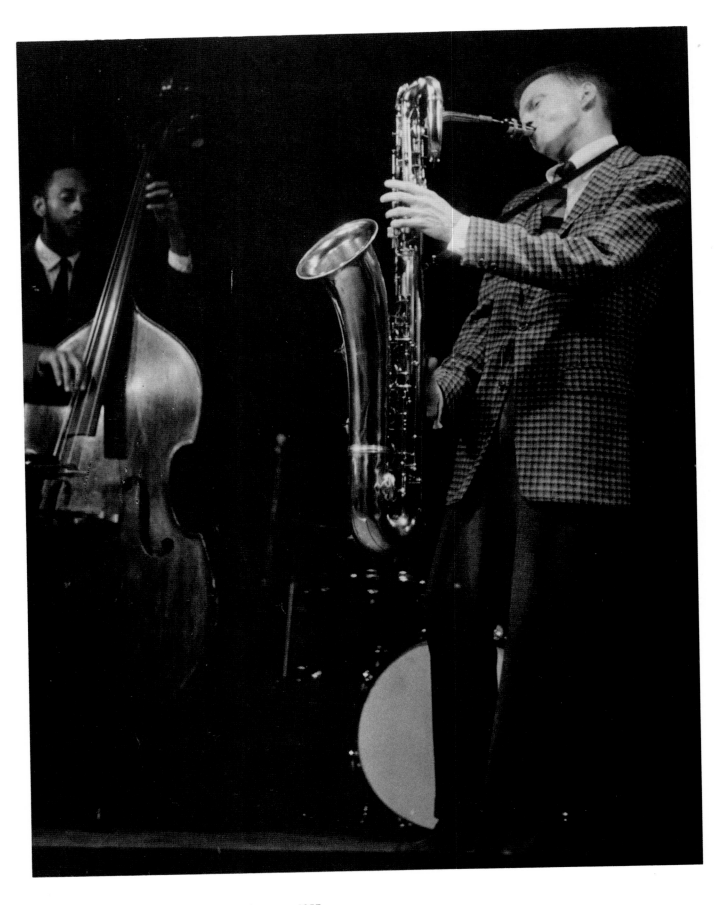

177 **Percy Heath and Gerry Mulligan** Music Inn, Lenox c. 1957

178 **Newport Jazz Festival, Opening** 1954 or 1956

179 **Rome** 1953

180 **Rome** 1953

181 **Rome** 1953

182 **Rome** 1953

183 **Rome** 1953

184 **Rome** 1953

185 **Studio of Armando Reverón** Venezuela 1954

186 **Studio of Armando Reverón** Venezuela 1954

187 **Studio of Armando Reverón** Venezuela 1954

188 **Studio of Armando Reverón** Venezuela 1954

Unless otherwise noted, documents are held in the
Estate of Lisette Model in the custody of the National
Gallery of Canada, Ottawa; and correspondence,
audiotapes, and notes on interviews are held in the
curatorial files, National Gallery of Canada, Ottawa.

Quotations from *Diane Arbus* (Aperture) are
copyright © Estate of Diane Arbus 1972, and from
the other writings of Diane Arbus are copyright ©
Estate of Diane Arbus 1990.

Quotations from Minor White correspondence are
used with permission of The Minor White Archive,
Princeton University. Written material is copyright ©
1990 by the Trustees of Princeton University.
All rights reserved.

Where page references are not indicated, the source
material is unpaginated or the information unavailable.

Frequently cited sources and names are identified
by the abbreviations following.

Arbus	Lori Pauli, telephone interview with Allan Arbus, Ottawa / Los Angeles, 27 June 1989.
Ash	Lori Pauli, telephone interview with Constantine Ash, Ottawa / Carmel, California, 28 April 1989.
AT	Ann Thomas.
Avshalomov	Lori Pauli, telephone interview with Jacob Avshalomov, Ottawa / Portland, Oregon, 19 April 1989.
Beller	Janet Beller, interview with Lisette Model, Port Washington, 27 July 1979.
BPRC	Lisette Model, lecture, 16 February 1979, Boston Photographic Resource Center, Boston.
Brackman	Ann Thomas, interview with Henrietta Brackman, New York, 30 September–1 October 1989.
Brown	Ann Thomas, telephone interview with Eve Tartar Brown, Ottawa / Carmel, California, 17 February 1989.
Bunnell	Ann Thomas, interview with Peter C. Bunnell, Princeton, New Jersey, 5 October 1989.
Caspilli	Ann Thomas, interview with Bianca Bauer (née Caspilli), St Paul de Vence, 20 October 1988.
Cooper / Hill	Tom Cooper and Paul Hill, interview with Lisette Model, 1977, Angela Hill (transcription), Tom Cooper / Paul Hill Photographic Studios, Trent Polytechnic, Nottingham, England.
Cravens	R.H. Cravens, copy of unpublished manuscript, 1982.
Ellman	Ann Thomas, interview with Elaine Ellman, New York, 2 October 1989.
EM	Evsa Model.
Gee	Ann Thomas, interview with Helen Gee, New York, 30 May 1986.
Gossage	Ann Thomas, interview with John Gossage, Washington, 9 March 1990.
Greissle	Ann Thomas, telephone interview with Hermann Greissle, Ottawa / Fleischmanns, New York, May 1989.
Haverford	Lisette Model, lecture, 4 March 1983, Comfort Gallery, Haverford College, Haverford.
Heinz	Ann Thomas, interview with Julia Heinz, New York, 7 February 1986.
Jones	Ann Thomas, telephone interview with Pirkle Jones, Ottawa / San Francisco, 1 August 1989.
Kaczmarek	Ann Thomas, interview with Marc Kaczmarek, New York, 1 October 1989.
Klausner	Lori Pauli, telephone interview with Bertha Klausner, Ottawa / New York, January 1989.
Knapp	Ann Thomas, interview with Dee Knapp, New York, 29 September–1 October 1989.
Lassance	Ann Thomas, interview with Anita Lassance, Paris, 10 October 1988.
LM	Lisette Model.
Lopate	Phillip Lopate, "Portrait of Lisette Model," unpublished manuscript prepared for Aperture Books, New York, 1979.
Magner	Ann Thomas, interview with Martin Magner, Los Angeles, 25 June 1989.
McQuaid / Tait	Jim McQuaid and David Tait, interview with Lisette Model, New York, 1977, International Museum of Photography at the George Eastman House, New York.
Piaskowski	Ann Thomas, telephone interview with Nata Piaskowski, Ottawa / San Francisco, 1 November 1989.
Porter	Ann Thomas, interview with Allan Porter, Lucerne, 26 January 1989.
Pratt Institute	Lisette Model, lecture, 22 March 1978, Photography Department, Pratt Institute, New York.
Rogers	Ann Thomas, interview with Celia Rogers, Los Angeles, 24 June 1989.
Rubinstein	Ann Thomas, interview with Eva Rubinstein, New York, September 1989.
Sander	Ann Thomas, interview with Gerd Sander, Sinzig, 24 January 1989.
Seuphor	Ann Thomas, interview with Michel and Suzanne Seuphor, Paris, 11 October 1988.
Seybert	Ann Thomas, conversation with Olga Seybert, Denver, 15 February 1989.
Steinitz	Ann Thomas, interview with Kurt Steinitz, Nice, October 1988.
TN	Lisette Model, teaching notebooks 1–29, 19[51]–19[82].
Vestal	Ann Thomas, interview with David Vestal, Bethlehem, Connecticut, 1 June 1986.
Wheelock	Ann Thomas, interview with Dorothy Wheelock, Newbury, 31 August 1989.
Wilcox	Ann Thomas, interview with Wilma Wilcox, New York, 6 October 1989.

INTRODUCTION AND CHAPTER ONE

1 LM, Ingram-Merrill Foundation grant application, 19 January 1970.

2 McQuaid/Tait.

3 Pratt Institute.

4 Lopate, p. 4.

5 Robert Waissenberger, "Politics in Vienna Before and After the Turn of the Century," *Vienna 1890–1920* (New York: Rizzoli, 1984), p. 31.

6 TN 5, p. 17b.

7 TN 12, p. 27.

8 Sisley Huddleston, *Europe in Zigzags* (England: Harrap, [1929]), excerpted from John Lehmann and Richard Bassett, *Vienna: A Traveller's Companion* (London: Constable, 1988), p. 158–59.

9 LM, birth certificate, issued 5 September 1958, Vienna.

10 Record from birth register for Victor Seybert, Österreichisches Staatsarchiv, Kriegsarchiv, Vienna.

11 Imperial and Royal Corps. Regiment Ritter von Ludwig No. 14 / Subdivision Personnel Registry Sheet / Main Personnel Register for Year 1885. His association with the International Red Cross was recounted by both Lisette (Cravens, p. 6) and Olga (Seybert).

12 Herbert Koch, Meldearchiv, Wiener Stadt- und Landesarchiv, Magistrat der Stadt Wien, letter to AT, 21 October 1988.

13 Caspilli.

14 Lopate, p. 5.

15 Post-mortem report on Victor Seybert (Maria Treu Parish, Vienna) gives the date of marriage as 15 December 1902, probably a religious ceremony.

16 Pratt Institute.

17 Seybert.

18 McQuaid/Tait.

19 Caspilli.

20 Stephan Zweig, *The World of Yesterday: An Autobiography* (Lincoln: University of Nebraska Press, 1969), p. 29.

21 McQuaid/Tait, and Heinz.

22 Heinz.

23 Olga Seybert, letter to AT, 18 July 1989.

24 Caspilli, and McQuaid/Tait.

25 Caspilli. Eda Löwy was a friend of the Caspilli family.

26 Ernst Hilmar, *Arnold Schönberg: Gedenkausstellung 1974* (Vienna: Universal Edition AG, 1974), p. 303.

27 Heinz. The Society for Private Musical Performances was founded by Schönberg in Vienna after World War I. It followed the Society of Creative Musicians founded in 1904.

28 Egon Schiele, citation from an unpublished essay "Neukünstler," in Jane Kallir, *Austria's Expressionism* (New York: Galerie St. Etienne/Rizzoli, 1981), p. 52.

29 The information on Austrian photography of the period owes a great deal to Monika Faber's chapter "Amateurs et autres: histoire de la photographie (1887–1936)," in Jean Clair (ed.), *Vienne 1890–1938: L'Apocalypse joyeuse* ([Paris]: Éditions du Centre Pompidou / SPADEM/ADAGP, 1986).

30 Faber, p. 378.

31 Faber, p. 381.

32 Malcolm MacDonald, *Schoenberg* (London and Melbourne: J.M. Dent and Sons, 1976), p. 39.

33 Arnold Schönberg, fiftieth birthday album, Arnold Schoenberg Institute Archives, School of Music, University of Southern California, Los Angeles.

34 Bernard Grun (ed.), *Alban Berg: Letters to His Wife* (London: Faber and Faber, 1971), p. 264.

35 Stanley Sadie (ed.), *The New Grove Dictionary of Music and Musicians*, vol. 16 (London: MacMillan, 1980), p. 702.

36 *Lehmanns Allgemeiner Wohnungsanzeiger* (Vienna: Holder, 1908), p. 675. Dr Luithlen's was located at 9 Auerspergstrasse.

37 McQuaid/Tait.

38 McQuaid/Tait.

39 Victor Seybert, letter to Arnold Schönberg, 3 November 1923, Music Division, Library of Congress, Washington.

40 Post-mortem report on Victor Seybert.

41 Cravens, p. 7.

42 McQuaid/Tait.

43 McQuaid/Tait.

44 McQuaid/Tait.

45 BPRC.

46 BPRC.

47 BPRC.

CHAPTER TWO

1 Ann Winters, transcript of tape of Sid Grossman's class, 1950, collection Miriam Cohen, New York.

2 Heinz.

3 Lassance.

4 McQuaid/Tait.

5 Seybert. Ylla's photographs were later exhibited along with Lisette's in *The Instant in Photography*, an exhibition directed by Berenice Abbott, 6 to 21 April 1945, under the auspices of the associate members of the New School.

6 Seybert.

7 Dianora Niccolini, "A Personal Tribute to Lisette Model," *PWP Times*, vol. 1, no. 4, Spring 1983, whole issue.

8 Haverford.

9 Stanley Sadie (ed.), *The New Grove Dictionary of Music and Musicians*, vol. 6 (London: MacMillan, 1980), p. 90. An associate of Brecht, Hanns Eisler immigrated to the United States in 1937 and took a position at the New School for Social Research, where he had previously taught a course in 1935–1936. He was finally extradited from the United States because of his political beliefs in 1948.

10 Lowell Handler interview with LM; Renée Belson, *Portraits de Peintres* (Paris: Éditions du Regard, [1981]); and Michèle and Michel Auer, *Encyclopédie Internationale de Photographes de 1839 à nos jours / Photographers' Encyclopedia International, 1839 to the present* (Geneva: Éditions Camera Obscura, 1985). Rogi André (Rosa Klein) was married to Kertész between 1928 and 1930. Model dates their association to just after the couple had separated, thus making it somewhere between 1931 and 1933. Renée Belson has Rogi living and working with Kertész up to 1933, and the Auer dictionary has the same information.

11 Cooper/Hill.

12 LM, project submitted to John Simon Guggenheim Memorial Foundation, 30 October 1948, New York.

13 Author's note.

14 McQuaid/Tait, and Artist's Files, Museum of Modern Art, New York.

15 Vestal.

16 TN 6, p. 21b.

17 TN 2, p. 37–38.

18 Author's note.

19 TN 2, p. 11.

20 TN 2, p. 11.

21 TN 2, p. 11.

22 TN 7, p. 11.

23 TN 6, p. 22b.

24 TN 2, p. 32b.

25 It is possible but unlikely that it was Lisette Seybert writing under a pseudonym.

26 Lise Curel, "Côte d'Azur," *Regards*, vol. 4, no. 59, 28 February 1935.

27 EM, letter to Lisette Seybert, 28 April 1936. This letter from Nice to Paris alludes to a journalist from "Re..." coming to view her photographs.

28 "La photo au service de la classe ouvrière," *Regards*, no. 14, February 1933, p. 19.

29 Beller.

30 Christopher Phillips generously shared his knowledge of European publications of this period by drawing my attention to this information.

31 Cooper/Hill.

32 Michel Seuphor, letter to EM, March 1937.

33 Seuphor.

34 Certificate issued upon the authorization of the Russian Provisional Government.

35 *Evsa Model*, exhibition brochure, The Pinacotheca, New York, April–May 1942; and Ash.

36 Certificate.

37 Seuphor; and Sandra Phillips et al., *André Kertész: Of Paris and New York* (Chicago: The Art Institute of Chicago, The Metropolitan Museum, and Thames and Hudson, 1985), p. 265.

38 Seuphor. Michel and Suzanne Seuphor knew Evsa from the late 1920s.

39 Exhibition announcements, The Pinacotheca, New York, May 1941 and April–May 1942. The latter lists the second gallery as The Gallery Paderewski.

40 EM, letter to Lisette Seybert, 5 October 1936.

41 EM, letter to Lisette Seybert, same.

42 EM, letter to Lisette Seybert, 27 December 1936.

43 EM, letters 21, 22–25, and 28 October, and 1 November 1936, to Lisette Seybert.

44 The Models' contract of marriage, Paris, 27 July 1937.

45 EM, letter to LM, 21 August 1938.

46 EM, letter to LM, same.

CHAPTER THREE

1 McQuaid/Tait.

2 Ash.

3 McQuaid/Tait.

4 Ash.

5 *U.S. Camera*, vol. 1, no. 14, February 1941, p. 14.

6 Félicie Seybert, letter to LM, 13 September 1939.

7 Félicie Seybert, letter to LM, 28 November 1940.

8 New York City directories, 1938–1939.

9 EM, letter to Douglas MacAgy, [March or April] 1946, San Francisco Art Institute Archives, Anne Bremer Memorial Library.

10 Erwin Stein (ed.), *Arnold Schönberg: Letters* (London and Boston: Faber and Faber, 1987 [reissue]), p. 204.

11 LM, letter to Arnold Schönberg, 30 November 1939, Music Division, Library of Congress, Washington.

12 Greissle.

13 Alfred Richard Meyer, *Querschnitt*, program for Valeska Gert and Sonja Wronkow performance 6 October 1940, Cherry Lane Theater, New York Public Library Performing Arts Research Center, Dance Collection.

14 Brown. Norman Rabin was the assumed name of Numa Rabinowitz, son of Sholom Aleichem.

15 Lopate, p. 60; and Heinz.

16 Valeska Gert, *Die Bettler-Bar von New York* (Berlin: Arani Verlag, 1950), p. 36.

17 Author's note.

18 Julia and Hans Heinz, letter to LM, 16 April 1980.

CHAPTER FOUR

1 R.H. Cravens, "Notes for a Portrait of Lisette Model," *Aperture*, no. 86, 1982, p. 64.

2 These are subjects to which she alludes in her teaching notebooks.

3 *Cue*, vol. 9, no. 50, 7 December 1940, p. 17.

4 *Cue*, p. 17.

5 Sheila Seed, interview with LM, 1978.

6 Carol Squiers, "'Art of the Split Second,' Lisette Model," *Interview*, vol. 10, no. 1, January 1979, p. 36.

7 Cooper/Hill.

8 Joe Cuomo, "The Fearless Eye," *Darkroom Photography*, vol. 6, no. 1, January/February 1984, p. 45.

9 Cooper/Hill.

10 Bryan Holme and Thomas Forman (eds.), *Poet's Camera* (New York and London: American Studio Books, 1946), p. 11x.

11 McQuaid/Tait.

12 *New York City Guide*, Federal Writer's Project (New York: Random House, 1938), p. 50.

13 *U.S. Camera*, vol. 1, no. 14, February 1941, p. 14.

14 Frank-Manuel Peter, *Valeska Gert: Tänzerin, Schauspielerin, Kabarettistin* (Berlin: Frolich und Kauffman, 1985); this illustrates one by Tobias.

15 Anne Teresa De Keersmaeker, "Valeska Gert," *Drama Review*, vol. 25, no. 3, Fall 1981, p. 56.

16 Keersmaeker, p. 65.

17 Gert cited in Keersmaeker, p. 56.

18 Eric Kocher, letter to AT, 4 August 1989.

19 Peter, p. 84.

20 Brackman, and McQuaid/Tait.

21 "Museum Symposium," *New York Times*, 5 November 1950, p. X16.

22 Avshalomov.

23 McQuaid/Tait. Her introduction to Sammy's by George Davis must have predated 1941 because Davis left *Harper's Bazaar* in 1941 (Carmel Snow, *The World of Carmel Snow* [New York: McGraw-Hill, 1962]), p. 140.

24 Weegee, *Naked City* (New York: Essential Books, 1945), p. 138–39.

25 Beller.

26 Knapp.

27 Beller.

28 *U.S. Camera*, vol. 7, no. 6, August 1944, p. 24.

29 Elizabeth McCausland, "Photographic Show at Modern Museum," *Springfield Sunday Union and Republican*, 2 April 1944, p. 4C.

30 John Adam Knight, "Acting Makes Photos Better," *New York Post*, 13 July 1944, p. 25.

31 LM, "On the Firing Line," *U.S. Camera*, vol. 7, no. 7, October l944, p. 5l.

32 I would like to acknowledge Gerd Sander's assistance in this. He identified the connection between the Model negatives and Weegee's *The Critic*.

33 Weegee, *Naked City*, p. 124.

34 Wilcox.

35 Ellman.

36 The relationship between Weegee, Arbus, and Model was explored in an exhibition curated by William Earle Williams, Director, Comfort Gallery, Haverford College, Connecticut, March 1983.

37 Ralph Steiner, postcard to LM, 27 February 1942.

38 Steiner, same.

39 Beller.

40 McQuaid/Tait.

41 *New School Bulletin*, vol. 9, no. 1, 3 September 1951, p. 110.

42 Author's note.

43 Cooper/Hill.

44 Cooper/Hill.

45 "Ace Photographer," *U.S. Camera*, vol. 5, no. 10, October 1942, p. 24–25.

46 "Their Boys Are Fighting," *Look*, vol. 6, no. 23, 17 November 1942, p. 68.

47 Lopate, p. 15.

48 *Artists in the War* (New York: A.C.A. Gallery, 1942), program of conference held 14 June 1942.

49 Author's note.

50 Cooper/Hill.

51 *Photo Notes*, March–April 1939, p. 2.

52 *Photo Notes*, October–November 1940, p. 1.

53 TN 2, p. 13–15.

54 TN 2, p. 16.

55 Lopate, p. 15.

CHAPTER FIVE

1 McQuaid/Tait.

2 Cooper/Hill.

3 Beaumont Newhall, journal, Beaumont Newhall, Santa Fe.

4 Newhall.

5 Beaumont Newhall, letter to AT, 8 July 1988. Both Model and Newhall have noted that their acquaintance was superficial. "I saw very little of Lisette, simply because I was overseas in the Air Force from 1942 to 1945, and Nancy and I moved to Rochester in 1948. During those years I know that Nancy saw Lisette frequently but, alas, I find very little about her in Nancy's files beyond the enclosed biographical note that Lisette dictated to her in 1943."

6 The Photography Center Print Room with its Library and Experimental Gallery was at 9 West Fifty-fourth Street.

7 "The New Department of Photography," *Bulletin of the Museum of Modern Art*, vol. 8, no. 2, December 1940–January 1941, p. 5.

8 Ralph Steiner, "In PM's Gallery: One Photographer's Explanation of Why France Fell," *PM's Weekly (PM's Sunday Edition)*, vol. 1, no. 31, 19 January 1941, p. 40.

9 Author's note.

10 Elizabeth McCausland, "Museum of Modern Art Embraces Photography," *Springfield Sunday Union and Republican*, 5 January 1941, p. 5.

11 In the 1930s and 1940s, the Museum of Modern Art's Department of Photography collected internationally, but periodically focussed on American photography through its exhibition program.

12 Edward Steichen, *Four Photographers*, press release, Museum of Modern Art, 1948.

13 Edward Steichen, letter to LM, 14 December 1964. This was a gift made by her in 1964.

14 Anne Tucker, *Photographic Crossroads: The Photo League Journal*, no. 25, 6 April 1978, p. 2.

15 *Photo Notes*, September 1940, p. 1.

16 Magner.

17 Cooper/Hill.

18 The talk was announced in the same issue of *Photo Notes* as that in which the review by McCausland appeared, i.e., May–June 1941, p. 1.

19 *Photo Notes*, July–August 1941, p. 2.

20 Elizabeth McCausland, "Lisette Model Shows 'Candid' Photographs: Forty Prints by the French Artist Revealing of Life and Character among the Idle Rich and the Dispossessed — Scenes in the Riviera, Nice, Paris and New York," *Springfield Sunday Union and Republican*, 27 May 1941, p. 6E.

21 Author's note.

22 McCausland, page 6E.

23 Elizabeth McCausland, "Camera Satire and Sympathy," *Good Photography*, no. 8, 1942, p. 30.

24 McCausland, "'Candid' Photographs," p. 6E.

25 Gee.

26 "Photo League Show," *U.S. Camera*, vol. 12, no. 2, February 1949, p. 53.

27 Oliver Pilat and Jo Ranson, "How Coney Island Got That Way," *Harper's Bazaar*, vol. 75, July 1941, p. 52–53, 86, 92. Illustrated with *Coney Island Bather* (standing), p. 53.

28 Wheelock.

29 John Flattau, Ralph Gibson, and Arne Lewis (eds.), *Darkroom II* (New York: Lustrum, 1978), p. 68.

30 Charles G. Shaw, *Nightlife* (New York: The John Day Company, 1931), p. 51–52.

31 Diane Arbus, "Hubert's Obituary: Or this was where we came in," unpublished, 1966, in *Diane Arbus: Magazine Work*, texts by Diane Arbus, essay by Thomas W. Southall, edited by Doon Arbus and Marvin Israel (New York: Aperture, 1984), p. 80–81.

32 Carmel Snow, *The World of Carmel Snow* (New York: McGraw-Hill, 1962), p. 186.

33 Snow, p. 82.

34 Snow, p. 90.

35 Ralph Steiner, *A Point of View* (Middletown: Wesleyan University Press, 1978), p. 17.

36 Snow, p. 83.

37 Snow, p. 89–90.

38 Flattau, Gibson, and Lewis, p. 68.

39 Snow, p. 111.

40 Cooper/Hill.

41 Beller.

42 Wheelock.

43 Sheila Seed, interview with LM, 1978.

44 Haverford.

45 *New York City Guide* (New York: Random House, 1939, 1972), p. 216.

46 Vestal.

47 Kaczmarek.

48 Haverford.

49 Carmel Snow, letter to LM, 19 January 1948.

50 Carmel Snow, letter to LM, 24 May 1946.

51 Carmel Snow, letters to LM, 28 June 1945, and 24 May, 10 June, and 17 June 1946.

52 Cooper/Hill.

53 Lopate, p. 64.

54 Carmel Snow, letter to LM, 26 May 1944.

55 Dianora Niccolini, "A Personal Tribute to Lisette Model," *PWP Times*, vol. 1, no. 4, Spring 1983, p. 3; and Beller.

56 Niccolini, p. 3.

57 Dorothy Wheelock, letter to LM, November 1954.

58 Beller.

59 "Armando Reverón: Famous Venezuelan Painter Shown for the First Time in the U.S.," *Vogue*, vol. 127, no. 3, 15 February 1956, p. 110; and "Camera at the Race Track," *Cosmopolitan*, vol. 141, no. 1, July 1956, p. 76.

60 Steiner, p. 19–20.

61 *Photo Notes*, May–June 1941, p. 1.

62 *PM*, 19 January 1941, p. 34–39.

63 Carol Squiers, "'Art of the Split Second': Lisette Model," *Interview*, vol. 10, no. 1, January 1979, p. 37.

64 Lopate, p. 26.

65 *PM*, 19 January 1941, p. 34–39.

66 *PM*, same.

67 McCausland, "'Candid' Photographs," p. 6E.

CHAPTER SIX

1 Germaine Krull-Ivens, letter to LM, 16 October 1944.

2 McQuaid/Tait.

3 Carl O. Schniewind, letter to LM, 5 April 1943.

4 John Adam Knight, "Acting Makes Photos Better," *New York Post*, 13 July 1944, p. 25.

5 Elizabeth McCausland, "Photographic Show at Modern Museum," *Springfield Sunday Union and Republican*, 2 April 1944, p. 4C.

6 Imogen Cunningham, letter to LM, 16 October 1946.

7 McQuaid/Tait; and Minor White, letter to LM, 11 January 1952. Model and Lange were never particularly close, but their relationship took a turn for the worse in 1949, after Model was turned down for a Guggenheim Fellowship.

8 Author's note.

9 California Palace of the Legion of Honor, letter to AT, August 1987.

10 *Photo Arts* [incorporating *Photography*], vol. 2, no. 1, Spring 1948, p. 98.

11 *San Francisco Chronicle*, 1 September 1946, p. 9.

12 Jones.

13 California Palace of the Legion of Honor, press release, 2 August 1946, San Francisco.

14 Zilfa Estcourt, "Lady with a Camera," *San Francisco Chronicle*, 20 August 1946.

15 Sander.

16 McQuaid/Tait.

17 McQuaid/Tait.

18 Ansel Adams, letter to LM, 7 December 1973; LM, letter to Adams, 14 February 1974; and Adams, letter to LM, 25 February 1974; Ansel Adams Archives, Center for Creative Photography, Tucson.

19 Ash.

20 LM, project submitted to John Simon Guggenheim Memorial Foundation, 30 October 1948, New York, p. 1.

21 McQuaid/Tait.

22 Ansel Adams, copy of letter recommending LM for a Guggenheim Fellowship, 6 December 1948.

23 Adams to LM, same.

24 Adams to LM, same.

25 McQuaid/Tait.

26 John Morris, letter to AT, 29 May 1989.

27 Roger Butterfield, "How Reno Lives," in the series "How America Lives," *Ladies' Home Journal*, vol. 66, no. 11, November 1949, p. 205.

28 "Court Voids Eviction Order: Justice Wahl Calls Papers in Greenwich Village Case Defective and Perjurious," *New York Sun*, 29 September 1949; *Compass*, 27 September 1949; and *New York Times*, no date.

29 Piaskowski.

30 Minor White, letter to Nancy and Beaumont Newhall, 27 August 1949, Minor White Archive, Princeton University, Princeton, New Jersey.

31 Vestal.

32 Beller.

33 Douglas MacAgy, letter to "Whom It May Concern," 20 September 1949.

34 The class list for "Photography 2", according to Peter C. Bunnell's records, which he generously shared, also included Cass Brink, Kenneth Innes, Theodora Maxwell, Gene Petersen, Vincent Scotto, Edgar Stephenson, Ted White, and Robert Young.

35 Douglas MacAgy, letter to Publicity Office of the Cow Palace, 27 September 1949.

36 Peter C. Bunnell with Maria Pellerano and Joseph B. Rauch, *Minor White: The Eye that Shapes* (Princeton, New Jersey: The Art Museum, Princeton University, 1989), p. 52.

37 Piaskowski.

38 White to the Newhalls, same.

39 Nancy Newhall, letter to LM, 26 April 1950.

40 Beller.

41 Beaumont Newhall, letter to LM, 16 October 1949.

CHAPTER SEVEN

1 Edward Steichen, Museum of Modern Art press release for *Four Photographers: Lisette Model, Harry Callahan, Ted Croner, Bill Brandt*, 30 November 1948 to 10 February 1949.

2 Pratt Institute.

3 Lisette had met Steichen earlier on a trip made to Washington in April 1943. He had been very impressed by the work she had showed him, and when he took over as the head of the photography department at the Museum of Modern Art, continued to include her work in their exhibitions.

4 Ann Winters, transcript of tape of Sid Grossman's class, 1950, collection Miriam Cohen, New York.

5 LM, "Pictures as Art: Instructor Defines Creative Photography as Scientific Eye that Captures Life," *New York Times*, 9 December 1951, p. 21. See also *New York Times*, 16 December 1951, for responses to Model article.

6 *New York Times*, 9 and 16 December 1951.

7 TN 2, p. 23.

8 Minor White, letter to LM, 11 January 1952, Minor White Archive, Princeton University, Princeton, New Jersey.

9 *New School Bulletin*, vol. 9, no. 1, 3 September 1951, p. 110.

10 Author's note.

11 Andy Grundberg, *Alexey Brodovitch 1898–1971* (New York: Harry N. Abrams, 1989), p. 142.

12 Porter.

13 *New School Bulletin*, 3 September 1951, p. 110.

14 Thomas Bender, *New York Intellect* (Baltimore: Johns Hopkins University Press, 1987), p. 302.

15 Bender, p. 301.

16 Bender, p. 331.

17 Clement Greenberg as cited in Bender, p. 334; Arthur C. Danto as cited in Bender, p. 335; Bender, p. 335.

18 Author's note.

19 Minor White, letter to Nancy and Beaumont Newhall, 26 January 1950, Minor White Archive, Princeton University, Princeton, New Jersey.

20 Minor White, postcard to LM, 20 March 1961.

21 Bunnell.

22 TN 17, p. 2–2b.

23 *New School Bulletin*, 3 September 1951, p. 111.

24 TN 15, p. 91.

25 TN 15, p. 90b.

26 TN 11, p. 54.

27 TN 15, p. 106.

28 "Model to Teach," Photography section, *New York Times*, 28 January 1951.

29 Gee.

30 Heinrich Jalowetz as cited in H.H. Stuckenschmidt, *Arnold Schoenberg* (London: John Calder, 1959), p. 77.

31 Greissle.

32 *New School Bulletin*, vol. 32, no. 5, 27 December 1974, p. 248.

33 "Students' Exhibit," *New York Journal-American*, 17 June 1951, p. 31.

34 Lisa Clifford, *PWP Times*, vol. 1, no. 4, Spring 1983, p. 5.

35 TN 12, p. 21b.

36 TN 21, p. 31.

37 Les Barry, "The Legend of Sid Grossman," *Popular Photography*, vol. 49, no. 5, November 1961, p. 51–94.

38 Barry, p. 92.

39 TN, throughout.

40 Gossage.

41 Rubinstein.

42 Barry, p. 51.

43 Malcolm MacDonald, *Schoenberg* (London and Melbourne: J.M. Dent and Sons, 1976), p. 39.

44 Clifford, p. 5.

45 TN 18, p. 27b.

46 TN 5, p. 12b.

47 TN 5, p. 12b.

48 LM, "Pictures as Art," p. 21.

49 Lowell Handler, transcript of interview with LM, 19 February 1981, p. 3.

50 From narration by the artist for the film *Jackson Pollock*, made by Hans Namuth and Paul Falkenberg, 1951.

51 TN 19, p. 45b.

52 TN 15, p. 9.

53 TN 17, p. 4b.

54 TN 15, p. 47.

55 TN 15, p. 9.

56 TN 15, p. 15.

57 TN 12, p. 28.

58 TN 12, p. 17–18b.

59 TN 12, p. 27b.

60 Pratt Institute.

61 TN 12, p. 27.

62 TN 3, attached pages, p. 8.

63 TN 6, p. 16.

64 TN 21, p. 30.

65 TN 9, p. 25b.

66 TN 18, p. 6.

67 Berenice Abbott, *New Guide to Better Photography* (New York: Crown Publisher, 1941, revised 1953), p. 111.

68 TN 2, p. 13b.

69 TN 2, p. 17b–20b.

70 TN 2, p. 12b.

71 TN 2, p. 19b.

72 TN 2, p. 27.

73 Haverford.

CHAPTER EIGHT

1 LM, *Lisette Model: A Retrospective*, New Orleans Museum of Art / Museum Folkwang, Essen, 1981.

2 Klausner.

3 Brackman.

4 Helen Gee, "Photography in Transition: 1950–1960," *Decade by Decade* (Tucson: Center for Creative Photography, University of Arizona, 1988), p. 62.

5 EM, letter to LM, 6 September 1953.

6 Author's note.

7 Author's note.

8 Author's note.

9 Cravens, p. 26.

10 LM, letter to Minor White, [Spring 1950], Minor White Archive, Princeton University, Princeton, New Jersey.

11 LM to Minor White, same.

12 LM to Minor White, same.

13 LM to Minor White, same.

14 LM, letter to Minor White, [Summer 1950], Minor White Archive, Princeton University, Princeton, New Jersey.

15 LM as cited in "What Is Modern Photography?," *American Photography*, vol. 45, no. 3, March 1951, p. 153.

16 Beaumont Newhall, "The Aspen Photo Conference," *Aperture*, vol. 3, no. 3, 1955. The conference was held 26 September to 6 October 1951.

17 Minor White, "Exploratory Camera: A Rationale for the Miniature Camera," *Aperture*, vol. 1, no. 1, 1952, p. 5–16.

18 LM, letter to Minor White, [1952], Minor White Archive, Princeton University, Princeton, New Jersey.

19 She photographed Dylan Thomas on the occasion of one of his three trips to the United States in 1950, 1951, or 1953.

20 *A Sense of Wonder* and *The Rocky Coast*.

21 McQuaid/Tait.

22 LM, letter to Minor White, [Spring 1950].

23 LM to Minor White, same.

24 *New York Herald Tribune*, 9 October 1954.

25 Peter C. Bunnell, "Remembering Limelight," *Helen Gee and the Limelight: A Pioneering Photography Gallery of the Fifties*, Carlton Gallery, New York, 12 February–18 March 1977.

26 1–30 December 1954.

27 It was purchased by Dorothy Eidlitz, the one regular patron of the Limelight, and donated by her to the National Gallery of Canada in 1968, along with other photographs and several American paintings.

28 Bunnell.

29 Brackman. Henrietta Brackman's recollection is that it was either August 1951 or 1952. The edge coding of negatives taken at this time would date it at 1952.

30 Arnold Rampersad, *The Life of Langston Hughes, Volume 2: 1941–1967* (New York, Oxford: University Press, 1988), p. 254.

31 Dorothy Wheelock, letter to LM, 2 May 1956.

32 Lopate, p. 86.

33 Brackman.

34 From her passport, we learn that she arrived in Paris 15 June 1953, travelled through Switzerland to Italy on 29 July, and departed Italy on 7 November. She arrived in New York on 8 November 1953.

35 Author's note.

36 For several generations Victor Seybert's family had owned property in Italy. A dispute arose between Lisette and her sister-in-law over the sale of this property in 1953.

37 TN 20, p. 30.

38 Allan Porter, "Lisette Model," *Camera*, vol. 56, no. 12, December 1977, p. 22.

39 McQuaid/Tait.

40 Dates obtained from her passport.

41 Beller.

42 "La Realidad Venezolana en el Gran Museo de Arte Moderno de New York," *Diario Occidente*, [September 1954].

43 She photographed the Minister of Defence and the Minister of Petroleum, among others.

44 "Los colores, y los motivos ornamentales juegan funcional en arquitectura," unidentified Venezuelan newspaper clipping, [1954].

45 Author's note.

46 Winthrop Sargeant, "The Cult of the Love Goddess in America," *Life*, vol. 23, no. 19, 10 November 1947, p. 81.

47 Gordon N. Ray, letter to LM, 21 June 1964, John Simon Guggenheim Foundation, New York; and LM, letter to Ansel Adams, 16 October 1964, Ansel Adams Archives, Center for Creative Photography, Tucson.

48 McQuaid/Tait.

49 "Lisette Model," *Camera*, p. 22.

50 James Borcoman, *Charles Nègre 1820–1880* (Ottawa: National Gallery of Canada, 1976), p. 38.

51 David Heath, "Dialogue with Solitude"; Robert Frank, "The Americans"; Walker Evans, "America".

52 Rogers, and Magner.

53 McQuaid/Tait.

54 Robert Venturi, Denise Scott Brown, and Steven Izenour,

55 *Learning from Las Vegas* (Cambridge: Massachusetts Institute of Technology, 1978), p. 18.

55 Umberto Eco, *Travels in Hyper Reality* (San Diego, New York, London: Harcourt Brace Jovanovich, 1986).

56 McQuaid/Tait.

57 McQuaid/Tait.

58 Knapp.

59 McQuaid/Tait.

60 She wrote to Henrietta Brackman about her illness, telling her about the photographs she was taking in museums, and asking advice as to whether she should return immediately to New York.

CHAPTER NINE

1 Thomas W. Southall, "The Magazine Years, 1960–1971," in *Diane Arbus: Magazine Work*, texts by Diane Arbus, essay by Thomas W. Southall, edited by Doon Arbus and Marvin Israel (New York: Aperture, 1984), p. 153.

2 Arbus.

3 Arbus.

4 Diane Arbus, *Diane Arbus* (New York: Museum of Modern Art / Aperture, 1972), p. [1].

5 Valeska Gert cited in Anne Teresa De Keersmaeker, "Valeska Gert," *Drama Review*, vol. 25, no. 3, Fall 1981, p. 58.

6 *An Exhibition of Work by the John Simon Guggenheim Memorial Foundation Fellows in Photography*, Photography Department, Philadelphia College of Art, 10 April–13 May 1966, p. 4.

7 Author's note.

8 *Diane Arbus*, p. 5.

9 Barbara Novak, *American Painting of the Nineteenth Century: Realism, Idealism, and the American Experience* (New York: Praeger, 1969), p. 23.

10 Pratt Institute.

11 *Diane Arbus*, p. 2.

12 *Diane Arbus*, p. 2.

13 Haverford.

14 *Diane Arbus*, p. 2.

15 *Diane Arbus*, p. 9.

16 Bunnell.

17 Sander's name appears in Model's teaching notebooks with greater frequency in the seventies.

18 Peter C. Bunnell, "Diane Arbus," *Print Collector's Newsletter*, vol. 3, no. 6, January–February 1973, p. 129.

19 Beller.

20 Beller.

21 Patricia Bosworth, *Diane Arbus: A Biography* (New York: Alfred A. Knopf, 1984), p. 164.

22 This image did not appear outside of its photojournalistic context in *Look* in 1942.

23 Beller.

24 *Coney Island Bather* (reclining). The photograph was installed in the exhibition *A Bid for Space No. 2*, November 1960.

25 From *Meditations of a Nonpolitical Man*, cited in Geoffrey Galt Harpham, *On the Grotesque: Strategies of the Contradiction in Art and Literature* (Princeton, New Jersey: Princeton University Press, 1982), p. xviii–xix.

26 Harpham, p. xx.

27 Beller.

28 *Diane Arbus*, p. 15.

29 Haverford.

30 Diane Arbus, postcard to LM, 2 January 1963.

31 Diane Arbus, postcard to LM, 1968.

32 Bunnell.

33 Diane Arbus, postcard to LM, 22 April 1963.

34 *Diane Arbus*, a thirty-minute video in the series *Masters of Photography*, Camera Three Productions, New York, 1989.

CHAPTER TEN

1 Cravens, p. 26.

2 Author's note.

3 LM, letter to Doctor Getlen, 11 April 1979.

4 LM, Ingram Merrill Foundation grant application, 19 January 1970.

5 Cravens, p. 26.

6 Author's note.

7 She gave a workshop at Berkeley in 1973.

8 Author's note.

9 Author's note.

10 Steinitz.

11 Precise dates do not exist for this body of work, but they appear to have been done between 1968 and 1975.

12 Author's note.

13 Model dated the Rome images as being from a later trip in 1967, but the edge codings date the majority as from the 1953 trip.

14 Author's note.

15 "Lisette Model: Re-Emergence from Legend," *Aperture*, no. 78, 1977, p. 4. Review of Sander Gallery exhibition, 25 September–30 October 1977.

16 Michael Hoffman, letter to LM, 5 August 1977.

17 Author's note.

18 Dianora Niccolini (ed.), *Women of Vision: Photographic Statements by Twenty Women Photographers* (New Jersey: The Unicorn Publishing House, 1982), p. 68.

19 Author's note.

20 Author's note.

21 Evsa's paintings were taken on by a dealer and ex-student of Lisette's, Manny Greer.

22 LM's letter of support for Diane Arbus's second Guggenheim application, 8 January 1965, John Simon Guggenheim Memorial Foundation, New York.

23 McQuaid/Tait.

24 Elizabeth McCausland, "Camera Satire and Sympathy," *Good Photography*, no. 8, 1942, p. 28.

25 McCausland, p. 28.

26 McCausland, p. 28.

27 Elizabeth McCausland, "Lisette Model Shows 'Candid' Photographs . . . ," *Springfield Sunday Union and Republican*, 27 May 1941, p. 6E.

28 BPRC.

29 McCausland, "Camera Satire and Sympathy," p. 28.

SELECT BIBLIOGRAPHY

GENERAL

Arbus, Diane. *Diane Arbus*. New York: Museum of Modern Art / Aperture, 1972.

— . "Hubert's Obituary: Or this was where we came in." In *Diane Arbus: Magazine Work*, texts by Diane Arbus, essay by Thomas W. Southall, edited by Doon Arbus and Marvin Israel. New York: Aperture, 1984.

Barry, Les. "The Legend of Sid Grossman." *Popular Photography*, vol. 49, no. 5 (November 1961), p. 51–94.

Borcoman, James. *Charles Nègre 1820–1880*. Ottawa: National Gallery of Canada, 1976.

Bosworth, Patricia. *Diane Arbus: A Biography*. New York: Alfred A. Knopf, 1984.

Bunnell, Peter C. "Diane Arbus." *Print Collector's Newsletter*, vol. 3, no. 6 (January–February 1973), p. 129.

— , with Maria Pellerano and Joseph B. Rauch. *Minor White: The Eye that Shapes*. Princeton, New Jersey: The Art Museum, Princeton University, 1989.

De Keersmaeker, Anne Teresa. "Valeska Gert." *Drama Review*, vol. 25, no. 3 (fall 1981), p. 56.

Diane Arbus. A thirty-minute video in the series *Masters of Photography*. New York: Camera Three Productions, 1989.

Faber, Monika. "Amateurs et autres: histoire de la photographie (1887–1936)." In *Vienne 1880–1938: L'Apocalypse joyeuse*, edited by Jean Clair. [Paris]: Éditions du Centre Pompidou / SPADEM / ADAGP, 1986.

Gert, Valeska. *Die Bettler-Bar von New York*. Berlin: Arani Verlag, 1950.

Grun, Bernard (ed.). *Alban Berg: Letters to His Wife*. London: Faber and Faber, 1971.

Grundberg, Andy. *Alexey Brodovitch 1898–1971*. New York: Harry N. Abrams, 1989.

Hilmar, Ernst. *Arnold Schönberg: Gedenkausstellung 1974*. Vienna: Universal Edition AG, 1974.

MacDonald, Malcolm. *Schoenberg*. London and Melbourne: J.M. Dent and Sons, 1976.

Novak, Barbara. *American Painting of the Nineteenth Century: Realism, Idealism, and the American Experience*. New York: Praeger, 1969.

Peter, Frank-Manuel. *Valeska Gert: Tänzerin, Schauspielerin, Kabarettistin*. Berlin: Frölich und Kaufman, 1985.

Rampersad, Arnold. *The Life of Langston Hughes, Volume 2: 1941–1967*. New York: Oxford University Press, 1988.

Snow, Carmel. *The World of Carmel Snow*. New York: McGraw-Hill, 1962.

Southall, Thomas W. "The Magazine Years, 1960–1971." In *Diane Arbus: Magazine Work*, texts by Diane Arbus, essay by Thomas W. Southall, edited by Doon Arbus and Marvin Israel. New York: Aperture, 1984.

Stein, Erwin. *Arnold Schönberg: Letters*. London and Boston: Faber and Faber, 1987 (reissue).

Steiner, Ralph. *A Point of View*. Middletown: Wesleyan University Press, 1978.

Venturi, Robert, Denise Scott Brown, and Steven Izenour. *Learning from Las Vegas*. Cambridge: Massachusetts Institute of Technology, 1978.

Waissenberger, Robert. "Politics in Vienna Before and After the Turn of the Century." In *Vienna 1890–1920*. New York: Rizzoli, 1984.

Weegee (Arthur H. Fellig). *Naked City*. New York: Essential Books, 1945.

WORKS ON LISETTE MODEL

Note: This bibliography includes some material from the Estate of Lisette Model archives, held at the National Gallery of Canada, Ottawa, for which information on sources is incomplete. Such items are designated [Estate].

BOOKS

Abbott, Bernice. *New Guide to Better Photography*. New York: Crown Publishers, 1953, revised edition of *A Guide to Better Photography*, 1941.

— . Introduction in *Lisette Model*. New York: Aperture, 1979.

— . *Lisette Model* (portfolio). Washington, D.C.: Graphics International, 1976.

Flattau, John, Ralph Gibson, and Arne Lewis (eds.). *Darkroom II*. New York: Lustrum, 1978.

Holme, Bryan, and Thomas Forman (eds.). *Poet's Camera*. New York and London: American Studio Books, 1946.

Maddow, Ben. *Faces: A Narrative of the History of the Portrait in Photography*. Boston: New York Graphic Society, 1977.

Naef, Weston J. *Counterparts: Form and Emotion in Photographs*. New York: E. P. Dutton, 1982.

Newhall, Beaumont. *The History of Photography from 1839 to the Present Day*. New York: The Museum of Modern Art, 1949.

Photography of the World. Tokyo: Heibonsha Publishers, 1958.

Szarkowski, John. *Looking at Pictures: 100 Pictures from the Collection of the Museum of Modern Art*. New York: Museum of Modern Art, 1973.

Whelan, Richard. *Double Take*. New York: Clarkson N. Potter, 1981.

White, Nancy (ed.). *Hundred Years of the American Female*. New York: Random House, 1967.

EXHIBITION CATALOGUES

About New York, Night and Day 1915–1965. New York: Museum of Modern Art, 1965.

Bunnell, Peter C. *Helen Gee and the Limelight: A Pioneering Photography Gallery of the Fifties*. New York: Carlton Gallery, 1977.

Chiarenza, Carl. *A Photographic Patron: The Carl Siembab Gallery*. Boston: Institute of Contemporary Art, 1981.

Enyeart, James (ed.). *Decade by Decade: Twentieth-Century American Photography from the Collection of the Center for Creative Photography*. Tucson: Center for Creative Photography, 1988.

Gee, Helen. *Photography of the Fifties: An American Perspective*. Tucson: Center for Creative Photography, 1980.

Hambourg, Maria Morris, and Christopher Phillips. *The New Vision: Photography Between the World Wars*. New York: The Metropolitan Museum of Art, 1989.

Invitational Exhibition 10: American Photographers 10. Milwaukee: University of Wisconsin, 1965.

Kraus, Ziva. *Models – New York City*. Venice: Ikona Gallery, 1984.

Lisette Model: A Retrospective. New York: New Orleans Museum of Art / Museum Folkwang, 1981.

Lyons, Nathan. *Photography in the Twentieth Century*. New York: Horizon Press in collaboration with the George Eastman House, 1967.

Mann, Margery. *Women of Photography: An Historical Survey*. San Francisco: San Francisco Museum of Art, 1975.

Mednick, Sol. *An Exhibition of Work by the John Simon Guggenheim Memorial Foundation Fellows in Photography*. Philadelphia: Photography Department, Philadelphia College of Art, 1966.

Model Photographs. Washington, D.C.: Sander Gallery, 1976.

Steichen, Edward. *The Exhibition of Contemporary Photography*. Tokyo: The National Museum of Modern Art, 1953.

— . *The Family of Man*. New York: Simon and Schuster and Maco Magazine Corporation, 1955.

Turner, Peter (ed.). *American Images: Photography 1945–1980*. London: Penguin Books / Barbican Art Gallery, 1985.

Travis, David, Sarah Greenough, Joel Snyder, and Colin Westerbeck. *On the Art of Fixing the Shadow: One Hundred and Fifty Years of Photography*. Chicago and Washington, D.C.: Bullfinch Press, 1989.

PERIODICALS

"4 Photographers: Model." *U.S. Camera*, vol. 12, no. 2 (February 1949), p. 38–39.

"9èmes Rencontres Internationales de la Photographie." *Zoom*, no. 56, (August/September 1978), p. 22–23.

Abbott, Berenice. "Lisette Model." *Camera 35*, vol. 25, no. 2 (15 February 1980), p. 22–27, 80.

Accomando, C. H. "Unpretentious, vital images." *Artweek*, vol. 16, no. 12 (summer 1985), n.p. [Estate]

Ackley, Clifford S. "Photographic Viewpoint: Selections from the Collection." *Bulletin of the Museum of Fine Arts, Boston*, vol. 80, no. 43 (1982), p. 42–43.

"Actualités: Lisette Model Enfin à Paris." *Connaissance des Arts*, no. 353 (July 1981), p. 21.

Andrews, Phillip. "Candid Photography." *Complete Photographer*, vol. 2, no. 10 (20 December 1941), p. 613–27.

Baynard, Ed. "Lisette Model Interviewed." *Village Voice* (8 December 1975), p. 87.

Bookhardt, D. Eric. "Reviews – Lisette Model: Recollections, Ten Women in Photography." *Art Papers*, vol. 5, no. 5 (September–October 1981), p. 14–15.

Bunnell, Peter C. "Lisette Model: An Aperture Monograph." *Print Collector's Newsletter*, vol. 11, no. 3 (July–August 1980), p. 108–09.

Carlson, Prudence. "Photography." *Art in America*, no. 69 (February 1981), p. 27, 29.

Carluccio, Luigi. "Lisette Model." *Panorama* (22 September 1980), p. 21.

Cohen, Ronny. "Lisette Model: An Aperture Monograph." *Artforum*, vol. 18, no. 9 (May 1980), p. 71–73.

Coleman, A. D. "Books: Five Interviews Before the Fact." *Printletter 23*, vol. 4, no. 5 (September–October 1979), p. 27.

Cramer, Konrad. "Composition Analysis for... Wall Street." *Complete Photographer*, vol. 1, no. 3 (10 October 1941), p. 184.

Cravens, R. H. "Notes for a Portrait of Lisette Model." *Aperture*, no. 86 (1982), p. 52–65.

Cuomo, Joe. "The Fearless Eye." *Darkroom Photography*, vol. 6, no. 1 (January/February 1984), p. 18–24, 44–45.

Deer, Victoria. "For Ladies Only." *The Camera*, vol. 71, no. 1 (January 1949), p. 64–69, 146.

Desvergnes, Alain. "Model, Izis, Klein Honoured at Arles." *Afterimage*, vol. 6, no. 3 (October 1978), p. 4.

Edwards, Owen. "Innocence Lost." *Saturday Review*, vol. 7 (1 March 1980), p. 10, 30–31.

Fonvielle, Lloyd. "The City's Lively Beat. A Spirited New York Exhibit Rediscovers Street Photography 1940–1955." *Aperture*, no. 81 (1978), p. 60–73.

Freeman, Tina. "Lisette Model: A Retrospective."
Arts Quarterly, vol. 3, no. 3 (July–September 1981), p. 12–13.

Grundberg, Andy. "Books in Review." *Modern Photography*,
vol. 43, no. 8 (August 1979), p. 104.

Hambourg, M. M. "Photography Between the Wars."
The Metropolitan Museum of Art Bulletin, vol. 45, no. 41
(spring 1988), p. 41.

Harris, Lin. "A Last Interview with Lisette Model."
Camera Arts, vol. 3, no. 6 (June 1983), p. 14, 90–92.

"How large should a print be?" *Modern Photography*, vol. 16
(November 1952), p. 46–49, 118.

"Imaginary Interviews with Five Photographers." *Afterimage*,
vol. 6, no. 8 (March 1979), p. 21.

"Interview – Lisette Model." *Cult*, n.d., p. 23–25. [Estate]

J.T. [Jonathan Tichenor]. "Photo League Show."
U.S. Camera, vol. 12, no. 2 (February 1949), p. 53.

Kissel, Howard. "Lisette Model." *The Press*, vol. 8, no. 1
(February 1980), p. 35–36.

"La photo en force." *Connaissance des Arts*, no. 379
(September 1983), p. 21.

"La Photo League." *Le Magazine Ovo*, vol. 10, no. 40/41
(1981).

LaRue, Alan. "Shows: Lisette Model." *Views*, vol. 1, no. 1
(May 1979), p. 15.

Leroy, Jean. "Expositions: Lisette Model, Diane Arbus,
Rosalind Solomon à la Galerie Zabriskie." *Photo Revue*
(June 1977), p. 382.

"Lisette Model." *Center for Creative Photography Bulletin*,
no. 4 (May 1977), whole issue.

"Lisette Model: Keeping the Legend Intact." *Infinity*,
vol. 22, no. 1 (January 1973), p. 14.

"Lisette Model. Œil sans peur, objectif sans reproche:
enfin le premier livre de la 'mama'." *Photo* (June 1980), n.p.

"Lisette Model." *Photomagazine* (December 1984–January
1985), n.p.

"Lisette Model: Re-Emergence from Legend." *Aperture*,
no. 78, (1977), p. 4.

Maloney, Tom. "Feet tell the story of Wall Street's bustling."
U.S. Camera, vol. 1, no. 14 (February 1941), p. 52.

—. "Lisette Model: Pictures by a Great Refugee Photog-
rapher." *U.S. Camera*, vol. 5, no. 10 (October 1942), p. 24.

Mann, Margery. "Women of Photography." *Camera 35*,
vol. 19, no. 6 (August/September 1975), p. 36–43.

McAlpin, Mary Alice. "Lisette Model." *Popular Photography*,
vol. 49, no. 5 (November 1961), p. 52–53, 134.

McCausland, Elizabeth. "Camera Satire and Sympathy."
Good Photography, no. 8 (1942), p. 28–33, 136–137.

—. "Feet." *Minicam*, vol. 5, no. 5 (January 1942), p. 14–17.

Mednick, Sol. "The John Simon Guggenheim Memorial
Foundation Fellows in Photography 1937–1965." *Camera*,
vol. 45, no. 4 (April 1966), p. 6, 62–63.

Murray, Joan. "Berenice Abbott and Lisette Model." *Artweek*,
vol. 11, no. 29 (22 November 1975), p. 11–12.

Niccolini, Dianora. "A Personal Tribute to Lisette Model."
PWP Times, vol. 1, no. 4 (spring 1983), whole issue.

"Notizie." *Il Fotografo* (October 1980), p. 20. [Estate]

Obituary. *Afterimage*, vol. 11, no. 2 (September 1983), n.p.

"Periscopio." *Progresso Fotografico*, vol. 88, no. 4 (April 1981),
p. 83.

Perloff, Stephen. "The Biting Vision of Lisette Model."
Philadelphia Photo Review, vol. 2, no. 4 (April 1977), p. 1–3.

Perrone, Jeff. "Women of Photography: History and Taste."
Artforum, vol. 13, no. 4 (March 1976), p. 31–36.

Porter, Allan. "A Child's Garden of Photography." Supplement
to *Camera*, vol. 58, no. 12 (December 1979), p. 56.

—. "Auto-portrait." *Camera*, vol. 57, no. 9 (summer 1978),
p. 587.

—. "Lisette Model." *Camera*, vol. 56, no. 12
(December 1977), p. 22.

Progresso Fotografico, vol. 85, no. 3 (March 1978), p. 79.

Rice, Shelley. "A Shrewd and Piercing Eye." *Portfolio*, vol. 2,
no. 4 (September–October 1980), p. 22–24.

—. "Essential Differences: A Comparison of the Portraits
of Lisette Model and Diane Arbus." *Artforum*, vol. 18, no. 9
(May 1980), p. 66–73.

Rosenblum, Walter. "What Is Modern Photography?"
American Photography, vol. 45, no. 3 (March 1951), p. 153.

Roussin, Phillipe. "Laisser dire la photographie" and "Atelier
Photo." *Canal*, no. 38 (April, 1980), p. 4, 5.

Sealfon, Peggy. "Lisette Model's Dynamic Reality." *Peterson's
Photographic Magazine*, vol. 8, no. 11 (March 1980), p. 10.

Schruers, Fred. "Lisette Model: pictures of striking people."
Rolling Stone, no. 312 (6 March 1980), p. 73.

Somer, Jack. "Gurus of the Visual Generation." *New York*,
vol. 6, no. 22 (May 28, 1973), p. 45–48.

Squiers, Carol. "'Art of the Split Second': Lisette Model."
Interview, vol. 10, no. 1 (January 1979), p. [7], 36–37.

Stettner, Louis. "Lisette with Love." *Camera 35*, vol. 19,
no. 4 (June 1975), p. 22, 72.

"The Finest in Photography." *See*, vol. 7, no. 5
(September 1948), p. 12–15.

Thornton, Gene. "Lisette Model." *ArtNews*, vol. 79, no. 6 (November 1980), p. 63.

Tighe, Mary Ann. "Lisette Model at Sander." *Art in America*, vol. 65, no. 1 (January–February 1977), p. 132.

Tucker, Anne. "Photographs of Women." *Camera*, vol. 51, no. 2 (February 1972), p. 4, 12.

Turroni, Giuseppe. "Foto / A Nuova York senza Ambiguità." *Il Corriere della Sera* (4 September 1980), n.p.

Van Haaften, Julia. Untitled book review of *Lisette Model*, Aperture. *Library Journal*, vol. 107 (15 February 1980), p. 501.

Vestal, David. "Lisette Model: The much admired photographer/teacher talks about her long illustrious career, her famous friends, and her first book." *Popular Photography*, vol. 86, no. 5 (May 1980), p. 114–119.

— . "Lisette Model, 1906–1983." *Popular Photography*, vol. 90, no. 6 (June 1983), p. 92.

— . "Talking About Lisette." *Infinity*, vol. 13, no. 3 (March 1964), p. 4–11, 25–26.

Welch, Marguerite. "After Evans and Before Frank: The New York School of Photography." *Afterimage*, vol. 14, no. 1 (summer 1986), p. 14–16.

White, Minor. "Exploratory Camera: A Rationale for the Miniature Camera." *Aperture*, vol. 1, no. 1 (1952), p. 5–16.

Zakia, R. D. "Spaced Out." *Exposure*, vol. 15, no. 1 (February 1977), p. 36–37.

Zucker, Jack. "Photos Reveal Social Reality." [Estate]

NEWSPAPER REVIEWS AND CLIPPINGS

"August photo exhibit shows 2 portraits." *Port Washington News* (26 July 1979), n.p. [Estate]

Barefoot, Spencer. "S.F. Art: Lisette Model's Photographs Show Realism." [*San Francisco Chronicle* (1946)], n.p. [Estate]

Cohen, Alan. "How the 20's Brought Photography Up to Date." *Washington Star* (15 August 1976), p. 6, 20.

Colby, Joy Hakanson. "Bulk is best. The svelte shooter with the four-figure photos." *The Detroit News* (n.d.), n.p. [Estate]

C.V. "Model: Le poids des images." *Femme Pratique*, (n.d.), n.p. [Estate]

"Die alte Dame der amerikanischen Fotografie." *Neue Ruhr Zeitung* (3 April 1982), n.p.

"Distinguished Photo Show Opens Tuesday at UWM." *Milwaukee Journal* (28 February 1965), p. 4–5, 8–9.

Esposito, Richard. "At 73, photographer emerges from darkroom." *Daily News* (10 February 1980), p. 34MB.

Estcourt, Zilfa. "Lady with a Camera." *San Francisco Chronicle* (20 August 1946), n.p. [Estate]

Forgey, Benjamin. "The Comparative Art of Lisette Model and Barbara Morgan." *Washington Star* (3 October 1976), p. 20.

G.G. "Von Glamour der Zeit." *Morab[u]* (5 November 1982), p. 66. [Estate]

"Hara en Caracas 5,000 Fotos Confidenciales: Una profesora de una Universidad de Nueva York." No source [1954], n.p. [Estate]

"Lisette Model im Museum Folkwang. Fotografin liebt das Bild des Menschen." *Neue Ruhr Zeitung* (27 March 1982), n.p. [Estate]

Kiffl, Erika. "Der grosse Dialog mit Coco Chanel." [Estate]

Kissel, Howard. "Lisette Model's Secret – the Eye and the Instant." *Women's Wear Daily* (11 December 1979), p. 28.

Knight, John Adam. "Acting Makes Photos Better." *New York Post* (13 July 1944), p. 25.

Kramer, Hilton. "Christmas Books: Photography." *New York Times*, vol. 84 (25 November 1979), p. 13.

— . "Photography Show by Women at Janis." *New York Times* (13 December 1975), p. L19.

Krause, Manfred. "Müssiggänger und Ausgestossene: Lisette Models Fotos im Folkwang-Museum." *Westdeutsche Allgemeine* (6 April 1982), n.p.

"La Realidad Venezolana en el Gran Museo de Arte Moderno de New York." *Dia[rio] [Occ]idente* [September 1954], n.p.

"Lisette Model to Teach." *New York Times* (28 January 1951), n.p.

"Lisette Models Fotografien sind unbequeme Herausforderungen." *Essen Revue* (May 1982), p. 22.

"Los Colores y los motivos ornamentales juegan papel funcional en arquitectura." No source [1954], n.p. [Estate]

Loewy, Hanno. "Feuilleton." *Frankfurter Rundschau* (4 May 1982), n.p. [Estate]

McCausland, Elizabeth. "Camera Records the 'Significant Moment'." *Springfield Sunday Union and Republican* (22 April 1945), p. 4C.

— . "Lisette Model Shows 'Candid' Photographs: Forty Prints by the French Artist Revealing of Life and Character among the Idle Rich and the Dispossessed – Scenes in the Riviera, Nice, Paris and New York." *Springfield Sunday Union and Republican* (27 May 1941), p. 6E.

— . "Museum of Modern Art Embraces Photography." *Springfield Sunday Union and Republican* (5 January 1941), p. 5.

— . "New League Considers 'Artists in the War.'" *Springfield Sunday Union and Republican* (21 June 1942), p. 6E.

— . "Photographic Show at Modern Museum." *Springfield Sunday Union and Republican* (2 April 1944), p. 4C.

"Milestones." *Time*, vol. 121 (11 April 1983), p. 82.

Miro, Marsha. "Photos reveal body and soul." *Detroit Free Press* (24 May 1981), p. 6B.

"Mit Mut zur Hässlichkeit." *Neue Ruhr Zeitung* (17 April 1982), n.p. [Estate]

"Museum of Modern Art Shows Products of Four Photographers." *New York Herald Tribune* (December 1948), n.p. [Estate]

New York Times (31 March 1983), p. B 17.

"Nota del Aeropuerto." No source [1954], n.p. [Estate]

Paris, Jeanne. "Art Review / In the Eye of the Lens." *Newsday* (10 August 1979), n.p.

Perry, Tony. "Experience of the Year." *Weekend Review* (1980), p. 6.

"Photos by Model." *San Francisco Chronicle* (1 September [no year]), p. 9.

Rennemeyer, Arnold. "Uber 100 Fotografien." *Westdeutsche Allgemeine* and *Essener Tageblatt* (3 April 1982), n.p. [Estate]

Richard, Paul. "The New York School. Lens Full of Life: Powerful Photographers at the Corcoran." *Washington Post* [1985], p. F1, F5.

Schwarze, Michael. "Mit dem kalten Auge der Kamera." *Frankfurter Allgemeine Zeitung*, no. 95 (24 April 1982), n.p. [Estate]

Sgarbi, Vittorio. "Fotografi alla Ikona Gallery 'Oggetti' della vita." *Il Gazzettino* (22 November 1980), p. 17.

Shirey, David. "Candid Photographs that Cut Artificiality." *New York Times*, Section 21 (19 August 1979), p. 16.

Wells, Patricia. "A World Just Past." *New York Times*, Section 3 (17 February 1978), p. 20.

Yerxa, Fendall. "Four Photographers State Their Aims." [*New York Herald Tribune* (1948)], n.p. [Estate]

— . "Photography: Modern Museum Covers the Field." *New York Herald Tribune* (11 April 1948), n.p. [Estate]

WORKS WITH PHOTOGRAPHIC ILLUSTRATIONS BY LISETTE MODEL

"A New Season Is in Rehearsal." *Harper's Bazaar*, vol. 77 (October 1943), p. 88–89.

"A Note on Blindness." *Harper's Bazaar*, vol. 85 (July 1951), p. 56.

"Accent on Ingénues." *Harper's Bazaar*, vol. 77 (October 1943), p. 124–25.

Advertisement for *Cosmopolitan*. *New York Times* (13 July 1943), n.p. [Estate]

Anderson, M. Margaret. "American Women." *Common Ground*, vol. 4, no. 2 (winter 1944), p. 5–12.

"Armando Reverón: Famous Venezuelan Painter Shown for the First Time in the U.S." *Vogue*, vol. 127, no. 3 (15 February 1956), p. 110–11.

"Ask Him to Share It with You: The Unrationed Christmas Dinner." *Harper's Bazaar*, vol. 77 (December 1943), p. 78–79.

"Backstage at Hollywood Pinafore." *Harper's Bazaar*, vol. 79 (July 1945), p. 47.

"Bowery Christmas, with Lisette Model's Photographic Impressions of Sammy's Famous Bar Down on the Bowery." *U.S. Camera*, vol. 7, no. 9 (December 1944), p. 28–29.

"Broadway Gallery." *Harper's Bazaar*, vol. 82 (October 1948), p. 187–88.

"Broadway Gallery 1947–1948." *Harper's Bazaar*, vol. 81 (October 1947), p. 220–21.

Butterfield, Roger. "How Reno Lives." *Ladies' Home Journal*, vol. 66, no. 11 (November 1949), p. 205–10, 254–60.

"Camera at the Race Track." *Cosmopolitan*, vol. 141, no. 1 (July 1956), p. 76–83.

Curel, Lise. "Côte d'Azur." *Regards*, vol. 4, no. 59 (28 February 1935), n.p.

"Dancing Feet." *Harper's Bazaar*, vol. 77 (December 1943), p. 102.

"Day Shift, Night Lift." *Harper's Bazaar*, vol. 77 (November 1943), p. 88–89.

Deschin, Jacob. "Coney Island — It's the Greatest." *Camera*, vol. 50, no. 3 (March 1971), p. 25, 34–35.

"Gallagher's People . . . photographed by Lisette Model." *U.S. Camera*, vol. 8, no. 3 (April 1945), p. 14–17.

"Home Is the Sailor." *Harper's Bazaar*, vol. 78 (February 1944), p. 94–95.

"Hot Horn Gabriel." *Harper's Bazaar*, vol. 77 (August 1943), p. 86–87.

"How Coney Island Got That Way." *Harper's Bazaar*, vol. 75 (July 1941), p. 52–53, 86.

"Jazz." *Harper's Bazaar*, vol. 80 (March 1946), p. 180–81.

"Leg with Flag." *Bulletin of the Museum of Fine Arts, Boston*, vol. 80, no. 43 (1982), n.p.

Lilliput, vol. 3, no. 3 (September 1938), 260–61.

Maloney, Tom (ed.). *U.S. Camera Annual*. New York: Duell, Sloan and Pierce, 1942, p. 98–99.

— . *U.S. Camera Annual*. New York: Duell, Sloan and Pierce, 1943, p. 180–81.

"Miracle Man of Valley Forge." *Harper's Bazaar*, vol. 78 (June 1944), p. 63.

"Music by Lisette Model." *U.S. Camera*, vol. 7, no. 6 (August 1944), p. 24–26.

"New Faces on Broadway and Vine Street." *Harper's Bazaar*, vol. 79 (May 1945), p. 80.

"New York." *Harper's Bazaar*, vol. 80 (February 1946), p. 22–27.

"Nick on jive, liquor and success." *PM's Weekly (PM's Sunday Edition)* (11 June 1944), n.p.

"Once an Actor Tragedians, Ingénues, Soubrettes and Stars of Vaudeville." *Harper's Bazaar*, vol. 81 (October 1947), p. 250–53.

"Opera à la Carte." *Harper's Bazaar*, vol. 80 (May 1946), p. 162–63.

"Pagan Rome" and editorial note. *Harper's Bazaar*, vol. 89 (February 1955), p. 72, 102–07.

"Photographs by Lisette Model." *Creative Camera*, no. 65 (November 1969), p. 386–95.

"Photography, A Contemporary Compendium." *Camera*, vol. 54, no. 1 (November 1975), p. 5.

Pilat, Oliver and Jo Ranson, "Hollywood Pinafore." *Harper's Bazaar*, vol. 79 (July 1945), p. 52–53, 86, 92.

"Plate Glass Phantasia." *Cue*, vol. 9, no. 50 (7 December 1940), p. 1, 17.

"Reflection New York City." *Creative Camera*, no. 238 (240) (December 1984) p. 1650.

"Rehearsal." *Harper's Bazaar*, vol. 79 (January 1945), p. 44.

"Sammy's on the Bowery." *Harper's Bazaar*, vol. 78 (September 1944), p. 88–89, 129.

Steiner, Ralph. "One Photographer's Explanation of Why France Fell." *PM's Weekly (PM's Sunday Edition)*, vol. 1, no. 31 (19 January 1941), p. 33–40.

"Sunday Fathers with Their Children." *Harper's Bazaar*, vol. 79 (July 1945), p. 58—59.

"Telepathy Goes on the Air." *Harper's Bazaar*, vol. 78 January 1944), p. 62–63, 94.

"The Greatest Show on Earth." *Harper's Bazaar*, vol. 79 (August 1945), p. 70–75.

"The Intellectual Climate of San Francisco." *Harper's Bazaar*, vol. 81 (February 1947), p. 220–23.

"The Right to Beauty." *Harper's Bazaar*, vol. 78 (October 1944), p. 94, 129–30.

"The Settlements Still Pioneer." *Harper's Bazaar*, vol. 78 (May 1944), p. 88–91.

"Their Boys Are Fighting." *Look*, vol. 6, no. 23 (17 November 1942), p. 68–73.

"They're News Because . . ." *Harper's Bazaar*, vol. 78 (February 1944), p. 98–99.

"To the Blind, Truly the Light Is Sweet." *Harper's Bazaar*, vol. 78 (October 1944), p. 100–01.

"Votes by Women." *Harper's Bazaar*, vol. 78 (June 1944), p. 60–62, 93.

"What Music Means." *Harper's Bazaar*, vol. 78 (September 1944), p. 84–87.

WRITINGS BY LISETTE MODEL

Essay. In Jonathan Greene. *The Snapshot*. New York: Aperture, 1974.

Introduction. In Charles Pratt. *The Garden and the Wilderness*. New York: Horizon Press, 1980.

New York Times (16 December 1951). [Estate]

"On the Firing Line." *U.S. Camera*, vol. 7, no. 7 (October 1944), p. 51.

"Picture as Art: Instructor Defines Creative Photography as Scientific Eye that Captures Life." *New York Times* (9 December 1951), p. 21.

1899 25 September
Evsei Konstantinovich (Evsa) born in Nicolayevsk on the Amur, to Sarah Feitzer and Constantin Model.

23 December
Victor Hypolite Josef Calas Stern marries Françoise Antoinette Félicité (Félicie) Picus, in a civil ceremony in Vienna.

1900 23 October
Birth of Salvatór Stern.

1901 10 November
Elise Amelie Felicie (Lisette) Stern born in Vienna.

1902 7 July
Birth of Gertrud (Trudi), first child of Arnold and Mathilde Schönberg.

15 December
Victor and Félicité Stern marry again, probably in a religious ceremony.

1903 23 February
Victor changes the family name from Stern to Seybert.

1909 23 May
Birth of Olga Seybert.

1918 Lisette studies piano with Edward Steuermann.

1920 Lisette becomes a student of Arnold Schönberg, in harmony, analysis, counterpoint, and instrumentation.

1921 Trudi Schönberg marries Felix Greissle.

1924–1926
Lisette studies with Marie Gutheil-Schoder.

1924 6 June
Victor Seybert dies at 9 Josefsgasse, aged 58 years, of heart failure.

1926 Félicie, Lisette, and Olga Seybert leave Vienna for Paris and Nice.

January
Lisette living in Paris, at 15 rue de la Tour in the Blum family pension.

1926–1933
She studies voice with Marya Freund.

1927 L'Esthétique opens on rue Montparnasse. It closes in 1930.

1933 For reasons which remain unclear, Lisette abruptly abandons singing and music. She discovers photography through her sister, Olga, who introduces her to darkroom techniques. She learns from Rogi André how to "see" Paris, and receives from her the only lesson in photography Lisette ever admitted to having: "Never photograph anything you are not passionately interested in." Her first subjects include Olga and Rogi, views along the Seine, street vendors and buskers, tramps, animals, fishermen, air shows, political events, her Russian friend, Georg, and Florence Henri.

1933–1934
After a conversation with Hanns Eisler, she decides to become a professional photographer.

1934 July
She starts her series of photographs of people along the Promenade des Anglais, Nice.

1934–1935
Lisette meets Evsa Model.

1935 February
Images from her *Promenade des Anglais* series are published in *Regards*.

1935–1938
Travels frequently to Italy and the Côte d'Azur, especially Milan, Trento, and Pamparato.

1936 Photographs landscapes and people in France.

October
An agent sells some of her photographs while she is in Italy.

1937 Undertakes a short apprenticeship with Florence Henri.

7 September
Evsa Model and Lisette Seybert are married in Paris. They move into 12 rue Lalande.

1938 24 March
Identity certificates are issued under the names Evsa and Lisette.

September
Famous Gambler is published in *Lilliput*.

27 September
They receive visas to leave for New York.

8 October
Evsa and Lisette arrive in New York.

December
They are living in the Master Apartments, 310 Riverside Drive.

1939 Lisette photographs Delancey Street, Battery Park, and Wall Street.
She writes to Schönberg, offering help with obtaining immigration for the Greissles.

1940 The couple now live at 50 Manhattan, apartment 6H.

31 October
Alexey Brodovitch and Ralph Steiner introduce Lisette to Beaumont Newhall and Ansel Adams. First works purchased by the Museum of Modern Art.

December
Several *Reflections* photographs published in *Cue*. For the first time, a magazine is interested in her American work.

31 December
Sixty Photographs: A Survey of Camera Aesthetics, the Museum of Modern Art, New York, until 12 January 1941, marks the creation of the Department of Photography at MOMA. *French Scene* becomes the first Model work exhibited in the U.S.A.

1940–1947
Her most productive years. She produces the majority of the photographs in her series *Reflections*; *Running Legs*; *Lower East Side*; *Sammy's*; *Nick's*; *Gallagher's*; *Lighthouse, Blind Workshop*; *Murray Hill Hotel*; *St Regis Hotel*; *Fashion Show*; *Hotel Pierre*; *Asti's*; and *Circus*; her portraits of the arts community of San Francisco; and many street scenes; as well as most of her assignments for *Harper's Bazaar*.

1941 Berenice Abbott's *A Guide to Better Photography* published; contains *Famous Gambler*.
The Greissles gain immigrant status.

January
Seven photographs by Lisette Model published under heading "Why France Fell" in *PM's Weekly*, including images from Paris, the Promenade des Anglais, and the market in Nice. Also a portrait of Model published.

February
Appearing in *U.S. Camera*, *Running Legs* photographs published for the first time.

13 April
Evsa Model exhibition at The Pinacotheca Gallery, New York, until 2 May.

17 May
Lisette Model exhibition at the Photo League, New York, until 6 June. She exhibits forty photographs, including images from *Promenade des Anglais*, *Running Legs*, and *Reflections*. Her first solo exhibition in the U.S.

27 May
Review of Photo League exhibition by Elizabeth McCausland.

13 June
At the Photo League, Lisette leads a discussion about her photographs.

July
Coney Island Bather illustrates *Harper's Bazaar* article, "How Coney Island Got That Way". Her first assignment for this publication.

October
Wall Street Banker published in *Complete Photographer*.

1942 Photographs Lower East Side extensively, war rallies. The word glamour appears in title of one of her photographs. First serious analysis of Model's photographs by Elizabeth McCausland, within the critical framework of satire.

19 January
Elizabeth McCausland and Berenice Abbott write letters to the U.S. District Attorney testifying to Lisette's political neutrality.

1 April
Photographs Fernand Léger, Piet Mondrian, and other artists at the opening of *Masters of Abstract Art* at H. Rubinstein's New Art Center, New York.

14 June
They Honor Their Sons exhibited at the A.C.A. Gallery, New York, as part of *Artists in the War*.

November
Six photographs of war rallies, "Their Boys Are Fighting", published in *Look*.

1943 Now residing at 55 Grove Street.
Photographs Paul Robeson, Joan Blondell, Pearl Primus, Georgia Sothern, Paula Laurence, Margaret Webster, Mary Martin, and Teddy Hart.

April
Lisette to Washington, where she meets Edward Steichen for the first time.

24 September
Photographs by Lisette Model, The Art Institute of Chicago, until 17 November.

October
Opening of the Photography Center, Museum of Modern Art, New York. Eight of Lisette's photographs in the opening exhibition.

4 November
Four Portraits by Lisette Model, The Art Institute of Chicago, until 7 December.

1944 Photographs settlement houses, women voting, Nick's, blind people, posters for the film "Dragonwyck", the telepath Dunniger, Raymond Daniell and Tana Long, Jean Gabin, and the Merchant Marine Rest Center, Gladstone, New Jersey.

22 March
New Workers 1 (Art in Progress), Museum of Modern Art, until 30 April.

April–May
Photographs blind people at the Lighthouse, a workshop where they work.

20 July
Naturalization papers completed in New York. Her name officially changed from Elise to Lisette Model.

25 July
Evsa's naturalization papers completed.

31 July
Contemporary Photography, A.C.A. Gallery, New York, until 31 August.

October
Her brother and sister-in-law are deported from France to Germany.

16 October
Receives news of her mother's ill health from Germaine Krull-Ivens.

3 November
Germaine Krull-Ivens notifies Lisette of her mother's death on 21 October.

1945 Photographs pianist Ray Lev; theatre rehearsals in Baltimore and Philadelphia; opera rehearsals; fathers and children; Gallagher's; and actor Richard Hart.

February
Evsa's painting *Oceanside* appears in "Time Out for Books on Art" by Jon Stroub, *Town and Country*.

6 April
The Instant in Photography, New School for Social Research, New York, until 21 April.

12 April
President Franklin D. Roosevelt dies. She photographs window displays which render him homage.

July
Harriet Janis writes and produces mock-up of *Evsa Model's American City* (never published).

1946 12–13 February
Photographs the Westminster Kennel Club Dog Show at Madison Square Gardens.

before May
Photographs Asti's Restaurant, New York.

20 June
The Museum Collection of Photography, the Museum of Modern Art, until 23 June. Second showing 2 July to 6 September.

24 June
Evsa and Lisette Model in San Francisco with friend Pauline Schubart. Evsa teaches summer course in textile design to painters at California School of Fine Arts.

July–August
Lisette establishes contacts within the photographic community of the West Coast. Photographs Robert Oppenheimer, Imogen Cunningham, Salvador Dalí, Thomas Carr Howe, Robinson Jeffers, Henry Kaiser, Dorothea Lange, Dorothy Leibes, Douglas and Jermayne MacAgy, Darius Milhaud, Henry Miller, Roger Sessions, Ansel Adams, and Edward Weston, as well as circuses. Photographs in San Francisco with Minor White.

1 August
Photographs by Lisette Model, California Palace of the Legion of Honor, San Francisco, until 31 August.

1947 Trudi Schönberg Greissle dies in New York.

1948 Official confirmation of the death of Salvatór, Lisette's brother, in a concentration camp.

6 April
In and Out of Focus: A Survey of Today's Photography, Museum of Modern Art, until 11 July.

between June and October
Photographs celebrities at the International Refugee Organization Auctions.

27 July
Fifty Photographs by Fifty Photographers, Museum of Modern Art, until 26 September.

19 October
Evsa Model, Sidney Janis Gallery, New York, until 6 November.

30 November
Four Photographers: Lisette Model, Harry Callahan, Ted Croner, and Bill Brandt, Museum of Modern Art, until 10 February 1949.

December
This Is the Photo League, Photo League, until spring 1949.

1949 Lisette applies for a Guggenheim Fellowship to produce a book on New York, its people, and its environment. Ansel Adams writes a letter of recommendation. The application proves unsuccessful.
Beaumont Newhall's *The History of Photography* is published (includes one photograph by Model).
Fifteen photographs by Lisette Model are included in the Museum of Modern Art's travelling exhibition series *Leading Photographers*, which tours until 1954.

16 June
Travels to Reno, accompanied by Evsa, on assignment for *Ladies' Home Journal*. Photographs gamblers in the casinos, women waiting for divorces at dude ranches, rodeos, and Harold's.

late August
Special instructor in documentary photography at the California School of Fine Arts, teaching mainly "Photography 2", Minor White's course. Continues until November. Goes on photographic excursions with Ansel Adams. Photographs San Francisco architecture, house façades, window reflections, street scenes, Union Square, parks, Evsa, Ansel Adams with students, and the San Francisco Opera opening.

1950 The Models take private classes with Sid Grossman. Towards the spring, Lisette immobilized by health problems. Offers her work to agencies, but without much success. Experiments with light, trees, different angles, night photography – new subjects for her.

20 October
Participates in Museum of Modern Art symposium, "What Is Modern Photography?", organized by Edward Steichen.

November
Flair refuses her photographs.

1950–1960
Photographs the people of New York sitting on benches, shadows of pedestrians, and Rockefeller Center. Photographs *Reflections*, Dorothy Pritkin, Evsa, and Christmas lights.

1951 Begins teaching at the New School for Social Research. Also begins giving private classes. Teaching draws enormously on her time and energy, and from this point on her photographic production falls. She also makes fewer prints from negatives. Death of Arnold Schönberg.

February
One of her courses in photography announced in the New School *Bulletin*.

2 March
"Function of the Small Camera in Photography Today," a workshop course by Lisette, begins. Also teaches "Photographing New York and Its People".

13 July
Twelve Photographers, Museum of Modern Art, until 12 August.

29 November
Christmas Photographs, Museum of Modern Art, until 6 January 1952.

1952 April
Launching of *Aperture*. In his article "Exploratory Camera", Minor White acknowledges his debt towards Lisette for stimulating his thinking on the miniature camera.

August
Lisette and Evsa spend the month in Provincetown. With Henrietta Brackman, she visits Hans Hofmann's studio and photographs him with his students. Conceives the idea of publishing a book of photographs of jazz musicians.

1952–1956
Works on this book, but it is never completed because of lack of funds.

1953 15 June
Returns to Europe for the first time. Spends five months in France and Italy. Photographs Paris, Vernet-les-Bains, Prades, Avignon, the Picasso Museum, Rome, Naples, Venice, Trento, and Ponza.

29 August
Contemporary American Photography, Museum of Modern Art, presented in Tokyo until 4 October.

September
As part of Senator Joseph McCarthy's witch-hunt for Communists, neighbours are questioned about Model's activities.

1954 12 August
Lisette leaves for Venezuela. She returns 10 October.
Photographs Maracaibo Indians, Caracas at night, oil derricks, infra-red landscapes, sculpture, architecture, Venezuelan Government Ministers, the University of Caracas, Armando Reverón's wife, and his studio.

November
The Models move to 247 West Thirteenth Street.

1 December
Great Photographers, including *Woman with Veil*, Limelight Gallery, until 30 December.

1954–1956
Photographs jazz musicians at the Newport Jazz Festival, Rhode Island.

1955 End of work for *Harper's Bazaar*.

24 January
The Family of Man, Museum of Modern Art, until 8 May.

1956 Photographs jazz musicians at the New York Jazz Festival, Downing Stadium, Randall's Island.

1957 Diane Arbus begins classes with Lisette.

26 November
Seventy Photographers Look at New York, Museum of Modern Art, until March 1958.

1958 The Models move to 137 Seventh Avenue South.

26 November
Photographs from the Museum's Collection, Museum of Modern Art, until 18 January 1959.

1959 Photographs Billie Holiday in her coffin.

1960 Takes over Berenice Abbott's course in advanced photography at the New School.

May
Lisette Model, Carl Siembab Gallery, Boston.

4 November
A Bid for Space #2, Museum of Modern Art, begins.

1962 Recommends Diane Arbus for a Guggenheim Fellowship.

3 April
A Bid for Space #3, Museum of Modern Art, until 13 February 1963.

1962–1964
Photographs people in parks, and the films *Kermesse*, *3 Penny Opera*, and *M*, shown on television.

1963 Diane Arbus receives a Guggenheim Fellowship.

1964 Encouraged by Arbus, Model applies a second time for a Guggenheim Fellowship, for "Glamour: The Image of Our Image". David Vestal, Edward Steichen, and Mark Schubart write her letters of recommendation.

1965 2 March
Invitational Exhibition 10, American Photographers 10 (travelling exhibition), Milwaukee, until 26 March.

17 March
Awarded Guggenheim Fellowship ($5,000).

18 October
About New York 1915–1965, Gallery of Modern Art, Columbus Circle, New York, until 15 November.

1966 January
Photographs Hugh Laing and other dancers at the Studio, New York.

after May
Travels to Los Angeles, where she stays with Marion Palfi and Martin Magner. Pursuing Guggenheim project theme "Glamour", she photographs Phyllis Diller, Hope Summers, Peter Ribman, and a Martin Magner theatre workshop production.
To Las Vegas for about one month, where she photographs stage shows, churches, and neon signs. Photographs Beatrice Wood in Ojai.

1967 17 February
Photography in the Twentieth Century, National Gallery of Canada, Ottawa, until 2 April.

2 March
Participates in "Alexey Brodovitch's Design Laboratory", an experimental workshop and conference on photography and design of the American Association of Magazine Photographers.

late October
Travels to Italy. Plans to photograph in museums in Rome, and in Sicily, Naples, and near Florence. Illness precipitates her early return to New York.

1968 29 May
Awarded honorary membership in the American Association of Magazine Photographers.

1969 6 December
The Camera and the Human Façade, The National Museum of History and Technology, Smithsonian Institution, Washington, D.C., until 8 March 1970.

12 December
The Best of the Seventies 1870 and 1970, the Floating Foundation of Photography, New York, until 5 January 1970.

1970 28 August
Awarded $2,000 over two-year period from the Ingram Merrill Foundation for "preparing a photographic study of the social and artistic history of modern times".

1970–1980
Photographs San Francisco, Lucerne, Venice, Paris, and Nice.

1971 29 October
The People Yes, the Floating Foundation of Photography, until 19 November.

1972 7 April
Brodovitch and His Influence, Philadelphia College of Art, Philadelphia, until 2 May.

1973 14 March
Receives Creative Artists Public Service Program award for $2,500.

1 June
Threads No Threads, the Floating Foundation of Photography, until 5 July.

July
Teaches summer workshop at Berkeley, California. Photographs students.

1974 Begins publication of portfolio of twelve photographs with Harry Lunn of Graphics International.

26 January
American Masters, National Museum of History and Technology, Smithsonian Institution, until 1 September.

7 December
Attitudes, and *Collector's Choice*, the Floating Foundation of Photography, until 19 January 1975.

1975 18 April
Women of Photography: An Historical Survey, San Francisco Museum of Modern Art, San Francisco, until 15 June.

June
Meets Gerd Sander.

4 November
Photographs by Lisette Model, Focus Gallery, San Francisco, until 29 November.

15 December
Christmas Group Show, the Floating Foundation of Photography, until 10 January 1976.

1976 January
Evsa suffers massive heart attack.

7 February
The Photographer and the Artist, Sidney Janis Gallery, until 6 March. Exhibits a portrait of Evsa.

1 May
A Celebration of Life Below 14th Street, the Floating Foundation of Photography, until 27 June.

25 May
Charles Pratt dies, leaving $15,000 in his will to Lisette.

25 September
Model Photographs, Sander Gallery, Washington, D.C., until 30 October.

19 October
Early in the morning, Evsa Model dies at 137 Seventh Avenue South.

20 October
Evsa's cremation at St Michael's Cemetery and Crematorium.

1977 Graphics International portfolio published. Aperture proposes a book project.

10 January
New York, the City and Its People, Yale School of Art, New Haven, until 28 January.

12 February
Appearances, Marlborough Gallery, New York, until 12 March.

25 March
The Photographs of Lisette Model, Bucks County Community College, Newtown, until 1 May.

3 May
Three Woman Show: Diane Arbus, Lisette Model and Rosalind Solomon, Galerie Zabriskie, Paris, until 21 May.

21 May
Photographs from the Collection #1: America, Philadelphia Museum of Art, until 31 July.

25 September
Photographs from the Collection of the Center for Creative Photography, Tuscon, until 30 October.

September–October
In Lucerne to work with Allan Porter on *Camera* issue devoted to her work. Photographs *Reflections*, building façades, and herself, among other subjects.

December
Twenty-four of her photographs are reproduced in *Camera*, "Lisette Model", whole issue devoted to her life and work.

1978 Lectures at the International Center of Photography, New York. Aperture book in production.

6 February
New Standpoints: Photography 1940–1955, Museum of Modern Art, until 30 April.

6 April
Photographic Crossroads: The Photo League, National Gallery of Canada, until 10 May.

July
To Arles to participate in the *Rencontres Internationales de la Photographie*. Honoured guest photographer along with Izis and William Klein. Returns to New York 12 October.

21 October
The Quality of Presence, Lunn Gallery, Washington, D.C., until 28 November.

25 October
How Photography Clicked, the Floating Foundation of Photography, until 26 November.

1979 February
Lectures at Photographic Resource Center, Morse Auditorium, Boston.

18 March
To Milan, Italy, to participate in *Salone Internazionale di Cine Foto Ottica é Audiovisivi*. Exhibits fifteen works, and gives workshop.

20 March
Lisette Model: Photographs, Vision Gallery, Boston, until 21 April.

May
Lectures at the Seattle Art Museum.

1 August
August Sander/Lisette Model, Port Washington Public Library, Port Washington, until 31 August.

10–15 September
Gives workshop in Venice entitled "Personal Encounters". Photographs architecture, people, and canals.

November
Aperture publication *Lisette Model* launched.

1980 Exhibition of Model's work at the Photographers Gallery, South Yarra, Australia.

1 April
Exhibition of Model's work at the Watari Gallery, Tokyo, until 22 April.

9 May
The Magical Eye: Definitions of Photography, National Gallery of Canada, until 22 June.

23 May
Photography of the Fifties: An American Perspective (travelling exhibition), Center for Creative Photography, until 13 September 1981.

September
Exhibition of her photographs at the Ikona Gallery, Venice, until 11 October.

5 September
Lisette Model, Galerie Fiolet, Amsterdam, until 11 October.

1981 PPS Gallery, Hamburg, Germany, includes her work in exhibition.

17 March
Carl Siembab: A Photographic Patron, Institute of Contemporary Art, Boston, until 10 May.

3 June
Lisette Model, Galerie Viviane Esders, Paris, until 11 July.

4 June
Honorary Doctor of Fine Arts awarded to Model by the New School for Social Research.

30 June
Gives lecture on her photographs in New Orleans.

1 July
Lisette Model, A Retrospective, New Orleans Museum of Art, until 16 August.

1982 *Lisette Model*, Berner-Photo Galerie, Berne.

4 April
Lisette Model, A Retrospective, Museum Folkwang, Essen, until 9 May.
Leaves New York for France and Germany.

5 April
Receives the Medal of the City of Paris.

4 July
Returns to New York.

1983 25 February
Weegee, Lisette Model, Diane Arbus, Comfort Gallery, Haverford College, until 27 March.

4 March
Gives her last lecture, at Haverford College.

16 March
Lisette Model, A Celebration of Genius, Parsons Exhibition Center, New York, until 15 July.

30 March
1:47 a.m., Lisette dies at the New York Hospital, aged 82.

1 October
Lisette Model, New York, New York, at Sander Gallery, New York, until 29 October.

1984 9 June
Lisette Model / Evsa Model: New York City, Ikona Gallery, Venice, until 16 September.

27 October
Lisette Model, Jane Corkin Gallery, Toronto, until 28 November.

1985 9 February
The New York School Photographs Part One, Corcoran Gallery of Art, Washington, D.C., until 14 April.

27 April
The New York School Photographs Part Two, Corcoran Gallery of Art, Washington, D.C., until 30 June.

30 August
Masters of the Street II, Museum of Photographic Arts, San Diego, until 13 October.

1987 17 October
Vintage Women, Photocollect, New York, until 14 November.

1988 4 April
Lisette Model Vintage Photographs, Germans Van Eck Gallery, New York, until 25 April.

1989 30 June
Noted Women Photographers of the 20's and 30's, Jan Kesner Gallery, Los Angeles, until 6 August.

22 September
New York, *Photography Between the Wars*, The Metropolitan Museum of Art, until 31 December.

LIST OF ILLUSTRATIONS

Titles of works of art are in *italics*. Works are listed alphabetically by artist's name, or, where the artist is unknown, by title or description. Unless indicated otherwise in the figure caption, all works are from the Estate of Lisette Model, held at the National Gallery of Canada.

NOTE ON THE PHOTOGRAPHS

The originals of all plates are gelatin silver prints. In dimensions, height precedes width. Titles of works are in bold; descriptions are in roman type. Unless otherwise noted, works are part of the Estate of Lisette Model, held at the National Gallery of Canada, Ottawa.

Unless otherwise specified, prints were made at or around the time of the negative. The term "printed later" applies to prints made from early negatives in the last fifteen years of her life. The dates for the images published here and in the accompanying exhibition differ considerably from those in the two previously published works on Lisette Model. The sources for the dating combined contemporary published material with the results of research on the contents of the photographs. For instance, two of the photographs from the *Promenade des Anglais* series could be assigned to a period three to four years earlier than previously specified by dating issues of *Paris Soir* visible in the photographs. A great aid in dating many of the later 35 mm negatives was the edge-coding system used by Kodak on Plus-X and Super XX film. This, along with other supporting evidence, often made it possible to date a body of work to the year; in other cases, it allowed for a date within two or three years. This method had to be used with caution, however, since Model used and purchased out-dated paper when money was short, raising the possibility that she would have used film beyond the expiry date if necessary.

The earliest prints by Model appear on 9 × 11 inch (22.8 × 27.8 cm) paper, a European paper size, and date from as early as 1933 up until approximately a year after her arrival in New York, allowing for the possibility that she might have brought paper with her. Shortly after her arrival in New York, several of her European prints were matted on roughly cut coloured bristol board stock.

As early as 1942, some of Model's negatives were being printed by someone else. For example, Berenice Abbott made a print of *They Honor Their Sons* for the A.C.A. exhibition, *Artists in the War*. It is not certain that this happened again for at least five years, at which time Edward Steichen had at least one print made by Fons Ianelli of an image from the *Promenade des Anglais* series (pl. 22). Given the narrow white borders that appear on several prints donated by Model in 1964 to the Museum of Modern Art, New York, an element unusual in her printing, it is possible that she hired a printer at this time. From the mid-seventies up until her death, she had several photographers printing for her. Among them were Richard Benson, Chuck Kelton, Sol Lopes, Gerd Sander, Gary Schneider, and Al Striano.

She does not appear to have moved to the larger, 16 × 20 inch (40.6 × 50.7 cm) print format until the early fifties, and then did not necessarily persist with this format until the mid-seventies, when her portfolio was produced by Gallery Graphics.

Images exist in variant forms altered through cropping or the flopping of the negative. The technique of cropping was central to Model's way of working. She did not believe that she could make the photographs she wanted by conforming to the square or rectangular proportions of the 2¼ inch (5.5 cm) or the 35 mm negative:

> Why should the photographer conform to two or three commercial proportions, like the square format of the 2¼ negative, or the elongated, too narrow shape of the 35 mm negative? Many photographers have the sacrosanct attitude that one must use the entire negative, and that cropping it is a sign of failure. Photography should not be compared to painting, but there is no painter who paints only in the same shape.*

The photographs that appear in this exhibition and that are reproduced in the book are generally the early prints. While the later large-format prints have the advantage of a clean elegance, the vintage prints were selected because they best express the extraordinary monumentality of her vision.

*John Flattau, Ralph Gibson, and Arne Lewis (eds.), *Darkroom II* (New York: Lustrum, 1978) p. 67–68.

1
Famous Gambler French Riviera
1934?
28.7 x 23.2 cm
National Gallery of Canada (29053)

2
New York
(man on sidewalk surrounded by legs)
between 1940 and 1941
34.2 x 26.2 cm
San Francisco Museum of Modern Art
(86.115)

3
Delancey Street New York
(man and baby carriage)
1942?
34.2 x 27.2 cm
J. Paul Getty Museum, Malibu
(84.XM.153.45)

3a
Delancey Street New York
(man and baby carriage)
1942?
34.4 x 27 cm
Center for Creative Photography, Tucson
Not reproduced in catalogue

4
International Refugee Organization Auction
New York (old man)
June, September, or October 1948
34.4 x 26.9 cm

5
Cardinal Nice
between 1933 and 1938
28.7 x 23 cm (mounted)

6
Westminster Kennel Club Dog Show New York
(woman holding dog)
February 1946
33.7 x 27 cm
J. Paul Getty Museum, Malibu
(84.XP.124.22)

6a
Untitled New York?
(dog and woman with cat on shoulder)
1946?
27.1 x 34.1 cm
Not reproduced in catalogue

7
Pedestrian New York
(woman carrying bag)
c. 1945
33.6 x 26.5 cm
J. Paul Getty Museum, Malibu
(84.XP.124.18)

7a
Pedestrian New York
(woman, half-length profile)
c. 1945
33.9 x 27 cm
Not reproduced in catalogue

8
Coney Island Bather New York
(standing)
between 1939 and July 1941
34.5 x 27.2 cm
National Gallery of Canada (29055)

9
Bois de Boulogne Paris
between 1933 and 1938
34.7 x 27.7 cm
Collection Frank and Peggy Canale,
Washington, D.C.

10
Woman with Veil San Francisco
1949
49.2 x 40.1 cm
National Gallery of Canada (20488)

11
Circus Man Nice
between 1933 and 1938 (printed later)
42.3 x 34.5 cm

12
Promenade des Anglais Nice
(lounging man)
7 August 1934 (printed 1940s)
34.2 x 27.6 cm
National Gallery of Canada (29041)

13
Blind Man in Front of Billboard Paris
between 1933 and 1938
29.2 x 22.4 cm (mounted)
National Gallery of Canada (29056)

14
Blind Man Seated on Sidewalk Paris
between 1933 and 1938
22.8 x 28 cm

15
Blind Man Walking Paris
between 1933 and 1938
28.4 x 23 cm (mounted)
Sander Gallery, New York (SG/588.9)

16
Valeska Gert, "Death"
1940
26.3 x 33.4 cm

17
Valeska Gert, "Olé"
1940
24.5 x 19.6 cm

18
Pearl Primus New York
1943
27.5 x 34.7 cm
Sander Gallery, New York

18a
Pearl Primus New York
1943
34.2 x 26.5 cm
Not reproduced in catalogue

19
Café Metropole New York
c. 1946
34.8 x 27.3 cm

20
Weegee (Arthur H. Fellig) New York
c. 1945
34.1 x 27 cm
J. Paul Getty Museum, Malibu
(84.XM.153.75)

21
They Honor Their Sons New York
between 1939 and 14 June 1942
(printed 1940s)
49.7 x 39.1 cm

22
Promenade des Anglais Nice
(woman in floral dress)
1934?
28.8 x 23.1 cm
The Metropolitan Museum of Art, New York,
Ford Motor Company Collection, Gift of Ford
Motor Company and John C. Waddell, 1987
(1987.1100.197)

22a
Promenade des Anglais Nice
(woman in floral dress)
1934?
49.5 x 39 cm
Not reproduced in catalogue

23
War Rally New York
(man with flag)
between 1941 and 17 November 1942
33 x 26 (sight)
Collection Norman and Carolyn Carr

24
Percy Pape, The Living Skeleton New York
1945
34.4 x 24.4 cm
J. Paul Getty Museum, Malibu
(84.XP.124.19)

24a
Percy Pape, The Living Skeleton
1945
35.5 x 27.9 cm
The Chrysler Museum, Norfolk, Virginia
(80.222)
Not reproduced in catalogue

25
Coney Island Bather New York
(reclining)
between 1939 and July 1941 (printed later)
39.4 x 49.5 cm

26
Running Legs, Fifth Avenue New York
(pedestrian with parcel)
between 1940 and 1942
34.1 x 27.3 cm
Collection John Erdman and Gary Schneider

27
**Albert-Alberta, Hubert's Forty-second Street Flea
Circus** New York
c. 1945
49.1 x 39 cm

28
Lower East Side New York
(dwarf in front of Belmar Hotel,
Bowery Street)
between 1939 and October 1942
34.7 x 26.1 cm
J. Paul Getty Museum, Malibu
(84.XP.124.17)

28a
Lower East Side New York
(dwarf in front of Belmar Hotel,
Bowery Street)
between 1939 and October 1942
34.5 x 27.2 cm
Collection Elaine Ellman
Not reproduced in catalogue

29
Lower East Side New York
(woman shielding her face)
between 1939 and 1945
34.5 x 27 cm
National Gallery of Canada (29050)

30
Sammy's New York
(couple at bar)
between 1940 and 1944
26 x 34.4 cm

31
Westminster Kennel Club Dog Show New York
(two bull terriers)
February 1946
25.8 x 33.8 cm
J. Paul Getty Museum, Malibu
(84.XM.153.6)

31a
Westminster Kennel Club Dog Show New York
(two bull terriers)
February 1946
33.7 x 27 cm
Not reproduced in catalogue

32
Vincennes Zoo Paris
(rhinoceros)
between 1933 and 1938
22.3 x 28.9 cm (mounted)

33
Vincennes Zoo Paris
(sea lion)
between 1933 and 1938
28.5 x 21.8 cm (mounted)

34
Vincennes Zoo Paris
(rhinoceros lying with head stretched up)
between 1933 and 1938
28.5 x 20.6 cm (mounted)

35
Vincennes Zoo Paris
(rhinoceros with open mouth)
between 1933 and 1938
28.5 x 23 cm

36
Vincennes Zoo Paris
(elephant)
between 1933 and 1938
28.5 x 22.4 cm

37
Man with Pamphlets Paris
between 1933 and 1938
49.5 x 39.4 cm

38
Woman Reading France
between 1933 and 1938
28.9 x 23 cm (mounted)

39
Sleeping on Montparnasse Paris
between 1933 and 1938 (printed 1940s)
34.6 x 42.2 cm

40
Sleeping by the Seine Paris
between 1933 and 1938
31.3 x 26.5 cm
Collection Andrew Szegedy-Maszak
and Elizabeth Bobrick

41
Young Man Asleep on Sidewalk Paris
between 1933 and 1938
22.6 x 28.8 cm
Private collection

42
Peanut Vendor Nice
between 1933 and 1938
28.9 x 22.7 cm (mounted)
J. Paul Getty Museum, Malibu
(84.XM.153.24)

42a
Man Seated on Doorstep Nice
between 1933 and 1938
28.5 x 20.8 cm
Not reproduced in catalogue

43
Man Mending Net Nice
between 1933 and 1935
28.4 x 23.3 (mounted)

44
Woman with Basket Nice
between 1933 and 1938
27 x 19.4 cm (mounted)
J. Paul Getty Museum, Malibu
(84.XM.153.25)

44a
Woman Seated on Sidewalk Nice
between 1933 and 1938
28.7 x 23 cm
Not reproduced in catalogue

45
Destitute Woman Seated on Bench France
between 1933 and 1938
28.9 x 22.6 cm (mounted)

46
Promenade des Anglais Nice
("The Poet")
1934?
28.8 x 23.3 cm
Collection Arnold Kramer and Emily Carton

47
Promenade des Anglais Nice
(woman with dog)
1934?
28.7 x 23.2 cm (irregular)
Collection Mr and Mrs Richard L. Menschel

48
Promenade des Anglais Nice
(man with cane)
1934?
28.8 x 23.2 cm (mounted)

49
Promenade des Anglais Nice
(man in checkered suit)
1934? (printed 1940s)
34.2 x 27 cm

50
Promenade des Anglais Nice
(man with bandaged ear)
1934? (printed 1940s)
34.2 x 27 cm

51
Promenade des Anglais Nice
(man with cigar)
2 September 1934 (printed 1940s)
34.5 x 27.6 cm

52
Promenade des Anglais Nice
(woman in polka dot dress)
1934? (printed 1940s)
34.4 x 26.6 cm
National Gallery of Canada (29051)

53
Promenade des Anglais Nice
(woman wearing sunglasses)
1934?
28.7 x 23.2 cm

54
Promenade des Anglais Nice
(woman kissing dog)
1934?
28.7 x 23.2 cm

55
Promenade des Anglais Nice
(woman with boa)
1934?
28.4 x 22.7 cm
Prints and Photographs Division,
The Library of Congress, Washington, D.C.
(DLC/PP/1984 :439)

56
French Riviera
("The Skinny Man")
1934?
28.7 x 23.3 cm
Museum Folkwang, Essen (84/86)

57
French Riviera
(woman and young boy)
1934?
28.7 x 23 cm
J. Paul Getty Museum, Malibu
(84.XM.153.11)

58
Promenade des Anglais Nice
(man in wheelchair)
1934?
28.8 x 23.1 cm (mounted)

59
First Reflection New York
(silhouette of man wearing fedora)
between 1939 and October 1940
42.3 x 34.6 cm
National Gallery of Canada (29360)

60
Man in Restaurant, Delancey Street New York
between 1939 and 1945
32.5 x 26.2 cm
The Metropolitan Museum of Art, New York,
Purchase, Gift of Various Donors and
Matching Funds from the National
Endowment for the Arts, 1981 (1981.1040)

60a
Reflections New York
(hats in window)
between 1939 and 1945
34.6 x 27 cm
Not reproduced in catalogue

61
We Mourn Our Loss New York
1945
32 x 27 cm
The Art Institute of Chicago, Mary and
Leigh Block Endowment Fund (1986.1383)

61a
We Mourn Our Loss New York
1945
34.5 x 27.8 cm
Not reproduced in catalogue

62
Chicken and Glamour New York
between 1939 and 1942
32.8 x 25.3 cm

63
Window New York
(top coats and light bulbs)
between 1939 and 1945
34.1 x 27.6 cm

64
Lower East Side New York
(man peering into window)
between 1939 and 1945
34.2 x 27.4 cm
Prints and Photographs Division,
The Library of Congress, Washington, D.C.
(DLC/PP/1984 :436)

65
Window San Francisco
1949
27.1 x 34.1 cm

66
Reflections, Rockefeller Center New York
c. 1945
34.5 x 27.5 cm
Collection Frank and Peggy Canale,
Washington, D.C.

67
Window, Bergdorf Goodman New York
(Ludwig Bemelmans's drawing
with legs of mannequin)
between 1939 and 1945
26.9 x 32.2 cm
J. Paul Getty Museum, Malibu
(84.XM.153.69)

67a
Window, Bergdorf Goodman New York
(Ludwig Bemelmans's drawing
with legs of mannequin)
between 1939 and 1945
55 x 40.5 cm
Not reproduced in catalogue

68
Window, Bonwit Teller New York
(man with cane reading newspaper)
between 1939 and 7 December 1940
34.7 x 28 cm
National Gallery of Canada (29037)

69
Reflections New York
(hand)
between 1939 and 1945 (printed later)
47.8 x 39.7 cm

70
Window New York
(mannequin with tattoo)
between 1939 and 1945
34.5 x 27.1 cm

71
Window, Bridal Couple New York
between 1939 and 1945
34.7 x 27.5 cm (irregular)
Collection Andrew Szegedy-Maszak
and Elizabeth Bobrick

72
Reflections, Fifty-seventh Street New York
between 1939 and 7 December 1940
34 x 27.9 cm

73
Reflections New York
between 1940 and 1945
31.6 x 26.3 cm
National Gallery of Canada (29039)

74
Reflections New York
(pedestrians looking into window)
between 1939 and 1945
27.2 x 33.3 cm
National Gallery of Canada (29038)

75
Pedestrian New York
(man with pipe)
c. 1945
33.7 x 26.3 cm

76
Pedestrian New York
(man with fedora)
c. 1945
34 x 26.8 cm

77
Pedestrian New York
(woman with beribboned hat)
c. 1945
33.7 x 26.8 cm

78
Wall Street New York
(man wearing bowler)
between 1939 and 10 October 1941
32.8 x 25.6 cm
Collection Dr Richard Sandor

79
Pedestrian New York
(woman with eyes closed)
c. 1945
33.8 x 26.4 cm

80
Pedestrian New York
(man, eyes in shadow)
c. 1945
34 x 26 cm

81
Lower East Side New York
(dwarf leaning on railing)
between 1939 and October 1942
34.7 x 27.2 cm
National Gallery of Canada (29049)

82
New York
(man on sidewalk, half-length profile)
c. 1945
34.1 x 26.5 cm

83
Lower East Side New York
(old woman in front of large car)
between 1939 and 1945
34 x 26.6 cm

84
Lower East Side New York
(small woman in sneakers carrying bag)
between 1939 and 1945
33.7 x 27 cm

85
Lower East Side New York
(woman seated on steps, holding railing)
between 1939 and 1945
34.3 x 27.1 cm
Collection Mr and Mrs Richard L. Menschel

86
Lower East Side New York
(large woman carrying bag)
between 1939 and 1945
34.5 x 26.9 cm

87
Lower East Side New York
(woman in shawl)
1942? (later print)
49.3 x 39 cm

88
Lower East Side New York
(woman with shawl pointing)
1942? (later print)
49.1 x 39 cm

89
Lower East Side New York
(woman walking dog)
between 1939 and 1946
34.2 x 27 cm

90
Lower East Side New York
(man entering restaurant)
between 1939 and 1945
34.4 x 27.1 cm

91
Running Legs, Forty-second Street New York
between 1940 and 1941 (printed 1940s)
40.5 x 48.8 cm

92
Running Legs New York
between 1940 and 1941
27 x 34.4 cm

93
Running Legs New York
between 1940 and 1941
34 x 27 cm
National Gallery of Canada (29359)

94
Running Legs New York
(car in background)
between 1940 and 1941
34.7 x 27.1 cm
National Gallery of Canada (29036)

95
Running Legs New York
between 1940 and 1941
26.9 x 34.1 cm

96
Running Legs New York
between 1940 and 1941
26.8 x 34.3 cm

97
Running Legs New York
between 1940 and 1941
27.8 x 34.8 cm
National Gallery of Canada (29358)

98
Running Legs, Forty-second Street New York
between 1940 and 1941
39 x 49.2 cm

99
Running Legs New York
(man carrying newspaper)
between 1940 and 1941
32.1 x 27.5 cm
Prints and Photographs Division,
The Library of Congress, Washington, D.C.
(DLC/PP/1984:434)

99a
Running Legs New York
(man carrying newspaper)
between 1940 and 1941
31.5 x 27 cm
Not reproduced in catalogue

100
Running Legs New York
(man carrying rolled newspaper)
between 1940 and 1941
27.6 x 34.7 cm
J. Paul Getty Museum, Malibu
(84.XM.153.49)

100a
Running Legs New York
(man carrying rolled newspaper)
between 1940 and 1941
27.6 x 34.7 cm
Not reproduced in catalogue

101
Running Legs New York
(women in rain)
between 1940 and 1941
34.2 x 27.1 cm
J. Paul Getty Museum, Malibu
(84.XM.153.59)

101a
Running Legs New York
(women in rain)
between 1940 and 1941
(printed by Gerd Sander, 1990)
34.2 x 27.1 cm
Not reproduced in catalogue

102
Running Legs, Fifth Avenue New York
between 1940 and 1941
35 x 26 cm
Museum of Fine Arts, Boston,
Sophie M. Friedman Fund (1980.453)

102a
Running Legs New York
between 1940 and 1941
34.7 x 27.4 cm
Collection Elaine Ellman
Not reproduced in catalogue

103
Running Legs New York
between 1940 and 1941
24.4 x 27.2 cm
National Gallery of Canada (29035)

104
New York
(man having shoes shined)
between 1939 and 1945
34.5 x 26.6 cm

105
Lower East Side New York
(man with trunk)
between 1939 and 1945
33.6 x 26 cm

106
New York
(woman with dog in cart)
between 1939 and 1945
34.6 x 27.3 cm
J. Paul Getty Museum, Malibu
(84.XM.153.71)

107
Sammy's New York
(couple, man with beret)
between 1940 and 1944
34.3 x 27.6 cm

108
Sammy's New York
(two male singers)
between 1940 and 1944
26.5 x 34.5 cm
National Gallery of Canada (29040)

109
Sammy's New York
(man lighting cigarette)
between 1940 and 1944 (printed later)
50 x 39.6 cm

110
Sammy's New York
(couple at table, man in fedora)
between 1940 and 1944
26.9 x 34.6 cm

111
Sammy's New York
(Tillie singing)
between 1940 and 1944
27.8 x 34.9 cm
J. Paul Getty Museum, Malibu
(84.XM.153.26)

111a
Sammy's New York
(Tillie singing)
between 1940 and 1944
27.5 x 34.9 cm
Not reproduced in catalogue

112
Lower East Side New York
("Fiesta Italian")
between 1939 and 1945
26.8 x 33.8 cm
Museum Folkwang, Essen (78/86)

112a
Lower East Side New York
("Fiesta Italian")
between 1939 and 1945
(printed by Gerd Sander, 1990)
26.8 x 33.8 cm
Not reproduced in catalogue

113
Metropolitan Opera New York
1943?
27.4 x 34.7 cm

114
Hanka Kelter New York
1945?
28.3 x 25.9 cm
Collection David Carrino

115
Nick's New York
(woman with cigarette)
between 1940 and August 1944
32.8 x 26.8 cm
J. Paul Getty Museum, Malibu
(84.XM.153.2)

115a
Nick's New York
(woman with cigarette)
between 1940 and August 1944
34 x 27.3 cm
Not reproduced in catalogue

116
Sammy's New York
(couple dancing)
between 1940 and 1944 (printed later)
50.5 x 40.2 cm

117
Female Impersonators
c. 1945
34.3 x 26.8 cm
J. Paul Getty Museum, Malibu
(84.XO.124.20)

117a
Female Impersonators
c. 1945
26.7 x 34 cm
Not reproduced in catalogue

118
Female Impersonator
c. 1945
34.4 x 26.8 cm

119
Sammy's New York
(sailor and girl)
between 1940 and 1944
34.8 x 26.9 cm
National Gallery of Canada (29034)

120
Gallagher's New York
(two men eating)
1945
28 x 34.5 cm
Collection Elaine Ellman

121
Sammy's New York
(man looking in window)
between 1940 and 1944
29 x 26.8 cm

122
Fashion Show, Hotel Pierre New York
between 1940 and 1946
34.5 x 42.2 cm

123
Asti's New York
(woman wearing feathered hat)
between 1945 and 1946
34 x 27.4 cm
J. Paul Getty Museum, Malibu
(84.XM.153.5)

123a
Gallagher's New York
("Relationship")
1944
27.5 x 34.1 cm
Prints and Photographs Division,
The Library of Congress, Washington, D.C.
(DLC/PP/1984:432)
Not reproduced in catalogue

124
Restaurant New York
(hand reaching across table)
1945
24.5 x 26.8 cm
J. Paul Getty Museum, Malibu
(84.XM.153.51)

124a
Restaurant New York
(hand reaching across table)
1945 (printed by Gerd Sander, 1990)
24.5 x 26.8 cm
Not reproduced in catalogue

125
Gallagher's New York
(woman holding glass)
1944
34.6 x 27.4 cm
J. Paul Getty Museum, Malibu
(84.XM.153.39)

125a
Gallagher's New York
(couple, woman's back)
1944
26 x 33.2 cm
Not reproduced in catalogue

126
Diana Vreeland New York
c. 1945
34.5 x 27.5 cm
Private collection

127
St Regis Hotel New York
(woman wearing pearl choker)
c. 1945
35.4 x 27.1 cm
J. Paul Getty Museum, Malibu
(84.XM.153.77)

127a
St Regis Hotel New York
(woman wearing pearl choker)
c. 1945
35.4 x 27.1 cm
Not reproduced in catalogue

128
Fashion Show, Hotel Pierre New York
(two women eating)
between 1940 and 1946
26.8 x 34.5 cm

129
St Regis Hotel New York
c. 1945
34.3 x 27.3 cm
Museum Folkwang, Essen (79/86)

130
Lighthouse, Blind Workshop New York
(man wearing cap)
1944
34.5 x 27 cm

131
Lighthouse, Blind Workshop New York
(woman in profile)
1944
34.6 x 26.9 cm

132
Lighthouse, Blind Workshop New York
(man making a broom)
1944
37 x 27.2 cm

133
Lighthouse, Blind Workshop New York
(woman weaving)
1944
29.9 x 25.5 cm

134
Circus New York
(figures in lobster costume)
1945
35.7 x 26.1 cm
J. Paul Getty Museum, Malibu
(84.XM.153.4)

134a
Circus New York
(figures in lobster costume)
1945
35.7 x 26.1 cm
Not reproduced in catalogue

135
Circus New York
(figures in bird costume)
1945
35.2 x 25.5 cm

136
Circus New York
("The Flying Wallendas")
1945
34.1 x 26.1 cm

137
Circus New York
("The Flying Wallendas")
1945
34.6 x 27 cm

138
Circus New York
("The Flying Wallendas" — trapeze artist)
1945
34.6 x 26.7 cm

139
International Refugee Organization Auction
New York (Oscar Homolka)
June, September, or October 1948
32.8 x 25.6 cm
Collection Dr Richard Sandor

140
International Refugee Organization Auction
New York (Mrs Holly Marcus)
June, September, or October 1948
34.1 x 26.4 cm

141
International Refugee Organization Auction
New York (James Mason)
June, September, or October 1948
34 x 24.5 cm

142
International Refugee Organization Auction
New York (two men consulting catalogues)
June, September, or October 1948
34 x 24.8 cm

143
Opera San Francisco
(couple, woman wearing long gloves)
1949
49.7 x 39.9 cm
National Gallery of Canada (29046)

144
Opera San Francisco
(woman with corsage)
1949
33.8 x 26.6 cm

145
Westminster Kennel Club Dog Show New York
(woman with glasses holding dog)
February 1946
Dimensions unknown
Collection Edward R. Downe, Jr

146
Opera San Francisco
(woman shielding face)
1949
34.5 x 27.8 cm

147
Dorothea Lange San Francisco
1946
34.3 x 26.8 cm
National Portrait Gallery, Smithsonian
Institution, Washington, D.C. (NPG.82.140)

147a
Dorothea Lange San Francisco
1946 (printed by Gerd Sander, 1990)
34.3 x 26.8 cm
Not reproduced in catalogue

148
Evsa Model New York
c. 1950
34.3 x 26.3 cm

149
Henry Miller San Francisco
1946
34 x 25.6 cm

150
Frank Sinatra New York
between 1939 and 1944
32.3 x 24.5 cm

151
Murray Hill Hotel New York
(profile of woman)
between 1940 and 1947 (printed later)
49.7 x 39.1 cm

152
Murray Hill Hotel New York
(man at table)
between 1940 and 1947
34.8 x 27.9 cm

153
Murray Hill Hotel New York
(woman seated in chair)
between 1940 and 1947
34.7 x 28 cm

154
Murray Hill Hotel New York
(man reading magazine)
between 1940 and 1947
34.7 x 27.7 cm

155
Dylan Thomas New York
probably 1953
34.4 x 24.1 cm
J. Paul Getty Museum, Malibu
(84.XM.153.43)

155a
Dylan Thomas New York
probably 1953
(printed by Gerd Sander, 1990)
34.4 x 24.1 cm
Not reproduced in catalogue

156
J. Robert Oppenheimer San Francisco
1946
34.4 x 25 cm
National Portrait Gallery, Smithsonian
Institution, Washington, D.C. (NPG.82.143)

156a
J. Robert Oppenheimer San Francisco
1946
33.9 x 26.4 cm
Not reproduced in catalogue

157
Edward Weston San Francisco
1946
34.3 x 26.8 cm

158
Reno
(woman at rodeo)
1949
34 x 27 cm
J. Paul Getty Museum, Malibu
(84.XM.153.63)

158a
Reno
(woman at rodeo)
1949 (printed by Gerd Sander, 1990)
34 x 27 cm
Not reproduced in catalogue

159
Street at Night Reno
1949
34 x 26 cm

160
Harold's Reno
(man in front of mural of dice)
1949
33.3 x 25.4 cm
Museum of Fine Arts, Boston, A. Shuman
Collection (1986.598)

160a
Harold's Reno
(man in front of mural of dice)
1949
34.5 x 27.6 cm
Not reproduced in catalogue

161
Reno
(couple playing cards)
1949
34.4 x 27.5 cm

162
Reno
("Play mainly for fun
and y'won't get stung")
1949
33.6 x 26.1 cm

163
Reno
(woman putting coin in slot machine)
1949
34.4 x 26.1 cm

164
Reno
(woman with purse)
1949
34.7 x 26 cm

165
Reno
(young woman playing slot machine)
1949
34.8 x 25.6 cm

166
Reno
(woman in a bar)
1949
30.4 x 23.2 cm

167
Belmont Park New York
1956
33.5 x 27.1 cm

168
Ella Fitzgerald
c. 1954
34.9 x 27.5 cm
National Portrait Gallery, Smithsonian
Institution, Washington, D.C.
(T/NPG.88.62)

168a
Ella Fitzgerald
c. 1954
34.8 x 27.5 cm
Not reproduced in catalogue

169
Erroll Garner New York Jazz Festival,
Downing Stadium, Randall's Island
between 1956 and 1961
33.1 x 27.4 cm

170
Bud Powell New York Jazz Festival,
Downing Stadium, Randall's Island
between 1956 and 1958
34.9 x 27.5 cm

171
John Lewis New York Jazz Festival,
Downing Stadium, Randall's Island
between 1956 and 1961
34.7 x 26.8 cm

172
Louis Armstrong
between 1954 and 1956
26.7 x 34.8 cm
National Portrait Gallery, Smithsonian
Institution, Washington, D.C. (NPG.82.138)

172a
Louis Armstrong
between 1954 and 1956
34 x 26.5 cm
Not reproduced in catalogue

173
Horace Silver Newport Jazz Festival,
Rhode Island
between 1954 and 1957
24.7 x 33 cm

174
Fritzie Scheff
1948 or 1949
26.6 x 33.9 cm

175
Percy Heath New York Jazz Festival,
Downing Stadium, Randall's Island
between 1956 and 1961
42.3 x 34.5 cm

176
Chico Hamilton Newport Jazz Festival,
Rhode Island
1956
27 x 34.9 cm

177
Percy Heath and Gerry Mulligan
Music Inn, Lenox
c. 1957
35 x 27.4 cm

178
Newport Jazz Festival, Opening
1954 or 1956
35 x 25.3 cm

179
Rome
(Roman sculpture of head)
1953
34.5 x 42 cm

180
Rome
(fragments of sculpture)
1953
34.2 x 42 cm

181
Rome
(reclining figure, Villa d'Este)
1953
39.3 x 49.3 cm

182
Rome
(fountain with lion's head, Villa d'Este)
1953
31.2 x 23.5 cm

183
Rome
(sun face)
1953
34.5 x 27.4 cm

184
Rome
(head of Hadrian?)
1953
42.3 x 34.6 cm

185
Studio of Armando Reverón Venezuela
(doll in front of sewing machine)
1954
38.4 x 49.4 cm

186
Studio of Armando Reverón Venezuela
(group of dolls)
1954
25.2 x 34 cm

187
Studio of Armando Reverón Venezuela
(doll)
1954
49.9 x 39.8 cm

188
Studio of Armando Reverón Venezuela
(sewing machine)
1954
25.5 x 34 cm